THE ARTS OF INDIGENOUS HEALTH AND WELL-BEING

THE ARTS OF INDIGENOUS HEALTH AND WELL-BEING

Edited by

NANCY VAN STYVENDALE,

J.D. McDOUGALL, ROBERT HENRY,

and ROBERT ALEXANDER INNES

UNIVERSITY OF MANITOBA PRESS

The Arts of Indigenous Health and Well-Being
© The Authors 2021

25 24 23 22 21 1 2 3 4 5

University of Manitoba Press
Winnipeg, Manitoba, Canada
Treaty 1 Territory
uofmpress.ca

Cataloguing data available from Library and Archives Canada
ISBN 978-0-88755-939-6 (PAPER)
ISBN 978-0-88755-943-3 (PDF)
ISBN 978-0-88755-941-9 (EPUB)
ISBN 978-0-88755-945-7 (BOUND)

Cover image by J.D. McDougall
Cover design by Kirk Warren
Interior design by Karen Armstrong

Printed in Canada

This book has been published with the help of a grant from the
Federation for the Humanities and Social Sciences, through the Awards
to Scholarly Publications Program, using funds provided by the
Social Sciences and Humanities Research Council of Canada.

The University of Manitoba Press acknowledges the financial support for
its publication program provided by the Government of Canada through
the Canada Book Fund, the Canada Council for the Arts, the Manitoba
Department of Sport, Culture, and Heritage, the Manitoba Arts Council,
and the Manitoba Book Publishing Tax Credit.

A portion of the royalties from the sale of this book will be donated to
support the programs of the Saskatchewan Aboriginal Writers' Circle Inc.

Funded by the Government of Canada | Canadä

For Dr. Jo-Ann Episkenew, whose word medicine
continues to inspire our collective commitment to
the arts of Indigenous health and well-being.

CONTENTS

PART 3: HEALING LAND, BODY, AND TRADITION

PART 4: RESISTANCE, RESURGENCE, AND "IMAGINING
 OTHERWISE"

"ART FOR LIFE'S SAKE":
Approaches to Indigenous Arts, Health, and Well-Being

NANCY VAN STYVENDALE, J.D. McDOUGALL,
ROBERT HENRY, AND ROBERT ALEXANDER INNES

In *Why Indigenous Literatures Matter* (2018), Cherokee literary scholar Daniel Heath Justice asserts the centrality of the arts to Indigenous peoples' survival and futurity, highlighting his preference for Cherokee-Appalachian poet Marilou Awiakta's concept of "art for life's sake" over the more familiar dictum "art for art's sake" (20–21). Justice frames the latter construction as a now outmoded aestheticist celebration of art that "exists independent of social usefulness or value beyond particularly elevated notions of beauty" (20). In Indigenous contexts, as Awiakta's phrase suggests, the arts— or creative expressions more broadly—are commonly recognized as integral components of culture, politics, spirituality, history, governance, economics, and other aspects of national, community, and individual identity (Cameron 2010; Muirhead and de Leeuw 2012; Settee 2013). As Linda Archibald et al. (2012, 4) stress, "for many Aboriginal people, traditional healing, culture, spirituality, and the arts are often so interconnected that attempts to speak of any one in isolation of the others [make] no sense at all." The very idea of "art for life's sake" gets to the heart of this edited collection, which focuses on the intersection of the arts with the health and well-being—the *life*—of Indigenous peoples, gesturing toward the centrality of both everyday and professional creative practices to what many Indigenous peoples describe as the "good life"—or *miyo pimâtisiwin* in Cree, one of

the primary Indigenous languages of Treaty 6 territory and the Métis homeland where the editors of this collection live.

Cree poet and Elder Louise Halfe, one of this volume's contributors, looks to the meaning of the word *pimâtisiwin* (or "life") in her chapter, pointing out that "at a deeper level" it "means 'the blowing life of the wind,' which is life and is sometimes referred to as culture." Others define the good life as "being alive well" (Dana-Sacco 2012, 10), as "'a worthwhile life,' 'a long, fulfilling life,' 'our walk in life'" (Debassige 2010, 17–18), and as an all-encompassing term rooted in wider understandings of ecological, spiritual, ethical, social, and political wellness rather than being limited to physiological health (Adelson 2000; Gross 2002; Gaudet 2016; Gehl 2017; Hart 2002). Although there is much more depth to this concept than we can know or discuss here, Halfe's description above is significant in that it gestures toward the relationship between Indigenous understandings of wellness and the natural world—in this case, the wind that animates the good life. This connection between human and non-human entities or relations, as Indigenous ontologies make clear, is core to the good life—to life itself. As Elder George Brertton explains in the video *Wahkohtowin: The Relationship of Cree People and Natural Law* (2009), "all things that were created are related—trees, grass, and rocks. We are related to everything." Many of the chapters in this collection advance a similar understanding of one's own good life as inseparable from the good life of others and, by extension, the good life of the whole. These chapters show the connection between the good life of the whole and the arts, broadly defined here as creativity and creative expression. As Gail MacKay and others in this collection assert, traditional values/knowledges such as *miyo pimâtisiwin*, *wîcihitowin* ("helping and supporting each other"), and *wahkohtowin* ("kinship") are embodied in and transmitted through the arts.

Crucially, the essential place of the arts in Indigenous communities is put into high relief by laws and policies enforced by the 1876 Indian Act in Canada and the 1883 "Code of Indian Offenses" in the United States. Both laws banned and ultimately attempted to eliminate creative socio-cultural activities, "including, amongst many, feasting and gifting rituals, petroglyphing, body ornamentation, singing, dancing, drumming, weaving, basket making, and carving" (Muirhead and de Leeuw 2012, 2). These Indigenous expressions of presence "were

simultaneously art, creative expression, religious practice, ritual models and markers of governance structures and traditional heritage, as well as maps of individual and community identity and lineage" (2). The endgame of the settler colonial agenda embedded in such laws and policies was not only to eliminate Indigenous arts and culture but also, in so doing, to destroy the social and political foundations of nationhood contained therein. Legislative bans on Indigenous cultural and artistic traditions enact a cultural genocide with the purpose of eliminating Indigenous peoples *as peoples* and therefore eliminating Indigenous life altogether (see Dorries et al. 2019; Morgensen 2013; Veracini 2010; Wolfe 1994). However, as the proliferation of the above and other more recently developed artistic genres (e.g., the film, literature, popular music, urban graffiti, and digital media discussed in this collection) attests, Indigenous arts have continued to survive—indeed thrive—despite this history of colonial suppression.

The above insights are common sense to many Indigenous peoples, but the field of Indigenous health, specifically arts and health research, has recently begun to recognize the fundamental connection between the arts and Indigenous health and well-being, in particular the uptake of visual and arts-based research methods in Indigenous health research (Gabel, Pace, and Ryan 2016; Hammond et al. 2018). In 2010, researchers explained that the field of arts and health in Canada had gained traction only in the past few years; "before that, arts and health initiatives were mostly unrecognized" (Cox et al. 2010, 109). Indeed, the researchers noted, it was only in the 1980s that the federal government identified "culture as one of 12 determinants of health . . . and, in the 1990s, . . . [that] research-based theatre and other arts-based methods" were introduced in health research (110). In 1996, the Royal Commission on Aboriginal Peoples (RCAP) documented the connection between the arts and Indigenous health specifically, and in the ensuing years there has been a "growing body of evidence . . . that art is beneficial in healing processes, cultivation of good health, and maintenance of well-being for individuals and communities, particularly for Aboriginal peoples" (Muirhead and de Leeuw 2012, 2–3). Shaped largely by the concerns of health researchers and the communities with which they work, the field of Indigenous arts and health has focused primarily on the following concerns: the therapeutic function (and limitation) of the arts (Fontaine 2011; Guerin et al. 2011; Hill 1995); the

role of the arts in community cohesion, resilience, and positive health outcomes (Fanian et al. 2015; Sasakamoose et al. 2016); and the use of art as a method for health research (Boydell et al. 2012; Flicker et al. 2014).

Certainly, much of this research has moved beyond a strictly biomedical definition of health as the "absence of illness" to consider the social determinants of health and a more holistic approach to well-being resonant with Indigenous epistemologies, yet the vast majority of this work remains anthropocentric. By focusing narrowly on human individuals and their singular social contexts as the sites and sources of health and well-being, the field risks overlooking the relational web of human and other-than-human beings within which our collection argues that health and well-being must be understood. Furthermore, there remains an emphasis on the well-known disparities between Indigenous and non-Indigenous peoples' health (Goulet et al. 2011; Kirmayer, Brass, and Tait 2000) and a suggestion that the arts can function as a remedy. The persistent call to address such disparities, though important, can also be seen to rehearse what Eve Tuck (2009, 409) calls a "damage-centred approach" to research—in other words, an emphasis on the systemic oppression and related traumas endured by Indigenous peoples to the possible exclusion of other emphases—for example, in the health context, on a range of creative, joyful, fulfilling, and empowering ways of being and living in the world. As the chapters in this volume attest, creative and artistic practices often embody, celebrate, and carry forward knowledge of Indigenous ways of "being alive well" (Adelson 2000), not always as a response to existing health disparities, but in their own right.

In *Determinants of Indigenous Peoples' Health: Beyond the Social*, Greenwood, de Leeuw, Lindsay, and Reading (2015) extend the expected focus and methodological range of research on Indigenous health, interspersing the works of Indigenous creative writers with more conventional health research. They observe that "it is impossible to parse a medicalized or even socially determined perspective on health from a humanities-informed vision about what makes Indigenous communities and peoples whole and well: song, ceremony, story, land, and poetry all make Indigenous peoples well" (xix). Taking a literary scholar's perspective, the late Jo-Ann Episkenew's path-breaking *Taking Back Our Spirits: Indigenous Literature, Public Policy, and Healing* (2009)

recognizes the importance of Indigenous literature and the arts more generally in contesting colonial myths and enacting well-being through narrative and self-expression. Episkenew's work is especially significant in the way that it unites a humanities approach to artistic production and literary analysis with health research and policy analysis. Taking inspiration from the above works, our collection extends their crucial recognition of the significance of artists and the arts to Indigenous well-being, turning primarily to artist-scholars and academics from the discipline of Indigenous Studies, many with a humanities focus. Humanities scholars bring a characteristic close attention to the particulars of creative works and gesture toward how *reading* itself, in the broadest possible sense of analysis and interpretation, is also an integral part of well-being.

The idea for *The Arts of Indigenous Health and Well-Being* arose from the 2013 meeting of the Native American and Indigenous Studies Association (NAISA), held in Saskatoon at the University of Saskatchewan. NAISA is an international and interdisciplinary professional organization for scholars, graduate students, independent researchers, and community members interested in issues affecting Indigenous peoples. As members of the local organizing committee for the Saskatoon gathering, co-editors Henry, Innes, and Van Styvendale applied for and received a Canadian Institutes of Health Research (CIHR) grant to support the dissemination of materials from the conference. We reviewed the conference program and attended relevant sessions in order to determine potential contributors to an edited collection on health. Our first collection, *Global Indigenous Health: Reconciling the Past, Engaging the Present, Animating the Future* (Henry et al. 2018), published by the University of Arizona Press, focuses on an interconnected range of local and global health issues, including the ethics and history of Indigenous peoples' health and health research; the centrality of environmental and ecological health to Indigenous peoples; the impacts of colonial violence, particularly on Indigenous kinship relations; and the role of health activism and collaborative community-based research in addressing health concerns. What we found during the first stages of assembling *Global Indigenous Health*, however, was that there was a substantial number of scholars working in the area of health and the arts. Rather than inviting only a few of these scholars to contribute to the first collection, we decided to develop an

additional collection that would do justice to the rich array of scholar-ship in this nascent field.

As a discipline, Indigenous Studies is inherently transdisciplinary, as are the chapters in this collection. Although the existing field of arts and health research is primarily the result of health researchers interested in the therapeutic and/or research capacity of the arts, our collection brings together scholars, artists, and community members with a range of disciplinary, artistic, and experiential knowledge, ex-tending the focus of arts and health research to consider the ability of the arts to represent and (re)imagine Indigenous health and wellness beyond the biomedical model or even the social determinants of health. In addition to arts-based health researchers (Pandey et al.), we feature artists with experiential knowledge of dance (Akinleye), music (Diamond), poetry (Halfe; Noodin), and performance arts (Kuppers), as well as humanities scholars, social scientists, and education scholars working in the fields of literary theory (Hellegers; Riley-Mukavetz), cultural rhetorics (MacKay; Riley-Mukavetz); linguistics (Halfe; Noodin); digital humanities (Recollet); gender studies (Hellegers; Kuppers; Recollet; Riley-Mukavetz); disability studies (Kuppers); ethnomusicology (Diamond); and film (Dragone). Because of this disciplinary diversity, the work in the collection is methodologically rich, featuring literary, film, music, and multimedia analysis; archival research; arts-based research; research creation; and a noted emphasis on community-engaged work, including with artists, arts-program facilitators, and community members.

The collection is organized into four sections: "Material Culture, Embodiment, and Well-Being," "Community Health and Wellness," "Healing Land, Body, and Tradition," and "Resistance, Resurgence, and 'Imagining Otherwise.'" Although each section has a distinct focus, elaborated in the section and chapter summaries below, the collection as a whole has a number of overlapping themes that together articu-late crucial insights into the relationship among the arts, health, and well-being. One such insight is that the arts enact Indigenous histories, cultures, and knowledges, deepening the relationality (Macdougall 2010; Wilson 2003) among individuals, communities, nations, and spaces, all of which are essential to holistic health and well-being. The arts thus impart and transfer knowledge across generations and geographies, contributing to the cultural and economic health of

communities, articulating and strengthening collective identities, and connecting Indigenous communities to each other and to non-Indigenous communities, both locally and globally. The arts share ancient and contemporary knowledge specific to health and healing, including particular ceremonies and ceremonial practices and protocols, as well as models for living the good life or living well in the world: from understandings of kinship which extend beyond the heteropatriarchal, biomedical, colonial model of kin, to transnational alliances and political organizing, to robust relationships with the land beyond colonial geographies. The arts are able to critique the colonial present and gesture toward decolonial, Indigenous futurities.

Part 1: Material Culture, Embodiment, and Well-Being

This section explores a variety of interactions between body, material culture, and well-being. The authors read physical engagements (sometimes their own) with cultural items and theorize the places of these items within their local Indigenous knowledge systems. The chapters highlight how material culture and embodied practices function to connect participants to the larger relational nexus in which such practices are situated and invite participants to inhabit and enact Indigenous epistemologies of relationality. From a beaded medicine pouch (MacKay) to a jingle dress (Akinleye), baskets, birchbark scrolls, and rock paintings (Riley-Mukavetz), material culture reflects and contains the relationships that inform its making and thus forges and strengthens the various relationships that makers have with a range of ancestral, contemporary, and other-than-human beings. For these authors, relationships are at the core of health and well-being, and material culture re-members these relationships. As acts of decolonization, embodied practices such as those described in this section, including the *making* of history (Riley-Mukavetz), the public performance of dance (Akinleye), and even research itself (MacKay), contribute to the health and well-being of Indigenous peoples.

Anishinaabe-Métis professor of Education Gail MacKay begins the collection with an interdisciplinary analysis of a cultural artifact—specifically, a beaded pouch—in "What This Pouch Holds." Drawing from the field of cultural rhetorics, which looks to the "material, embodied, and relational aspects of research and scholarly production" (Riley-Mukavetz), MacKay provides a model for how to make meaning of

a cultural artifact through a detailed reading of its physical features and visual symbols. She draws also from the principles of Anishinaabe pedagogy, which emphasize the importance of self-directed inquiry in meaning making. She reads the pouch in light of the Anishinaabe philosophy of *pimadizewin/bimaadiziwin* (or "being alive well/the good life"), which she sees as embodied and "held" by the pouch. This philosophy underscores the importance of respect for all things, the balance among elements, and the importance of relationships—in this case, with the pouch as an animate subject, with the Elder/teacher who gifted MacKay the pouch, and with aspects of the wider environment contained and metaphorized in the pouch (e.g., deerhide, vegetation, insect life, etc.). The model that MacKay provides is a "culturally re-storative approach" that informs and sustains Indigenous wellness in a number of ways: first, by identifying the existence and coherence of the Anishinaabe philosophy of *pimadizewin/bimaadiziwin* through her reading of the pouch, MacKay contributes to her own wellness and sense of place within a particular cultural and epistemological reality; second, in reminding her of how to be in a good relation with the "human and wider environment," the pouch contributes to the surviv-ance (Vizenor 1998) of Anishinaabe ways of being and knowing and strengthens Anishinaabe relations with others. MacKay concludes the chapter by suggesting how her model provides a culturally appropriate Anishinaabe exercise that can be adapted to be used with youth in ele-mentary and secondary schools to affirm their own senses of meaning making and cultural continuity.

In "Baskets, Birchbark Scrolls, and Maps of Land: Indigenous Making Practices as Oral Historiography," Anishinaabe scholar Andrea Riley-Mukavetz provides a theoretical meditation on the *making* of Indigenous oral history—what she calls Indigenous oral historiography. She discusses a "complex set of constellated practices," including bas-ket making, storytelling, mapmaking, birchbark biting, rock painting, and mothering, through which Indigenous people, and in particular Indigenous women, *make* history. She advances an approach to making oral history that emphasizes relationality, materiality, and embodiment as she asks how the making of oral history connects to wellness through embodied practices of decolonization. Turning to the works of Lisa Brooks (Abenaki), Louise Erdrich (Anishinaabe), and Elder Frances Manuel (Tohono O'odham) in collaboration with anthropologist

Deborah Neff as examples, Riley-Mukavetz demonstrates how the process of making history can be part of imagining a decolonial future in that it connects makers to their ancestors, including the land as an ancestor. In the material practice of birchbark biting or basket making, for example, creators are connected to the intergenerational relational nexus in which such practices take place. Making history thus allows the maker to "practise relationality" and enliven intergenerational knowledge transfer. Threaded through the chapter is a call for readers to pay attention to how bodies function in making oral history. As Riley-Mukavetz asks, "what happens to the making of oral history when our bodies are healthy and well ... [or] when our bodies are sick and dealing with trauma?"

In Chapter 3, "For Kaydence and Her Cousins: Health and Happiness in Cultural Legacies and Contemporary Contexts," artist-scholar Adesola Akinleye discusses the process of creating a performance piece for Indigenous youth entitled *Rose's Jingle Dress*, which she did on the occasion of her *tiyospaye* (Lakota model of extended family/kin group) niece Kaydence's birth. The chapter combines story, personal reflection, and academic analysis to suggest that both the process of creating and the act of experiencing this contemporary dance performance piece contribute to and reflect the notion of being "in relationship," a core component of Lakota ontologies and epistemologies. Taking a strengths-based approach to her artistic production, which recognizes and celebrates the process of making a jingle dress for Lakota youth, Akinleye critiques colonial logics of fragmentation and the dualistic divide of mind/body and demonstrates how contemporary Indigenous art embodies the interconnectedness of individual, community, and environment necessary for health and well-being. The collaborative, relational underpinnings of the dance are seen first in the process of creation, which involved collaboration between Indigenous youth and Elders, and second in the performance itself, which built intentional opportunities for audience engagement into its structure. Ultimately, Akinleye shows how the making of a jingle dress, as a component of Lakota material culture, is not the making of an "object" in the conventional sense but a relational nexus that heals colonial fragmentation and invites an embodied experience of Indigenous ways of being in relationship.

Part 2: Community Health and Wellness

This section focuses on community expressions of health and well-being, bringing into focus the perspectives of artists and arts program facilitators on the role of the arts for the collective, as well as turning to Indigenous literatures as models for community relations and sovereignty. Using community-based research, the two chapters analyze the importance of the arts to community cultural and economic resilience (Rosen) and youth empowerment (Pandey et al.), respectively. In both chapters, artistic and cultural practices promote the health and well-being of wider relationship networks. Again, as in the first section, we see how artistic products and practices contain Indigenous knowledges and values related to living well.

In "Stories and Staying Power: Artmaking as (Re)Source of Cultural Resilience and Well-Being for Panniqtumiut," settler Canadian scholar Alena Rosen discusses the insights gained through her community-based research with Inuit artists and community members from Pangnirtung, Nunavut. Art, she finds, is a source of community well-being and cultural resilience, a primary cultural value for Inuit. Although resilience is an important concept in much health research, Rosen draws attention to the crucial distinction between Western definitions of resilience, which tend to invoke a linear narrative about the individual and their "capacity to spring back from adversity," and Indigenous (specifically Inuit) conceptions, in which the focus is on the collective and the cultural, as well as the individual and the family. She uses the term "cultural resilience" to "describe the character of Indigenous communities engaged in the preservation and rehabilitation of cultural heritage." Through qualitative analysis of interviews with Inuit artists, Rosen shows how Inuit art provides a "visual" oral history that passes down traditional stories, records and authorizes personal and collective experiences and events, and encourages knowledge exchange across generations. Her chapter is also important for the way that it traces the historical context of art production in Pangnirtung, pointing to the role of art in early trade relations and the ongoing commercial success of the Inuit art market. This success gestures toward the significance of art to the economic health of Indigenous communities, as well as the ways in which it can promote intercultural and international relations and understanding of Indigenous peoples.

Chapter 5, "Healthy Connections: Facilitators' Perceptions of Programming Linking Arts and Wellness with Indigenous Youth," presents the work of a diverse team of community and university researchers who worked for over ten years in arts-based health research in southern Canada. Building upon existing research that has shown the negative impacts of colonization on Indigenous health, as well as art's positive effects, the authors analyze the outcomes of three art programs for Indigenous youth, specifically from the perspective of program facilitators. These programs included a mask-making workshop for elementary school–aged children, a graffiti wall project for teens, and the creation of a documentary video by a group of young adult upgrading learners. Through a thematic analysis of interviews with the facilitators, the researchers show that the programs contributed in a "holistic way to participants' self-perception and cultural health and creat[ed] community assets through the arts." Whereas many studies of arts-based interventions focus on individualized health benefits, this chapter is unique in examining how specific social situations and interactions—between participants themselves, participants and facilitators, and participants and their wider communities—lead to transformative change in participants and, arguably, facilitators and communities. As the researchers stress, the collaborative nature of the art projects created a space for enacting traditional values, including the Cree value of *wicihitowin*, which means "helping and supporting each other," and underscored the importance of balance between individual responsibility and working together to support others. In addition to building particular skills in communication, conflict resolution, self-expression, and teamwork, the youth produced tangible products for their communities, which helped to build and solidify community relations. These creations, the researchers observe, were "gifts" to the communities. As such, the artwork "strengthened community ties, reconstructed history, and affirmed positive individual identities and the identities of the communities at large."

Part 3: Healing Land, Body, and Tradition

The third section focuses on the role of artistic and cultural practices in the healing of individuals, nations, and the land, all of which have experienced forms of trauma and grief, particularly as a result of ongoing

settler colonialism but also as a result of inter-Indigenous conflicts. From the pain of personal loss (Dragone) to the duress of the residential school system (Diamond) and the suffering of the land (Kuppers and Noodin), this section explores the intergenerational character of trauma and grief and how arts and culture—including song, ceremony, film, and performance—are forms of personal, national, and ecological healing as well as resistance. Building upon the considerable body of work on the role of the arts in healing, these chapters offer novel insights into the importance of recovering and sustaining long-held Indigenous tradi-tions of addressing trauma, such as the Mohawk condolence ceremony (Dragone), the healing power of the drum (Kuppers and Noodin), and the Indigenization of imposed colonial education—in this case, the music education of the residential schools (Diamond). Like others in the collection, this section also foregrounds the centrality of Indigenous epistemologies of the "good life" (Kuppers and Noodin) and the "good mind" (Dragone), carried in language and oral tradition, to the health and well-being of Indigenous peoples.

In Chapter 6, "The Doubleness of Sound in Canada's Indian Residential Schools," settler musician and ethnomusicologist Beverley Diamond turns to historical sources to analyze how sonic expressions were used in the Indian residential school (IRS) system, which operated in Canada from the late nineteenth century to 1996. Extending work on the role of the arts in healing (Archibald 2012; Castellano 2010; Igloliorte 2009), Diamond offers the important caution that, though music and other forms of expressive culture have often been aligned uncritically with healing, they can be experienced in multiple ways. In the IRS system, she argues, sonic expression was used not only as a mechanism of control but also as a form of student resistance and resil-ience—what she calls a "doubleness of sound." From incessant buzzers to Christian hymns, sound was used to discipline and assimilate, but it also functioned at times to "soften" the impact of this disciplinary regime, providing the children with a modicum of pleasure, a sense of achievement, and self-esteem. Diamond also highlights many instances of active resistance in which the children engaged in "resistant listen-ing," indigenized the songs that they were taught, found spaces for their own sonic expressions "beyond the reach of hearing," and subverted the colonizers' songs through parody. In conclusion, she turns to the work of contemporary Indigenous musicians who enact what she calls

"expressive sovereignty," honouring intergenerational IRS survivors, using music as a component of personal healing, and situating the IRS legacy in its larger contemporary settler colonial context.

In Chapter 7, Nicholle Dragone (Lakota), a professor of Native American Studies who grew up in Haudenosaunee territory, illuminates traditional Haudenosaunee teachings about grief, healing, and the good mind as represented in Mohawk film director and multimedia artist Shelley Niro's directorial debut *Kissed by Lightning* (2009). Through the story of Mavis Dogblood, a painter who suffers from depression after losing her husband, Niro's film contemporizes traditional oral teachings about the first condolence ceremony, which took place over 1,000 years ago when the Peacemaker met and assisted Hiawatha, similarly grieving the loss of his partner, as well as his child. The condolence ceremony helped to restore Hiawatha (and later Mavis) to a "peaceful, rational, and healthy" state of mind—what the Haudenosaunee call a "good mind." The principle of the good mind, Dragone explains, was also instrumental in the union of the original Five Nations—Mohawk, Oneida, Onondaga, Cayuga, and Seneca—in what is now known as the Haudenosaunee or Six Nations Confederacy (Tuscarora joined in 1722). This was a peaceful union of once warring nations facilitated by the Peacemaker and Hiawatha after the latter had been restored to a good mind. "When people work for peace and the good mind," Dragone emphasizes, "they work together for a common purpose. Their unity of purpose is strength." A good mind restores balance and acknowledges the relationships with and responsibilities of the people to each other and to all beings, seven generations forward and backward. The condolence ceremony is both a spiritual and a legal ritual that operates at the level of the individual and the nation: it can heal an individual who suffers loss, as well as a nation after it suffers the loss of a leader. Ultimately, healing in this chapter takes on a communal character: relationships between individuals and, on a socio-political level, between clans and nations are integral to Haudenosaunee health and well-being.

The final chapter in this section is "*Minobimaadiziwinke* (Creating a Good Life): Native Bodies Healing" by settler scholar, disability culture activist, and community performance artist Petra Kuppers and Anishinaabe professor of Linguistics and poet Margaret Noodin. Describing their rich experience as members of the Swamp Singers, an Anishinaabe drum group with Indigenous and non-Indigenous

members, Kuppers and Noodin provide a poetic meditation on the healing power of the drum—the "steady beat of songs on skins"—for the land and its inhabitants. They ask "how can a community be healthy if the hearts and minds within it are not? And, to balance that question, how can individuals heal if the social and ecological arteries that they depend on are not sustained?" It is to these arteries—the various waterways visited by the Swamp Singers—that the chapter turns, tracing the movement of the drum group through multiple spaces, "from studio space to sacred mounds, from land to water." Kuppers and Noodin explain how *minobimaadizi* ("our good life") is intimately bound up with rivers, lakes, and cities—specifically, Detroit, Milwaukee, and Toronto—"places that suffer and that can welcome our performance interventions to come to new ways of understanding health." Beginning with the Native Women Language Keepers Symposium in Michigan, Kuppers and Noodin trace the journey taken by the Swamp Singers to places with deep histories of Indigenous presence: from sacred burial mounds in Detroit, to a medicinal plant walk in Milwaukee, and to Fort York National Historic Site in Toronto. "How," they ask, "can history be repatriated?" In drumming and singing at each of these locations, they practise such repatriation, highlighting particular palimpsests of colonial trauma and Indigenous presence in these spaces. In sharing stories of water and land with each other, and in singing and drumming on the land that they visit, the women engage in the healing process of what they term "rivering"—a process of "becoming one with the river."

Part 4: Resistance, Resurgence, and "Imagining Otherwise"

The chapters in this final section look at a range of artistic and cultural expressions—including literature, ceremony, dance, hip-hop, and games—that enact and model anticolonial, resurgent, and speculative orientations to identity, politics, culture, and land. The arts in this section can be seen to model ways of *resisting* colonial ideologies and practices, particularly through transnational alliances and political organizing (Hellegers). They also contribute to the *resurgence* of Indigenous knowledge and spiritual practices, including specific ceremonial protocols embedded in Indigenous languages (Halfe). And they "imagine otherwise," mobilizing the creation of worlds beyond the settler colonial present and gesturing toward "Indigenous futurities of love, joy, and justice" (Recollet). The powerful triumvirate of anticolonial praxis

articulated in these chapters—resistance, resurgence, and "imagining otherwise"—concludes the collection by pointing to the necessity of the arts for enacting, imagining, and bringing into being a decolonial, Indigenous future.

In her chapter, "Body Counts: War, Pesticides, and Queer Spirituality in Cherríe Moraga's *Heroes and Saints*," settler scholar Desiree Hellegers analyzes the titular play by Chicana poet, essayist, and playwright Cherríe Moraga. Inspired by the United Farm Workers' grape boycott of the 1980s, Moraga's play provides a trenchant critique of environmental racism—or, in this case, the toxic effects of pesticides on the mostly Chicanx and Latinx low-wage farmworkers in California's San Joaquin Valley. Such neocolonial violence against workers and the land, Moraga's play stresses, not only exists in California but also is connected to similar exploitative practices throughout Mesoamerica, including the paramilitary violence against Indigenous peasant farmworkers in El Salvador and Guatemala in the 1980s and 1990s. In drawing this connection, the play highlights transnational alliances forged between exploited farm and factory workers in the United States and Indigenous peasant farmers fleeing repression in Central America and seeking work and refuge in the San Joaquin Valley. Such transnational movement building must question, however, its patriarchal and heteronormative constraints. The play thus situates environmental justice organizing in the context of transnational anticolonial resistance that, as Hellegers argues, is "expressly queer." Through its protagonist, who, because of exposure to toxins, has a head but no body, the play highlights not only the "disabling effects" of chemicals but also toxic effects of "coercive constructions of gender and sexuality that sanction violence against women (and queers more broadly), devalue the body, and obstruct and constrain decolonizing struggles." Moraga links pesticide poisoning and the "poisonous reproduction of normative gender roles," particularly in the context of movement politics and transnational organizing. In performing queer desire, the protagonist "associates sexual agency with revolutionary politics guided not by patriarchal violence and domination but by a commitment to the health and well-being of women and children."

In her meditation on the nature of Cree spirituality, ceremony, and ceremonial protocols, "The Language of Soul and Ceremony," esteemed Cree poet Louise Halfe stresses the importance of listening to the

wisdom of the Elders: "Our Elders are diminishing in numbers, and time is running short. More than ever we are in need of their wisdom." In response to this caution, Halfe's work draws from the wisdom of six Elders and a language specialist to reveal and support the resurgence of crucial teachings related to ceremony and ceremonial conduct. Bringing her characteristic close attention, as a poet, to the meaning of words, Halfe delves into the etymology of specific words in both Cree and English and illustrates how these etymologies are echoed in ceremonial practices and healthy ways of being in the world. The Cree language, she makes clear, carries the foundation of the teachings in the natural world—in "earth, plant, insect, and animal life." Cree spirituality is a lifeway, a journey that must acknowledge all four elements of the medicine wheel and human existence: the physical, mental, emotional, and spiritual. This journey has individual and communal responsibilities, including the enactment of particular values, such as respect and caring for others, as well as the pursuit of self-directed and experiential knowledge. "What does your heart feel? It's up to *you*. You have a mind, think for yourself," the Elders inform Halfe. Drawing from her own participation in ceremony and the specific teachings that have been given to her, Halfe clarifies key terms, such as what a "bundle" is and what it means to be "carried" by the pipe, as well as the importance of women's "moon time" (menstrual period). She does so, she says, to assist those in search of spiritual knowledge and to ease conflict in ceremony that can arise out of misunderstanding.

In closing, Karyn Recollet's (Cree) "*Sâkihiwâwin*: Land's Overflow into the Space-tial 'Otherwise'" develops new theoretical language and frameworks to think through how embodied, sonic, and/or visual cultural practices animate possibilities for "imagining otherwise"— imagining Indigenous futurities of love, joy, and justice. Recollet discusses a constellation of such cultural practices, including a contemporary dance collaboration between Indigenous artists in Canada and Peru, choreographed by Starr Muranko (Cree-Métis); a hip-hop song and video by queer Cherokee-Mohawk rapper Dio Ganhdih; and a singing game for healing water by Elizabeth LaPensée (Cree-Métis) that passes on songs in Anishinaabemowin. These practices, as expressions of *sâkihiwâwin* (or "love in our actions" in Cree), challenge settler colonial perceptions of "land as nation-state—static and valuable only as property"—which, Recollet stresses, "affect the bodies

and lives of Indigenous women, Two Spirit, queer, youth, and adults in our communities through increasing forms of intersectional violence." Land and body are intimately connected in what she calls *kinstillatory* relations (a neologism that combines the words *kin* and *constellation*, referencing land's celestial plane) between human and non-human entities. Land must be understood as multi-scalar—it exists not only on the fixed and flattened scale of colonial geographies but also in multiple dimensions, from the celestial to the subterranean. Like petroglyphs or urban graffiti, the cultural productions that Recollet discusses "tag" and activate multi-scalar relationships with land, mobilizing the possibility of "alternative modes of social organization" that intervene in "the flow of continual forms of capitalistic, extractive, and harmful relationships to land," creating instead new worlds grounded in an ethic of love.

References

Adelson, N. 2000. *"Being Alive Well": Health and the Politics of Cree Well-Being.* Toronto: University of Toronto Press.

Archibald, L., J. Dewar, C. Reid, and V. Stevens. 2012. *Dancing, Singing, Painting, and Speaking the Healing Story: Healing through Creative Arts.* Ottawa: Aboriginal Healing Foundation.

Archibald, L., and J. Dewar. 2010. "Creative Arts, Culture, and Healing: Building an Evidence Base." *Pimatisiwin* 8, no. 3: 1–25.

Boydell, K., B.M. Gladstone, T. Volpe, B. Allemang, and E. Stasiulis. 2012. "The Production and Dissemination of Knowledge: A Scoping Review of Arts-Based Health Research." *Forum Qualitative Sozialforschung/Forum: Qualitative Social Research* 13, no. 1: Art. 32.

Cameron, L. 2010. "Using the Arts as a Therapeutic Tool for Counseling—An Australian Aboriginal Perspective." *Procedia Social and Behavioural Science* 5: 403–7.

Castellano, M.B. 2010. "Healing Residential School Trauma: The Case for Evidence-Based Policy and Community-Led Programs." *Native Social Work Journal* 7: 11–31.

Cox, S.M., D. Lafrenière, P. Brett-MacLean, K. Collie, N. Cooley, J. Dunbrack, and G. Frager. 2010. "Tipping the Iceberg? The State of Arts and Health in Canada." *Arts and Health* 2, no. 2: 109–24.

Dana-Sacco, G. 2012. "Health as a Proxy for Living the Good Life: A Critical Approach to the Problem of Translation and Praxis in Language Endangered Indigenous Communities." *Fourth World Journal* 11, no. 2: 7–24.

Debassige, B. 2010. "Re-Conceptualizing Anishinaabe Mino-Bimaadiziwin (the Good Life) as Research Methodology: A Spirit-Centered Way in Anishinaabe Research." *Canadian Journal of Native Education* 33, no. 1: 11–28.

Dorries, H., R. Henry, D. Hugill, T. McCreary, and J. Tomiak, eds. 2019. *Settler City Limits: Indigenous Resurgence and Colonial Violence in the Urban Prairie West.* Winnipeg: University of Manitoba Press.

Episkenew, J. 2009. *Taking Back Our Spirits: Indigenous Literature, Public Policy, and Healing.* Winnipeg: University of Manitoba Press.

Fanian, S., S.K. Young, M. Mantla, A. Daniels, and S. Chatwood. 2015. "Evaluation of the K ts' *iihtła* ('We Light the Fire') Project: Building Resiliency and Connections through Strengths-Based Creative Arts Programming for Indigenous Youth." *International Journal of Circumpolar Health* 74, no. 1: 27672. https://doi.org/10.3402/ijch.v74.27672.

Flicker, S., J.Y. Danforth, C. Wilson, V. Oliver, J. Larkin, J.P. Restoule, and T. Prentice. 2014. "'Because We Have Really Unique Art': Decolonizing Research with Indigenous Youth Using the Arts." *International Journal of Indigenous Health* 10, no. 1: 16–34.

Fontaine, L.M. 2011. "Spirit Menders: The Expression of Trauma in Art Practices by Manitoba Aboriginal Women Artists." MA thesis, University of Manitoba.

Gabel, C., J. Pace, and C. Ryan. 2016. "Using Photovoice to Understand Intergenerational Influences on Health and Well-Being in a Southern Labrador Inuit Community." *International Journal of Indigenous Health* 11 no. 1: 75–91.

Gaudet, J.C. 2016. "An Indigenous Methodology for Coming to Know *Milo Pimatisiwin* as Land-Based Initiatives for Indigenous Youth." PhD diss., University of Ottawa.

Gehl, L. 2017. *Claiming Anishinaabe: Decolonizing the Human Spirit.* Regina: University of Regina Press.

Goulet, L., W. Linds, J. Episkenew, and K. Schmidt. 2011. "A Decolonizing Space: Theatre and Health with Indigenous Youth." *Native Studies Review* 20, no. 1: 35–61.

Greenwood, M., S. de Leeuw, N.M. Lindsay, and C. Reading, eds. 2015. *Determinants of Indigenous Peoples' Health: Beyond the Social.* Toronto: Canadian Scholars' Press.

Gross, L. 2002. "Bimaadiziwin, or the 'Good Life,' as a Unifying Concept of Anishinaabe Religion." *American Indian Research and Culture Journal* 26, no. 2: 15–32.

Guerin, P., B. Guerin, D. Tedmanson, and Y. Clark. 2011. "How Can Country, Spirituality, Music and Arts Contribute to Indigenous Mental Health and Wellbeing?" *Australasian Psychiatry* 19, no. 1: 38–41.

Hammond, C., W. Gifford, R. Thomas, S. Rabaa, O. Thomas, and M.C. Domecq. 2018. "Arts-based Research Methods with Indigenous Peoples: An International Scoping Review." *AlterNative: An International Journal of Indigenous Peoples* 14 no. 3: 260–76.

Hart, M. 2002. *Seeking Mino-Pimatisiwin: An Aboriginal Approach to Helping.* Black Point, NS: Fernwood Publishing.

Henry, R., A. Lavallee, N. Van Styvendale, and R. Innes. 2018. *Global Indigenous Health: Reconciling the Past, Engaging the Present, Animating the Future.* Tucson: University of Arizona Press.

Hill, B.H. 1995. *Shaking the Rattle: Healing the Trauma of Colonization.* Penticton, BC: Theytus Books.

Igloliorte, H. 2009. "Inuit Artistic Expression as Cultural Resilience." In *Response, Responsibility, and Renewal: Canada's Truth and Reconciliation Journey,* edited by G. Younging, J. Dewar, and M. DeGagne, 123–36. Ottawa: Aboriginal Healing Foundation.

Justice, D.H. 2018. *Why Indigenous Literatures Matter.* Waterloo, ON: Wilfrid Laurier University Press.

Kirmayer, L.J., G.M. Brass, and C.L. Tait. 2000. "The Mental Health of Aboriginal People: Transformations of Identity and Community." *Canadian Journal of Psychiatry* 45, no. 7: 607–16.

Macdougall, B. 2010. *One of the Family: Metis Culture in Nineteenth-Century Northwestern Saskatchewan.* Vancouver: UBC Press.

Morgensen, S. 2013. "The Biopolitics of Settler Colonialism: Right Here, Right Now." *Settler Colonial Studies* 1, no. 1: 52–76.

Muirhead, A., and S. de Leeuw. 2012. *Art and Wellness: The Importance of Art for Aboriginal Peoples' Health and Healing.* Prince George, BC: National Collaborating Centre for Aboriginal Health.

Sasakamoose, J., A. Scerbe., I. Wenaus, and A. Scandrett. 2016. "First Nation and Metis Youth Perspectives of Health: An Indigenous Qualitative Inquiry." *Qualitative Inquiry* 22, no. 8: 636–50.

Settee, P. 2013. Pimatisiwin: *The Good Life, Global Indigenous Knowledge Systems.* Vernon, BC: J. Charlton Publishing.

Tuck, E. 2009. "Suspending Damage: A Letter to Communities." *Harvard Educational Review* 79, no. 3: 409–27.

Veracini, L. 2010. *Settler Colonialism: A Theoretical Overview.* Houndmills, UK: Palgrave Macmillan.

Vizenor, G. 1998. *Fugitive Poses: Native American Indian Scenes of Absence and Presence.* Lincoln: University of Nebraska Press.

Wahkohtowin: The Relationship of Cree People and Natural Law. 2009. Edmonton: Native Counselling Services of Alberta/BearPaw Media Productions.

Wilson, K. 2003. "Therapeutic Landscapes and First Nations Peoples: An Exploration of Culture, Health and Place." *Health and Place* 9, no. 2: 83–93.

Wolfe, P. 2006. "Settler Colonialism and the Elimination of the Native." *Journal of Genocide Research* 8, no. 4: 387–409.

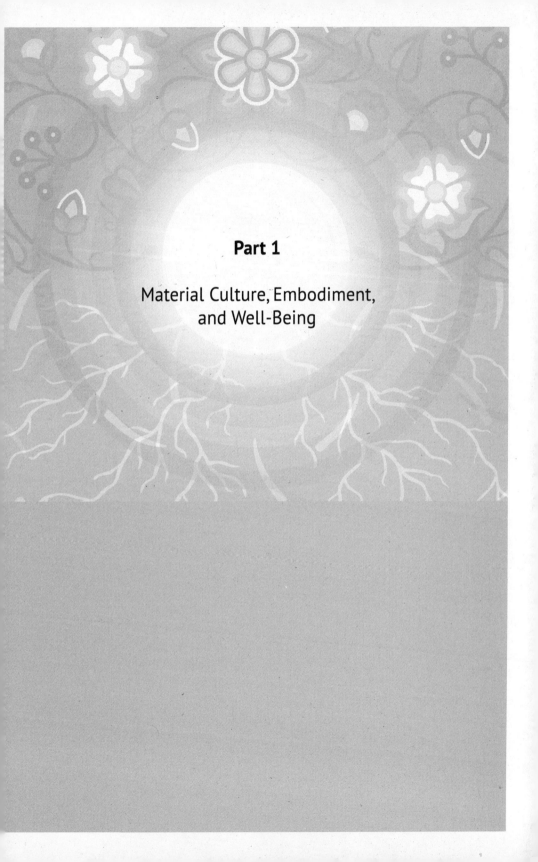

Part 1

Material Culture, Embodiment, and Well-Being

CHAPTER 1

WHAT THIS POUCH HOLDS

GAIL MACKAY

In this edited collection of writing about the interplay between art and health, my chapter leads the reader through an interpretation of a cultural artifact—specifically, a pouch—to articulate beliefs about well-being. I conceive of it as a study in Indigenous rhetoric (Powell 2014), observing the principles of Saulteaux philosophy of education (Akan 1999; Johnston 1998a, 1998b) and following the ethics of Indigenous Studies (Ermine, Sinclair, and Browne 2005; Kulchyski 2000). These Indigenous intellectual traditions are the roots of my inquiry, but in conducting a scholarly study of how meaning is made my questions branched out to find rhizomatic[1] relationships with lin- guistics, cultural studies, art history, and cultural rhetorics to create an interdisciplinary space wherein I can employ those disciplines' models, theories, and methodologies of analysis. I value this study as a phe- nomenological experience of enlivening an Anishinaabe pedagogical practice of self-directed contemplative inquiry that explores the com- plexity of my identity, my being, and my relationships in a particular cultural and socio-historical context. It contributes to my sense of personal well-being in identifying the coherence and presence of the Anishinaabe, Cree, and Métis teachings of being alive well. I present my understanding as I reflect on it at this stage of my life. I aspire to continue learning, so I expect that I will look at this as a stage in my growth and understanding. If, dear readers, you see where this can be improved, where an alternative understanding will bring clarity and benefit, I look forward to hearing your thoughts.

The chapter records my exploration of an animate artifact as a coherent text about my experience of a specific contemporary Indigenous culture. I describe a pouch that has personal significance to me in order to explore how cultural knowledge is conveyed through symbol and metaphor. The pouch is more than a physical object to have or behold. In mindful interaction, I perceive it as a metaphysical subject. It has power because it brings into focus my relatedness to time, place, people, and ancestral belonging. This power is much like the essential power in my birth and ceremonial names that connects me to a deep self-knowledge as a spiritual being living a physical life in a network of social relationships. This close examination traces a move to view the pouch as a subject that has metaphysical power. I demonstrate how, in the process of looking closely at the principles and elements of a material design, my mind associates the information with my understanding of the Saulteaux principle of *pimadizewin*,[2] "a worthwhile life." This analysis demonstrates that a culture's value system and epistemology orient how we relate to a work of material culture to interpret its visual rhetoric and attach meaning to it.

Parameters of This Interdisciplinary Study

In this section, I define the interdisciplinary nature of the study and the terms, goals, and methods of the study. I define how I understand and use rhetoric, literacy, Indigenous rhetorics, cultural rhetorics, and Indigenous Studies perspectives. I define key terms such as "survivance" and the principles of an Anishinaabe philosophy of education. I acknowledge the Elder who guided my learning for more than a decade and who reviewed my manuscript.

The elements that characterize this as a study in Indigenous rhetoric relate not only to disciplinary scope but also to social justice and Indigenous survivance. I deliberately use the term "rhetoric" because rhetoric extends beyond the limits of literacy. In a Canadian context, it might seem to be unproductive to argue to expand the common notion of rhetoric, the art and science of using language to persuade an audience. And it might seem that in recent decades the expanding definitions of multi-modal literacies and the scope of research in New Literacy Studies would be sufficient to include a study of meaning in a visual representation in this non-alphabetic form. De Silva Joyce and Feez (2016, 57) explain the range of definitions of literacy:

At one end of the spectrum is the view that literacy is a set of generic and portable skills for deciphering written language, skills most often learned in the early years of school, a view sometimes associated with studies from the field of psychology (Barton 2007). At the opposite end of the spectrum are more expansive multidisciplinary definitions based on the view that literacy is "the flexible and sustainable mastery of a repertoire of practices with the texts of traditional and new communications technologies via spoken language, print and multimedia" (citing Luke, Freebody, and Land 2000, 9), or more concisely "how people use and produce symbolic materials fluently and effectively." (citing Freebody 2007, 9)

Visual literacy would be found at the latter end, but in interrogating an Indigenous mode of communication even visual literacy does not implicitly demand a consideration of contextual factors at play, the meta-rhetoric or requisite prior knowledge, or the pastiche of cultural references to locate and critique the Indigenous perspective. Critical literacy comes the closest to analyzing the context of the communication event by studying literacy as situated social practices, but still the emphasis is on "pedagogies that build knowledge and skills for controlling texts across diverse contexts" (De Silva Joyce and Feez 2016, 83). Although in Saskatchewan's elementary and secondary schools multi-literacies are addressed through the six strands of communication (hearing, speaking, reading, writing, viewing, and representing), there is an implicit bias toward alphabetic texts, languages, and semiotics of Western European origin. An Indigenous perspective is warranted in the effort to create culturally responsive pedagogy in teaching literacy and communication, but there is next to no help for teachers to guide students to explore how meaning was represented in Indigenous cultures before English and alphabetic text were exerted as cognitive and linguistic imperialism (Battiste 1985).

A study of Indigenous rhetoric in a cultural artifact is a determined personal act of survivance in a generation beyond an era of cultural genocide by neglect through education. Vizenor (2008, 1) explains that survivance means more than the merging of survival and resistance: "Native survivance is an active sense of presence, over absence,

deracination, and oblivion; survivance is the continuance of stories, not a mere reaction, however pertinent. Survivance is greater than the survivable name."

It is this determination, this activism, that I sense at the heart of the advancement of the study of Indigenous rhetorics. As Powell (2014, 471) tells us, "when we study Native rhetorics, then we study meaning making practices. We study *how* those practices constitute things like text and baskets. We study *how* those things carry culture—both the traditional practices around which tribal cultures cohere and pan-tribal Indigenous practices that create our web of Native relations. This is what Native rhetorics scholars do—we study *how*." Riley-Mukavetz (2014, 109) identifies affirming self-healing done through cultural rhetorics, a determined study of meaning in our everyday objects. She explains that "'cultural rhetorics is an orientation to a set of constellating theoretical and methodological frameworks'" (citing Cultural Rhetorics Theory Lab 2012, 2). She details that culture "is not defined so much by any combination of race, ethnicity, gender, or class, but by the spaces/places people share, how people organize themselves, and how they practice shared beliefs. This emphasis on practice—the things that communities do to make something—is central to understanding how rhetoric and culture are interconnecting concepts" (109). Riley-Mukavetz highlights the critical humanizing, healing, and culturally restorative site that studies in cultural rhetoric can be:

> A cultural rhetorics orientation is to enact a set of respectful and responsible practices to form and sustain relationships with cultural communities and their shared beliefs and practices including texts, materials, and ideas. This orientation rejects the idea that "everything is a text" to be read and instead engages with the material, embodied, and relational aspects of research and scholarly production. One engages with texts, bodies, materials, ideas, or space knowing that these subjects are interconnected to the universe and belong to a cultural community with its own intellectual tradition and history. This is a very different methodological approach from the distant researcher who reads the text (re: object) through a lens to excavate or discover meaning. (109)

The theoretical framework of Indigenous rhetoric, cultural rhetoric, and survivance breaks the mould of oppressive exclusion, genocide by denial, and deracination.

Researchers who adhere to principles of Indigenous Studies position themselves in relation to Indigenous historical and contemporary communities and populations, privilege an Indigenous perspective, commit to returning benefits to Indigenous communities, and respect Indigenous knowledge (Kulchyski 2000). Sacred knowledge is not to be written; although I write about an object that to me is sacred in function, I do not profane it by giving away the knowledge or the processes of engaging the ceremonial uses of it. I trust that this conforms to the guidance that the Elders provide regarding research ethics with Indigenous peoples (Ermine, Sinclair, and Browne 2005).

Akan's (1999) interview with Elder Alfred Manitopeyes helps the reader to understand the principles of Saulteaux education. Elders give youth good talks that connect them in place and time and kinship, to prime their minds to think cooperatively with the Elders, and to develop their own powers of thinking and insight. The learner has the autonomy and responsibility to find meaning, to learn on her or his own, and to recall and practise an Elder's teaching. In looking closely at the pouch as a cultural artifact, I apply the understanding of an Anishinaabe, Cree, or Métis value and belief system to the degree that I have learned it.

I pause here to acknowledge Maria Campbell as my teacher. I was fortunate to be welcomed by her as a lodge helper and friend for sixteen years. Through hearing stories that she told, being a part of ceremonies that she conducted, and having conversations with her, I learned about nurturing family, raising children, writing, and thinking about cultural knowledge and language. When I was hesitant to speak about my understanding, Maria reminded me that I had followed cultural protocols in my process of learning. She read an early draft of this chapter and offered suggestions for its improvement. Through her words and example, I have come to understand something of where I stand and the stand that I take. The pouch contains mnemonics of teachings that guide and sustain me.

At the time of the contemplative study of the physical aspects of the pouch, I drew from my training in fine art and generally followed a method of inquiry set out by Jules Prown (2000), an art historian.

Teachers of art, history, social studies, languages, and Native students could use this method of analyzing an object (preferably one mass produced) to gain insight into the culture within which it was produced. Prown's method has five steps: description, deduction, speculation, research, and interpretation/analysis. There were two ways in which I stepped away from the prescribed method: instead of a mass-produced object, I used an object made specifically for me, and the culture into which I sought insight was my own.

Another method of visual analysis comes from cultural studies and linguistics. Strategies of decoding the meaning of visual rhetorical texts include the close observation of elements and principles of design and the interpretation of symbol and metaphor. Sturken and Cartwright (2001) introduced a method of visual analysis based on a model of semiotics introduced by Barthes (1977) and based on Saussure (1916) which operates on the assumption that the meaning attributed to something in the world is arbitrary and that meanings change according to contexts and the rules of language (Sturken and Cartwright 2001, 28). Barthes named the sense stimulation of image/word/sound as *signifier* and the meaning of it as *signified*, and together they constituted a *sign* dependent on the context. The Sturken and Cartwright process of visual analysis demonstrates a straightforward way to interpret visual representation with a rich lexicon of metalanguage to identify and name visual details and the associations that form meanings in the viewer's mind. Sturken and Cartwright's (2001) *Practices of Looking: An Introduction to Visual Culture* lends itself well to rhetorical analysis of visual representations with a focus on the images, textual meanings, audiences, social and psychological patterns of looking, and study of the contexts of images.

This section, describing the disciplinary orientation of my study and the interdisciplinary borrowing of methods and methodologies, prepares the reader for the next section, the description of the pouch.

Description of the Pouch

If you interpret the phrase "what this pouch holds" in a literal sense, then you might expect a description of the pouch's physical contents. Although I do talk about the things that I put in the pouch, I focus more on the meanings contained by the pouch's elements. To readers interested in the topics of cultural rhetoric, Indigenous rhetoric, visual literacy, culturally sustaining curriculum, Indigenous Studies, identity,

kinship, health, beadwork, and craft, I hope that you find something here to inspire you and support you in your work.

My pouch was made by Cree artist Hilary Harper and given to me in December 2004 by her cousin and my former teacher, Maria Campbell, at our lodge family's winter solstice feast, held at my house that year. In the Cree tradition, a lodge is identified by its specific ritual ceremonies and with the person who has been given the responsibility and training to conduct those ceremonies. Maria, the grandmother of the lodge, gave me and my lodge sisters each a pouch and said, "I want to see you wearing it in ceremony." In that moment, I looked at the pouch and saw deerskin decorated with beads, abalone buttons, and fringes. I smelled it for the sweet musky scent of smoke tanning. My hands stretched to encompass it and touch fingertip to fingertip. I have used the pouch over the years. It has carried my tobacco, sage, knife, and sewing kit. It has become familiar to me through touch and use. I know its weight and have felt its fringes splay between my fingers. I have physical memories of the rough and smooth textures, the snug firmness of the beads, and the reluctant yielding of the buttons. I know the soft touch of the cotton lining. But the pouch engages me in more than sensuous observation.

The pouch speaks the quiet direction of *mahtêsa nihtohta*, a Cree phrase, which when spoken in a gentle tone indirectly guides a person to self-awareness: to use their minds and senses fully to consider not just their physical surroundings but also their relationships and the consequences that will follow the actions that they are considering. The meaning of *mahtêsa nihtohta*, as Maria Campbell explained to me, depends on the context and on the tone used. It can mean "just a minute/focus here," or it can mean "stop and observe: see what you are doing." The process of writing and rewriting this chapter has been slow because I have had to take time to consider the implications that could follow from it. In the years that have passed since I received the pouch and first wrote about it, these relationships, though they have changed, continue to be deeply meaningful.

A critical reader might be wondering at this point what singular label identifies the contemporary Indigenous culture to which I refer. Beginning with my understanding that ceremonies were conducted and prayers were offered in Cree and Saulteaux, and that teachings were shared in English, the language identifier would be multilingual.

That members lived in urban centres and rural municipalities, many remote from each other, indicates a dispersed geographical location. That the self-naming terms among members were diverse, that federal recognition of Indian status included 6.1 and 6.2 and non-status, and that the ancestries acknowledged parents and grandparents of inter-tribal and cross-cultural unions make a single label either fictional or contested. From my perspective, the culture was defined by reciprocal relationships, mindful action, shared worldview, and ceremonial practices. In this parkland region, spiritual practices vary. Within the Cree, Saulteaux, and Michif languages themselves are various dialects marked by pronunciation, vocabulary, spelling, and speed of speaking. Cultural identifiers are fluid, sometimes compatible, sometimes distinct. A single definition could not satisfy all opinions or be satisfactorily inclusive or exclusive of all personal observations and experiences in all groups and communities. So I offer this: the culture is a contemporary expression of Cree and Saulteaux and Métis traditions, and I represent it through my observations and experiences. I expect that some readers might recognize compatibilities with their own experiences and understandings, whereas other readers might identify incompatibilities with what they know. Sustaining cultures are made vibrant by dialogue and multiple views. I present my experience as one perspective.

What the Pouch Is and What It Holds

I return to examine the pouch and contemplate my awareness of two conceptions of it: what the pouch is and what it holds.

Intuitively, I view the pouch in two distinct orientations, from the front (Fig. 1.1) and from the top (Fig. 1.2). The first orientation is observational and objective. But even so the life in the pouch emerges by close observation of the materials and design. Here I ask for your forbearance in allowing me to guide your attention to the details that bear meaning to my interpretation. I invite you to consider what meaning you attach to these details of design consciously included by the artist.

The Pouch as a Visual Object

The deerhide has a textured roughness but also a velvety smoothness: the beads sparkle and absorb light, and the lines suggest movement and balance of opposites. The top third of the pouch is comprised of a flap that is the smoothly polished side of the deerhide. The bottom two-thirds of

Figure 1.1. Front view of pouch. Photo by Gail Mackay.

the pouch are made from the roughly textured side of the deerhide. The edge of the flap has an undulating line, which on the left side appears scalloped and containing, and on the right side it appears incised and carving. The flap's edge sparkles as light is caught and reflected by the translucent and iridescent seed beads. In this first orientation, the elements of the pouch conform to the placement and proportions of a face. The flowers appear to have three petals each, but the dissimilar shapes and associated green beads defy a coherent reading until I conceive of the flowers shifting orientation, seeing the pouch from two different perspectives: one from the side, the other from above. The bottom seam of the pouch waves into the body of the pouch with five almost regularly spaced indentations. This bottom seam is decorated with middle-green translucent seed beads in a band the width of three beads. The fringes extending from the indentations in the bottom seam do not lie flat and instead have clusters of three, four, and five fringes, respectively, that lie on top of the neighbouring fringes.

The Pouch as an Animate Subject

The second orientation is more sensuous and subjective. I am wearing the pouch on a belt, and it sits at my waist to my left side. I study it from above my head, bowed and turned to the left. It is a posture reminiscent of cradling a baby. The pouch is turned around to face the direction that

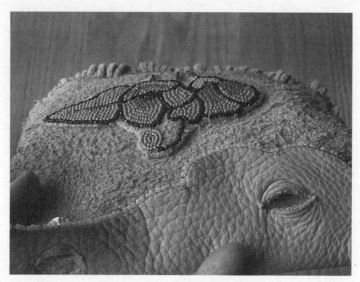

Figure 1.2. Top view of pouch. Photo by Gail Mackay.

I face. The pouch recedes down into a space where the fringes are fore-shortened. The bulging body of the pouch hides from view most of the waving seams of blue-green. When I move the pouch to let it sit on my lap, the unseen undulating seam of the pouch waves perfectly between the fingers and thumb of my left hand. The size, fit, and proportions are suggestive of the hand-squeezed impression of six hills and five valleys left on a malleable ball of clay. The fringes curl under the pouch and flow over my lap. I direct your attention to the centrally positioned oval of middle-green beads connected by a line of dark-green translucent beads and the middle-orange and scarlet-red beads outlined by black shiny beads. From here, I see flower petals transform into the shape of a butterfly; from this point of view, the tendrils become antennae. If you look to the movement in the top flap, the most prominent element from this point of view, the living elements of the design are felt in the contrast of the smooth medium-yellow deerskin of the flap and the roughly textured earth-orange deerskin of the body of the pouch. Movement is perceptible in the undulating edge demarcated by emerald and turquoise beads. Light bounces off the abalone shells in waves and streaks of green, pink, silver, pearl, orange, and yellow. The line edging the flap moves from convex and scalloped to concave and incised. The smooth deerhide appears to have patterned cross-hatch marks similar to the skin on my hand.

If we look at the pouch as an art object or a historical artifact, then we could undertake a very interesting analysis of it, drawing on historical and ethnohistorical interpretations of Cree, Saulteaux, and Métis art traditions. As well, we could look for its referents to the history of the bead, fur, and craft trade or consider how centuries of beadwork have been archived in European collections of cultural curiosities. Or we could trace the cultural exchange of imagery and function and use of the object in historical and contemporary tribal cultures. And, though those topics of inquiry are richly informative, they belong to a perception of the pouch as an object.

Instead, I invite you to look at the pouch as a tangible object containing the means to meditate on Cree and Saulteaux and Métis values and ways of knowing. The pouch symbolizes the principle of relationship, but it is also a way to recognize being human as an action. Across cultures, it is understood that material objects contain symbols and metaphors to communicate meanings. To decode these meanings, Prown (2000, 2–3) tells us, "we can discover the mind hidden within a cultural object by looking closely for analytic hooks in our intuitive recognition of the polarities embedded in the object." Rather than seeing single polarities, I see the coherent balance of opposites as an important belief contained in the pouch. There is light reflecting off the outside facets of beads and shells, and the darkness is contained inside the pouch. There is outward release and inward containment. There is a balance between death and life. The deer's, the abalone's, and the cotton's remaining physicalities have released their vitalities, yet the floral motif of orange petals and green leaves suggests the idea of life. The pouch holding ceremonial tobacco participates in human physical, spiritual, and social relationships. Physical movement is balanced with stability. The fringes move, the flap opens, the lines appear to move, but the buttons stay, and the beads are fixed tightly in place. There is fullness and vitality and emptiness and decay suggested in the shape of the line of the flap. These are structural metaphors "which conform to the shape of experience, which resemble actual objects in the physical world" and "are based on physical experience of the phenomenal world" (Fernandez 1974, cited in Prown 2000, 18–19). These metaphors of natural phenomena of light, life, containment, dark, decay, and release are the structural metaphors in the pouch that express the experience of the physical world and reveal the coherence of human experience

and place in the world. Contemplating the meaning of these metaphors connects me to this specific time and place and within the infinite mystery of being. This is a visceral experience of being alive in a finite reality but being a part of infinite being.

A reading of the symbols of the pouch and the feelings that they invoke is a study of textual metaphors. Fernandez (1974) explains how "textual metaphors are based on the emotive experience of living in that world, [and they are] based on the feelings of experience" (cited in Prown 2000, 18–19). The emotive readings of the object are dependent on the cultural orientation of the reader. This is demonstrated by using the Saulteaux principle of *pimadizewin* [parallel to the Anishinaabe principle of *bimaadiziwin*] as an interpretive tool.

The concept of *bimaadiziwin* is instructive in understanding an Anishinaabe philosophy of life that provides coherence to spiritual, social, and physical relationships. Lawrence Gross (2002, 19) states that

> the teaching of *bimaadiziwin* operates at many levels. On a simple day-to-day basis, it suggests such actions as rising with the sun and retiring with the same. Further, *bimaadiziwin* governs human relations as well, stressing the type of conduct appropriate between individuals, and the manner in which social life is to be conducted. *Bimaadiziwin* also covers the relationship with the broader environment. So, for example, it teaches the necessity of respecting all life, from the smallest insects on up. *Bimaadiziwin*, however, does not exist as a definitive body of law. Instead it is left up to the individual to develop wherever it can be found. This makes the term quite complex, and it can serve as a religious blessing, and moral teaching, value system, and life goal.

Bimaadiziwin as a concept may be used as a tool to interpret all components of the tobacco pouch, including elements of the design, the framework of Anishinaabe cultural values and beliefs and relations, and the survivance beyond the socio-historical context of the Anishinaabe ethnohistory.

The pouch may be seen as an inanimate object acted on and valued for its use and aesthetic. I look beyond that when I heed the directive *mahtêsa nihtohta*. Let me conclude with a summary of which meanings are embodied by the pouch in my interpretation.

First, the pouch is animate. As an adult learner of my Anishinaabe language, Anishinaabemowin, my comprehension of animate gender in the language is still in its infancy. Rightly or wrongly, I conceive of the notion of animacy as having an energy or potential to affect other animate beings. My language teacher, Helen Pelletier, whom I quote here from memory, guided me to understand it this way: "Animate things have the power to change and to move. *Mishimin*, 'apple,' is animate. Think of it. In its mature state, it still can change from green to red. *Asin*, 'stone,' is animate. Why? Because it moves." A child who learns Anishinaabemowin as a first language does not struggle to comprehend through translation to and from English concepts or ontology. A first-language learner experiences the concept with all aspects of her being and assimilates the language through experience, interaction, intellect, emotion, spirit, and body. The English word that I have used to identify it is *pouch*, mostly because of its size, but also because I first identified and named it from my English-language place of knowing. But the Anishinaabemowin word is *gashkibidaagan*, an animate noun that Nichols and Nyholm (1995, 49) gloss as "a bag with a closable top, a tobacco or pipe bag." My adult-stage language learning has taught me that Anishinaabe names of things, nouns, are formed by adding a suffix to a verb. Exploring the root of the word *gashkibijige*, I learn that it is an intransitive animate verb translated as "to wrap or tie things in a bundle" (Nichols and Nyholm 1995, 49). Language revitalists will understand the tremendous difference in understanding the action that breathes life and movement and interactive being with a phenomenon that has inherent values and beliefs and tangential meanings associated with necessity, the action and process of wrapping, tying, and bundling life-sustaining materials. The words *pouch* and *bag with a closable top*, though they conjure up an image, do not make the linguistic connection to ancestral knowledge and ways of being. The recovery of my ancestral language is a restoration of the bonds of belonging with my grandparents and the land and ancestors that sustained the life force that animates me. Regarding *gashkibidaagan* in this way, seeing it as an animate being, I can extrapolate how it changes my social, physical, and spiritual relationships when I use it in ceremonies and carry tobacco and make offerings, being mindful of my interactions with others. It also transforms from deer to pouch, from flower to butterfly, from gift to new gifts. It is present in the transformation of energy and life.

Second, the pouch contributes to living a good life by reminding me of being in relationship with the human and wider environments. Our health is in our good relations. The floral motif suggests to me human reliance on the plant world for sustenance and healing. In Anishinaabe culture, not only the physical but also the spiritual components of the plant make the curative elements. Thus, beadwork interpreted from a traditional Anishinaabe worldview is expressive of an individual's relationships with the forces of the universe, spirit helpers, animals, and kin. Beadwork can be used as a vehicle of proper relations, engaging the maker, presenter, recipient, and user in a cycle of reciprocity.

Third, the pouch represents the wisdom that I seek as recorded in the natural world or order of life. From Anishinaabe, Cree, and Métis worldviews, life is for doing, not having. Change is part of the natural law. Our being human obeys this law. How we understand and respond to change is up to us. How we use the knowledge depends on how mindful and observant we are, considering the consequences of our actions. It is the power of our minds that makes it possible for us to conform to the ethics of living a good life, of following the natural way.

Through this chapter, I have shown how a culture's value system and epistemology orient how we relate to a cultural artifact, how we interpret its visual rhetoric, and how we attach meaning to it. Cultural rhetorics are not only avenues of discovery of cultural values and beliefs but also affirmations of one's relationship to an animate subject that participates in reciprocal physical, social, and spiritual relationships. This is an intellectually and intuitively satisfying interpretation. In this interpretation, the pouch expresses the adaptive, creative, and syncretic aspects of Anishinaabe, Cree, and Métis interactions with each other and with other cultural groups. The pouch is the vehicle for a meditative engagement with the philosophy of life that will have good consequences for me and my relatives.

In elementary and secondary school education, a textual metaphorical reading is an appropriate academic exercise in history, social studies, communication, and language arts. For the teacher building a curriculum that includes First Nations, Inuit, and Métis perspectives and culturally responsive pedagogy, the textual metaphorical reading is a means to go beyond simply adding factual content. It supports the broad areas of learning and developing knowledge, skills, and attitudes to develop youth's sense of self, place, and community. Health

in an Indigenous worldview is not the absence of illness or disease; rather, well-being is the balance of the four aspects of being: physical, emotional, spiritual, and intellectual. We have a will, and we can make choices that will move us along the spectrum of well-being. If we guide our actions to be true to respect ourselves, each other, and our environment, then we will have a sense of well-being. A culturally relevant and sustaining learning activity by definition contributes to Indigenous students' holistic health and recovery from a history of cultural genocide.

Notes

1 The rhizome is a metaphor used in media theory to identify a non-hierarchical, non-centralized, non-static relationship of dimensions of knowledge. French philosophers Deleuze and Guattari (1987) are credited with developing the metaphor as a way to describe how thought can develop in many directions and be accessed through various points of entry. As an ontological model, in contrast to the tree of knowledge with roots, trunk, and branches, the rhizome has no source root, but its stem grows horizontally through the soil and supports growth in clusters (Gartier n.d.). The rhizome as a metaphor is suited to organizing complex, provisional, and fluctuating relationships of interdisciplinary studies. Parsons and Clarke (2013) explore how rhizomic thinking can drive a social studies curriculum to contend with the change, complexity, and contingency in analyzing social issues.

2 Linda Akan, working with a Saulteaux Elder from Muscowpetung Reserve, glosses this as "a worthwhile life." Lawrence Gross, referencing Anishinaabe teachings from White Earth Reservation, explains *bimaadiziwin* as meaning "living a good life." The close cultural relationship between Saulteaux and Anishinaabe can be seen in the linguistic similarities. Taking care not to overstate the commonalities between Saulteaux and Anishinaabe, it is helpful to access the larger body of literature on Anishinaabe cultural teachings and language when studying Saulteaux. Because I identify as Anishinaabe-Métis, I will use the identifier Anishinaabe to reference my personal interaction with the pouch. This acknowledges my relationship with my Saulteaux teachers and situates my own orientation and perspective.

References

Akan, L. 1999. "*Pimosatamowin sikaw kakeequaywin*: Walking and Talking. A Saulteaux Elder's View of Native Education." *Canadian Journal of Native Education* 23 no. 1: 16–39.

Barthes, R. 1977. *Image, Music, Text.* London: Fontana Press.

Battiste, M. 1985. "Micmac Literacy and Cognitive Imperialism." In *Indian Education in Canada*, edited by D.N. McCaskill, Y.M. Hébert, and J. Barman, 32–53. Nakoda Institute Imprint. Vancouver: UBC Press.

Cultural Rhetorics Theory Lab. 2012. "What is Cultural Rhetorics?" Brochure. Print.

Cultural Rhetorics Theory Lab (M. Powell, D. Levy, A. Riley-Mukavetz, M. Brooks-Gillies, M. Novotny, and J. Fisch-Ferguson). 2014. "Our Story Begins Here: Constellating Cultural Rhetorics Practices." *enculturation: a journal of rhetoric, writing, and culture* 18. Retrieved from: http://enculturation.net/our-story-begins-here.

Deleuze, G., and F. Guattari. 1987. *A Thousand Plateaus: Capitalism and Schizophrenia.* Minneapolis: University of Minnesota Press.

De Silva Joyce, H., and S. Feez. 2016. *Exploring Literacies: Theory, Research and Practice.* New York: Palgrave Macmillan.

Ermine, W., R. Sinclair, and M. Browne. 2005. Kwayask Itôtamowin: *Indigenous Research Ethics Report of the Indigenous Peoples' Health Research Centre to the Institute of Aboriginal Peoples' Health and the Canadian Institutes of Health Research.* Regina: Indigenous Peoples Health Research Centre. http://iphrc.ca/pub/documents/IPHRC_ACADRE_Ethics_Report_final.pdf.

Fernandez, J. 1974. "The Mission of Metaphor in Expressive Culture." *Current Anthropology* 15, no. 2: 119–45.

Freebody, P. 2007. *Literacy Education in School: Research Perspectives from the Past, for the Future.* Camberwell, Australia: Australian Council for Educational Research.

Gartier, M. N.d. "Rhizome." In *The University of Chicago: Theories of Media: Keywords Glossary.* http://csmt.uchicago.edu/glossary2004/rhizome.htm.

Gross, L. 2002. "*Bimaadiziwin,* or the Good Life, as Unifying Concept of Anishinaabe Religion." *American Indian Culture and Research Journal* 26, no. 1: 15–32.

Johnston, B. 1998a. "'Is That All There Is?' Tribal Literature." In *An Anthology of Canadian Native Literature in English*, edited by D.D. Moses and T. Goldie, 105–12. Toronto: Oxford University Press.

———. 1998b. "One Generation from Extinction." In *An Anthology of Canadian Native Literature in English*, edited by D.D. Moses and T. Goldie, 99–104. Toronto: Oxford University Press.

Kulchyski, P. 2000. "What Is Native Studies?" In *Expressions in Canadian Native Studies*, edited by R.F. Laliberte et al., 13–26. Saskatoon: University of Saskatchewan Extension.

Luke, A., P. Freebody, and R. Land. 2000. *Literate Future: Report of the Literacy Review for Queensland State Schools.* Brisbane, Australia: Department of Education.

Nichols, J. and E. Nyholm. 1995. *A Concise Dictionary of Minnesota Ojibwe.* Minneapolis: University of Minnesota Press.

Parsons, J., and B. Clarke. 2013. "Rhizomic Thinking: Towards a New Consideration of Social Studies." *Social Studies Research and Practice* 8, no. 3: 89–98.

Powell, M. 2014. "A Basket Is a Basket Because. . . . Telling a Native Rhetorics Story." In *The Oxford Handbook of Indigenous American Literature*, edited by J.H. Cox and D.H. Justice, 471–88. Oxford: Oxford University Press.

Prown, J.D. 2000. "The Truth of Material Culture: History or Fiction?" In *American Artifacts: Essays in Material Culture*, edited by J.D. Prown and K. Haltman, 11–27. East Lansing: Michigan State University Press.

Riley-Mukavetz, A. 2014. "Towards a Cultural Rhetorics Methodology: Making Research Matter with Multi-Generational Women from the Little Traverse Bay Band." *Rhetoric, Professional Communication and Globalization* 5, no. 1: 108–25.

Saussure, F. 1916. *Course in General Linguistics*. Lausanne and Paris: Payot.

Sturken, M., and L. Cartwright. 2001. *Practices of Looking: An Introduction to Visual Culture*. New York: Oxford University Press.

Vizenor, G. 2008. *Aesthetics of Survivance: Literary Theory and Practice in Survivance Narratives of Native Presence*. Lincoln: University of Nebraska Press.

BASKETS, BIRCHBARK SCROLLS, AND MAPS OF LAND:
Indigenous Making Practices as Oral Historiography

ANDREA RILEY-MUKAVETZ

Dear readers, as Shawn Wilson (2008) writes, I come to you with a good heart. What I've learned about Indigenous research and storying is that it's important for the storyteller to take the time to introduce herself and to honour the ceremony of story. This is a practice in making right relations. So let me introduce myself and set the stage:

> Aaniin, Andrea Riley-Mukavetz nindizhinikaaz. Deshkan Ziibiing Anishinaabeg. Ahjijawk nindoodem. Waawiyaataanong Nindonjibaa. My mother's people, the Bakkals and Mansours, come from Baghdad, Iraq. Currently, I live in Gaaginwaajiwanaang, at the place of the long rapids. Michigan is the recognized territory of the People of the Three Fires: Ojibwe, Odawa, and Bodéwadami (Potawatomie). What I do well is due to the brilliance and care of my ancestors and relatives. What I do poorly is mine and mine alone.

> This chapter has journeyed with me through various life stages. I have sat on an exercise ball in preterm labour while incorporating editor feedback. As I put the finishing touches on it, my two children are cuddled next to me watching a movie. I come to you as a mother, a teacher, an in-betweener invested in the lifelong work of learning Anishinaabek

teachings, and as a writer. One of the things that I am try-
ing to learn is how to form and sustain the right relations
with people, the universe, and the land. To do that requires
vulnerability, reciprocity, accountability, and transparency. I
plan to demonstrate these practices and my ongoing learning
in this chapter.

I was raised to believe that all stories are important no matter how
tangential, obscure, or small. I am interested in making visible an
Indigenous approach to the *making* of oral history that emphasizes
relationality, materiality, and embodiment. I am calling this approach
oral historiography. This theory is heavily influenced by two oral his-
tory projects on which I worked with a group of multi-generational
Odawa women from Lansing, Michigan. I do not plan to talk about the
women or those oral history projects here since I have written about
them elsewhere (Riley-Mukavetz 2014, 2018). I bring up this research
and the women because I want to be clear that this theory of oral his-
toriography is relational and influenced by these intellects. I have not
created this theory in isolation. I consider myself an Indigenous and
cultural rhetorician. I consider oral history to be a practice, a method,
and a narrative form of knowledge making (Cruikshank 2000; Herndl
1991). Oral history as a practice and method is a tool used to gather,
listen to, and understand the stories and perspectives of people within
communities. From an Indigenous perspective, I consider oral history
to be a collaborative and multi-generational approach in which it's
not enough to gather the stories; one must use and understand them
in a way determined by the subjects of the oral history. As a form of
narrative, oral history is a process of gathering stories told orally from
one person to another and then often transferred into another form or
modality. Oral history, then, is always relational, collaborative, and con-
stellated. It is always an embodied practice. As a scholar of Indigenous
rhetorics, I am interested in learning from the stories that American
Indian women tell about their lived experiences *as* theory. These stories
complicate the ways in which we consider how theory is made and used,
as well as illuminating important teachings about how to navigate dom-
inant and paracolonial structures, mentor, research, teach, and navigate
everyday life. For me, to understand the stories that American Indian
women tell about their lived experiences in this way is a reorientation

toward community-based research: from studying Indigenous people to showing *how* the knowledge made by Indigenous people is meaningful in multiple venues of life.

Since this chapter is part of a collection on well-being and health, I plan to frame this theory of oral historiography within decolonial thinking and doing. It is within a framework of decoloniality in which I see connections between oral historiography and wellness. In fact, I operate under the notion that all of us, Natives and settlers, are complicit in colonial rhetorical practices and live in a paracolonial world. Drawing from Walter Mignolo (2011, 3), we can all benefit from delinking from the colonial matrix of power—in other words, from "a narrative that builds Western civilization by celebrating its achievements while hiding at the same time its darker side, 'coloniality'" (3)—and seeking, instead, a decolonial reward. The decolonial reward will not look like the rewards that one receives by maintaining and sustaining colonial projects. Instead, it is to imagine, invent, and build decolonial futures. From Idle No More to the Walking with Our Sisters grassroots movement to teaching youngsters how to make moccasins or speak in their Indigenous languages, all are examples of delinking from colonial practices and building a decolonial future that is collaborative, relational, and embodied.

I understand the decolonial reward similar to how we might think of well-being and health because of the fact that living with and making knowledge using colonial practices do not feel good. They're bad for the body, the mind, and the soul. They're bad for our communities. We've been told this through boarding school stories or learning how hetero-patriarchal colonialism affects gender roles and visibility, to name just a few examples. These are some of the reasons that we must dechain from imperial designs while imagining our future for generations to come. I want to be clear, though, that to do decolonial work can be exhausting. It can be defeating and time consuming. Yet there's something about watching a drum being carried to the front of a protest or listening to an Elder's story that continues to warm my body and feeds me to keep going. It is in this negotiation between defeat and healing that I think a conversation about wellness in relation to decoloniality and making oral history can occur. To build an Indigenous theory of oral historiography, I will draw from the stories that American Indian women tell in oral history narratives, academic scholarship, and a travel memoir to

make visible the ways that memory, ancestry, consideration of land and space, and embodiment are crucial to making an oral history narrative and methodology. This approach to theory, like decoloniality, has an emphasis on doing—on practice.[1]

Oral History, Why?
To Remember Our Ancestors (With).

In *The Common Pot: The Recovery of Native Space in the Northeast*, Lisa Brooks relies on a set of theoretical frames, including body, place, and culture, to map how Indigenous people use writing to reclaim and reconstruct communities. For Brooks (2008, xxii), "mapping is a tool of rememberment"—one with which to navigate a fragmented world. To map, one must engage in rememberment, an embodied and material practice deeply rooted in the land and Indigenous bodies across time and space. To engage in rememberment is a complex historiographical practice. Like relationality, it is used to create and sustain relationships while acknowledging how we are all interconnected. I would like to explore further this type of historiography, one rooted in land, memory, body, and ancestry, as a way to make and do oral history narratives. I begin here, with Brooks and mapping, to honour the relationality of this story and pay respect to the American Indian women who have shaped my worldview and scholarly practice. By making those connections visible, I hold myself accountable to the women, their stories, and their network of relations. It is how I practise rememberment and mapping through narrative. As Brooks theorizes mapping, she draws from Louise Erdrich's *Books & Islands in Ojibwe Country: Traveling in the Land of My Ancestors* (2003), another map of Indigenous space, to weave a discussion about how Indigenous writers theorize the relationship between orality and literacy. Brooks looks to Erdrich and her "journey journal" to explain how writing and drawing are both examples of image making and to show that there is not a binary between the word and the image (xxi). To contemplate this relationship, Brooks begins with a scene inspired by *Books & Islands*. She leads us to a making moment in which she is outside on the land of her ancestors, the Abenaki, with her family and laptop. She writes that "we are sitting on the grass, stretching our legs, talking about birchbark scrolls, Mayan codices, and the intertwining of writing and the oral tradition. 'I always knew,' Natalie says, 'that there were things that were taken from us, kept from us ... knowledge that was

hidden. Deep inside me, I always knew. . . .' This book is only an attempt
. . . to weave together fragments found, fragments of words written down,
recorded by our ancestors" (xx). Brooks relies on Erdrich to assist her
in developing a map to remember her ancestors and to understand *how*
Indigenous people of the northeast *use* writing.

I begin with Brooks and her contemplation of her relationship to
the land of her ancestors, and including Erdrich in her web of relations,
because both makers help me to understand how mapping is a material,
embodied, and relational practice. To map, we must consider the land as
a constantly storying ancestor. We must also consider our own bodies in
relation to the land and how this relationship affects how we make and
share knowledge. We must listen to our bodies and the stories that they
tell to, for, and alongside the land. When we engage with land-based
knowledge, we are undertaking decoloniality. We rebuild and reconstruct
our bodies, minds, and relationships with the world. To achieve this
engagement requires a particular willingness to disrupt the Cartesian
(i.e., Westernized) notion of the mind/body separation. It is a way to
approach the land and knowledge making entirely and in one whole
body that has not been separated, divided, or catalogued. It is how we
heal. By returning to the land, I believe, like Brooks, we return to our
ancestors and relatives. And it is this sentiment that creates an opening
to make oral history.

In *Books & Islands in Ojibwe Country*, Louise Erdrich (2003) weaves
her personal history as a mother, book reader, and writer with the story
of her travels to the Lake of the Woods islands to create a relational
history of Ojibwe traditions. Erdrich is one of the most visible American
Indian women and authors in both Indian Country and dominant so-
ciety. Her fictional work is canonized and has been discussed in both
trade magazines and scholarly journals. Yet *Books & Islands* is a different
type of publication for Erdrich; it is a travel memoir, published as part
of the National Geographic series. Although Erdrich is extremely
visible, she has tried to keep her personal life private. In *Books & Islands*,
however, she creates a relational and participatory framework in which
she shares her personal life with the public. She speaks to her audience
as a mother, a book lover, an Anishinaabekwe, and a traveller. I would
like to enact a relistening of how I hear Erdrich use her position as a
mother and an author to draw attention to the interconnectedness of
literacy, land, and Ojibwe history. From her position as a mother, this

interconnectedness is embodied and material. It is rooted in birchbark bitings and rock paintings. It is rooted in the understanding of her body as a new-old mother. In *Books & Islands*, Erdrich visits the Lake of the Woods islands in Minnesota and Ontario. These islands are sacred for many Anishinaabeg and home to plants, animals, and rock paintings that hold important traditional knowledge. Throughout her travels, Erdrich, along with her eighteen-month-old daughter, Kiizhikok, visits with friends, family members, and ancestors.

Books, Why?
To Create Relationships (With).

Throughout the narrative, Erdrich (2003) asks "Books, why?" I have adopted this playful game of asking and answering for the structure of this chapter as a way to build a relational and participatory framework—one inspired by her own methodology. For Erdrich, there is a connection between her love of books and her love of these islands. By asking "Books, why?" she seeks to understand better the connection between islands and books, books and islands. Erdrich argues that the Ojibwe were always writing, making books and things:

> *Mazina'iganan* is the word for "books" in Ojibwemowin or Anishinaabemowin, and *mazinapikiniganan* is the word for "rock paintings.".... As you can see, both words begin with "mazina." It is the root for dozens of words all concerned with made images and with the substances upon which the images are put, mainly paper or screens.... The Ojibwe had been using the word *mazinibaganjigan* for years to describe dental pictographs made on birchbark, perhaps the first books made in North America. Yes, I figure books have been written around here ever since someone had the idea of biting or even writing on birchbark with a sharpened stick. Books are nothing all that new. (5)

By showing the relationship among birchbark biting, books, and rock paintings, Erdrich demonstrates that she is not engaging with a Eurocentric understanding of literacy that begins with the printing press. For those of us in Indian Country, this is not a new idea, and it is not supposed to be. Here Erdrich takes the time to communicate this history to her non-Indigenous audience. Yet what I find meaningful about her

observation is how these literacy practices emphasize *making*. Like biting or painting, these books—these islands—are made. In addition, Erdrich emphasizes that these writings and drawings are made not only by ancestors of the Ojibwe but also by modern Ojibwe (6). This observation is important because she connects the traditional practices of the Ojibwe to the Ojibwe people: still here, still making. I believe that this is even more evident as Erdrich explains how the Ojibwe got their name and what it means:

> Ojibwe is also slurred into the word Chippewa and in its original form, Anishinaabe, it is pronounced "Ah-NISH-in-AH-bay." The word is very loaded and bears a host of meanings and interpretations and theories.... I've heard that Anishinaabe means "from whence is lowered the male of the species," but I don't like that one very much. And then there is the more mystical Spontaneous Beings. The meaning that I like the best of course is Ojibwe from the verb *Ozhibii'ige*, which is "to write." Ojibwe people were great writers from way back and synthesized the oral and written tradition by keeping mnemonic scrolls of inscribed birchbark. The first people, the first books. (10–11)

As Erdrich theorizes a relationship between birchbark biting, Ojibwe history, and the naming of Ojibwe people, I hear her making a complex argument that the Ojibwe people have always been and will always be here on Turtle Island making knowledge. This is a different understanding of Indigeneity in which she reorients from arguing that Ojibwe people were the "first people" to noting that they have always been and will always be here because of their relationships with the land, practice, and history. Through these passages, Erdrich builds her own theory of making, including what it looks like for Ojibwe people and how Western and Ojibwe notions of literacy affect history and historiography. It is in this theory that I understand a relationship between Indigeneity and historiography. In fact, I would argue that this understanding of Indigeneity (making and embodied) *is* historiographical especially since it emphasizes relationality and disrupts a Eurocentric approach that emphasizes linearity and individualism.[2] This type of decolonial thinking and making provides another option—an old

option for engaging with the land, for making, and for understanding one's relationship with the world.

"Books, why?
So that I will never be alone." (Erdrich 2003, 141)

By including this notion of *always* in Ojibwe history, Erdrich destabilizes the book. It is no longer a neat and tidy thing. In fact, it is not a thing at all but a relative—rooted in the land—nurtured and cared for by ancestors. The books, like ancestors, travel with her. She reminds me of how Michel de Certeau theorizes historiography through his own obsession with ghosts—with phantasms. In *The Writing of History*, de Certeau (1992, xxvii) theorizes the practice of making history and asks "what alliance is there between *writing* and *history*?" He answers this question as he begins his quest to examine the creation and celebration of the book. He creates this path for examination by beginning with a meditation on how history functions in *History of France* by Michelet. De Certeau connects the practice of making history to a ritual with the dead: "These ghosts find access through writing on the condition that they remain *forever silent*" (2). By beginning with this ritual, de Certeau makes an argument that historiography is about travelling and living with ghosts. As he forms relationships with these ghosts or phantasms, he is able to ask "history, what?" or "history, how?" Within this framework, de Certeau forms a connection between historiography and the material product of the book, for the book signifies the emphasis on the product of history and not the production (30). In other words, the book itself encourages a certain static telling of history with which de Certeau takes issue. I've brought *The Writing of History* into this narrative not to bring value to or justify Erdrich's history of literacy but to draw attention to the echoes—the apparitions—between an Ojibwe-German historiographer and a French theorist, whose ancestries are much more linked than they appear to be at first. Here I take up the Abenaki idea of the common pot, or honouring the complexity of relations, to draw attention to the complexity of recognizing and honouring where knowledge comes from, how it is used, and what we can do with it in the service of decoloniality. Like de Certeau, Erdrich uses books as ghosts—as ancestors—to theorize Indigenous rhetorical practices. As I travel through these pages, I too remember the ghosts

who travel with me, the ghosts who protect me as I live and work on my ancestral lands. And, if you are willing, dear reader, I encourage you to join me. Please take a moment, step outside, and spend some time with the land and your ancestors. I will wait for you.

To carry stories—ancestors—through one's travels is to practise relationality. It provides an opportunity to contemplate what it means to carry stories and our ancestors and relatives into making practices such as birchbark biting, drawing, or historiography. To dwell here for a moment, I ask what might it look like to do this while engaging with oral history? What does it *look* like, and what does it *feel* like, to carry stories while transcribing, interviewing, and relistening to the stories told? Like Brooks and Erdrich, I believe that the word and the drawing and the map are all forms of making. And I believe that I can learn how to make oral history from those who bite birchbark, map the land, or weave a basket. To make these forms of making more relational and interconnected is to honour the complexity of knowledge-making and -sharing practices.

In the next section, I examine how Erdrich makes herself visible through a theory of motherhood. As an Anishinaabekwe writing, she contributes to *reinventing the enemy's language* by creating history through motherhood—through islands.

"Books, why?
To read while nursing a baby." (Erdrich 2003, 17)

At the time that she wrote *Books & Islands in Ojibwe Country*, Erdrich was a new-old mother at the age of forty-seven, with her previous children already becoming teenagers and adults. Throughout the narrative, she allows her reader to see her teaching her daughter, little Kiizhikok, Ojibwe traditions. Erdrich invites the audience in to learn from her teachings:

> The word for "tobacco" is *asema*, and it is essential to bring some for this reason: Spirits like tobacco. . . . Before I take a trip like the one I am taking now, I always buy a pound or two of this tobacco and divide it into smaller bags. Some are for the baby to give to other people and some are for the spirits of the places we're going to visit. . . . Whenever I offered tobacco I was for that moment fully there, fully thinking, willing to

address the mystery. Therefore, I've taught my children to offer tobacco (At the same time that I rail at them not to smoke it). The baby is adept at dipping her hand into the bag and waiting for the right moment to scatter the flakes. If allowed to, she'll keep offering tobacco until the bag's used up. (15–16)

With the baby, we learn the significance of laying down the tobacco. As I revisit this passage, I feel a deep yearning to pull out my bag of tobacco and go outside and spend some time with my relations. It feels good to put down tobacco. It feels good to know that Erdrich is taking the time to teach her little one, and it reminds me to take the time to teach my own daughter. After all, isn't this one way to carry the stories and honour our relatives? Isn't this the way that we care for each other and our children?

These teachings provide an opportunity to form relationships with Erdrich, her child, and the books and islands. Through relationships, Erdrich takes the opportunity to practise reflexivity—to re-examine her relationship with Ojibwe traditions from her perspective as a mother. Throughout the narrative, she also takes the time to reflect on her circumstances as a mother, highlighting how her relationship with rock paintings and her experience travelling through the Lake of the Woods islands reveal the complexity of being a mother: "A period of emptiness, unusual to my life, now begins, in which I can either fret or accomplish that rare thing, *the doing of nothing. Or rather, with the baby, the doing of what the baby wants.* This kind of doing is very much part of the trip, and although there is a dreamy blankness to it—the hours merge and the edges of the days grow fuzzy—these times when I devote my whole self to Kiizhikok are also times of great complexity and learning" (2003, 28). Here Erdrich draws attention to the challenges of motherhood, specifically to the complexity of being both selfish and selfless. She negotiates her desires as a woman, traveller, and book reader with her desire to take care of her baby and, to make things more complicated, the desire of the baby to play or be read to or put stones in her mouth. By dedicating herself to caring for and teaching another being, Erdrich considers these moments as opportunities to learn from her child, reflect on her circumstances, and listen to the universe.

Erdrich further complicates these desires as she narrates her experience of climbing to see the thunderbird paintings in Spirit Bay. As she travels to Spirit Bay, she pays close attention to the baby: how little Kiizhikok adapts to water travel, how the animals and spirits respond to Kiizhikok, and how she can keep her little girl safe. In doing so, Erdrich connects the rock paintings and their significance to mothering. To complicate this connection further, she depicts how her role as a mother creates new responsibilities and orientations to the rock paintings:

> I grab my camera, my tobacco offering, and retie my running shoes. I already have my twenty extra pounds left over from having a baby. I am just pretending that I am strong and agile. Really, I am soft and clumsy, but I want to see the painting. I am on fire to see it.... Like all women are accused of doing, I claw my way to the top. Sweaty, heart pounding, I finally know I'm there. All I have to do is inch forward and step around the edge of the cliff, but that's the thing. I have to step around one particular rock and it looks like there's nothing below it or on the other side. I could fall into the rocks. My children could be left motherless.... So I don't go around the rock, but seek another route.... Again, I nearly take the chance and lower myself over the cliff but I can't see how far I'd fall.... I know I am a mother and I just can't do it. (67)

Although Erdrich has waited her entire life to see these paintings, her new position as a mother requires her to rethink her desire and consider the safety of her family. The father of her child continues the climb, and Erdrich cannot help but feel angry with him for jumping off the cliffs and almost endangering himself. She juxtaposes her responsibility as a mother with her partner's responsibility as a father to show that a theoretical practice of motherhood is different, perhaps more self-sacrificing. Yet I am also drawn to how Erdrich talks throughout the narrative about her own body as a mother—how motherhood and mothering have changed her body, especially as she talks about the rock paintings. In some ways, it seems as if she cannot talk about the rock paintings without talking about her role as a mother. At first appearance, this sentiment—that motherhood and mothering change bodies—might seem to be so simple and obvious. And, even though

Erdrich has been able physically to give birth to her daughter, I believe that there is the potential to explore how mothering practices in relation to bodies occur for those who do not have the opportunity physically to give birth but engage in these roles and responsibilities. I hear Erdrich think about her own body in relation to mothering and rock paintings as meaning-making practices: that is, to consider her own body is to contemplate survival but also to practise responsibility and accountability and reflexivity. As I listen to Erdrich theorize her own mothering body as making, I see an opening to think intently about how bodies function in making oral history—real, live, breathing, blood-pumping bodies. As she asks "books, why?" I want to explore "bodies, how?" How do we pay attention to our bodies as we navigate our research—as we tell stories—as our bodies' stories? What happens to the making of oral history when our bodies are healthy and well? What happens to the making of oral history when our bodies are sick and dealing with trauma?

There is a lot of discourse about the importance of reflexivity and accountability in oral history. Often this is expressed while working with participants, acknowledging one's own authority as an agent of the institution, or maintaining Institutional Review Board (IRB) protocols. I believe that Erdrich's theory of motherhood creates opportunities to ask questions about the role of desire in the making of the oral history product. For example, what are my desires as a researcher, storyteller, teacher, or Anishinaabekwe for the structure, meaning, and use of the oral history product? As the researcher, how can I engage in a sense of giving more than I take when engaging in oral history work? How can I use Indigenous knowledge practices to make oral history and to use this oral history in the service of decoloniality, autonomy, and self-determination as dictated by my participants, whom I see not as participants but as collaborators, tradition keepers, Elders, and youngsters all vital to the survival of the community? As Erdrich speaks about desire and responsibility, I believe that it is deeply embodied and rooted to the land—like the desire that I felt to visit with my ancestors while relistening to Erdrich. To continue building an Indigenous approach to oral historiography, I will turn to another Native space: the Indigenous land of the Tohono O'odham and another form of Indigenous writing: the oral history.

Stories and Dreams:
Weaving Theory through Indigenous Bodies

Desert Indian Woman: Stories and Dreams (2001), a text co-authored by Tohono O'odham Elder Frances Manuel and Deborah Neff, maps Manuel's life story of growing up and raising children on the American-Mexican border throughout the twentieth century. This text is the product of a twenty-year relationship in which Manuel and Neff first met each other at a cultural awareness centre in Tucson where Neff was the "project specialist" and Manuel was the resident basket weaver. I am drawn to this book because of how the authors create a collaborative and multi-generational approach to oral history. In this section, I will show how I listen to the stories that Manuel tells about weaving baskets, and the stories that Manuel and Neff tell about working together, as a way to understand the embodied and material aspects of oral historiography. While speaking about her relationship with basket weaving, Manuel grasps for words, explaining that "I don't know how to put it but it's THERE/ (softly) you're all together when you are making baskets/ there are no other things" (97). I am taken by this emphasis on the word *there*. In fact, I have written elsewhere about how a theory of thereness (i.e., presence and visibility) is instructive in doing intercultural community-based research.[3] Through thereness, Manuel explains how her connection to basket weaving is embodied, which is why it is so difficult to articulate with Western language.

When Manuel uses the word *there*, I imagine her gesturing toward her heart with her hand to direct that this knowledge lives in her body and has lived in the bodies of previous generations of basket makers. Since a Western language disconnects soul and body, she must tell a story instead. As she explains,

> I think when you talk about baskets, what is there to talk about? You tie a knot and you go around and around, whatever's in your mind, you're just thinking about it when you are doing it. It's not like when it's broken and you fix it, when you do different things in the basket, it's not there. It goes round and round, the design is in your head—what color you're gonna put in, how much bear grass you're gonna put in, if you feel you need some more, it's just that. . . . What I think about the basket is that nowadays, young ladies, even

older ladies—I'm talking about us. When they see pretty things or pretty house or pretty furniture in there, they feel like making baskets to get some money to buy these things. So they are not really careful, they just hurry to get the things they want. That's why the baskets aren't the same as they were before. Because at the time, there was nothing. Ladies took their time, do their work, what was given to them. They work with their eyes, their hands, their mind, their thoughts. They work hard, their body warms and they sweat—that's the real thing. Nowadays we hurry. Like me, I'm hurrying to save some money to buy a sandwich. So this is what I want to say. (102)

In this story, Manuel explains what making baskets looks like and how the practice of making them has changed from the colonial past to the present. She makes Indigenous women's bodies visible while discussing how baskets were made and valued before colonialism. Also, she draws attention to how contemporary Indigenous bodies have become invisible with contemporary weaving practices. As Manuel examines how the practice of basket weaving has changed, she draws attention to her thoughts and stories created while basket weaving, an important aspect of the weaving itself. Through story, she emphasizes the body in basket weaving. By paying attention to the weaver's body, she can argue that, through weaving, she is able to trace the visibility of one's identity within both mainstream and tribal societies. I find Manuel to be an extremely complicated storyteller and theorist. In just a short passage, she weaves a historical sense of Tohono O'odham basket weaving practices, how colonialism has affected these practices, and how bodies are central to both issues. She teaches me that a basket has a lot to say about how Indigenous history is made and understood.

Yet what's missing from her stories are her accomplishments. Manuel marks her theories on basket weaving not by the awards that she has won but through the relationships that she has formed with the materials, with the world, and with the people whom she has met during her demonstrations. I see this negotiation as an example of how she positions herself and makes herself visible to both Indigenous and non-Indigenous peoples. To be a weaver is to put forth a certain type of visibility that is an awareness of one's body and the bodies of

fellow weavers. I see how Manuel carries a knowledge—a history of the relationship of one's body to basket weaving and thus to colonialism. From her perspective, history and knowledge and practice are held in the bodies of basket weavers.

In preparing to tell the story of her husband's death, Manuel reflects on her identity and what it might look like to outside perspectives. She recalls that she "raised six kids. I'd call myself a strong woman, even if nobody thinks I'm a strong woman. [Softly, thoughtfully] I went through a lot sometimes" (Manuel and Neff 2001, 60). Here I hear Manuel refer to strength both literally and figuratively: the embodied strength to carry six children to term and raise them, as well as the strength to live in Tucson on the income made from cleaning houses and making tortillas. Manuel identifies as "strong" by building a theory out of embodied and material experiences. For example, she is strong because her fingers are strong from weaving, her hands are strong from patting tortillas, and her body is strong from bearing and raising children. By examining identity beyond character or metaphor and through our bodies, we can pay attention to how our bodies take up space and move as they endure colonial impacts. Manuel encourages me to wonder how my own body takes up space and to think about what type of space I should take up. She reminds me that we need to pay attention to our bodies and their presence throughout the research process and product.

While thinking about the relationship between oral historiography and weaving, I think about what Manuel says about gathering materials. There is a ceremony for gathering materials for baskets (an offering, a prayer). Manuel reminds me of the importance of understanding the ceremony of gathering materials and that this ceremony instructs and is deeply connected to the finished product. She encourages me to ask "what is the material gathering process of oral history?" And "how can I approach oral historiography as a ceremony?" "As an oral historian, what are my materials?"

On Stories and Dreams:
"How Can I Tell My Grandmother What to Do?"

Throughout the narrative, Manuel and Neff (2001) transparently negotiate oral historiography that engages with many of the criticisms that Indigenous Studies scholars have rightfully given regarding the

relationship between anthropologists and Indigenous peoples. In fact, this text teaches us how we can research with and for Indigenous peoples. As Neff writes, "it has not been common practice to credit the native speaker with coauthorship of life histories. Over one hundred collaborative works about Native Americans have been written in the 'as told to' format, with the non-Indian as sole author. We have departed from this tradition on the basis that oral tradition is literature" (xviii). Manuel and Neff challenge how oral histories are made and their possibilities. Neff doesn't spend time in the introduction rewriting Manuel's history or rationalizing it to readers in her disciplinary field. Instead, the introduction serves as a series of stories about how the project began, and it draws out the silences normally brushed away during a research process. Neff writes that, "for the reader less interested in lengthy introductions and an afterword, these can be skipped or read later; Frances's words stand on their own" (xvii). Her words do not need to be rationalized or justified because Manuel, too, is an intellectual.

In this section, I will pay attention to a series of conversations in which Manuel and Neff take turns telling stories about their relationship and how it affected their research process. One of my favourite stories is from Neff's journal excerpts from the three months that Neff lived with Manuel:

> In spite of our difficulties, we have a lot of fun! I love our jokes about the coffee pot being jealous of the pan, and how hard it is to get it to boil. . . . Through play, I am learning how events have life, bring things into creation or negate those things, or join with new things, transform them. . . . But being here, things are way out of my control, I'm just waiting. Frances is busy, tired, sick, resting, not in the mood, disorganized, and waiting on me, too. I think she sees me as directing things, but how can I tell my grandmother what to do? I tried meeting the same time every day, but that turned out to be impossible. Well, like Frances says, if it's not real, it won't come out—the time has to be right. So, I need to just be there. Is this what it is all about? I keep asking myself what is this thing that we are doing? (200)

Neff emphasizes here something important about researching with people, something that it took me a long time to realize as I conducted

oral history work. Remembering the relational aspect of oral history creates space in which to play and collaborate. Play and exploration have been encouraged when working with texts, but seldom with people, because once work is collaborative there is the risk of wasting time; we are impatient and fear making messes. Yet this relational and playful approach isn't perfect. Neff expresses her frustrations about completing the project and her co-researcher's understanding of realness. Like relationships, data collection thrives on patient nurturing and cultivation. In the same way that Manuel might take the time to tend to her materials, oral historians need to consider the stories as materials. We need to figure out how to gather them, tend to them, and preserve them for cultural continuance. I am reminded of something that my mentor, Susan Applegate Krouse, once said to me when working on oral history projects together: "The best stories are success stories." It took me a long time to welcome this idea because I was stuck in anger. Yet I carry this teaching and continue to listen to it. This passage about play provides me with an important memory of how multi-generational conversations—how older generations and younger generations—form relationships with each other and demonstrate a particular type of decolonial relationship. Making play and success visible, we expand decoloniality by making room for the type of relationships and approaches to knowledge that embrace joy and happiness.

As Neff notices that her relationship with Manuel has developed into a grandmother-granddaughter research relationship, the position of power is difficult to negotiate. Neff, as an academic woman from a Euro-immigrant background, has a much more visibly accepted position than Manuel. But it's clear from the passage above that Neff is trying to decentre her own power to privilege Manuel's story. It's through such a passage that we can learn about the rhetorical complexity of making oral history and transcribing an oral narrative into a book for publication. Manuel and Neff draw attention to something important regarding community-based work: what happens when research relationships represent grandmother-granddaughter relationships? What does such a relationship look like, and how does it affect how knowledge is made and shared?

Whereas Neff identifies Manuel as her grandmother to explain the complexities of research, Manuel talks about her identity in terms

of her knowledge-making practices, such as dreaming, weaving, and storytelling. By situating herself as a weaver and a dreamer, Manuel relates the significance of her everyday tasks to how stories get made—to how she expects her interviews with Neff should happen: it's about the practice of patience, listening, and watching. These attributes are not always encouraged or seen as intellectual endeavours. Manuel recalls a dream in order to make this argument:

> I don't really believe in dreams, but sometimes the dream is so clear, so sometimes I think it is true. The other night I dreamed that a tall man in shorts came in with a notebook and he asked me if I wanted to die and I said, "Of course not, I'm afraid to die," and then he marked something and he turned around to my friend, Lorenzo, and asked him if he wanted to die, and he said, "yes." Then he turned around to me and said, "well, you're going to live to be ninety." Then I looked at his shoes, they were so raggedy and the toe was peeping out. And I was wondering all day why I dreamed that and I remembered it, and what it means. I don't usually remember my dreams so clearly. I was in bed, dreaming I was laying on the couch and Lorenzo was sitting in the chair. My recent life is almost the same, get up in the morning and do cooking. If I'm lazy, I don't do anything. I just do things that has to be done. And, um, if I really feel like working on baskets, I'll just soak the yucca and wait. Sometimes, I don't get to it until afternoon. And um, some days I work and some days I play. But I'm not the kind of person who gets to somebody's house and sit and talk. That's the way I am from way back. Because I don't have enough things to say, and I don't say things that I feel they won't be interested. I don't like to talk for just the sound, without meaning anything to them, when it's not part of their ways.
>
> And I don't try to make things interesting, I don't add anything, I just talk about things the way it happens. I don't lie, but sometimes I say I don't know, but I just don't want to talk about it. If I don't feel like talking about it, I don't talk about it. It just goes on like that. And another thing, I don't just come out and ask for all of the details, I just . . . slowly, little by little. It's a lot easier than asking a question straight

out, it just loses something! That's why the people don't
get straight answers. (199)

Manuel's identity is rooted in practice. For example, if I want to
understand how Manuel identifies as a weaver, I have to listen to
her talk about gathering materials and making baskets. In the same
way that Neff is frustrated with how to proceed with the oral history,
Manuel recognizes the difficulty of collaborating on making one's
lived experiences public. So she provides a teaching on how to ap-
proach research similar to how we practise weaving, storytelling, or
forming relationships with the people with whom we share space.

Oral Historiography, Why?
To Show that It Is Made.

Dear readers, it feels a little funny to write about oral historiogra-
phy without talking about the oral history projects on which I have
worked. As I have said, those stories live elsewhere. Instead, I wanted
to dwell with some of the stories that help me to think about the
making and sharing of oral history. I'm invested in the idea that a
basket has just as much intellectual usefulness as an academic article
(Powell 2014). What authors such as Lisa Brooks, Louise Erdrich,
and Frances Manuel and Deborah Neff remind me is that—whether
we are talking about baskets, stories, maps, birchbark biting, or oral
history—it's all made by people. I'm reminded of the ongoing tension
that I feel while writing an academic article compared with sewing a
ribbon skirt, mothering, or gardening. These other making practices
are instinctively designed for our health and survival. In many ways,
I hope that we as academics can find ways for our academic writing
to empower, energize, and heal us, especially while we work with, for,
and alongside our Indigenous communities. For me, my ancestral
making practices instruct me on how to research, write, and share that
research. These practices remind me that all stories are gifts and that
we must create a set of practices that honour these gifts in a good way.

Miigwetch for listening.

Notes

1 I began writing this chapter in 2013. Since then, the conversations about decolonization and decoloniality have changed immensely. For the purpose of this chapter, I am addressing the relationship between knowledge making and decoloniality. It is also important to emphasize that this is not where decoloniality should end. Instead, it should be interwoven with the ongoing efforts to recuperate Indigenous land and life.

2 Both de Certeau (1992) and Foucault (1982) have made similar critiques about historiography.

3 For more information, see Riley-Mukavetz (2014), in which I use my research with the Odawa women to highlight two practices for intercultural research: thereness and relationality. Both practices are informed by the stories that these American Indian women tell about their lived experiences.

References

Brooks, L. 2008. *The Common Pot: Recovery of Native Space in the Northeast*. Minneapolis: University of Minnesota Press.

Cruikshank, J. 2000. *The Social Lives of Stories: Narrative and Knowledge in the Yukon Territory*. Lincoln: University of Nebraska Press.

de Certeau, M. 1992. *The Writing of History*. New York: Columbia University Press.

Erdrich, L. 2003. *Traveling in the Land of My Ancestors: Books and Islands in Ojibwe Country*. Washington, DC: National Geographic Society.

Foucault, M. 1982. *The Archeology of Knowledge*. New York: Routledge.

Herndl, C. 1991. "Writing Ethnography: Representation, Rhetoric, and Institutional Practices." *College English* 53, no. 3: 320–32.

Manuel, F., and D. Neff. 2001. *Desert Indian Woman: Stories and Dreams*. Tucson: University of Arizona Press.

Mignolo, W. 2011. *The Darker Side of Western Modernity: Global Futures, Decolonial Options*. Durham, NC: Duke University Press.

Powell, M. 2014. "A Basket Is a Basket Because . . . : Telling a Native Rhetorics Story." In *The Oxford Handbook of Indigenous American Literature*, edited by J.H. Cox and D.H. Justice, 471–88. Oxford: Oxford University Press.

Riley-Mukavetz, A. 2014. "Towards a Cultural Rhetorics Methodology: Making Research Matter with a Group of Multi-Generational, Urban, Native Women." *Rhetoric, Professional Communication, and Globalization* 5, no. 1: 108–25.

———. 2018. "Females, the Strong Ones: Listening to the Lived Experiences of American Indian Women." *Studies in American Indian Literatures* 30, no. 1: 1–23.

Wilson, S. 2008. *Research Is Ceremony: Indigenous Research Methods*. Black Point, NS: Fernwood Publishing.

FOR KAYDENCE AND HER COUSINS:
Health and Happiness in Cultural Legacies and Contemporary Contexts

ADESOLA AKINLEYE

> *"...a state of harmony and beauty between people and their environment." (Mahina 2002, 304)*[1]

My motivation for writing this chapter is to suggest that the arts nurture the connectedness and state of being *in relationship* with the world that underpin health and healing. My belief is that the arts contribute to this balance and harmony of health in two ways: through the act of *making together* and through the *shared experiencing* of artworks/performances. By using the term "performance" throughout this chapter, I do not mean to bring to mind the onlooker-spectacle relationship of many Western heritages. By "performance," I am referring to the gathering together to share a marked event in which all those involved have a role. This is the cathartic ritual for which art creates a space through the shared encounter of experiencing together. The sense that we are unwitnessed and unseen, and that our experiences are isolated and ignored, is at the heart of trauma—imbalance and numbness (Van der Kolk 2014). Through making, performing, and experiencing art, we express and develop our sensations, imaginations, empathies, and connections with the world around us (Dewey 2005).

Therefore, when my *tiyospaye* niece Kaydence was born, I created an artwork for her in the form of a contemporary performance piece for children called *Rose's Jingle Dress*.[2] This was to honour her birth and a

wider appeal for her health and happiness (Chipps and Chiat 2003): "At the center of the old Sioux society was the tiyospaye, the extended family group, . . . which included grandparents, uncles, aunts, in-laws, and cousins. . . . Kids were never alone, always fussed over by not one but several mothers, watched and taught by several fathers" (Crow Dog and Erdoes 1990, 13). Kaydence is my niece through my ceremony *tiyospaye*. I had danced in ceremony with her mother, Raelene, for twenty-two years (almost all of her life).

The Oglala Lakota belief in connection and network that *tiyospaye* embodies reflects many Indigenous nations' worldviews that we are "all connected" or "all related" (*mitakuye oyasin*). The importance of being in relationship extends beyond people to our connections with world and environment: "Aboriginal women do not see the land as a wild material resource. . . . Rather the land is a relative with whom we have a special relationship" (Anderson 2000, 180). The relationship of world with self requires an openness to sensation, feeling, and intuition. The same qualities are cultivated by the experiences of "the arts," as they are called in contemporary Western language. Qualities and experiences that compel a unity between the reflections of the *mind* and sensations of the *body* make, and give meaning to, the world around us (Dewey 2005; Mahina 2002; Pratt 2002). Connectedness with world around is a shared value across Indigenous nations throughout the world, predating Western dualist systems of colonialism (Allen 1992).

Background: Me, Kaydence, and the Boy-With-No-Voice

I am a dancer, sometimes working as a performer, sometimes as an artist-in-residence in schools, sometimes as a lecturer, and sometimes as a choreographer. Like many dancers, I have a transnational identity, moving multiple times to allow me to keep working as an artist. I was raised in the United Kingdom and moved by myself to the United States of America in my teens to dance for Dance Theatre of Harlem. Since then I have lived in Canada, Europe, and the United States of America, as well as visiting my father's homeland of Nigeria. Throughout my adult life, the only thing that has remained constant is that, wherever I am each July to August, I have travelled to South Dakota to dance with my ceremony *tiyospaye*. Coming together every year with the same extended family has allowed us to watch each other grow. Kaydence was the first child born to my *tiyospaye* niece Raelene. Making *Rose's Jingle*

Dress to celebrate Kaydence's birth embodied shared prayers: *for the next generation* (a performance work for children and their families to come together), *for bad to be turned to good* (a contemporary performance work rooted in a Lakota worldview of connection as an alternative to negative Western mainstream media), and *for health and happiness* (a contemporary artwork that connects to, and gives a positive voice to, young Lakota children).

Around the world, I have seen too often how Indigenous children's interaction with contemporary art is an unhealthy one that reflects them as *othered* or even *wrong*, leaving them unseen in their own contemporary experiences and unheard because of a lack of spaces where people stop to listen to them. This voicelessness was brought home to me the year before Kaydence was born. I was working as an artist-in-residence in schools and had a two-week residency (exploring math through dance) in a school in rural Manitoba, Canada. This school was located near a reserve, and a large majority of the children in the school lived on the reserve. Working as an artist-in-schools across the United States of America, Canada, and the United Kingdom, I have witnessed how, as many children (and their parents) step across the threshold of the classroom, studio, or theatre, their sense of self, cultural capital, and understanding of their connection with the world is overshadowed by Western dualist values that include no concept of where they are coming from. This school was no exception. Usually, when I visit schools, it is rare that I am told much about the children.[3] For the reasons noted above, I make the most of being able to meet the children unaware of the school's (often negative) expectations of them. However, in this school, although I was not given any background, I was warned about a "troublesome" boy who would not speak or participate in classes.

However, the boy-with-no-voice joined in enthusiastically with the math and dance project. As it continued, I noticed that the other students treated him with more respect and reverence than I had expected, considering the description the teachers had given of him, as a despondent semi-dropout. Once or twice a student caught up in the excitement of dancing called him by what I would guess is his traditional name (reflecting what is special about him), different from how the teachers had registered him. All children are sacred, but the boy-with-no-voice reminded me of a person who is *Heyokha*,[4] a special kind of *Wakhan* ("sacred, a part of prayer"). I made a point of "listening"

to him within the terms of his wordless interactions with me. Contrary to the teachers' predictions, he joined in with everything that we did. At the end of my residency, we had a whole school sharing, and each group showed the interactive dances that they had created for each other. This went quite well, with all of the students enjoying each other's work and feeling proud of their own. At the end of my last day, as I was busy packing up, I heard a *girl* say goodbye to me, and I responded without looking up right away. When I did look up, I saw that I was talking to the boy-with-no-voice.

During my long journey back to where I was living, I thought about what I should have done. Because it was my last few minutes at the school, in the moment that I realized he had spoken, I chose not to make a fuss about it since I would not be back to follow up with him. I also felt that his silence was a form of resistance to the conformity of the Western-based school system. I wondered how much he would lose if he did not resist it. I wanted him to continue to protect himself, which might mean maintaining his silent resistance at school. But I also knew that children fighting to balance and maintain their identities must have constructive ways to express themselves to avoid the isolation of disconnection. I thought that the dance arts that I had shared had made bridges across the separation of expressive, sensing selves and articulated voices for many of the children in the school setting. As I journeyed home, the seed was planted for the importance of creating artwork that specifically gives voice and connects to the familiar experiences of children's Indigenous backgrounds.

Witnessing and Storying

I walk up to the big house from the fire pit. I had been standing by the fire, down the hill. The sounds of the pops and crackles of the wood are the music of the place where I was standing. The colour of the night is lit by the licks and tendons of the fire reaching up to the deep star-lit sky. Small bats appear and disappear as I look up. "The fire is almost ready." The warmth of the flames tickles my cheeks and forehead, so as I start to walk away from the fire pit, up the hill to the house, I feel the hairs on my skin still grasp for the warmth of the fire. As I leave the others caring for the fire, the sound of the wood still sings in my ears and merges with the sound of my blood pumping as I start to breathe more deeply at the steepness of the hill and coolness of the air away from the fire.

As I near the house, the light changes from the stars to electric light so bright that I can no longer see in the dark. All I can see now are the lit windows. And I start to hear music and voices and sounds that I recognize seeping into the night air—it's a video game. I open the door. "About ten minutes," I say to those inside. People start to gather things to walk back down with me. Most of the children are up here in the house. They are playing the Grand Theft Auto *video game. Little ones watching older ones play like uncles might have played the night before. The bright light and multi-layered sounds and colourful animation: they are enthralled. One or two may stay in the house in the light,*[5] *playing the video game. After all, it is cold outside past the spill of the electric lights. And the warmth of the fire requires them to face this cold first. They don't walk down the hill with us to the people waiting for them, standing at the fire.*

I believe that healing can happen when people's experiences, sensations, feelings, thoughts, and stories are recognized and responded to through art. Artwork "speaks to you" and in doing so "listens to you" because the interaction of art and self creates experience, and experience becomes story. Art offers us capacities to imagine, care for, describe, and locate ourselves in our communities in boundless ways. Although the concept and form of story change across, and are specific to, different cultures (Long 1999), storytelling involves imagination and imagery, the same tools that have been used by healers across centuries: "The return of imagery into our lives through art re-establishes imagery as a wise guide and healing agent in our contemporary lives" (Lovell 2001, 184). Evoking imagination and imagery, story has been used as a mode of healing across Indigenous nations (including the Americas and Africa). The witnessing and telling of experiences become a recognition of feelings and an acknowledgement of existence: "Personal stories are not merely a way of telling someone (or oneself) about one's life; they are the means by which identities may be fashioned. . . . The misfortunes of childhood may censor both memory and desire, impoverishing both the narrative past and how the narrative might seize the future. . . . We assume that all stories are told and that all self-understanding is realized within the narrative frames each culture provides its members" (Rosenwald and Ochberg 1992, 1–2).

I wanted the experience of the performance piece to be one that Kaydence would relate to within her *cultural frame*. This story would be one in which she could see a reflection of herself as beautiful, successful,

and familiar and have the opportunity to story herself joyfully. It would be a work of art that acknowledged her existence by showing a love of what is important in her life. I knew that as Kaydence grew up she would go to powwows, where she would see Jingle Dress dancing. Said to be Chippewa-Ojibwe in origin (Blackwolf and Jones 1996; Garcia 1992; Johnston 1992; Stephenson 1993), Jingle Dress dancing has now become a way for girls from many First Nations to embrace their personal cultures and connect with their communities through intertribal powwows (Axtmann 2001). Jingle Dress dancers wear dresses that have small metal cones attached to them that jingle/sing together when they dance to create a sound in rhythm with the drum of the music. This is a healing dance taught to young dancers by an Elder. A *tiyospaye* might come together to help manifest a young girl's Jingle Dress. The dance is performed today at powwows across the world. The story that emerged as the work started was about how a young girl (Rose) creates her Jingle Dress. Because Jingle Dresses make a sound when you dance in them, the story became an embodied metaphor for how a young girl creates the environment for her own voice.

Using movement and dance (rather than spoken words), *Rose's Jingle Dress* tells the contemporary story of Rose, left a suitcase by her grandma that contains part of a Jingle Dress. The performance is aimed at children three years of age and older. The performance opens with Rose asleep in the centre of the performance circle and the other two dancers moving around the edge of the circular performance space bringing her the suitcase. Across the centre of that space is an arch made of two parallel hoops. Therefore, the space has two enormous circles: one on the floor creating the space for the dance and one made of the hoops going from one side of the performance space to the other, with half of each hoop seemingly underground (the unseen ancestral world) and half visible as an arch across the space. Items to complete the dress are attached to the arches. During the performance, Rose finds these items to help her finish her dress.[6]

The two dancers bringing the suitcase enter the space and wake up Rose, who dances with her bed sheets, giving the impression that she might be dreaming. When she opens the suitcase, it has a number of special objects in it from her grandma. They include a completed miniature Jingle Dress for her teddy bear and an incomplete dress that fits her. Her dress has no jingles. When her teddy bear is moved in its

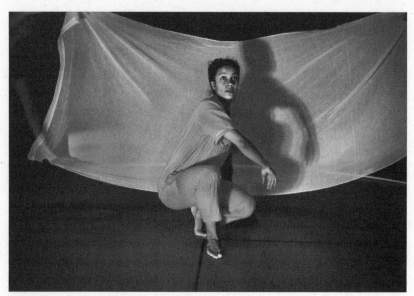

Figure 3.1. Rose waking. Photo by Barry Lewis.

Jingle Dress, it makes a sound (it sings), but when Rose moves in her dress it makes no sound (as if she has no voice). The audience does not see the jingle cones around the performance space, but they are added to the dress as the performance develops. During the performance, Rose finds or is given jingles in each of the four directions of the circular performance space. The other two dancers (like friends) experience and encourage her feelings as Rose courageously discovers the jingles in each of the four directions. Ultimately, the children in the audience become Rose's community as they help with attaching individual jingle cones to her dress.

The piece uses contemporary dance movements. As well as a story of success, *Rose's Jingle Dress* is an allegory recognizing that for Indigenous young people all of the "things" that they need to grow are sometimes hidden or hard to find but can be manifested through a connection with their world, community, and environment. The story recognizes that it can be especially difficult as they move into contemporary situations that their grandparents might never have experienced or prepared for, but through their creativity they can find a sense of their authentic selves. Rose has a dress—a start from her grandmother—but she needs to be proactive to find all that she needs for herself to be complete. The

story suggests that she is not a victim who needs things done for her; she is in a process of discovery. What she needs to find is in her environment, in her danced connection with the world around her.

The Importance of Connection and Interaction

As a dancer, I believe that healing and creativity are developed through the movement of connection and interaction. This becomes explicit to me as I dance: I am connected through the reflective movements that are my expressive dance steps and connected as I feel and sense the places around me—reshaping space to create my dance steps and responding to the music, sounds, and echoes of where I am dancing. This is the moving relationship of self with environment: world around me: "Sunlight on my skin, the warmth or chill of the ground under me, the rise of my breath joining the movement of the breeze. As the field of my attention spreads out I begin to notice a sense of response moving within me—response which my body continually makes but of which I am usually unaware" (Tufnell and Crickmay 2004, 7). The importance of being *in relationship*: connection and interaction were therefore at the heart of the *Rose's Jingle Dress* performances, in using dance as the non-language to tell the story, in the process of making the work, and in the performance itself. Over a period of two years, I held creative workshops and summer schools with young people from different Indigenous Nations in Manitoba and South Dakota and with children of Roma descent in the United Kingdom. Some workshops were with young children (from three to five years old), at whom the final performance was aimed, and some were with teenagers who thought about what they would want to say to and create for their younger siblings. All children in these workshops helped to craft the story (e.g., giving the character the name Rose, developing a background for her, and determining where her dress came from, as well as how the jingles would be found). During this time, I also spoke to Elders and shared ideas and prayers with my *tiyospaye*.

Once the work was at the performance stage, I wanted the importance of *in relationship* to be a principle that the audience experienced. Therefore, the performance was participatory. I did not expect the young audience members to sit silently during the performance. In particular, the children needed to feel involved and a part of it all. The performance addressed this in two ways. First, its space was in the round. This

meant that wherever you sat you could also see other people watching the performance. You were a part of the picture.[7] Second, throughout the performance were places where children were invited to join in; the performance was interactive. I was aware that for many people, especially families who do not usually have contemporary artwork directed at them, coming into a performance setting feels unfamiliar and the last place where they would want to join in. Many people dread the idea of being "called up on stage." But because the performance was in the round, there was no fourth wall between audience and performer. Nonetheless, the performance invited audience participation gently and gradually.

As the audience entered the performance space, Rose was asleep in the centre of the space. The other two dancers in the performance welcomed people as they came into the space and gave them a single jingle cone on a short ribbon with Velcro on the other end. The performers helped people to their seats and checked that Elders were comfortable. (Performers and performance space organizers knew that, if a child got up and started to dance or sing at any point, they would be supported.) This start established a sense of permission to connect with each other. Once the dancing and music started, the next time that there was a direct invitation to audience members, it was to ask them to clap to help keep the beat of the music. They did not have to move from their seats if they did not want to, but they started to hear their own sounds in the space. The clapping demonstrated that they could affect the space that they were in and be a part of it all in a good way. At a few points in the performance, groups of three or four children were invited to assist with "making" the dress by helping Rose to put the jingle cones on it. Next there was a section in which children were invited to stand and dance with the performers to cheer up Rose and encourage her to complete her dress. When the dress was almost complete, she moved through the audience so that the children could complete it by velcroing onto the single cone that they had been given to take care of when they entered the space. At the culmination of the performance, the whole audience was invited up to dance in celebration with Rose in a community round dance style.[8] After this, as Rose lay down to go back to sleep and the children returned to their seats, many of them went to tuck her sheet more carefully around her, check that she had her teddy bear, or say goodnight to her before they sat back down in their seats or left the performance space.

The story is about Rose, not about Jingle Dress dancing itself. The performance choreography did not "source" traditional dances (i.e., use traditional movements as the starting point for choreography, since doing so would be disrespectful to the dances, which have other purposes). Nor did it contemporize Jingle Dress dancing, which would have taken the dance itself out of its context. The performance did not involve explicit gestures (e.g., miming) or spoken words but, through contemporary dance,[9] told the story in movement and music. The steps and choreography were there to tell the story through the non-verbal means of dance movement. Movement was created through the workshops with children and devised with the professional dancers who performed the work. The aesthetic of the whole performance was informed by colours, directions, relationships with "things," and rhythms familiar to Kaydence where she lives.

The Importance of Rhythm, Relationship, and Response

The choreography used rhythms and directions that Kaydence, her mother Raelene, and I share. For instance, performed in the round, the choreography and movement patterns went only in a clockwise direction. The whole performance travelled within the circle in quarter segments of west, north, east, and ended with the completed dress in the south (the order in which our *tiyospaye* would honour each direction). It was through recognizing each of the sections/directions, by moving in that part of the stage that Rose found her jingle/voice. This was not explicit: if you did not come from this background, you might not consciously notice the sequence. But it is important to acknowledge that cultural meanings of spatial awareness unconsciously underpin how we are in relationship with the world around us. How we place ourselves relationally within our environments affects how we self-witness and confirm our presents. Across many Indigenous worldviews, how we move through our environments shapes us as much as we shape them. I was seeking subtly to offer a spatial relationship other than the more common Western practices for locating self in the environment that are so pervasive in the films and video games frequently marketed to children.

Each direction has a colour that represents it. The colours that our *tiyospaye* use for this were the palette of the performance space. The work was designed to be performed easily in schools and community centres

(it did not take a lot of setup or require complicated lighting). Aimed at children and their families who often did not relate to Western mainstream aesthetics, *Rose's Jingle Dress* tried to create new rhythms and relationships between families and performance spaces. The goal was to address the lack of diversity in arts programming in schools, community spaces, and small theatres. In the end, the performance was presented in places outside Kaydence's home environment of South Dakota. Although the work drew on our shared personal experiences, one cannot ignore that some of the familiar things that Kaydence and I shared have larger cultural connotations.

Objects such as the Jingle Dress have been misused as signifiers of a homogeneous Western concept of Native American identity, and such signifiers of Indigenous experiences have been appropriated to support a Western grand narrative about "culture" and what it is to be "American" (Deloria 1998). I was aware that, as an artist making contemporary work rooted outside the dominant Western culture, elements of the work itself might take on dual meanings. For instance, the lived relationship that Kaydence might have with something (within her own cultural frame) could be very different from the projected stereotype that that *thing* has come to represent in the frame of Western mainstream media. There was a danger that "the colonial and racist gaze" (Johnson 2003, 7) could commandeer the contemporary voice of the performance. The projection of the racist gaze constructs non-Western culture as synchronic, fossilizing Indigenous knowing as a relic of the past. This kind of cultural imperialism casts contemporary dance as synonymous with Western dance. Kwame Appiah (1991) suggests that contemporary art suffers from a conflation of contemporary with Western in his essay "Is the Post in Postmodernism the Post in Postcolonial?" Non-Western artists are alive today, and therefore our work is contemporary. "I want to argue," Appiah says, "that to understand our—our human—modernity we must first understand why the rationalization of the world can no longer be seen as the tendency either of the West or of history. ... Simply put, the modernist characterization of modernity must be challenged" (343–44). Although the performance drew on my personal relationships, the Western Grand Narrative that attempts to tell a single Eurocentric story about experience could have usurped *Rose's Jingle Dress* and made it representative of an entire "culture." Whereas contemporary work by Western artists is considered an expression of

individual reflection on society, contemporary art of non-Western origin is often expected to be an explanation of what it is to *be* non-Western. The wages of non-Western identity, for artists, are to be condemned to creating artwork that *explains* our experiences rather than creating artwork from *within* our experiences—as if we should be making artwork in order to help the ignorant racist gazer better understand "us."

I realized that the work could also be hijacked by my own self-silencing: throughout the creative process and during many of the performances, I second-guessed how parts of the performance could be *consumed*. I felt a heavy responsibility for the relationship that the piece would have with the colonial and racist gaze. The performance challenged racist expectations about who could create contemporary art, which contemporary stories could be told, and how.[10]

It took me some time to find the confidence to see that neither I nor the work could be defined by the racist gaze. It dehumanizes through objectification (hooks 1992; Johnson 2003). Throughout this chapter, I have suggested that "things" are not objects; they are relationships, rhythms, and interactions. Although part of my experience with the work involved racism, *Rose's Jingle Dress* was all of its interactions. It was summer workshops for teenage participants writing and developing stories. It was dance and music workshops for young children, it was conversations with Elders, it was part of a prayer, it was a residency in a school, and it was a performance to attend. Now it is part of a book. As we share experiences of workshops, conversations, and movements with the intention of creating something together, *Rose's Jingle Dress* emerges. Just like the children whom it was aimed at, the work gains vitality through its connections. Just like the children whom it is aimed at, it must resist being defined by the energy that it takes to shelter from the negative gaze of the Western mainstream.

Health in Connections of Art

The relationships formed as we make artwork for and with young people allow us to demonstrate to them that it is possible to respond to contemporary contexts within an Indigenous worldview. By making the performance piece *Rose's Jingle Dress* for young children, I wanted to create something that would share the connectedness of art, using the non-verbal language of dance, which exemplifies the unity of mind and body. Art creates relationships and rhythms in which we can allow

ourselves to be transformed. Art teaches us to return to the well-being of our sensing, intuitive body as something to acknowledge and trust. As we bravely make artworks that tell the many complicated and beautiful stories of how we experience our own lives today, we create places to share our voices in healing.

Western dualism separates body and mind, privileging the mind as the site of "I am" ("I think, therefore I am") and casting the body as a kind of shell that needs to be trained or changed. The dualist body is objectified into a thing that threatens to fail or betray the person within it (Burkitt 1999). This failure of the dualist, isolated, shell-like body underpins many Western narratives of health (Krippner 2012;[11] Mahina 2002). Dancing (in ceremony or in the dance studio) has led me to reject dualist separations of body and mind, subject and object, and to replace them with the notion that we are embodied, connected through the shared relationships of existing together, the shared rhythm of the land, the drum, the heart. A connection that provides an environment for health and healing. The lived experience of environment, physical sensations, reflective responses, and memories are woven together in the fabric of well-being and self-worth. Because the art form of dance involves the moving and expressing of body, it has a special role in the arts' ability to awaken the connectedness of body-environment-self. The Western separation of self from the experiencing, sensing body is part of the ongoing legacy of colonialism, which has fragmented not only mind and body but also families, identities, and nations (Anderson 2000; Crow Dog and Erdoes 1990; hooks 1992; Smith 1999; Trask 1999). These separations from whole self, whole family, and whole world contribute to an unhealthy imbalance. Although this legacy reaches back hundreds of years, the resulting dislocation is very much alive in the contemporary experiences of Indigenous young people. The arts' attributes of sensation, imagination, and empathy can play a role in exploring and expressing how these separations manifest, are experienced, and are healed in the twenty-first century.

In this chapter, I have discussed the contemporary dance performance piece *Rose's Jingle Dress* in order to underline the importance of remembering children in the making of contemporary Indigenous art (as an alternative to Western mainstream media). In a Western climate that often limits Indigenous works to collectible commodities (Appiah 1991), the ability for artworks to hold the space of being

both Indigenous and contemporary is often stifled. I am suggesting that we contest this, knowing the value that the arts have in offering contemporary contexts of expression for Indigenous young people. I am not suggesting that the "people" have ever stopped making art or dancing (to paraphrase Murphy 2007). I am merely stressing that it is important for us to claim the full spectrum of expression of contemporary experiences. Articulation and celebration of this expression are part of maintaining the healthy balance of well-being, happiness, and connection in our lives (*mitakuye oyasin*).

Notes

1 Throughout this chapter, I refer to both Lakota and non-Lakota Indigenous scholars and artists. It is important to note that there are differences, of course, among Indigenous philosophies and worldviews. However, as we express experiences, there can be a shared exchange of healing across global Indigenous resistances to and survivors of colonization and occupation.

2 *Rose's Jingle Dress* was supported and produced by State of Emergency productions.

3 Nonetheless, it is good practice to have a handover from a school.

4 *Heyókha kin táku kin oyás'in íchic'uya echúnpi naíns eyápi s'a* ("The heyokhas always did and said everything in the wrong or opposite way") (*New Lakota Dictionary* 2008). "Heyoka ceremonies are being held to make sacred clowns" (Fools, Mails, and Chief Eagle 1990, 31).

5 In his novel *Invisible Man*, Ralph Ellison (2001) uses "light" as a metaphor for validation/being recognized within the context of mainstream "White America."

6 When making a Jingle Dress traditionally, each cone is a prayer. The making of a dress is done with reflection.

7 The circle (hoop) is sacred for the Oglala Lakota and within many worldviews of connectedness (Allen 1992; Black Elk and Neihardt 2008).

8 This was the only time that recognizable cultural dance steps were shared in the performance. I chose this step to encourage audience members to participate since it would be a familiar community dance movement for many Indigenous children and their families.

9 American modern dance is not a monocultural Anglo-Western invention. It is the result of the coming together of many cultures. Choreographers including Martha Graham, Ted Shawn, and Lester Horton, whose movement techniques underpin codified modern dance, exchanged practices with Indigenous North American dancers (Murphy 2007). There is also a history of dancers from Indigenous Nations, such as Maria Tallchief, having principal positions in pioneering American dance companies in the 1900s (Tallchief and Kaplan 1997).

10 The nature of dance forefronts the experiencing body. Historically a politicized location of resistance and domination (Foucault 1979), Brown and Black bodies are often constructed as sites of protest rather than celebration. Dualist narratives of the

unreliable (Brown or Black) body were challenged in the face of expressive, sensing, and open joyous dancing (Akinleye 2018).

11 Although Krippner's essay is not in complete correspondence with my argument, it illustrates differences in ideological constructions of the body and illness.

References

Akinleye, A. 2018. "Narratives in Black British Dance: An Introduction." In *Narrative in Black British Dance: Embodied Practices*, edited by A. Akinleye, 1–15 London: Palgrave Macmillan.

Allen, P.G. 1992. *The Sacred Hoop: Recovering the Feminine in American Indian Traditions*. Boston: Beacon Press.

Anderson, K. 2000. *A Recognition of Being: Reconstructing Native Womanhood*. Toronto: Sumach Press.

Appiah, K. 1991. "Is the Post in Postmodernism the Post in Postcolonial?" *Critical Inquiry* 17, no. 2: 336–57.

Axtmann, A. 2001. "Performative Power in Native America: Powwow Dancing." *Dance Research Journal* 33, no. 1: 7–22.

Black Elk, and J.G. Neihardt. 2008. *Black Elk Speaks: Being the Life Story of a Holy Man of the Oglala Sioux*. New York: SUNY Press.

Blackwolf, and G. Jones. 1996. *Earth Dance Drum: A Celebration of Life*. Salt Lake City: Commune-A-Key Publishing.

Burkitt, I. 1999. *Bodies of Thought: Embodiment, Identity and Modernity*. Thousand Oaks, CA: SAGE Publications.

Chipps, V., and S. Chiat. 2003. *Pray from Your Heart*. Melbourne: Morning Star Publishing.

Crow Dog, M., and R. Erdoes. 1990. *Lakota Woman*. New York: Harper Perennial.

Deloria, P. 1998. *Playing Indian*. New Haven, CT: Yale University Press.

Dewey, J. 2005. *Art as Experience*. New York: Perigee.

Ellison, R. 2001. *Invisible Man*. Harmondsworth, UK: Penguin.

Fools, C., T.E. Mails, and D. Chief Eagle. 1990. *Fools Crow*. Lincoln: University of Nebraska Press.

Foucault, M. 1979. *Discipline and Punish: The Birth of the Prison*. Translated by A. Sheridan. Harmondsworth, UK: Penguin.

Garcia, L. 1992. "A Short History of the Jingle Dress." In *Whispering Wind, Crafts: American Indian: Past & Present*, Annual 5, 2nd ed., 14–15. (Reprinted from *Whispering Wind Magazine* 24, no 2: 1991.

hooks, b. 1992. *Black Looks: Race and Representation*. Boston: South End Press.

Johnson, E.P. 2003. *Appropriating Blackness: Performance and the Politics of Authenticity*. Durham, NC: Duke University Press.

Krippner, S. 2012. "Shamans as Healers, Counsellors, and Psychotherapists." *International Journal of Transpersonal Studies* 31, no. 2: 72–79.

Long, D.S. 1999. "In Search of a 'Written Fagogo': Contemporary Pacific Literature for Children." In *Inside Out: Literature, Culture Politics and Identity in the New Pacific*, edited by V. Hereniko and R. Wilson, 231–46. Lanham, MD: Rowman and Littlefield.

Lovell, S. 2001. "Loving Body Is Embracing Spirit: Coming Home Stories." In *Spirituality and Art Therapy: Living the Connection*, edited by M. Farrelly-Hansen, 182–203. London: Jessica Kingsley Publishers.

Mahina, 'O. 2002. "*Atamai, fakakaukau* and *vale*: 'Mind,' 'Thinking' and 'Mental Illness' in Tonga." *Pacific Health Dialog* 9: 303–08.

Murphy, J.S. 2007. *The People Have Never Stopped Dancing: Native American Modern Dance Histories*. Minneapolis: University of Minnesota Press.

New Lakota Dictionary: Lakhotiyapi-English/English-Lakhotiyapi and Incorporating the Dakota Dialects of Yankton-Yanktonai and Santee-Sisseton. 2008. Bloomington, IN: Lakota Language Consortium.

Pratt, S.L. 2002. *Native Pragmatism: Rethinking the Roots of American Philosophy*. Bloomington: Indiana University Press.

Rosenwald, G.C., and R.L. Ochberg. 1992. *Storied Lives: The Cultural Politics of Self-Understanding*. New Haven, CT: Yale University Press.

Smith, L.T. 1999. *Decolonizing Methodologies: Research and Indigenous Peoples*. London: Zed Books.

Stephenson, L. 1993. *The Powwow: Questions and Answers*. Bismarck, ND: United Tribes Technical College.

Tallchief, M., and L. Kaplan. 1997. *Maria Tallchief: America's Prima Ballerina*. New York: Henry Holt.

Trask, H. 1999. *From a Native Daughter: Colonialism and Sovereignty in Hawai'i*. Honolulu: University of Hawaii Press.

Tufnell, M., and C. Crickmay. 2004. *A Widening Field: Journeys in Body and Imagination*. Southwold, UK: Dance Books.

Van der Kolk, B.A. 2014. *The Body Keeps the Score: Brain, Mind, and Body in the Healing of Trauma*. New York: Viking.

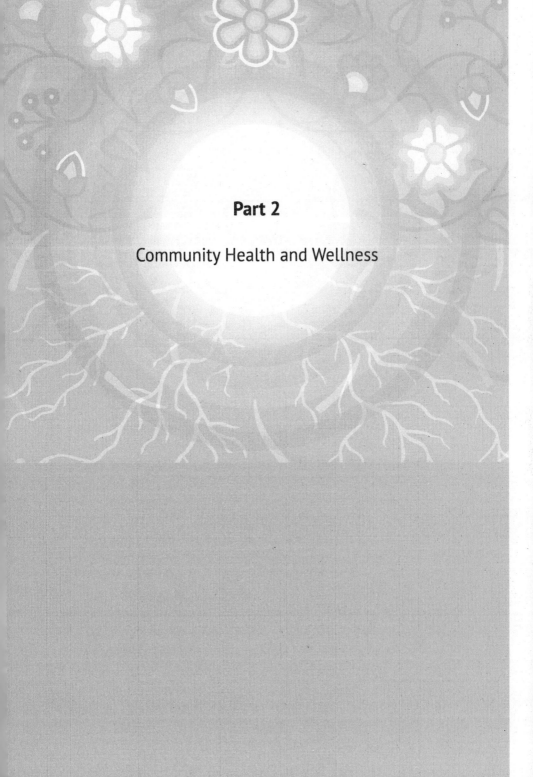

Part 2

Community Health and Wellness

CHAPTER 4

STORIES AND STAYING POWER:
Artmaking as (Re)Source of Cultural Resilience and Well-Being for Panniqtumiut

ALENA ROSEN

There is a strong relationship between Inuit art and Inuit knowledge, and artists play a key role in knowledge production. In this chapter, I discuss artmaking in Pangnirtung, Nunavut, or Panniqtuuq, the Inuktitut name for the location that means "the place of many bull caribou." Pangnirtung is the anglicized version of the name (Minogue 2004). As established by the Pangnirtung artists and community members whom I spoke with, story is central when considering works of Inuit art. If the story is what is important, then it follows that the reading of the story, or the process of interpretation, takes on an imperative role. Looking at works of Inuit art as a form of "visual" oral history, I understand artists as knowledge holders. Knowledge production through artmaking promotes cultural resilience, and in this way Inuit artists have an important role in the well-being of their communities.

Positioning Self
Writing from within the disciplinary environment of Indigenous Studies, I believe that it is important to locate myself, to tell you who I am, and to describe my relationship with the community and people of Pangnirtung.

Q. *Namimiutauvit?* ("Where are you from, where do you live?" in Inuktitut)

A. Peace River *miutaujunga, kisiani Torontomiutaujajunga* ("I currently live in Peace River, but I am originally from Toronto.")

My position as a *qallunaaq* ("non-Inuk"), southerner, and white settler researcher means that the discussion and analysis that follow are necessarily limited. I locate myself and my relationships to respect principles of relational research methodology (Kovach 2009; Wilson 2008). Attempting to decentre Western/European/settler perspectives, my approach is to highlight the words of Panniqtumiut ("people of Pangnirtung" in Inuktitut) artists and community members and to foreground ideas coming from and relevant to the community. Respected Inuk writer Mini Aodla Freeman has addressed this point explicitly: "We have never been asked to write about ourselves. We have always been written about" (1994, 16). The following discussion is based on my interpretation of ideas and experiences shared with me by artmakers and other Inuit living in Pangnirtung. My relationship with Pangnirtung began in the summer of 2010 when I visited the community with the Pangnirtung Bush School while in my first year of the master's program in the Department of Native Studies at the University of Manitoba. The Pangnirtung Bush School was started in 1997 by Peter Kulchyski (at Trent University at the time) and is no longer actively running. When I travelled with the program in 2010, it was well established. The Pangnirtung Bush School emphasized experiential, land-based pedagogy, and it combined classroom teaching with summer camping, placing students and staff in close involvement with Inuit Elders and community members. Students learned about Inuit culture, went out on hunting trips, learned how to scrape seal skins and sew, and learned some basic Inuktitut. For me and many participants, the program was a life-changing experience and the start of a lifelong relationship with Pangnirtung.

I returned to Pangnirtung in September 2011 to interview artists and other community members as research for my MA thesis, which examines artmaking in Pangnirtung and the connection of art to Inuit knowledge and cultural resilience in more depth (Rosen 2013). Community member Henry Mike and I were discussing the project

that I was undertaking, and he stated that "story is the key. It's very important to Inuit art." The understanding of Inuit stories must be embedded within Inuit epistemologies, Inuit ways of knowing, reading, and seeing stories. How could any *qallunaat* ("non-Inuit person") speak with authority about Inuit stories told through works of visual art? This bond between artmaking and Inuit knowledge is significant, for the interaction contributes to cultural resilience. Through this process, artmaking strengthens Inuit culture and becomes a crucial element of healing for Inuit communities affected negatively by continued colonialism.

Resilience

Inuit take pride in their ability both personally and collectively to adapt to changing circumstances (Ace and Papatsie 1997; Freeman 1994; Wenzel 1999). Features of resilience and tenacity are represented and respected in Inuit value systems. Success and survival are tied to people's "capacity for self-reliance and their ability to meet life's challenges with innovation, resourcefulness and perseverance" (Pauktuutit 2006, 32). Descriptions of Inuit values resonate with the Western concept of resilience, expressed as "the capacity to spring back from adversity and have a good life outcome despite emotional, mental or physical distress" (Stout and Kipling 2003, iii–iv). The term "cultural resilience" has been used to describe the character of Indigenous communities engaged in the preservation and rehabilitation of cultural heritage in the face of challenges stemming from colonization (Fleming and Ledogar 2008).

Cultural resilience is typically used in the field of psychology to express how communities or cultural systems act "as a resource for resilience in the individual" (Fleming and Ledogar 2008, 10). In a literature review examining the concept of resilience in Indigenous research, Fleming and Ledogar (2008) list resources supporting resilience on three levels: individual, family, and community/culture. They outline, at the community level, the following as cultural resources: activities, languages, spirituality, and healing. These resources all relate to traditional Indigenous ways of knowing and being. Within this context, the term "tradition" refers to oral traditions, worldviews, and evolving practices. It is essential to note that oral tradition is not limited to the old days; as Julie Cruikshank writes, "[oral tradition] continues to provide guidelines for the present and to lay a foundation

for thinking about the future" (1998, 103; see also Kublu, Laugrand, and Oosten 1999). Terry Cross (Seneca) points out that, in academia and clinical social work practices, resilience is usually conceptualized as a linear process that therefore can be measured—this should not be surprising given the linear worldview dominant in Western societies (1998, 145–46). Western theoretical frameworks of resilience emerge from psychology, and the earliest studies were phenomenological, trying to understand the strengths held by individuals who lived with risk. Resilience theory, according to Richardson (2002, 313), describes resilience as a complex "force" that all humans have: "There is a force within everyone that drives them to seek self-actualization, altruism, wisdom, and harmony with a spiritual force of strength." Cross (1998) makes a strong argument for the need to view Indigenous resilience from a relational worldview instead.

Artmaking in the Context of Colonialism

Artmaking in northern Canada takes place within the context of colonialism. Just as there are a multiplicity of worldviews, some linear, some relational, so too there are many histories and many truths. The Western system of knowledge, on which colonization depends, relies on creating a convincing facade that there is only one history or only one set of truths (Smith 1999). As European colonizers seized Indigenous words and material cultures, they simultaneously attacked Indigenous ways of life on ideological and socio-economic fronts and defined a master historical narrative (Blaut 1993; Said 1994). Colonial discourses strive both to control and to define Indigenous peoples as "others" by the eradication and appropriation of Indigenous objects and their meanings (Phillips and Steiner 1999). Within a few centuries, Inuit have dealt with profound and often traumatic changes, including the ongoing colonization of Inuit *nunangat* (Inuit "land, ice, and water") by the Canadian nation-state.

For Inuit in the Cumberland Sound area, what is now in the Eastern Arctic of Canada, their first contact with *qallunaat* whalers was in the mid-1800s. During the 1850s and 1860s, Inuit participation was critical to *qallunaat* commercial whaling activities in the area. By the 1870s, the *qallunaat* whalers had moved on to other areas, and Inuit life largely returned to the way that it had been before. Anglican missionaries brought Christian belief systems at the turn of the century, and over the

next twenty years fur traders and law enforcement officials arrived as well (Stevenson 1997). The Canadian government slowly increased its presence, and this internal colonialism continues to affect Inuit today.

Inuit in the Eastern Arctic began to make carvings and drawings for trade with *qallunaat* in the beginning of the nineteenth century (Swinton 1992). These pieces were mostly souvenir-type objects. At this time, arts and crafts for trade were informal and initiated by desires among various *qallunaat*, including whalers, explorers, and anthropologists (Hessel 1998). In the 1880s, Franz Boas (1964) collected drawings made by Inuit, as did Diamond Jenness between 1913 and 1916. Drawings were also made for missionary Edmund Peck between 1894 and 1905 when he was living on Uumanarjuaq (Blacklead Island) in Cumberland Sound (Laugrand, Oosten, and Trudel 2002; see also Oosten et al. 2000). Pangnirtung artist and Elder Elisapee Ishulutaq recalled that her father, Arnaquq (born in 1902), used to make drawings for trade: "[The] first time [I] ever saw someone drawing was [my] father, Arnaquq. [I] must have learned from him. Southerners would ask him [to] do some drawings or some art of the lifestyle up here. They would trade for the rations, like tea, tobacco, and like pilot biscuits and whatnot. There was no money exchanged with the art" (E. Ishulutaq, personal communication, September 2011). Anna Akulukjuk is an Elder who was living just a few doors down from Elisapee Ishulutaq. Anna also told me about her father, Pauloosie Qappik (sometimes spelled Karpik, born in 1911), making carvings for *qallunaat*: "[He] used to carve, long time ago, and he used to carve beluga and whale [bones].... The father used to carve a beluga; they have to use berries [for] paint" (A. Akulukjuk, personal communication, October 2011; see also Jones 1991). Inuit in the Cumberland Sound area maintained a relatively traditional economy and social organization until the mid-twentieth century, when the federal government began to take a greater interest in northern development.

Federal government involvement in Inuit art production increased sharply during the 1950s and 1960s. The Department of Resources and Development saw the developing carving and handicraft industry as a way to alleviate economic need. The government wanted to encourage self-sufficiency and avoid dependency. The development of such an industry was seen as a successful project, with fewer relief payments handed out in communities where people were involved in

handicrafts. The government-sponsored carving program officially came to Pangnirtung in 1962, the same year that the hamlet was established and that many families living in camps nearby lost their dogs to illness and were compelled to relocate temporarily and then permanently (Tester 2010). Etuangat Aksayook, who worked for the area doctor as a helper and guide, vividly described his experience during this period: "The people no longer had the means of transportation for themselves. At the time I became an instructor in carving. I was ordered by the government to teach all the Inuit men how to carve, because the government regarded it as the only means of economic development in the community. Soapstone and other items were brought into the community, and everybody got into carving" (quoted in Knotsch 2002, 34).

"Visual" Oral History?

Works of Inuit art serve as records of life and community histories and traditional stories—Inuit art is embedded within Inuit knowledge. Artmaking is valuable in the way that it contributes to the exchange of knowledge. Colonialism purposefully, if unsuccessfully, disrupts intergenerational flows of knowledge. Inuit knowledge production continues to coexist uneasily with dependence on government funding and capitalist economies.

Inuit art, like Inuit knowledge, is produced from events that an individual has experienced and attains a level of authority as a result. As carver Norman Komoartuk explained to me in September 2011, "[carving] does bring out the culture a lot, and it does show a lot of the different cultures about ours. With carvings he [Norman] makes, he likes to use all the experiences he went through, like trying to harpoon a seal, drum dancing, dogsledding, the old lifestyle." His statement touches on several themes: most Inuit art is destined for homes far from Inuit *nunangat*, what he makes is informed directly by his knowledge and experience, and his artwork expresses or presents Inuit culture. Through artmaking, by depicting scenes and images of Inuit cultural practices, the knowledge of this lifestyle and of Inuit *nunangat* is passed on both to the world in general and to younger generations of Inuit—two very different audiences, with the latter arguably having stronger sway over the industry. Although some Inuit artists choose to depict modern Inuit life, or other themes, Elisapee Ishulutaq made a strong case in September 2011 for a continued emphasis on Inuit tradition: "It would

make a lot more sense to show that kind of culture ["the old ways"] because the young generation would also learn from it. Feeding young brains through the art like that could encourage them to ask questions of the lifestyle they had and of the culture. . . . It is important to draw cultural ways and lifestyles because it will give a similar knowledge as oral history." This statement came in response to a question that I had asked Elisapee about what she thought about art that shows more traditional themes and scenes compared with art that shows scenes of contemporary life. Elisapee stated clearly that Inuit art has significant value in terms of the intergenerational exchange of Inuit knowledge. Works of Inuit art communicate knowledge about traditional values and practices in a meaningful way that supports Inuit communities. Following Elisapee, Inuit art should be thought of as sharing a space with oral history. For her, this narrative element of Inuit art is very important. Inuit works of art are valuable as tools to teach young people who have not had the opportunity to gain knowledge from their Elders. As Elisapee remarked, Inuit artmaking can encourage dialogue between youth and Elders. Looking at Inuit art as a form of "visual" oral history places artists in the role of knowledge holder (for more on the topic of stories and knowledge, see Cruikshank 1998).

The subject matter and narrative content of works of Inuit art involve several different kinds of knowledge. Zebedee Nungak (2008) has defined four different kinds of knowledge represented in works of Inuit art: *unikkaaqtuat* ("traditional stories"), *unikkaat* ("stories in general," "historical accounts"), *inuusirminitait* ("life stories"), and *isumaminitait* ("inspired imaginations"). *Unikkaat* stories are educational, serving to pass on knowledge, as well as entertaining. The story could be about any everyday event at any time, such as an account of a hunting trip a few months earlier or a funny thing that someone did the other day.

Unikkaaqtuat are older stories, longer stories, or "traditional stories" about physical and spiritual worlds. A sculpture by Jaco Ishulutaq from 2001 called *Qalupalik* ("*Sea Monster*") is a good example. The sculpture depicts the *qalupalik*, a well-known creature in Inuit cosmology. Such creatures live near the tide line by the sea and are known to steal children (Briggs 2000). Ame Papatsie, also from Pangnirtung, made a short film, *Qalupalik*, about these creatures (Brisebois, Mazur, and Papatsie 2010). A story told by Iqaluit Elder Naqi Ekho disrupts the notion that *qalupaliit* are only creatures from old stories: "Laipa [Lypa] Pitsiulak,

who lives in an outpost camp, was the one who caught the *qalupalik*. They used the skin that they took off as evidence to show other people. It had a perfectly round head, unlike that of any animal. This is not an old story, it's quite new" (quoted in Briggs 2000, 116). Lypa Pitsiulak was also a well-known Pangnirtung artist who depicted *qalupaliit* in a print—and if asked he would likely tell us that it was not an imagined depiction of what he thought that *qalupaliit* would look like but something that he saw with his own eyes.

Inuusirminitait (also referred to as *inuusirminik unikkaat)* are "life stories," autobiographical in nature (Martin 2009, 93; Nungak 2008, 19; Seidelman and Turner 2001, 14). In a 1987 interview with Dorothy Eber, Elisapee Ishulutaq discussed this in reference to her own artwork: "I also like to draw things I have seen and lived, what I have experienced in my life. I recall camp life; the sealskin tents, the *kayaks*, just how the sealskins were set up" (Eber 1993, 432). A tapestry based on one of Elisapee's drawings, *Inuit Ways* (1979), is a good example of a work that fits this description.

Finally, *isumaminitait* would be something that just emerges from the artist's "imagination." Two drawings made by Cornelius Nutaraq from Pond Inlet in 1964 are included in *Travelling and Surviving on Our Land*, the second volume of the *Inuit Perspectives on the 20th Century* series (Oosten, Laugrand, and Nutaraq 2001, 131, 135). Written on the front of the drawing titled *Finding the Seal Pup* are detailed descriptions of what is happening in the scene, as well as specific identifications of parts of the images. Similarly, written on the back of the drawing *Catching a Narwhal* is a retelling of a narwhal hunting experience from Nutaraq's life. Also included is information about traditional and pres-ent-day use of the narwhal by Inuit. The narratives included with these drawings are good examples of the rich information and knowledge shared by Nutaraq through his drawings.

Artmaking Toward Well-Being

Within the context of colonialism, relaying the past by means of artmaking involves "taking an active stance in relation to one's own culture and to the dominant culture" (Berlo 1990, 138). Jaco Ishulutaq succinctly described for me in September 2011 this active relationship between art and Inuit knowledge: "When Inuit art is being displayed or exhibited it highlights the traditional way of life." Recall that the

term "traditional" does not mean locked away in the old days. "Such remembrance," as Benita Parry suggests of postcolonial African fiction, "does not encourage a passive yearning for reinstalling an unrecoverable past, but is an intervention winning back a zone from colonialist representation" (quoted in Berlo 1990, 138). It is in this zone of "winning back" that Inuit art becomes a part of cultural resilience.

The transformation, transmission, and re-enacting of Inuit knowledge through artmaking contribute to the well-being of Inuit communities and individuals. The term "well-being" is used to reference an understanding of health as encompassing more than physical health. I use the term here not in a strictly socio-economic sense but in terms of a holistic or broader sense that encompasses happiness; mental health; social, cultural, and community health; and physical health. This use of the term reflects how the World Health Organization defines the term "health" in its constitution (1948). For Inuit scholar, artist, and curator Heather Igloliorte (2010, 45), the concept of resilience is "in line with the Inuit worldview as communal and based on the well-being of the collective." As Kublu, Laugrand and Oosten (1999, 6) state, Inuit Elders consistently emphasize the importance of maintaining and passing on traditions for the well-being of future generations (see also Stevenson 2006). The commonly used Inuktitut greeting "*Qanuippit?*" is translated as "How are you?" but literally it means something more like "Is there anything wrong with you, troubling you, et cetera?" (J. Houston, personal communication, January 2016). A very informal social media query that I conducted about the concept of well-being in Inuktitut elicited some terms that might fit: *makimaniq* ("standing up straight" or "upright") and *isumatiangniq* ("solid non-judgmental or well-informed thinking") (M. Qumuartuq, E. Arnaqaq, personal communication, January 2016).

Artmaking supports Inuit cultural resilience because of the strong relationship between artmaking and knowledge. As Inuit artists in Pangnirtung and across the Arctic have remarked, there is much information of historical and personal value evident in works of art. It is important that *unikkaat* and in particular *unikkaaqtuat* are told in the right way and that the work of art is *suligasuatuk* and *sulitsiartuq*, Inuktitut terms that describe the concepts of "expressing the truth well" and "endeavouring toward the truth." Interpretations of Inuit art that aim for cultural resilience must respect protocols of narrative memory, Inuit knowledge production, epistemology, and ontology.

Inuit artists transmitting cultural knowledge through their art is not a new theme in literature on Inuit art, nor is the relevance of traditional stories to contemporary life. Inuit artists are conscious of this process, and some have expressed a clear vision of how this is accomplished through artmaking. Simon Shaimaiyuk, from Pangnirtung, in speaking with July Papatsie, explained why he chose to inscribe information on his drawings:

> I thought in my mind about the fact that Inuit refer to their seal hunting equipment as ammunition. They say *sakuka* ["my ammunition"] referring to the harpoon, harpoon head, harpoon line and sealskin float which are the source of survival to all Inuit. Just like a rifle today. But back then the harpoon was their primary hunting tool that they could only throw by hand to catch animals, for they did not have any rifles to hunt with. That is why I started writing inscriptions on my drawings, to show how we worked just to survive. All the way from childhood, one worked very hard with all of one's strength and endurance with a strong will to live a happy life. Just like the hunter has his *sakuka* to be more successful, I have my inscriptions so that people will understand what I witnessed of the good life that has passed. Most importantly, I want my drawings to be understood for their historical value. (Papatsie 1997, 22)

For Shaimaiyuk, artmaking is a tool (or set of tools) like the hunter's *sakuka*. For Inuit, hunting is essential to survival, and similarly Inuit knowledge presented through artmaking is essential for survival. Although hunting has always been essential, artmaking in the form of carvings, drawings, prints, and tapestries—as well as written words—is a newer tool in Inuit survival kits.

Pangnirtung carver Simeeonie Pitsiulak told me in 2011 about his interest in starting a program at his family's outpost camp to teach hunting, camping, and carving skills for people who did not get that opportunity growing up. Again, carving was considered alongside hunting and camping as a kind of "cultural" skill, a practical skill. Inuvialuit artist Abraham Anghik Reuben related to me in October 2012 the importance of the visual for both survival and carving. His father once told him that on the land one needs to be conscious of

everything around him and have a 360-degree awareness. This keen awareness necessary for hunting is the same kind of awareness that one needs to be good at carving. Conscious observation is essential to create great works of art.

Jack Anawak (1989) observes that for Inuit the importance of incorporating knowledge of the past into our understanding and behaviour in the present is something that even very young children recognize. In Pangnirtung, the elementary school and high school run a yearly spring camp in which students participate in land-based learning. During the rest of the year, Elders and community members are often invited into the classroom to share their knowledge (for an in-depth discussion of the existing integration of culture and curriculum in Pangnirtung, see Sullivan 2013).

Jaypetee Arnakak (2000) explains how Inuit *qaujimajatuqangit* (IQ; Inuit "traditional knowledge") is not exclusively "traditional knowledge" but "living technology":

> To many people, the "traditional knowledge" aspect of IQ is often the only side that is seen, but that describes only one half of it. IQ (as we envisioned it at DSD [Department of Sustainable Development]) is really about "healthy, sustainable communities" regaining their rights to a say in the governance of their lives using principles and values they regard as integral to who and what they are. ... IQ is a living technology. It is a means of rationalizing thought and action, a means of organizing tasks and resources, a means of organizing family and society into coherent wholes.

One of the eight guiding principles of Inuit *qaujimajatuqangit* set out by the government of Nunavut is *qanuqtuurniq*, translated as "being innovative and resourceful" (Official Languages Act). *Qanuqtuurniq* also translates as "exploring or discussing ideas" (Simailak, quoted in Tester and Irniq 2008, 50). Arnakak (2000) states that "there is no single defining factor of being Inuit, but this comes close. Inuit culture is *qanuqtuurniq*." These descriptions of Inuit values correspond closely to the centrality of resilience of an individual and a community at a cultural level. Pangnirtung photographer David Kilabuk told me in September 2011 that, "yeah, staying power ... because I mean, when I first started seeing carvings, I was thinking that it's only done for

white people, I mean that's what I thought. But then when I saw some of the pictures of carvings done from, I don't know when it was, they found carvings from . . . before [the] white man came up here. And I realized that it's part of our culture." When he stated that he thought Inuit art was "only done for white people," he was saying a lot about the success of the commercial Inuit art market in the way that Inuit culture has been packaged for decades and sold in the form of fine art to avid collectors who are predominantly *qallunaat*. Observing continuity of Inuit skills and evolution of practice through artmaking and material culture, Kilabuk illustrated that Inuit artmaking is inseparable from Inuit "staying power" or cultural resilience. Inuit traditional knowledge is rooted in practice and always connected to the present (Kublu, Laugrand, and Oosten 1999, 7). The concept of cultural resilience encompasses the dynamic and adaptive character of culture, and so accepts and acknowledges this fluidity, reflecting a position asserted in Indigenous oral traditions.

Carver Norman Komoartuk made the following comment in September 2011 in response to a question about the idea of Inuit art that shows both contemporary life and the old ways: "The artist—that person is free to carve what he feels, makes that person happy. . . . One person can learn a lot about themselves when they carve freely." The importance of being able to "carve freely" links artmaking with self-expression or community expression and speaks strongly to the Inuit idea of knowledge that comes from practice and experience. Artist Jimmy Kilabuk also spoke on this subject in October 2011:

> And you do a lot of soul searching. You look for inspiration in all kinds of things. You start to see things people don't see. You start to see colours you never saw. You start to appreciate little plants out there and look at them closer. You look at little birds and be amazed how a little egg in the north can fly all the way down south and keep doing that each year. And you start to respect the land a little more because you are doing a lot of soul searching I guess. And you learn a lot of, I don't know what the right word is, but you learn how to deal with things a lot more calmly, like emergencies or whatever. You're much more calm, you don't freak out when everybody else panics and stuff. I found that it has really

helped me stay calm, over the years, after losing parents and sisters and suicide, there's been like almost fifty suicides here now, and death is a part of life here, pass by the graveyard every day, constantly reminded. Our airstrip's in the middle. No privacy. Dust. And we put up with it. We don't say stop the planes from coming, move the graveyard. We deal with it, we accept things. That's how Inuit are basically, they adapt a lot more easily for some reason, they adapt to change.

Jimmy talked about how artmaking has helped him to work through difficult, adverse experiences, connecting artmaking with both individual resilience and Inuit cultural values. In a discussion with Elder Pauloosie Nauyuk, he also spoke about how he is happier when he is carving and that he always finds himself going back to carving. Both Jimmy and Pauloosie emphasized artmaking as beneficial to an individual's well-being as that person moves through life. Artmaking helps a person to feel good, on an individual level, and self-esteem, or positive self-image, is a generally acknowledged resource for or "protective factor" in resilience (Archibald and Dewar 2010; Fleming and Ledogar 2008, 23). Through art, Inuit knowledge is transformed, transmitted, and re-enacted, contributing to the process of cultural resilience.

Conclusion

Through artmaking, *panniqtumiut* artists engage in knowledge production and support the process of Inuit cultural resilience. As Inuit artists in Pangnirtung and across the Arctic suggest, there is much information of historical and personal value stored in works of art. Elisapee Ishulutaq's discussion of artists and works of Inuit art as holding knowledge is an important statement of how Inuit artmaking contributes to cultural resilience for Inuit. Artworks for and in the community mean that interpretation, the process of telling and retelling stories, takes on an imperative role as the site of cultural resilience.

References

Ace, B., and J. Papatsie. 1997. *Transitions: Contemporary Indian and Inuit Art of Canada*. Ottawa: Minister of Indian Affairs and Northern Development.

Anawak, J. 1989. "Inuit Perceptions of the Past." In *Who Needs the Past? Indigenous Values and Archaeology*, edited by R. Layton, 45–50. London: Unwin Hyman.

Archibald, L., and J. Dewar. 2010. "Creative Arts, Culture, and Healing: Building an Evidence Base." *Pimatisiwin: A Journal of Aboriginal and Indigenous Community Health* 8, no. 3: 1–25.

Arnakak, J. 2000. "What Is Inuit *Qaujimajatuqangit?*" *Nunatsiaq News*, 25 August. http://www.nunatsiaqonline.ca/archives/nunavut000831/nvt20825_17.html.

Berlo, J.C. 1990. "Portraits of Dispossession in Plains Indian and Inuit Graphic Arts." *Art Journal* 49, no. 2: 133–41.

Blaut, J. 1993. *The Colonizer's Model of the World: Geographical Diffusionism and Eurocentric History*. New York: Guilford Press.

Boas, F. 1964. *The Central Eskimo*. Lincoln: University of Nebraska Press. (Original work published 1888.)

Briggs, J. 2000. *Interviewing Inuit Elders: Childrearing Practices*. Iqaluit: Nunavut Arctic College.

Brisebois, D., D. Mazur (prods.), and A. Papatsie (dir.). 2010. *Qalupalik* (animated short film). National Film Board of Canada. https://www.nfb.ca/film/nunavut_animation_lab_qalupalik.

Cross, T.L. 1998. "Understanding Family Resiliency from a Relational Worldview." In *Resiliency in Native American and Immigrant Families*, edited by H.I. McCubbin, E.A., Thompson, A.I. Thompson, and J.E. Fromer. Thousand Oaks: SAGE Publications.

Cruikshank, J. 1998. *The Social Life of Stories: Narrative and Knowledge in the Yukon Territory*. Lincoln: University of Nebraska Press.

Eber, D. 1993. "Talking with the Artists." In *In the Shadow of the Sun: Perspectives on Contemporary Native Art*, edited by Canadian Museum of Civilization, 425–42. Hull, QC: Canadian Museum of Civilization.

Fleming, J., and R.J. Ledogar. 2008. "Resilience, an Evolving Concept: A Review of Literature Relevant to Aboriginal Research." *Pimatisiwin* 6, no. 2: 7–23.

Freeman, M.A. 1994. "Introduction." In *Inuit Women Artists: Voices from Cape Dorset*, edited by O. Leroux, M.E. Jackson, and M.A. Freeman, 14–17. Ottawa: Canadian Museum of Civilization.

Hessel, I. 1998. *Inuit Art: An Introduction*. Vancouver: Douglas and McIntyre.

Igloliorte, H. 2010. "The Inuit of Our Imagination." In *Inuit Modern: The Samuel and Esther Sarick Collection*, edited by G. McMaster, 41–46. Toronto: Art Gallery of Ontario; Vancouver: Douglas and McIntyre.

Jenness, D. 1922. "Eskimo Art." *Geographical Review* 12, no. 2: 161–74.

Jones, H.G. 1991. "Pauloosie Karpik's First Drawings." *Inuit Art Quarterly* 6, no. 3: 30–33.

Knotsch, C. 2002. "Views of the Past." In *Nuvisavik: The Place Where We Weave*, edited by M. von Finckenstein, 23–41. Montreal and Kingston: McGill-Queen's University Press.

Kovach, M. 2009. *Indigenous Methodologies: Characteristics, Conversations, and Contexts.* Toronto: University of Toronto Press.

Kublu, A., F. Laugrand, and J. Oosten. 1999. "Interviewing the Elders." In *Interviewing Inuit Elders: Introduction*, edited by F. Laugrand and J. Oosten, 1–12. Iqaluit: Nunavut Arctic College.

Laugrand, F., J. Oosten, and F. Trudel. 2002. "Hunters, Owners, and Givers of Light: The Tuurngait of South Baffin Island." *Arctic Anthropology* 39: 27–50.

Martin, K. 2009. "'Are We Also Here for That?' Inuit *qaujimajatuqangit*—Traditional Knowledge, or Critical Theory?" *Canadian Journal of Native Studies* 29, nos. 1–2: 183–202.

Minogue, S. 2004. "From Pangnirtung to Panniqtuuq: 'If You Don't Say It Right It Means Nothing.'" *Nunatsiaq News*, 9 July. http://www.nunatsiaqonline.ca/stories/article/from_pangnirtung_to_panniqtuuq/.

Nungak, Z. 2008. "Inuit Culture: A Deep Well of Inspiration." In *The Harry Winrob Collection of Inuit Sculpture*, edited by D. Wight, 19–22. Winnipeg: Winnipeg Art Gallery.

Oosten, J., F. Laugrand, and C. Nutaraq. 2001. *Travelling and Surviving on Our Land.* Iqaluit: Nunavut Arctic College.

Oosten, J., F. Trudel, F. Laugrand, and A. Kublu. 2000. Tuurngait tautunnguaqtauningit/*Representing* tuurngait. Iqaluit: Nunavut Arctic College.

Papatsie, J. 1997. "Historic Events and Cultural Reality: Drawings of Simon Shaimaiyuk." *Inuit Art Quarterly* 12, no. 1: 18 22.

Pauktuutit. 2006. *The Inuit Way: A Guide to Inuit Culture.* http://www.uqar.ca/files/boreas/inuitway_e.pdf.

Phillips, R., and C. Steiner. 1999. "Art, Authenticity, and the Baggage of Cultural Encounter." In *Unpacking Culture: Art and Commodity in Colonial and Postcolonial Worlds*, edited by R. Phillips and C. Steiner, 3–19. Berkeley: University of California Press.

Richardson, G.E. 2002. "The Metatheory of Resilience and Resiliency." *Journal of Clinical Psychology* 58, no.3: 307–21.

Rosen, A. 2013. "Inuit Art, Knowledge and 'Staying Power': Perspectives from Pangnirtung." MA thesis, University of Manitoba.

Said, E.W. 1994. *Orientalism.* New York: Vintage Books.

Seidelman, H., and J. Turner. 2001. *The Inuit Imagination: Arctic Myth and Sculpture.* Vancouver: Douglas and McIntyre.

Smith, L.T. 1999. *Decolonizing Methodologies: Research and Indigenous Peoples.* London: Zed Books.

Stevenson, L. 2006. "The Ethical Injunction to Remember." In *Critical Inuit Studies: An Anthology of Contemporary Arctic Ethnography*, edited by P.R. Stern and L. Stevenson, 168–86. Lincoln: University of Nebraska Press.

Stevenson, M. 1997. *Inuit, Whalers, and Cultural Persistence: Structure in Cumberland Sound and Central Inuit Social Organization.* Toronto: Oxford University Press.

Stout, M.D., and G.D. Kipling. 2003. *Aboriginal People, Resilience and the Residential School Legacy.* Ottawa: Aboriginal Healing Foundation. http://www.ahf.ca/downloads/resilience.pdf.

Sullivan, C. 2013. "Integrating Culturally Relevant Learning in Nunavut High Schools: Student and Educator Perspectives from Pangnirtung, Nunavut, and Ottawa, Ontario." MA thesis, Carleton University.

Swinton, G. 1992. *Sculpture of the Inuit.* Toronto: McClelland and Stewart.

Tester, F.J. 2010. "Mad Dogs and (Mostly) Englishmen: Colonial Relations, Commodities, and the Fate of Inuit Sled Dogs." *Études/Inuit/Studies* 34, no. 2: 1–16.

Tester, F.J., and P. Irniq. 2008. "Inuit *qaujimajatuqangit*: Social History, Politics and the Practice of Resistance." *Arctic* 61, no. 1: 48–61.

Wenzel, G. 1999. "Traditional Ecological Knowledge and Inuit: Reflections on TEK Research and Ethics." *Arctic* 52, no. 2: 113–24.

Wilson, S. 2008. *Research Is Ceremony: Indigenous Research Methods.*

World Health Organization. 1948. *Constitution of the World Health Organization.* Geneva: World Health Organization.

CHAPTER 5

HEALTHY CONNECTIONS:
Facilitators' Perceptions of Programming Linking Arts and Wellness with Indigenous Youth

MAMATA PANDEY, NUNO F. RIBEIRO, WARREN LINDS, LINDA
M. GOULET, JO-ANN EPISKENEW,[1] AND KAREN SCHMIDT

Years of colonization have taken a toll on the mental, physical, and so-cial lives of Indigenous people (Kirmayer, Simpson, and Cargo 2003). Policies and measures developed to address the "Indian problem" were driven by colonial agendas and aimed to subjugate Indigenous com-munities (Episkenew 2009). Through economic, political, social, and educational institutions, colonization violated the trust and invaded the spirit of the Indigenous people residing in Canada.

The effects of colonization continue to have negative impacts on Indigenous communities today, resulting in poor health outcomes (Kirmayer, Brass, and Tait 2000). Goulet and colleagues (2011) contend that the arts can be a decolonizing practice that results in positive health outcomes for Indigenous youth. Yuen and colleagues (2013) argue that decolonization, and the process of healing for both individuals and their communities, begin when individuals develop the ability to step back and critically appraise current behaviour. Goulet et al. (2011) emphasize the importance of the imagination, explaining that, before behavioural patterns can be altered, one must imagine what the alternatives can be and how they can be achieved. Yuen et al. (2013) have shown that the effects of colonization can be reduced and that the imaginations of Indigenous youth can be fostered when youth are given safe spaces in which to explore their thoughts through an artistic medium. They

describe how youth who participated in their arts programming were able to employ their imaginations to conceptualize complex concepts such as the characteristics of a healthy community and those of a good leader.

Many of these studies focus on the perspective of the youth participants in arts-based programming. Like Oreck (2006), who investigated how teachers used the arts in their classrooms, we believe that the experiences of adult facilitators who work with youth can also inform research on using the arts to engage youth at emotional and cognitive levels. In this chapter, we explore these ideas based on individual interviews with eleven artist facilitators from three arts-based programs with Indigenous youth in southern Canada. A thematic analysis of the interviews revealed that facilitators thought that they were able to address several arts and health goals through these workshops. The programs offered a safe space and a medium of expression for youth and young adults to explore issues and feelings, and facilitators noted that they were able to generate feelings of well-being among the youth and overcome challenges by channelling mental and emotional resources and re-engaging participants in the creative process. We will explore how the Nehinuw concept of *wicihitowin* ("helping and supporting each other") (Goulet and Goulet 2014) enabled facilitators to model and teach positive responses to conflicts and negative emotions. We will outline how this collaboration created a community asset and celebrated individual and collective achievements because of the focus on *wicihitowin*, which enabled youth engagement and transformation of their relationships and their views of themselves. We explore the role of the facilitators and how they viewed the arts program as contributing in a holistic way to participants' self-perception, fostering cultural health, and creating community assets through the arts.

The Arts in Health Research

Researchers argue that various forms of creative expression—such as visual arts, drama, photovoice, and so on—can provide individuals with a medium to explore their thoughts, emotions, behaviours, and actions. Such expressions lead to the creation of new meanings and strategies for transformation that can mobilize the process of decolonization and healing (Perry 2012; Yuen et al. 2013). In recent years, various arts-based methods have been used increasingly to collect

data, disseminate information, gain comprehensive understandings of patients' perspectives, and involve patients in the treatment process (Boydell et al. 2012; Cox et al. 2010; Lapum et al. 2012; Sharma, Reimer-Kirkham, and Meyerhoff 2011; Stuckey 2009). For example, Russell and de Leeuw (2012) employed arts-based methods to identify challenges and barriers that Indigenous women might face when accessing sexual health-care services in northern British Columbia. Working with Alaskan Indigenous people, Cueva (2011) observed that expressive arts—such as moving, drawing, and sculpting—can facilitate self-expression that might not be possible using words. Her work with cancer patients explored how the arts support holistic ways of creating meaning, enabling participants to learn new ways of expressing their thoughts about cancer.

The Arts and Community Health Outcomes

Archibald and Dewar (2010) investigated the connection between participation in the arts and healing in different Indigenous communities across Canada. Many participants reported positive outcomes, such as gaining confidence and learning new skills, as well as feeling more relaxed, open, and creative. They described the expressive arts as powerful tools that enabled them to examine their thoughts, feelings, defence mechanisms, and strategies and to gain greater insights into negative behaviours. Through creative expressions, the individuals were able to evoke memories and vocalize personal experiences and thus possibly initiate the process of healing.

Hammond and colleagues (2018) wrote a scoping review of the application of creative research methods and artistic practices with Indigenous people around the world. They identified five fields in which arts-based methods benefit Indigenous research agendas: "participant engagement, relationship building, Indigenous knowledge creation, capacity building, and community action" (260). In particular, Hammond and colleagues refer to a program with Māori youth in New Zealand where arts-based methods "offered a flexibility and openness towards different ways of knowing that enabled the youth to incorporate their cultural knowledge into the process and outcome of research," (271). Flicker and colleagues (2014) explored health promotion with Indigenous youth, particularly with reference to HIV, and found that the arts created a decolonizing process to enable critical dialogue on

health. However, as Ansloos and Wager (2020, 63) point out in their study of applied theatre and Indigenous youth homelessness, arts-based research is not, by default, decolonizing but holds "a decolonizing promise in the ways that it helped youth to reconstitute hopeful kinship relations with one another and with land, even in urban spaces."

Carson, Chappell, and Knight (2007) found that community members were likely to respond favourably when given an opportunity to become involved in something positive, such as the celebration of an individual accomplishment or an asset of the community, rather than yet another intervention strategy directed toward addressing yet another negative aspect of themselves that an external "expert" has identified. Landy (2010) observed that painful memories and experiences could form the basis of community connectedness when such experiences are revisited and new meanings are found through expressive arts. The author found that a performance developed by children to make sense of the tragic events of 9/11 brought together the children, their parents, and other adults. The play re-established a bond initiated by the shared pain that all experienced and the shared need to find meaning, support, and, most importantly, hope for the future during difficult times.

At the community level, Fuery and colleagues (2009) observed that responses to interventions are determined by the extent of ownership of issues claimed by communities. Hanson (2018) found that arts-based research validated the work of people in communities to create cohesiveness and change. Linking it with a participatory action research approach, Hatala et al. (2020, 4) found that arts-based methods such as photovoice became a way to enter youth's worlds, fostering relationality between youth and researchers and encouraging a "storying of the sacred and creative aspects of one's journey." Arts-based methods give communities appropriate tools to examine an issue, gain ownership of it, and help to re-engage in issues in a way that could lead to their resolution (Fuery et al. 2009). Fuery and co-authors wrote that arts-based methods provide participants with safe spaces in which to distance themselves from traumatic events and engage in something positive that promotes self-expression. Through self-expression and engagement in the creative process, individuals and communities can be encouraged to appraise critically their thoughts and behaviours to find alternative meanings in their current situations that might be hindering the development of good health (Fuery et al. 2009; Landy 2010).

A review of participants' perspectives in various studies provides evidence that engagement in arts leads to several health, social, and emotional benefits; however, these benefits are often very personal. These effects cannot be generalized, and at times they are unavailable for quantitative evaluation, leading to scepticism among academics and health-care policy makers (Hamilton, Hinks, and Petticrew 2003). However, the healing effect of arts cannot be discounted just because it cannot be delivered in discrete packages to address specific health conditions. We suggest that facilitators of arts-based workshops might witness the impacts of arts on participants during the workshops; therefore, they can provide a different perspective that can lead to a more comprehensive analysis of the beneficial effects of arts on health.

In this chapter, we examine the perspectives of facilitators to explore two ideas. First, we were interested in identifying the presence of specific social situations or interactions that might evolve in these programs and lead to transformative changes in the participants. Second, we wanted to understand the role of the artist facilitator in orchestrating these social situations or interactions that led the group toward creative expressions that culminated in a tangible piece of art.

Our Study

Our research team was engaged between 2006 and 2017 in an arts-based health research partnership with a First Nations tribal council in southern Canada.[2] During this time, we found that participation in the arts generates emotional and spiritual well-being in Indigenous youth and functions as a health intervention (Goulet et al. 2011). Although Indigenous individuals with artistic talents respond well to individual art projects, in a larger group many who do not see themselves as artistically capable willingly engage in the arts if the process and product are collaborative, congruent with aspects of traditional modes of Indigenous education.

Interaction, action, and reciprocity are integral to Indigenous thought (Goulet and Goulet 2014). This thinking is evident in Cree Elder Peter Waskahat's description of traditional Indigenous education: "We had our own teachings, our own education system teaching children that way of life, and how children were taught how to view, to respect the land and everything in Creation.... Talk revolved around a way of life based on these values. For example: respect, to share, to

care, to be respectful of people, how to help oneself. How to help others. How to work together" (quoted in Cardinal and Hildebrandt 2000, 16). The values that Waskahat identified point to the importance of balance between individual responsibility and support for others in working together. In addition to the importance of self-determination, one of the key concepts in social relations of the Nehinuw (Cree) is *wicihitowin*, which translates as "helping and supporting relationships" (Goulet and Goulet 2014, 98). Helping and supporting one another can reduce the individual risk inherent in any learning task so that youth might be more willing to engage when the activity is collaborative. When individual decision making and collaborative decision making are combined in education, they align with Indigenous concepts of learning to help oneself, help others, and work together.

We initiated a number of collaborative arts-based programs with Indigenous youth in cooperation with staff in a number of educational settings and undertook an exploratory approach to investigate the experiences of Indigenous facilitators involved in these programs. The programs were collaborative for both the youth and the adults involved. Educational staff organized and supported the artist facilitators who delivered the programs. The facilitators introduced different art techniques to the youth participants, and the participants and facilitators then came to a consensus on what the final product would be. The skill levels and interests of participants were considered during decision making. The programs emphasized participants' cultural identities, and the final products created were celebrations of their achievements and the accomplishments of their communities.

The programs helped to construct social spaces, enabling both facilitators and participants to engage in social interactions for the purpose of creating art. The safe spaces fostered these interactions, and art as a medium allowed participants to express themselves in a new way. The social interactions between facilitators and youth were guided by the goal of creating a unique piece of art collaboratively. Therefore, during our analysis of the interviews, we concentrated on identifying those interactions, behaviours, and emotions that emerged as the group worked together to create art.

The Programs

The mask. Students from Kindergarten to Grade 6 participated in the creation of a school mask. The program was facilitated by two Indigenous artists, Aaron[3] and Lucas, with assistance from school staff. Olivia, a Grade 4 classroom teacher at the First Nations school, helped to organize the program and liaise with community members and Elders, particularly in implementing the spiritual protocol that emphasized the cultural identity of the community. Each grade contributed to the project based on its skill level. Students from Kindergarten and Grade 1 were involved in making plaster for the mask, and Grades 2 and 3 were involved in the development of the mask. They also prepared, with guidance from their teacher and Aaron, matching little masks that they used to perform Maurice Sendak's play *Where the Wild Things Are.* Grades 4, 5, and 6 worked with Lucas, the artist, to build the actual mask, and all students contributed to the final painting of the mask.

The graffiti wall. Aaron, the Indigenous artist facilitator, worked in a school with nine boys between the ages of eleven and sixteen, encouraging them to think about different ways of using art. After assessing their interests and capabilities, Aaron introduced the idea of arts that emerge from everyday living. The group decided to construct and paint a two-sided wall (four feet by six feet) with graffiti to depict their views of love and hate. A non-Indigenous graffiti artist, Rubin, facilitated the program in collaboration with Aaron. The participants illustrated their perceptions of love on one side of the wall and hate on the other side. Rebecca, a social worker at the school, recruited and organized students for the program. She also supported Aaron in program facilitation, and Rubin, a youth resource worker, served as a positive role model.

The documentary video. Aaron worked with twelve participants enrolled in a young adult education program offered by the Prairie Upgrading Centre. The aim of the program was to initiate thinking about students' history and about veterans from their area. The group was initially interested in working on a mini script and a full-length video; however, after assessing the levels of skill and interest of the participants, the group decided to make a short informational documentary instead. Cody, an employment consultant at the community employment training centre, acted as a support person, and Craig was the videographer and editor. Sophia, an employability skills coach, and

Amber, a manager of an Indigenous employment and training centre, acted as support persons for the program. Elizabeth was the instructor of the students involved.

At the end of each program, the artwork collectively created by the participants was presented to the community. For the mask program, the school mask was unveiled at a public reception at the governance building. Students also performed with their individual masks in the play *Where the Wild Things Are.* The graffiti program had a public reception at the participants' school. It was organized and presented as an art opening at which the student artists were introduced and recognized, and the community had an opportunity to view the graffiti wall. When completed, the documentary had a public showing attended by members of the different tribal council communities.

Interviews with Facilitators

All eleven organizers, artists, teachers, and facilitators involved in the delivery of these three programs agreed to participate in open-ended, recorded interviews. Facilitators were asked to describe

- their roles in the different arts-based programs;
- their experiences in the programs;
- the impacts of the programs on them, the participants, the teachers, and the community;
- the challenges faced and how they were addressed;
- the social interactions between the facilitators and organizers, with the participants, and among the participants; and
- any behavioural, social, and emotional transformation that they observed in the participants.

The first and second authors of this chapter independently analyzed the interview transcripts to highlight important sections that mentioned social situations and or interactions, transformations in the participants, outcomes for the participants and facilitators, and any other information relevant to the research topic. The two authors shared their analyses, resolved any disagreement through discussion, and consensually identified four themes: goals, strategies for youth engagement, changes observed in the youth participants by the facilitators, and affirmation of positive identities. All are discussed here in detail.

Goals

The facilitators, the research team, and the community members all had different expectations of what could or should be achieved in the programs, and these expectations became the project goals. These goals influenced the facilitators and the participants, affecting their social interactions, behaviours, and emotions. The facilitators were interested in engaging the participants and emphasized creating the artwork collaboratively. The research team was interested in the impact of participation in the arts, so their emphasis was on the social interactions of and behavioural and emotional outcomes for the participants. Community members were interested in ensuring that the youth developed new skills and were exposed to positive role models; thus, they emphasized completion of the program with a tangible art product. The differing perspectives sometimes created tension that threatened the continuation of the project. Yet these tensions provided opportunities for participants to express their views and feelings. The facilitators realized that these issues had to be addressed to continue to engage the participants in the creative processes.

Strategies for Youth Engagement

In spite of the challenges that they faced, the facilitators were very motivated and truly believed that participants would benefit from participating in the program in many ways. Therefore, they adopted various strategies to resolve any problems and continued the program until the completion of the final artwork. In the documentary video program, Elizabeth, the instructor, recognized that the participants needed a positive and supportive environment to engage in the activities of the workshop. She encouraged the participants to believe in themselves and kept the atmosphere positive and enthusiastic: "I just kept telling them over and over again that I believed that they could do it. And I did. I knew they could do it." Rebecca, the social worker involved in the graffiti program, mentioned that the participants' learning needs varied. Two facilitators had different teaching styles. The one, who was more relaxed, engaged better with the younger participants. The other, an older facilitator with a more structured approach, worked well with the older youth. Together they were able to meet the learning needs of individual youth and therefore were more successful in engaging them.

Similarly, in the documentary video program, facilitators observed that participants were more engaged when opportunities were provided to learn the skills required to complete the tasks and when their creative efforts were acknowledged.

In the graffiti program, Aaron, the artist, recognized the social and behavioural needs of the youth and set up ground rules to reduce unproductive behaviour. He talked about some of his personal experiences with the male participants. As his style became more personal, his interactions with the youth became more positive. He began listening to the youth, adopting creative strategies to let them vent negative, unproductive behaviour and then steered them toward creativity and positive self-expression. These responsive strategies were not prescribed interventions proven to modify behaviour but employed to address the situation at hand. Aaron mentioned that in the graffiti workshops he asked the participants to "hold up that piece of paper [with negative expressions on it], crumple it, [and] throw it in the garbage, and so they would do that, [and] then all of a sudden they were like, they'll be looking around, and like what the heck was that all about? But what it did was it got the junk out of their head, and now they were able to think in more of a creative kind of a way. They were able to focus a little bit more." Similarly, Elizabeth observed that, when a problem arose in the documentary video program, a session allowing students to vent negative emotions was required to help them re-engage in the creative process. She added that the challenges that the participants faced in the program also provided them with opportunities to learn positive ways to express themselves and resolve conflicts. She said that in a couple of sessions the participants learned "how to communicate what you feel with no personal attacks." The facilitators mentioned that a deeper understanding of the needs of the participants was required to determine strategies for youth engagement. The strategies adopted by the facilitators were unique and custom-developed to address the situation at hand. These findings are consistent with the results of Dawes and Larson's (2011) grounded theory study of the role of personal connection in youth engagement where there is an integration of personal goals with programming goals: "learning for the future, developing competence and pursuing a purpose (259)."

Youth Transformation

Various strategies adopted by the facilitators initiated gradual transformations in the youth such that they were now engaged in self-expression, learning the skills to complete the tasks, and actively involved in working on the projects. The facilitators recalled specific instances when these transformations were observed. Rebecca, who managed the graffiti program, reported that youth in it who did not respond to the previous programming were able to open up and share their thoughts because their unmet needs were addressed: "When they started talking about very personal stuff, I think Rubin did something on—I can't remember what he did actually, but it was a lot of personal issues, like they called [them] 'man issues.' Therefore, I couldn't be in the group with them. But I think that's what changed them a lot. Like their attitudes toward the group." Rebecca noted that the consistency and the commitment that artists Aaron and Rubin demonstrated, and the support that they provided, were important for the youth to engage in the programs.

Similarly, Elizabeth, in the documentary video program, observed that continual support and encouragement were crucial for the participants to make the efforts required to complete the video. She also observed that the participants in this program needed a safe space for unrestrained self-expression and a non-judgmental person genuinely interested in their stories: "I had the feeling that these students never had that opportunity. And they were so excited about wanting to talk about—I mean sometimes we just talked about UFOs. But just that somebody was listening to them, that it was a safe environment to explore ideas. There wasn't going to be any ridicule or anger. There was no fear that conversations might escalate."

Aaron also observed youth transformation when participants were offered a safe place to express themselves: "It took them from when I met them from the first day. . . . They, a lot of them, were very quiet and very withdrawn. I just [saw] them sort of go from very sort of holding in to really letting . . . being themselves, and I think that the fact that I allowed them to be themselves without censoring their ideas or the way that they express themselves, allowed them to let down their guard and enjoy it, and I think that that really helped them."

The facilitators in the graffiti program reported several behavioural transformations in the youth once their social needs were addressed. Those previously reluctant to attend the program began to attend it voluntarily. Rebecca, who supported the artists, also reported that one of the youth made a positive behavioural choice in a conflict that happened outside the program: "He actually walked away from a confrontation that could have [gone] ugly very quickly. He was usually a very short-tempered individual."

Facilitators observed another youth making a behavioural change that averted disciplinary action by the school, and they noted another participant beginning to work on his schoolwork. As Rebecca said, "one of the participants in the group towards the end of the graffiti program, he actually handed in his very first assignment ever in his high school years."

Elizabeth pointed out that many of the participants in the documentary program had experienced very little success in academic institutions, so their confidence was low. They began to experience success in the program and started to gain ownership of the project when they received clear instructions on actions that could lead to specific deliverables and an opportunity to execute the actions successfully. As Elizabeth mentioned,

> I think . . . things really started to turn around for them when they actually got some hands-on kind of stuff. So we talked a bit about just footage that they could get locally. And they had all kinds of ideas about what they might do. And then they got cameras, and we put together a schedule with crews—separate teams. Once they got in their vehicles and took off to actually do some videoing and come back, then they were really excited about it. Because they felt now, I guess, a stronger connection to the project. They felt they were making their decisions about what they wanted to see instead of just in a classroom having somebody lecture at them.

The facilitators noted that, once participants learned the art of unrestrained self-expression, they were able to employ those skills to accomplish a creative goal, such as writing poems or finding imaginative ways of describing love and hate. Rubin observed that "one of the success stories from [the] graffiti program was that they eventually

expressed themselves through words and really opened up, came out of their shells, did what they had to do, and then they got their graffiti wall at the end of it." Similarly, facilitators in the documentary program pointed out that it offered a way for the participants to learn to express their emotions in acceptable ways. Annabelle, Elizabeth, Sophia, Olivia, and Rebecca pointed out that participants developed better social skills, learned appropriate ways of interacting with each other, and embraced working collaboratively in a group. Rubin and Rebecca, facilitators in the graffiti program, observed that involvement in arts allowed participants to distance themselves from their current realities and accept each other without becoming judgmental. Involvement in arts offered a chance for them to develop favourable attitudes toward others. Participants became more accepting of their peers, and the group became more cohesive and engaged in the creative process. As Aaron reported, "I was told by Rebecca that after a while Clive [a participant] was becoming accepted, like with the rest of the groups, and how they were beginning to warm up and let their guard down and actually be friendly to each other. . . . That again proved . . . the whole process of creative collaboration, and just getting them to work on something, just forget about their outside world, and their perceptions of each other, and think about the creative process of engaging and building teamwork."

Several transformations were also observed after the projects were finished. The completed documentary provided participants with a tangible product that confirmed their ability to create something positive and valuable for the community. As Elizabeth said, "for these people who have experienced so much failure in their lives, I think that that was really, really valuable to know. Not just to suspect that you can do something, but to know that you can do it."

The artwork created in the mask program served as a cultural mask for the community. Lucas was an established Indigenous artist with a strong work ethic and close ties to his cultural identity. Through this program, Lucas and Olivia incorporated ceremonies and explored the cultural identity of the community of the participants. The process honoured the spiritual traditions of the community, and the completion of the project provided an opportunity to celebrate the artistic contributions of all the participants. It offered participants and others in the community an opportunity to revisit their cultural identities and re-establish ties between individuals and generations within the community.

In the graffiti program, facilitators noticed an important transformation when the youth observed how their accomplishments were recognized by successful adults in the community. As Aaron, one of the artists, observed, "when these boys walked in and they saw their own work, and they saw a group of people, and like artsy types standing around drinking coffee and eating from meat and fruit platters, and these guys walked in, they were blown away. They were like . . . I did this!"

Finally, the facilitators experienced a sense of pride and accomplishment when the final products were displayed or shared with the communities. They also told us that the same thing happened to the participants. The words *huge* and *pride* were used most frequently to describe the impacts of the finished products on the facilitators, participants, and communities.

Affirming Positive Identities

Facilitators reported that positive identities were affirmed for the participants by creating the finished artworks. The arts workshops provided safe spaces in which to release and resolve negative aspects of participants' lives hindering their emotional, social, and academic progress. In these safe spaces, negative thoughts were replaced with creative ideas, and participants began engaging in the creative process physically and emotionally. With support from positive role models, participants learned to express themselves, verbalize their needs, and work through their thought processes. As the workshops progressed, participants learned, practised, and gained proficiency in artistic skills, and creating the final products collectively transformed their perceptions of who they were and what they could do.

As Olivia explained, "the kids were just impressed with Lucas [one of the artists]; he was just amazing to them. One of them said, 'I want to be an artist when I grow up,' which is really awesome. Quite a few of my students see themselves as artists in the community." As well, the positive collective identity of the community was reaffirmed, and this strengthened the bonds with the community members and between the generations, as Olivia noted: "The mask itself is called *Young Dog*, which reflects the community itself and the identity of the community and the identity of the participants that were there, the children themselves, and the teachers."

When participants in the graffiti program realized that their negative circumstances need not be a barrier to what they could accomplish, individual identities also underwent transformations. Rather, such circumstances fuelled creativity and positive self-expression. Aaron mentioned that what "I saw from them was they were associating with that whole sort of subculture of the hip-hop world, of like the ghetto, of graffiti, you know we come from the ruins, [but] we're not ruined."

The final product served as a gift to the community from individuals who have not had many opportunities to contribute positively to it. Their creations brought honour to themselves, their families, and the community. As Elizabeth observed, "they felt that they were not just connecting with their community, but they were doing something that was important. They were honouring their ancestors, but they were also creating a gift for their children and their grandchildren."

The facilitators noted that artwork helped the younger children to bond with their culture, instilling pride in their work, in themselves, and in their communities. The positive identities of the participants created through these workshops changed how external community members viewed the participants. The facilitators noted that the actions and the final product were instrumental in revealing and reaffirming the positive identities of the participants. "They also learned, you know," Annabelle mentioned, "because of the racism [toward] our community, [that it] is [important] to have young people seen in a positive way, and by bringing that mask, what they created, [it] says this is the community, these are the kids of the community, and this is what they did. This is their contribution to the community." The facilitators acknowledged that, although it is difficult to measure outcomes, the positive impact was observed and felt by both facilitators and community members. Annabelle elaborated: "I think maybe [the impact of the program is] not something that you can really measure, but they were really proud of what they had accomplished. And I could see their parents were really proud. Like one of the students' mothers came, and she said, 'I was so proud of Monica. I just about started to cry.' And that's not necessarily something you can measure."

Implications of the Study

The interviews with the facilitators and the organizers reaffirmed the findings of other studies (Archibald and Dewar 2010; Bygren, Konlaan,

and Johansson 1996; Cohen et al. 2006; Crouch, Robertson, and Fagan 2011) that participation in arts-based programs is associated with several positive behavioural, social, and emotional outcomes. The facilitators in our study reported that the arts-based programs offered safe spaces and venues for the participants to express their thoughts and bring alternative meanings to their situations. When participants were able to perceive their situations and themselves differently, the process of transformation was initiated. The facilitators observed that the skills learned and the artworks created in these programs served as new measures of participants' self-efficacy and identity. Each artwork created served as a gift to the community, the value of which was amplified by how the artwork strengthened community ties, reconstructed history, and affirmed positive individual and communal identities. Our study provides greater insights into the roles of the facilitators in creating social situations and social interactions conducive to the positive changes observed in the participants. Furthermore, several interesting themes emerged, a detailed examination of which suggests that engagement in the arts can help to alter self-perceptions and cultural identities, thereby healing the negative effects of colonization on individuals and communities.

Facilitators' Roles in the Arts

Although the facilitators initiated the creation of the artworks, the programming called for organized efforts from all involved. As the facilitators and the participants interacted to determine the steps that would lead them toward their goals, they encountered several challenges. The facilitators, therefore, adopted various strategies to address them and steer the groups toward completion of their goals. The facilitators reported that they worked hard to keep the atmosphere in the programs respectful and supportive, which allowed the participants to express themselves without the fear of being judged. It was through self-expression that the participants were able to examine their thoughts and behaviours and gain insights into how they were detrimental to their health and the goals of the programs. The facilitators talked about actively creating opportunities for the participants to express themselves, learn new skills, and practise those skills to accomplish subtasks and progress toward the completion of the artworks. The collaborative nature of the process and the product created a situation

in which, in interactions with the facilitators, the participants had op-
portunities to practise traditional social skills. These were identified by
Elder Peter Waskahat as respect, sharing, caring, helping oneself, and
helping others—the skills needed to be effective in working together.
Facilitators themselves learned to take leadership roles, including im-
plementing strategies to problem-solve and incorporating arts in the
regular curriculum. Indigenous artists found opportunities to work
with youth and give back to their communities. Community members
were able to evaluate the potential of arts-based programs in creating
community assets. As with Carson et al. (2007), through the creation of
these assets, community bonds were strengthened while new skills were
identified and learned. Communities found new ways of celebrating
and connecting to their culture. Unlike in colonial history, in which
Indigenous accomplishments are often invisible, the video project doc-
umented stories of great sacrifice by the veterans of their communities
and in doing so honoured the participants' relatives and ancestors. A
new collective identity emerged through the artwork, which instilled
pride in the community and in individual participants.

What was accomplished through these programs was far more than
Indigenous youth learning art skills. The facilitators reported that the
impacts of these programs were far-reaching, and engagement in arts
was instrumental in initiating a process of positive growth for the youth.
They also emphasized that the process was unique and relevant to the
context in which it was created, so it is difficult to quantify or create
discrete program packages as prescriptions for certain conditions, as can
be done by a doctor who prescribes medications for specific ailments.
As Vettraino, Linds, and Goulet (2013) point out, the background
experiences of artist facilitators enable this to happen; in leading a
group through an arts activity, "authority and control shift back and
forth between the participants and the facilitators from the structure
offered by the activities in the workshop to the youth participants who
determine how they will participate, what they will share, and what
they will learn. Students' freedom and authority to choose what story
they will share or show means authority is always being negotiated
in the in-between space between the stories of the students and the
structure of the activities" (195). Therefore, arts-based programs need
to be designed and adapted in situations for specific populations based
on the specific life experiences of the participants. Nevertheless, there

are certain challenges that emerged in the programs, and the facilitators' responses to them should be considered in any arts program with Indigenous youth.

Arts and Cultural Health

Health is a holistic concept that involves improvements in physiological, behavioural, emotional, and spiritual aspects of a person and a community. Fuery et al. (2009) proposed that changes in health status can occur when individuals and communities become actively engaged in issues related to health. Art can be an effective intervention because, as a medium, it allows individuals and groups to construct the paths toward their growth and therefore gain ownership of their health and the process by which they think that well-being can be achieved (Wright et al. 2013).

Consistent with these views, facilitators reported that some of the youth in the graffiti program were on the brink of being expelled from their high school; they had not responded to other programs offered, their motivation was low, and they had attended the other programs because they had been required to do so. It seemed that the participants were caught up in a vicious cycle in which failure led to poor motivation that discouraged them from engaging in any activity; consequently, they failed again. The frustration created by this cycle of failure was expressed in the form of negative behaviour, such as poor regard for personal space, inappropriate outbursts of anger, and challenges to authority figures. Attempts to alter the behaviour in an authoritarian way had yielded little success, and a holistic approach was required.

The facilitators in the mask and video programs also learned from this experience even though these programs did not include this troubled group. Rather than focusing on negative behaviour, the facilitators tried to engage the participants in the artwork. The facilitators consistently encouraged the participants, provided safe spaces for them to express negative feelings, simplified the tasks to match the participants' skill levels, and, most importantly, provided opportunities to execute learned skills successfully.

The facilitators reported that the process of self-growth was initiated as participants worked with each other and with the various materials, such as paint and papier mâché, that provided opportunities for alternative ways of self- and group expression. The facilitators recalled that

the successes experienced by the participants while working with these art media acted as a balm, soothing the spirit and releasing the anger felt toward those who had not kept their promises or had given up on them. Artmaking helped the participants to shift their focus from past negative experiences, failures, and lost opportunities to current opportunities, newly learned skills, and new ways of self-expression. This refocusing deconstructed identities of failure and initiated reconstruction of identities of success. The facilitators observed that participants were able to find positive meanings in their present conditions.

Wright et al. (2013) propose that it is important to evaluate the efficacy of arts-based programs to understand the connection between arts and healing. The facilitators reflected that these programs offered ways for participants to alter self-perceptions and affirm positive identities. The programs offered opportunities to celebrate the achievements of the participants and the community as a whole through the creation of community assets.

Altering Self-Perceptions of Cultural Identities

The facilitators reported that many of the participants had experienced little previous success, which had led to the development of negative self-perceptions. The participants often described themselves by saying that "we cannot do it" or "we are difficult to manage." These perceptions guided their actions, and the participants in the graffiti and documentary programs were ready to quit whenever the tasks became a bit challenging. The facilitators recognized that the participants needed to experience genuine successes directly tied to their actions. When the tasks were simplified so that they could be completed, and when the facilitators coached the participants to execute these actions, they began to experience successes. In the documentary program, this became the turning point for the participants; they became more engaged in creating the video and took ownership of the project. Facilitators observed that participants' accomplishments in the arts-based programs became the new reference point that affirmed their positive views of themselves. This was evident from the way that participants talked about themselves: instead of "we cannot do it," they began to say "we did this" and "we can do it."

As the participants restructured their self-perceptions, their new identities became more stable as their peers, teachers, family members,

community members, and outside experts acknowledged their contributions. One facilitator noted that the frustration and anger experienced because of past failures were replaced by immense pride when the participants saw their names in the credits of their creations.

Healing through the Creation of Community Assets

The artworks created in these programs were tangible testimonies of what can be achieved through such endeavours. Apart from being aesthetic pieces, the artworks were gifts from the participants to their communities. Affirming what Mackey (2012) proposes, the facilitators communicated that these tangible material items will serve as memory aids and help participants to celebrate key moments from their pasts, evoking immense pride.

As suggested by Carson et al. (2007), the true value of these gifts can be understood as we look at their impacts on both individuals and communities and the meanings that evolved while the participants created the artworks collaboratively. For example, the facilitators in the mask program observed that the mask became a community asset, offering a way to connect with one's culture that helped to heal the negative impacts of alienation and disconnection from traditional practices that resulted from years of colonization.

The facilitators in the video program observed that the documentary became a community asset that introduced younger generations to aspects of cultural heritage associated with great pride. Thus, again it relieved some of the trauma experienced because of the negative portrayal of Indigenous history by colonial scholars.

The facilitators in the graffiti program observed that the graffiti wall became a symbol of the participants' creativity, self-efficacy, and pride. Indigenous youth also realized that a disadvantaged lifestyle was not their identity and that self-efficacy is not constrained by their past.

Conclusion

Collaborative creativity was key to the success of these arts programs as each program in its own way aligned with the values of traditional Indigenous education systems. Through *wicihitowin* ("helping and supporting each other"), facilitators modelled and taught positive responses to conflicts and negative emotions. As youth practised the traditional values of respect, sharing, caring, and working together, the

positive relations led to the creation of safe spaces of trust—in the facilitators and in themselves—where youth could express both negative emotions and cultural connections. As the facilitators taught new skills, the youth came to believe in their own creative abilities, engendering feelings of success and pride connected with positive self- and group identities. The creative products related to the lived culture and history of the youth and their communities. When the beauty of their creations was shared with others, it reinforced feelings of pride in their abilities and identities as the public presentations affirmed and strengthened connections to community. The facilitators played a crucial role in encouraging the participants to use arts as media of self- and collective expression, supporting them unconditionally while the participants explored positive self- and community identities through the creation of community assets that will serve as memory aids into the future of the positive expression of Indigenous youth in the community.

Acknowledgements

This work was supported by the Canadian Institutes of Health Research, Institute of Aboriginal Peoples' Health, under Grant 132195 and the Saskatchewan Health Research Foundation under Grant 2782.

Notes

1 Our research team was saddened by the passing of our colleague Dr. Episkenew in February 2016. She was integral to our research and contributed to this chapter before she began her spiritual journey.
2 We had a research agreement with our First Nations tribal council partner that outlined ethics as approved by the tribal council chiefs and the University of Regina.
3 All names and host organizations used in this chapter are pseudonyms.

References

Ansloos, J.P., and A.C. Wager. 2020. "Surviving in the Cracks: A Qualitative Study with Indigenous Youth on Homelessness and Applied Community Theatre." *International Journal of Qualitative Studies in Education* 33, no. 1: 50–65.

Archibald, L., and J. Dewar. 2010. "Creative Arts, Culture, and Healing: Building an Evidence Base." *Pimatisiwin: A Journal of Indigenous and Indigenous Community Health* 8, no. 3: 1–25.

Boydell, K.M., B.M. Gladstone, T. Volpe, B. Allemang, and E. Stasiulis. 2012. "The Production and Dissemination of Knowledge: A Scoping Review of Arts-Based Health Research." *Forum: Qualitative Social Research* 13, no. 1: Article 32. http://nbn-resolving.de/urn:nbn:de:0114-fqs1201327.

Bygren, L.O., B.B. Konlaan, and S. Johansson. 1996. "Attendance at Cultural Events, Reading Books or Periodicals and Making Music or Singing in a Choir as Determinants for Survival: Swedish Interview Survey of Living Conditions." *British Medical Journal* 313: 1577–1580. doi: 10.1136/ bmj.313.7072.1577

Cardinal, H., and W. Hildebrandt. 2000. *Treaty Elders of Saskatchewan.* Calgary: University of Calgary Press.

Carson, A.J., N.L. Chappell, and C.J. Knight. 2007. "Promoting Health and Innovative Health Promotion Practice through a Community Arts Centre." *Health Promotion Practice* 8: 366–74.

Cohen, G., S. Perlstein, J. Chapline, J. Kelly, K. Firth, and S. Simmens. 2006. "The Impact of Professionally Conducted Cultural Programs of the Physical Health, Mental Health, and Social Functioning of Older Adults." *Gerontologist* 46, no. 6: 726–34.

Cox, S.M., D. Lafrenière, P. Brett-MacLean, K. Collie, C. Nancy, J. Dunbrack, and G. Frager. 2010. "Tipping the Iceberg? The State of Arts and Health in Canada." *Arts and Health: An International Journal for Research, Policy and Practice* 2, no. 2: 109–24.

Crouch, A., H. Robertson, and P. Fagan. 2011. "Hip Hopping the Gap Performing Arts Approaches to Sexual Health Disadvantage in Young People in Remote Settings." *Australasian Psychiatry* (1): 34–37.

Cueva, M. 2011. "'Bringing What's on the Inside Out': Arts-Based Cancer Education with Alaska Native People." *Pimatisiwin: A Journal of Indigenous and Indigenous Community Health* 9, no. 1: 1–22.

Dawes, N.P., and R. Larson. 2011. "How Youth Get Engaged: Grounded-theory Research on Motivational Development in Organized Youth Programs." *Developmental Psychology* 47, no. 1: 259–69.

Episkenew, J.A. 2009. *Taking Back Our Spirits: Indigenous Literature, Public Policy and Healing.* Winnipeg: University of Manitoba Press.

Flicker, S., J.Y. Danforth, C. Wilson, V. Oliver, J. Larkin, J.-P. Resoule, C. Mitchell, E. Konsmo, R. Jackson, and T. Prentice. 2014. "'Because We Have Really Unique Art': Decolonizing Research with Indigenous Youth Using the Arts." *International Journal of Indigenous Health* 10, no. 1: 16–34.

Fuery, P., R. Smith, K. Rae, R. Burgess, and K. Fuery. 2009. "Morality, Duty and the Arts in Health: A Project on Indigenous Underage Pregnancy." *Arts and Health: An International Journal for Research, Policy and Practice* 1, no. 1: 36–47.

Goulet, L., and K. Goulet. 2014. *Teaching Each Other: Nehinuw Concepts and Indigenous Pedagogies.* Vancouver: UBC Press.

Goulet, L., W. Linds, J. Episkenew, and K. Schmidt. 2011. "A Decolonizing Space: Theatre and Health with Indigenous Youth." *Native Studies Review* 20, no. 1: 35–61.

Hamilton, C., S. Hinks, and M. Petticrew. 2003. "Arts for Health: Still Searching for the Holy Grail." *Journal of Epidemiological Community Health* 57: 401–02.

Hammond, C., W. Gifford, R. Thomas, S. Rabaa, O. Thomas, and M.-C. Domecq. 2018. "Arts-Based Research Methods with Indigenous Peoples: An International Scoping Review." *AlterNative* 14, no. 3: 260–76.

Hanson, C. 2018. "Stitching Together an Arts-Based Inquiry with Indigenous Communities in Canada and Chile." *Canadian Journal for the Study of Adult Education* 30, no. 2: 11–22.

Hatala, A., C. Njeze, D. Morton, T. Pearl, and K. Bird-Naytowhow. 2020. "Land and Nature as Sources of Health and Resilience among Indigenous Youth in an Urban Canadian Context: A Photovoice Exploration." *BMC Public Health* 20, no. 538. https://doi.org/10.1186/s12889-020-08647-z.

Kirmayer, L.J., G.M. Brass, and C.L. Tait. 2000. "The Mental Health of Indigenous People: Transformations of Identity and Community." *Canadian Journal of Psychiatry* 45, no. 7: 607–16.

Kirmayer, L., C. Simpson, and M. Cargo. 2003. "Healing Traditions: Culture, Community and Mental Health Promotion with Canadian Indigenous People." *Australasian Psychiatry* 11: 15–23.

Landy, R.J. 2010. "Drama as a Means of Preventing Post-Traumatic Stress Following Trauma within a Community." *Journal of Applied Arts and Health* 1, no. 1: 7–18.

Lapum, J., P. Ruttonsha, K. Church, T. Yau, and A.M. David. 2012. "Employing the Arts in Research as an Analytical Tool and Dissemination Method: Interpreting Experience through the Aesthetic." *Qualitative Inquiry* 18, no. 1: 100–15.

Mackey, S. 2012. "Of Lofts, Evidence and Mobile Times: The School Play as a Site of Memory." *Research in Drama Education: The Journal of Applied Theatre and Performance* 17, no. 1: 35–52.

Oreck, B. (2006). Artistic choices: A study of teachers who use the arts in the classroom. *International Journal of Education & the Arts* 7(8). http://www.ijea.org/v7n8/.

Perry, A.J. 2012. "A Silent Revolution: 'Image Theatre' as a System of Decolonization." *Research in Drama Education: The Journal of Applied Theatre and Performance* 17, no. 1: 103–19.

Russell, V.L., and S. de Leeuw. 2012. "Intimate Stories: Indigenous Women's Lived Experiences of Health Services in Northern British Columbia and Potential of Creative Arts to Raise Awareness about HPV, Cervical Cancer, and Screening." *Journal of Indigenous Health* 8, no. 1: 18–27.

Sharma, S., S. Reimer-Kirkham, and H. Meyerhoff. 2011. "Filmmaking with Indigenous Youth for Type 2 Diabetes Prevention." *Pimatisiwin: A Journal of Indigenous and Indigenous Community Health* 9, no. 2: 423–40.

Stuckey, H.L. 2009. "Creative Expression as a Way of Knowing in Diabetes Adult Health Education: An Action Research Study." *Adult Education Quarterly* 60, no. 1: 46–64.

Vettraino, E., W. Linds, and L. Goulet. 2013. "Click, Clack, Move: Facilitation of the Arts as Transformative Pedagogy." *Journal of Transformative Education* 11, no. 3: 190–208.

Wright, P., C. Davies, B. Haseman, B. Down, M. White, and S. Rankin. 2013. "Arts Practice and Disconnected Youth in Australia: Impact and Domains of Change." *Arts and Health: An International Journal for Research, Policy and Practice* 5, no. 3: 14–19.

Yuen, F., J. Episkenew, W. Linds, H. Ritenburg, L. Goulet, and K. Schmidt. 2013. "'You Might as Well Call It Planet of the Sioux': Indigenous Youth, Imagination, and Decolonization." *Pimatisiwin: A Journal of Indigenous and Indigenous Community Health* 11, no. 2: 269–81.

Part 3

Healing Land, Body, and Tradition

THE DOUBLENESS OF SOUND IN CANADA'S INDIAN RESIDENTIAL SCHOOLS

BEVERLEY DIAMOND

This chapter emerged from a team project[1] on the uses of expressive culture in the work of the Truth and Reconciliation Commission (TRC) on Indian Residential Schools in Canada. It honours the courage of the many survivors who have broken the silence in recent years about Indian residential schools' (IRS) abuses while also respecting the decision of many not to participate in the work of the TRC. In this chapter, I explore how sonic expression was used in the residential schools that operated in Canada from the late nineteenth century to the 1990s both as a colonial mechanism of assimilation and control and occasionally as a form of student resistance and resilience. I argue that these uses of sound and music are related, both negatively and positively, to issues of health and wellness as defined from First Nations perspectives. In the final part of the chapter, I describe some recent responses by contemporary musicians to the IRS tragedy, reflecting on how they carry forward deeply rooted Indigenous concepts of health, wellness, and balance through listening, sonic creation, and performance.

This chapter extends other work on the role of creative arts in healing (e.g., Archibald 2012; Castellano 2010; Igloliorte 2009). I focus on sonic expression, in part because of my disciplinary training as a musician and ethnomusicologist, but more importantly because within decolonization literature it has received less attention[2] than other types of

expression, such as stories or images. This focus reveals how the unique dynamism and relational qualities of sound-shaped colonial encounters. Ideas about the right way to sound or to make sound always precede and determine how sound is produced and heard by different populations, even though its capacity for both precise referentiality and abstraction render it one of the most multivalent tools of communication. Sound is not containable in space but exists in motion, travelling through barriers, defined by the waves that link sound producer and listener. At the same time, sound is ephemeral, leaving no trace after it stops. These qualities give the sonic particular relational and political valence and shape its role in relation to health and well-being. My research demonstrates that the uses of sound and music were diverse and contradictory: colonizing Indigenous children on the one hand and serving as a means of alleviating trauma and even resisting the strictures of the schools on the other. Within a broader frame, the recognition of this doubleness of sound contributes to a "decolonial history of the voice," one that seeks not only to "identify the constitution of an alterity of the acoustic as part of the political theology of the state" but also to uncover "different modes of relating alterity and the voice that do not fit such a paradigm" (Ochoa Gautier 2014, 20–21). Expressive culture and music in particular have sometimes been associated uncritically with "healing" when actually they are invariably polysemic and may be deployed for diametrically opposed purposes or experienced in dramatically different ways.

Although sonic culture within the Canadian-based Indian residential schools[3] has rarely been studied, references abound in IRS histories and primary sources (church policy documents, photographs of performers, school newsletters, survivor interviews, and testimony and oral history). By assembling evidence of music and other sonic expression in the schools, I reflect on the expediency[4] of sonic expression in them as both assimilation and survival. Yúdice's (2003, 38) broad definition of the term "expediency," which "focuses on the strategies implied in any invocation of culture, any invention of tradition, in relation to some purpose or goal," pertains here, although I adapt his argument in a different direction. Yúdice writes broadly about culture "as a manageable resource" "located at the intersection of economics and social justice agendas" (17). My focus here is not on economics, and the uses of culture are "manageable" only from the perspective of the IRS system.

I contend, however, that even relatively powerless individuals also use expressive culture in small creative ways that might make their lives more bearable, if only for rare moments here and there. Expediency, then, is more related to a struggle for well-being in an abusive context.

IRS Sonic Culture and Indigenous Concepts of Health and Well-Being

Studying the sonic cultures of residential schools helps to nuance the dichotomy that many have drawn between Western institutionalized medical practices and Indigenous approaches to health and well-being (Simpson 2008; Waldram, Herring, and Young 1995). Where institutional mainstream medicine might focus on individuals with the intention of isolating and eradicating illness, Indigenous approaches often have been described as both individual and social, holistic, resisting compartmentalization, and rooting self-knowledge in experience. Cree Elder and psychologist Joseph Couture described this difference as follows: "A system that defines the self as separate and hierarchically measurable is usually marked in Western cultures by power-based dominance patterns. In such systems, the self-boundary serves as protection from the impinging surround and the need for connection with, relatedness to, and contact with others is subjugated to the need to protect the separate self. Abstract logic is viewed as superior to more 'connected knowing'" (Couture, Couture, and McGowan 2013, 198). The burgeoning literature on Indigenous approaches to health and well-being stresses integration of the physical, mental, spiritual, emotional, and social (Graham and Stamler 2013; Kirmayer, Tait, and Simpson 2009; Loiselle and McKenzie 2006; Portman and Garrett 2006). Although every First Nation and community has local and distinct knowledge, the emphasis on integration is widely shared. The interconnectedness of humans with other humans across generations, with non-humans, and with other aspects of Creation is central to seeking and maintaining the balance of all these dimensions. Hence, the health of the Earth is related integrally to the health of life on the Earth, as Leanne Simpson (2004), among others, has eloquently described. Such multidimensional concepts are embodied in First Nations languages. For instance, *eshi-innuit* in Innu Aimun refers to "a condition of physical, mental, spiritual and emotional well-being" (Mailhot and Mackenzie 2014); the Navajo principle of *sg'ah naaghdibik'eh hozhg*

recognizes that "the conditions for health and well-being are harmony within and connection to the physical/spiritual world" (Lewton and Bydone 2000, 478); *ilusiq* in Inuktitut implies "a person's state of health, habits or behaviour" (Schneider 1985, 74).[5]

The roles of song and ceremony in (re)vitalizing individuals, nations, and all life forms, preparing for new and difficult experiences, and (re)integrating individuals into their communities have been widely acknowledged.[6] Both the Aboriginal Healing Foundation[7] and the Truth and Reconciliation Commission on Indian Residential Schools[8] emphasized the importance of expressive culture in the work of healing the "wounds" of colonialism. Others, including J.P. Gone (2014), have demonstrated the complexity of "historical trauma." Less attention has been paid to both the negative work and the positive work of sonic culture in relation to health and well-being within the schools themselves. The children were ever alert to context, like environmental activists, who, as Rob Nixon (2011, 108–09) observes, know that in the face of "slow violence"[9] "interventionist writing required versatility and cunning," and such cunning often involved the ability to "adjust [their] register and focus" and adopt "generic versatility." The same cunning is evident in the sonic actions of the children, and contemporary Indigenous singers, dancers, and drummers have been particularly adept in this regard.

Indian Residential Schools in Canada

Like the boarding schools to which Indian children were sent in the United States, the residential school system in Canada was designed to assimilate First Nations, Inuit, and Métis children by removing them from their families, denying their traditional lifeways, and forbidding the use of their own languages. Couched in euphemistic metaphors of "civilizing" and "Christianizing" Indigenous children, the system was bent on destroying First Nations, Inuit, and Métis cultures, which constitutes cultural genocide by the terms of the United Nations Convention on the Prevention and Punishment of the Crime of Genocide (1948). It was a form of "slow violence" (Nixon 2011), destructive actions that occurred over a long period with devastating social and environmental effects that accumulated across generations. The history of the schools, which operated from the 1870s to 1996, has

now been described in a number of publications, the most thorough and reliable being the report of the TRC (2015).

Problematizing Narratives of Victimization and Agency

Assumptions underpinning responses to narratives of trauma are often problematic. If settlers respond with pity to the testimonies of survivors, then they reify settler privilege rather than unsettle it (Simon 2013, 131–35). Even the hopefulness of the concept of reconciliation can obscure assumptions of social hierarchies, ignoring the fundamental need to respect incomprehensibility and difference—to recognize the independent coexistence of Indigenous and settler sovereignties—rather than seek some sort of harmonization or cultural merger.

Indigenous scholars and Elders recognize these problems. Métis art historian David Garneau (2012) has argued that spaces of irreconcilability are fundamentally important. Survivors have problematized victimization. An Anishinaabe survivor identified as Henri (Pikogan, Quebec) asserted that "the version that everyone knows makes us out to be victims. This is dangerous. I don't want to be a victim. I can be someone who went through a terrible experience but I refuse to be a victim" (First Nations of Quebec and Labrador Health and Social Services Commission 2010, 39). A Mi'kmaw survivor, Isabelle Knockwood, similarly refused the position of victim when she ended her testimony before the TRC by saying that "my happiness is my revenge."[10] Stereotypes of Indigenous people as "passive victims in the era of settlement" (Brownlie and Kelm 1994, 544) are antiquated in academia, but the role of witnessing at the TRC can reanimate traces of this stereotype as one hears hundreds of hours of stories of physical, psychological, and sexual abuse. Listening *for* victimhood, however, might be a form of settler condescension that obscures a hearing aimed at determining collaborative action for social change.

While some writers, artists, and musicians might choose to name the system's injustice, others describe Indigenous perspectives and acts of resistance in both historical and contemporary work. I am drawn to small expressive acts of agency and resistance by children in the schools, sometimes to provide personal solace or reconnect to pleasant memories, sometimes to parody what they were taught or subvert the schools' restrictions, particularly bans on the use of their own languages.

But my regard for these small acts might have unhelpful implications. A debate among Canadian historians in the 1990s problematized an emphasis on Indigenous agency as "colonialist alibi" (Brownlie and Kelm 1994). With reference to studies that emphasized agency, historians Brownlie and Kelm observed that some "uses of Native resilience and strength may soften, and at times deny, the impact of colonialism, and thus . . . implicitly . . . absolve its perpetrators" (545). They suggested that scholars who "minimize the extent of the very real and observable damage inflicted on Aboriginal societies" can implicitly assert the right of settler governments and religious institutions to intervene and might overdraw the "altruistic intent of the colonizers" (545). Kelm describes the "sigh of relief" that she sensed among fellow graduate students when they read historical accounts of agency in the wake of the Oka stand-off in 1990. As she asks, "how were we, in our own writing, to examine power relations under colonialism in a way that did not underestimate Aboriginal agency, yet would not produce that 'sigh of relief' which said that maybe colonialism never happened at all?" (Cole, Miller, and Kelm 1994, 640). As a settler, this is a challenge that I must face.

I have chosen to search the historical record for the multiple functions—oppressive, assimilative, and resistant—that music served within the schools themselves. Agency is prominent here but includes the agency of several different players: the Canadian government, church authorities, teachers and IRS administrators, and the children themselves. My hope is that a more balanced picture will emerge in which alibis of any sort are excluded.

The individual experiences of survivors appear in a large number of print and video sources[11] and are theirs to tell. However, having attended four of the seven national events of the TRC, I play a role as a witness. I acknowledge that there were devoted and caring teachers as well as abusive ones, but the system tolerated and even encouraged abuse. I am outraged by the stories of sexual abuse but also cognizant that other types of abuse have been dismissed at times in the courts as less serious and less provable. The lasting physical effects of concussions from being struck repeatedly on the head, broken eardrums from cuffs on the ears, scars from burns, injuries from hard physical labour or corporal punishment, injuries from heavy equipment that did not function properly, jaw dislocation from wedges placed in the mouth for speaking one's language, and many other injuries are unthinkable

but true. Equally traumatic are the psychological effects of repeated attempted drowning, head shearing, removal of clothes or toys, isolation in dark cells, separation from one's brothers and sisters, shaming for bedwetting or vomiting, and very few expressions of love or affection.

Children were forcibly taken from their homes as young as four years of age. They often remained in the school until they were in their teens. Statistics show high mortality rates (TRC 2012, 28–30). Inadequate health care, particularly the intentional neglect of tuberculosis, was partially responsible for the high death rates.[12]

Sound, Silence, and Music in the Residential Schools: Colonizing Bodies

Historical sources that document sound within the schools are varied with regard to both genre and perspective. Some documents offer the church or state view on discipline.[13] More rarely, directives to teachers have been preserved. A small number of songbooks, hymn books, and handwritten music manuscripts exist. Photograph collections are more plentiful, as are regular newsletters written by the students but under the watchful eyes of teachers or administrators. Survivors' memoirs, narratives (not only in interviews but also in fictional writing, documentary film, and theatre), and testimony,[14] in conjunction with the TRC, offer valuable Indigenous perspectives. They describe many instances of resistant listening, Indigenizing songs that they were taught, defining space beyond the reach of hearing, and overturning the meaning of the colonizers' music through parody.

The violence at the heart of the IRS system is clear, but the uses of sound and music in the schools complicate the human encounter, not only reinforcing the "slow violence" but also, in some instances, softening the students' negative experiences. The children's sonic experiences at school differed dramatically from those at home. Survivors describe the oppressive regulation of bells and buzzers (as many as eighteen a day) that organized their lives from the moment that they awakened to the moment that they slept. An Anglican Synod document explains the system:

> On week days the rising bell rings at six o'clock; at six-thirty another bell calls bigger girls to help with the work in the kitchen and dining-room, and the bigger boys to help

with the work at the barn; at seven o'clock the bell is rung
again to call all to breakfast, and at seven-thirty prayers are
conducted. . . . After prayers the children assist in washing
the dishes, sweeping floors, dusting furniture, and on wash
days a certain number of them are assigned to the Laundry
Supervisor to assist her in that work. At eight forty-five the
warning bell for classroom work is rung, and at nine o'clock
all who have not been assigned to some special duties enter
their respective classrooms. Bells are rung again at recess, at
noon, and at various times in the afternoon, each ring having
a definite meaning, well understood by all, until the final bells
of the day are rung for evening study, choir practice, lights
out, and go-to-bed. ("Commission Report" n.d.)

This system of regimentation caused discomfort to the children, as
many survivors have attested. "Bells and buzzers. Bells and buzzers. It
was like being a mouse. When this happened, you did this. When that
happened, you did that. Everything was laid out for you, and there was
very little choice," explained one survivor.[15]

The obsessive organization of the day's activities was particularly odd
and oppressive for Indigenous children, whose earlier lives had been
organized in response to variable phenomena such as the time of sunrise
and sunset, the weather, and the daily needs of their families. Hence,
the bells disrupted important social and environmental relationships
within the birth communities of the children. Additionally, regimen-
tation robbed the children of any self-determination. One of the most
eloquent critiques[16] of the IRS bells appears in the first chapter of
Anishinaabe author Basil Johnston's *Indian School Days* (1988), in which
Johnston describes the bell and the black book as two powerful tools of
oppression in the school at Spanish, Ontario, that he attended as a boy.
The first chapter focuses on non-verbal soundscapes, perhaps reflecting
the dimension that most students could understand initially given that
they often had no knowledge of the languages of their teachers and
were forced not to speak their own languages. A short excerpt from
Johnston's account describes the impact: "Bells and whistles, gongs and
clappers represent everything connected with sound management—
order, authority, discipline, efficiency, system, organization, schedule,

regimentation, conformity—and may in themselves be necessary and desirable. But they also symbolize conditions, harmony and states that must be established in order to have efficient management: obedience, conformity, dependence, subservience, uniformity, docility, surrender" (43). Survivors also describe the silence and silencing that brought terror to their hearts: teachers and clergy who silently walked the aisles of the school with a sharp stick that might be used at any moment. The prohibition on speaking their Indigenous languages drove some of the children to be silent for several years since they knew no other language. As Knockwood explained, "for a long while, about three years, I kept quiet so I wouldn't be noticed" (2001, 56).

Music was a tool of control and assimilation, as a directive to teachers illustrates.[17] The set of instructions reveals much about what Ochoa Gautier described (quoted earlier) as the "constitution of the alterity of the acoustic." The voice expected of Indigenous students was described as mumbling or shouting spasmodically. In contrast, according to "Instructions to Teachers" held in the Nova Scotia Provincial Archives, the school's voice ("songs and hymns," "patriotic," "bright and cheerful") was both domesticated and patronizing (expressing a low opinion of the children's aptitude):

> Reading: Pupils must be taught to read distinctly. Inspectors report that Indian children either mumble inaudibly or shout their words in spasmodic fashion. . . .
>
> Vocal Music: Simple songs and hymns. The themes of the former to be interesting and patriotic. The tunes bright and cheerful.
>
> General: The unnecessary use of textbooks is to be avoided. Do not classify students in advance of their ability.

Songs at times taught a settler-centred history that made no sense. Knockwood (2001, 52) notes the irony of singing songs in honour of Christopher Columbus, particularly "Columbus sailed across the sea and found this land for you and me," to one of "the tunes bright and cheerful."

Music in the Residential Schools:
Softening the Impact of Colonial Trauma

Most schools used songbooks, generally with nursery rhymes or Christmas carols, although not many of these published materials have made their way to archives. Some teachers wrote out words and music and some composed teaching materials themselves. Hymn books and liturgical music prevailed. Students often responded positively to music in the schools. A Cree student at the Shingwauk IRS in the late 1950s explained that "the only time I felt peace was in the church, sitting there listening to the hymns especially. . . . I heard the choir singing, and somehow my soul got lifted" (Wilshire interviews). Students with good singing voices were sometimes selected for participation in the choir, and this was regarded by many as a positive experience.[18] Innu singer-songwriter Florent Vollant explained that "at residential school I learned and I heard religious chants. . . . I found Gregorian chants were fascinating—I really liked them" (Audet and Vollant 2012, 410). Of course, Christian music was familiar to some of the students before they entered residential schools and, in a few instances, had special meaning that the priests and nuns might not have known about. An example is a hymn for which the Anishinaabe text references a pine tree as an allusion to Chief Shingwauk, whose name means "pine" and whose vision for education coupled traditional Indigenous knowledge with training in English and mathematics. The pine tree reference does not appear in the English translation.[19]

Although both non-musical sound and music were means of colonizing the bodies of students, then, music, along with sports, also softened "the impact of colonization within their lives" (Kelm 1998, 5) and gave them a sense of aesthetic pleasure and achievement that contributed in a small way to their well-being. Of course, singing, playing musical instruments, acting in dramatic performances, dancing, and playing sports were also healthy forms of physical activity and pleasurable ones in contrast to the hard physical labour required of them much of the day. Students enjoyed diverse repertoires and had an appetite for learning any kind of music that they encountered. Some individuals were taken under the wings of teachers who knew how to play the piano or violin. These special arrangements were important for skill acquisition, but even more they were rare instances of being

recognized as individuals. One girl who received piano lessons from a teacher at the Shingwauk school in Sault Ste. Marie, Ontario, explained that the lessons were important because "you felt validated, in a way, that you were a person" (Wilshire interviews).

Some of the records of cultural activity, however, are hard to evaluate given the power dynamics involved in their creation. Most information available about music in the schools was written for school newsletters,[20] under the close supervision of teachers and administrators since they were vehicles for presenting the schools in a positive light. The newsletters describe formal and informal music making, pageants and theatrical productions, handicrafts, as well as visiting performers. Although most often the performances described were church-related special events, the performance genres were eclectic. The following concert description, for instance, appeared in the *Beautiful Valley Echo*, the Beauval School newsletter, in the 1950s.[21] The Beauval School operated in Saskatchewan from 1885 to 1983. Its history included traumatic events such as a fire in 1927 that took the lives of twenty boys and a flu epidemic in 1936 that took sixty victims. There have also been sexual abuse prosecutions of former clergy at the school. The cheery tone of the newsletter article, signed by Flora George, is in marked contrast to what must have been very troubling memories for teachers and perhaps older students. The concert celebrated the birthday of the Sister Superior, said in the article to "replace our own mothers" along with the other nuns:

> A nice little concert had been prepared by the children and their teachers for the eve of her feast. It was a means of conveying our gratitude and affection to the one who spares not time or energy to help render us happy. The numbers of the program were as follows:
>
> 1. Festal Song: Bright be each Face.
> 2. "Two Little Kittens one stormy night. . . ." Recitation by Florence Piché.
> 3. The Rose Drill:[22] Ten pretty girls in long flowered dresses and wearing side-brimmed hats (bonnet style) danced and did pretty motions with rose-wreaths to the tunes of Country Waltz, the Submarine Waltz,

From Frisco to Cape Cod etc. The dancers were Claire Opikokew, Mathilda Byhette, Pleagie Iron, Therese Harry, Veronica Sylvestre, Leona Baer, Flora George, Suzanne McCallum, Mary Iron and Mary Ann Meresty. Before leaving the stage they sang the Beautiful Voices from the Woods.

4. Piano trio: The Rhinelander played by Yvonne Apisis, Delia Iron and Elizabeth Opikokew.

5. The Little Baker: Act I. In this act a little baker (Leon Catarat) very fond of cake receives a customer, Mary Ann Meresty, who comes to order a cake. He is to deliver it on a certain day for a children's party. The customer distrusts her clerk, but warns him to be on time and especially not to eat the cake.

6. Ten little Chinamen dressed in yellow Chinese costumes with caps and pig tails.... They really were a sight as they acted and sang.

7. Mistress Spring in a hurry personified by Pelagie Iron was a very pretty recitation and especially well done.

8. A number of children from the Beginner's Class sang with all their hearts a few of the numerous and cute little songs they learned this year.

9. The Little Baker Act II. The party is ready, the children are at the table and still no cake. The nurse going out, comes back with a humiliated baker and a cake in pieces. He confesses having broken the cake while attempting to break off a piece to eat. He receives a sincere pardon from one of the little girls who even gives him a piece of cake but who warns him that "never again must he take his customers' cakes without permission."

10. Waltz of the Roses: Piano Solo by little Miss Vitalina Campbell.

11. Master Oliver Kimbley really showed talent for reciting as he told us of SUCH FUNNY THINGS they say....

12. The villagers wishing to contribute a part in the concert, performed their little horse drill with riders dressed as

> cowboys. The little horses made and painted by Sister Auras and her pupils are well worth seeing.

13. Reverend Sister Superior then addressed the children and thanked them for the concert, "which," she said, "was a real success." She thanked the staff and pupils for the Spiritual Bouquet prepared by them and painted by Sister A.M. Mageau. She, then, distributed pop-corn bags to each child and bade them a happy good-night.

Although my selection of this one concert description for close reading is arbitrary to some extent, it has features that occur frequently in other programs. The event includes music in diverse idioms, recitations, and skits; the repertoire is often sentimental; certain items such as the Rose Drill enact (female) gender normativity; ethnic parodies that exoticize (the "Chinamen . . . really were a sight") are often included; and moral instruction is often communicated via the skit (in this case, one that chides someone who steals food, a temptation in the schools given that the students were undernourished). The indication that villagers "wished" to contribute is less usual.

By the late 1960s, some schools had richer and more diverse music programs that sometimes referenced First Nations traditions. The Muscowequan school had both a band instructor and a "music and upgrading" teacher by 1969. According to the school newsletter from that Easter, the programs for girls included concerts and dances: "Friday or Saturday nights we have concerts or dances in the playroom. Our program consists of songs, dances—modern, square, jigs, Scottish [*sic*] and pow-wow; baton twirling, guitar playing and imitations such as our hippies. These are enjoyable ways to spend evenings and everyone does something. When a concert isn't planned we have a dance—old time or modern. . . . When there is no organized activity the girls . . . listen to records or provide their own entertainment with a make-up band—spoons, guitars, tin cans and our own western singers."[23]

There is less information about music for the boys, whose recreation seemed to be committed more to sports or band practice. Boys engaged in pop music ensembles in some schools. Teachers took the lead in forming student bands, perhaps to facilitate their own musical ambitions. One popular visiting band was The Eagles of the Muscowekwan IRS, described by music instructor Peter Koett in the

1969 *Muskowekwan Newsletter* (n.p.) account as follows: "There were five of them; one on the bass guitar whose nickname was the 'Joker,' one on the drums, and one chording on the five-string guitar. These three were from Kamsack. George Guimond, the lead guitar player and the singer for the group comes from Fort Alexander. The whole group is under the direction of Father Plamondon who also plays the violon [*sic*] for them. All were dressed in colourful costumes and the stage was lit with different colored lights. It was very beautiful."[24]

Photographs offer further evidence of the sorts of imitative expressive culture presented to the public. Ethnic dance styles (especially Scottish Highland dance and Irish step dance) are depicted. Marking ethnicity, however, also became self-parody, as in the games of Cowboys and Indians often promoted. Upper-class parody was also allowed at times; one photo depicts a group of girls wearing the mitred hats of bishops. Pop music idols were also imitated; one photo shows a pseudo-Beatles group with long black fabric/yarn strips worn as the long hair associated with the British band.

Mr. Koett, the Shingwauk music teacher in the late 1960s, reported in the *Muskowekwan Newsletter* that twelve students were learning how to play the guitar, had learned to recognize instruments by listening to records, could read music, and were making progress on "the Bell recorders." Photographs offer ample evidence of musical instruments in the schools, but survivors rarely mention them, except for band instruments in certain regions. In British Columbia, a tradition of brass band music flourished in Indigenous communities independently of the schools; both English-style brass bands and American-style marching bands had taken root there in settler and Indigenous communities at least as early as the 1870s (Stride 2012). Non-Indigenous scholars and civic leaders point to these institutions as evidence of high achievement within the residential schools, usually failing to note the irony of their establishment around the time when traditional ceremonial practices were being criminalized. Survivors, including TRC Commissioner Chief Wilton Littlechild, mentioned at one of the TRC national events the bands and hockey as sources of pleasure for many of the boys.

In the United States, Indian boarding school bands were public symbols that marked the schools as successful (Troutman 2009). There were marked differences, however, between the Canadian bands and their American counterparts. Instruments and repertoire often came

from the British brass band tradition and its French relative, the fanfare band, rather than the military-style concert or marching bands of the United States. Some First Nations and Métis bands predated the residential school bands (although some originated in the schools). Hence, community bands that existed prior to the school bands often Indigenized the practices of band performance. The structures of band leadership replicated the traditional hierarchies of clan roles and functions (Neylan and Meyer 2006). Bands played not only for imperial events (e.g., Dominion Day and visits by royalty or civic authorities) but also for community functions such as weddings, fishery worker strikes, and welcome home celebrations for seasonal cannery workers.[25] Bands then had positive associations for some of the students and might even have reminded them of the clan structures and other forms of relationality that they learned prior to entering Indian residential schools.

Seeking Health and Well-Being through Expressive Acts of Resistance

Sound was used to enforce discipline and regiment the lives of children, but its ephemerality[26] and capacity to exceed boundaries proved to be useful in small acts of resistance. A number of scholars (among them Kelm 1998; Maxwell 2011; Regan 2010) have connected resistance to well-being as an action that defied the inequality that the children were made to embody. Control of the children was paramount for the school authorities, but there were rare opportunities to challenge the system, particularly by speaking an Indigenous language. Larger schools had extensive grounds with places out of earshot of school staff. A student at the Shingwauk IRS in the 1950s explained that "we couldn't speak our language in front of a staff member. But again, because of the expanse of Shingwauk and the bush and everything else, it was pretty hard for them to enforce it" (Wilshire interviews). There was a downside to the inability to enforce regulations, however, in that many children were accused unfairly of speaking their languages and punished accordingly. A Mi'kmaw student who attended the Shubenacadie IRS in Nova Scotia wrote that, whereas speaking one's language was forbidden, "that didn't keep me from thinking in my language" (First Nations of Quebec and Labrador Health and Social Services Commission 2010, 23). The sound of one's Indigenous language is connected to well-being as part of Indigenous oral traditions that, as Cree Elder Couture has described,

actuated healing (Couture, Couture, and McGowan 2013, 200). These small opportunities for resisting the proscription on using one's own language hardly replaced the experience of hearing and learning from stories in that language.

Although children taken from their families at such young ages in many cases had little knowledge of traditional healing practices, some were keenly aware that connecting intergenerationally to their families and ancestors was essential for their well-being. Some children used traditional sonic means to make such connections. They listened for birds, which in many First Nations traditions are the voices of ancestors. One Mi'kmaw survivor commented that she had not heard an eagle during her time at the Shubenacadie IRS, but after the school burned down seventeen eagle feathers were found near the ruins, equal to the number of children who had died in the school (Tribute to Sarah Barnard, Halifax National Event, 2011). Reverend Henry Morrow, a teacher at the Shingwauk IRS from 1947 to 1952, related that a Cree student from Saskatchewan (whom he taught in the early 1940s) broke a window to whistle down the northern light where the ancestors reside in many First Nations traditions, attempting, according to Morrow (n.d.), to test whether traditional medicine was stronger than that of the clergy.

More often expressive acts of resistance involved turning the meaning of music they were taught in new directions. Both listening and performing were vehicles for personalizing the meanings of songs. Children developed keen capacities for double meanings, some of which were only thought since they dared not express them. A young woman at Shingwauk in the late 1930s and early 1940s, however, related a story about a Cole Porter hit of the 1930s: "I remember when that song first came out. I think it was Roy Rogers made that song 'Don't Fence Me In.' I never forgot that song. We used to go around and around in circles, singing that song. We made sure the matrons heard us, eh? Singing 'Don't fence me in!' We used to reach a certain spot and just shout it, 'Don't fence me in!' I never forgot that song. None of us have. We thought it was a very good song" (Wilshire interviews).

Opportunities for parody were limited, but there are traces of creative revisions of music taught in the schools. Elizabeth Graham printed a hymn parody on the cover of her book concerning the "Mush Hole," the nickname of the residential school in Brantford, Ontario. With reference to the food served there, and sung to the tune of the

hymn "There Is a Green Hill Far Away" composed by William Horsely in the mid-nineteenth century, the parody became "There is a boarding school far far away / Where we get mush 'n' milk three times a day" (Graham 1997, back cover). Commissioner Littlechild performed what he described as a "residential school song" at the talent show of the Inuvik National Event of the TRC in 2011. "I'm going to teach you a residential school song, but it only works between 2:15 and 2:30," he quipped, referencing the regimentation of activities at the schools. He carefully taught the Cree words that the children adapted to a simple tune. He then translated the playful text: "Tomorrow I'm going home. Tomorrow I'm going home. If you love me, kiss me right away."

Knockwood (2001, 126) describes how "children would use their knowledge of language to undermine the nuns' authority." She illustrates this with a story about a classmate, Clara Julian, who "could reduce us all to helpless laughter in church when she would take a line from the Latin hymn for Benediction, '*Resurrecsit sicut dixit*' ['He said he would rise again']. But Clara would sing at the top of her voice, '*Resurrecsit kisiku piktit*,' which in Mi'kmaq means, 'When the old man got up, he farted.' The whole choir would start laughing and poor Sister Eleanor Marie thought we were laughing at Clara for mispronouncing Latin and she'd stop and patiently teach Clara the proper pronunciation. Clara would just stand there and grin." Such parodies were probably used more widely as forms of resistance than these few examples suggest.

IRS students also created songs or wrote poems in private contexts to express loneliness, sadness, and fear, such as "I Want to Go Home to Nain," written by Labradorians Beatrice Hope and Joan Dicker.[27] These examples demonstrate a number of important strategies for coping. Openness to all kinds of music that they encountered helped the students to develop a sort of generic agility and sensitivity to context. The rare instances in which they used their own languages, listened for birdsong to communicate with their ancestors, drew their homes in the dust, or parodied music to which they were exposed were undoubtedly important moments of autonomy and positive self-esteem. Aesthetic pleasure in music, the sense of selfhood that sometimes related to performing it, the potential of sonic communication that defied the strictures of the schools and travelled through the walls and windows, and the uses of music in acts of resistance all related to health and well-being by softening the impact of trauma and enhancing self-esteem.

Music as Reflection and Critique in the Post-IRS Era

In the post-IRS era, Indigenous musicians—many of whom are intergenerational survivors—continue to affirm that their own journeys toward health and wellness or those of the people whom they love are social, spiritual, emotional, and physical. Intergenerational relationships have been the focus of many musical creators. Musicians have made songs to honour parents or grandparents who suffered in the schools. Russell Wallace and his sisters effected their own healing and paid tribute to their mother, Elder Flora Wallace, and her courage and resilience in the first album that they produced as Tzo'kam (2000). In arranging both traditional and new repertoire, they honoured her positive as well as her negative experiences by using harmony because Flora had learned to love harmony in the residential school at Mount Currie. The Métis songwriter Fara Palmer (1999) traces an emotional journey in "Bring Back Yesterday" from the album *Pretty Brown*. It begins with an explicit narrative about her mother's abuse in the schools, intensifies as it sonically depicts a storm, and ends with a calm choral response interlaced with an archival recording that brings the voices of the past into the present. Jani Lauzon's (2006) instrumental trio, "Stolen," honours her father and other survivors. It begins with sombre minor chords and sustained notes played on a traditional block flute, but the feeling shifts when jazz inflections on the keyboard and plucked cello are introduced. The final section of the composition is dominated by the flute, the sound of which now has more traditional style elements and eventually transforms into an eagle call.

Some musicians have created songs as part of personal healing. Mike MacInnis(2013), a Mohawk social worker in the Mi'kmaq community of Eskasoni, Nova Scotia, worked with men in his "Tunes and Talk" healing circle to make *Journey of Healing*. Although many of the songs on this CD reflect the difficult emotional legacy of their IRS experiences, the healing, as Mike explained it to me in October 2013, was the feeling of pride in their collective achievement and in their professionalism, playing alongside some of the best musicians in Cape Breton. Mishi Donovan (Métis, 2000) regards much of her music as part of personal healing. Some of her songs about IRS abuse, particularly "Almost Broken," address the perpetrators:

We've done nothing to your children

We've not locked away the sun

We've not given you food to eat that is strange upon your tongue

We've not shaved your heads, or took away your spoken words

We've not taken your dances and blamed you of devil's work.

Naming the abuse and voicing anger, then, can be an important choice for some survivors as a means of living well. There are many other examples.

Songs also address the fears among Elders about speaking publicly of their traumatic experiences. Susan Aglukark (Inuit) explained to me in January 2013 that she wrote "Circle of the Old" because of the "particularly heartbreaking realization of the deep, deep fear entrenched in our Elders to speak out, just simply to speak out." The song switches to Inuktitut for one phrase when she addresses the Elders directly: "*Kappiasungilanga, Ilirasungilanga, Ilirasungilanga, Kappiasungilanga*" ("May I not be afraid. May I not feel fear of disapproval") (Aglukark 2006). The shift in language, break from stanzaic form, and change to chromatic harmony mark this line as stylistically different, arguably outside the pop genre world with its mainstream expectations. This is the sort of stylistic/generic fluidity that transforms a song into an intervention, like much Indigenous popular music in the late twentieth century and early twenty-first century.

Many contemporary singers refuse to see the IRS issue in isolation as they describe the interrelated social challenges that emerged from colonialism and the continuation of social inequities, among them youth suicide, missing and murdered Indigenous women, racism, second-tier health and education, and poor housing. Their music articulates the "slow violence" of settler colonialism. Cheryl Bear has written a residential school song but also addresses other tragic social issues, such as the murdered and missing Indigenous women in British Columbia and elsewhere. In broadcaster, filmmaker and political leader Wab Kinew's (2009) music video, "Last Word," some participants wear t-shirts with the word *Survivor* written boldly across the chest and carry RIP signs for those named in his rap as victims of many sorts of social violence.

Although the genres and styles of these songs vary, some elements are distinctive. Many use Indigenous languages as well as English and incorporate traditional elements, insisting on a modernity that reflects the wholeness of Indigenous experience and asserts expressive sovereignty by playing on the varied sonic memories that bring the past into the present with a view to the future.

Conclusion

In this chapter, I have demonstrated that the soundscapes (natural, human made, musical, and non-musical) of Indian residential schools were not simply multivalent but also contradictory in relation to the health and well-being of the children incarcerated in them. As colonial mechanisms, bells regimented the life of the school in a mechanistic way. Silence—the proscription on the use of Indigenous languages as well as the silent classrooms—evoked fear and prevented the students from having access to the oral traditions that, as mentioned earlier, were not only teachings but also activators of well-being. The music, dance, and drama similarly replaced rich Indigenous cultural lineages with "simple songs" and stereotypical models of otherness. Music was used to assert Christian messages and settler histories and values and to denigrate Indigenous cultures. In these ways, then, the sonic life of an Indian residential school was detrimental to the health and well-being of the students.

At the same time, however, students often took pleasure in musical participation, finding that it offered them a sense of self-worth and aesthetic pleasure that eased the pain of abuse. Additionally, they tried to use sound at rare times to connect with family members and ancestors who, they knew, would offer them mental, emotional, and spiritual support. They were also sometimes able to resist the proscriptions on speaking in their languages (even though the risk of punishment was high) and to resist the strictures on their lives by using music to name problems or parody authorities. In these ways, then, they created opportunities, albeit rare ones, to improve their well-being.

In the post-IRS era, musicians continue to use their arts for healing. In some instances, their strategies are similar to those of the IRS children; for instance, they often make intergenerational and human-spirit connections in songs that honour parents, grandparents, and other ancestors. They use music to name continuing forms of violence and

social inequity. They now have a wide array of culturally diverse styles from which to draw and can juxtapose or interweave genres, languages, and sonic elements in ways that offer cogent appraisals of colonial experiences past and present. The "doubleness" of sound in the Indian residential schools now becomes a multivalent interpretive space where different experiences and perspectives can be voiced for all to hear.

Contemporary musicians and other artists, then, no longer sustain themselves with shards of autonomous Indigenous expression, as the IRS children had to do. They are now part of a strong movement of resurgence that understands the sovereignty of their cultures, their values, and their messages. Like the activist writers described by Rob Nixon (2011), they and their sonic arts move with versatility across languages, media, styles, and genres, across temporal references that bring the past into the present, as cosmopolitans still rooted in places and communities. Inequities in Indigenous health care rooted in racist and colonial perceptions still demand rectification, as Allan and Smylie (2015) have convincingly argued. However, new arts-based modes of finding balance and insisting on the interdependence of the physical, mental, social, and spiritual offer powerful tools for health and well-being for all who choose to do anti-racist work.

An earlier version of this chapter was published in *This Thing Called Music: Essays in Honor of Bruno Nettl*, edited by Victoria Lindsay Levine and Phillip V. Bohlman, 267–79 (Lanham, MD: Rowman and Littlefield, 2015). I am grateful to the editors and publisher for permitting me to extend and develop the essay in a somewhat different frame for this volume.

Notes

1 The team was led by Keavy Martin (University of Alberta) and Dylan Robinson (Queen's University) and included Indigenous and settler scholars who work in literary studies, cultural studies, art history, and ethnomusicology (see Martin and Robinson 2016).

2 Although this is still true generally, recent publications (especially Martin and Robinson 2016; Robinson 2020) have rectified the deficit to some extent.

3 Historian John Troutman (2009) has explored music policy in relation to Indian boarding schools in the United States.

4 I use George Yúdice's (2003) concept while also suggesting that expediency is applicable much earlier than the late twentieth century, when we saw the emergence of the neoliberal regard for culture as a manageable resource.

5 Of course, simple glosses fail to convey the deeper layers of meaning and experiential complexity of such concepts.

6 In her work for the Aboriginal Healing Foundation, Joanne Archibald (2012, 9) quotes Coast Salish artist Carrie Reid's description of physical, emotional, and spiritual preparation for war and for returning home. Not only were children taken from their families not given preparation for residential school, Reid noted, but also "when people returned from residential school ... they were not given time to prepare for homecoming."

7 Between 1998 and 2014, the Aboriginal Healing Foundation organized meetings, exhibitions, and publications in support of IRS survivors. The foundation was disbanded by the Harper government in September 2014 after funding cuts that began, ironically, shortly after the prime minister's apology in 2008 to IRS survivors.

8 The TRC worked from 2010 to 2015, led by Commissioners Chief Justice Murray Sinclair, Chief Wilton Littlechild, and Marie Wilson. They issued a prominent call for songs and poems about IRS experiences in the hope of publishing a "compilation ... that will inspire Canadians to tune into stories of survival and messages of hope" (www.trc.ca).

9 A term that he uses to refer to both environmental degradation and colonialism.

10 TRC testimony at www.trc.ca or Vimeo websites referenced there.

11 In addition to documents on the website of the Truth and Reconciliation Commission (www.trc.ca), there are numerous print publications, among them Archibald (2008); Haig-Brown (1993); Knockwood (2015); Rogers et al. (2012); and several volumes published online by the Aboriginal Healing Foundation (www.ahf.ca).

12 Government officials selected certain schools as part of an experiment on the health impacts of malnutrition. The *Globe and Mail*, for example, reported evidence of "a post–Second World War experiment in which food was deliberately withheld from some aboriginal students at six schools in four communities across the country" (www.globeandmail.ca, 13 December 2013). See also www.cbc.ca, 16 July 2013.

13 Stricter discipline was the norm in the education system in the early and mid-twentieth century, but the rigour of IRS discipline exceeded that in other schools of the day.

14 Although all speech genres have particular characteristics, "testimony" in particular is shaped institutionally by the mandate and format of the TRC.

15 Survivor interviews were conducted by MA student Don Wilshire (hereafter noted as the Wilshire interviews). The names of interviewees have been withheld.

16 Another is described later in this chapter in conjunction with a performance by Commissioner Littlechild at one of the TRC national events.

17 The document is preserved in the Nova Scotia Provincial Archives and reproduced in Isabel Knockwood's important memoir, *Out of the Depths* (2015, 49–50).

18 One narrative stated that enforced participation in the chapel choir was used as punishment for talking during a service, but this was the only negative comment uncovered thus far (Wilshire interviews).

19 Thanks to Donald Jackson for drawing my attention to this hymn and to Lana Grawbarger, a member of The Pine Family Singers, on whose CD the hymn is recorded, for confirmation.

20 Copies that I have seen date from the 1940s to the 1970s.

21 *Beautiful Valley Echo*, 1951, Shingwauk Archives, Algoma University, Sault Ste. Marie, ON, Grey Nuns Fonds, 2012-21-001-005-040 and 041. Not all issues were precisely dated.

22 Drills were female-oriented, choreographed group dances with gymnastic elements promoted as physical education for girls in mid-twentieth-century Canadian schools, in contrast to the more physically demanding and competitive games that boys were encouraged to play. The Rhinelander Trio in item 4 might refer to music that came from a program in Rhinelander, Wisconsin, in the 1940s and 1950s in which chamber music arrangements of simplified music were made for high school use. Descriptions appeared in the *Rhinelander Daily News*.

23 Muscowequan (Muscoweken) School Newsletter, Easter 1969, Shingwauk Archives, Algoma University, Sault Ste. Marie, ON, Grey Nuns Fonds, 2012-21-001-042.

24 Newsletter for the Catholic Indian Missionary Record, 1969, Shingwauk Archives, Algoma University, Sault Ste. Marie, ON, Grey Nuns Fonds, 2012-21-001-042.

25 One First Nations band leader, Job Nelson, who conducted bands in New Metlakatla (Alaska) Port Simpson and Aiyansh, was also a composer. His march, "Aiyansh," was performed at one of the most famous band competitions of the early twentieth century, the Dominion Exhibition in New Westminster in 1905, and later it was renamed and published, ironically, as the "Imperial Native March."

26 At times, visual art could also be ephemeral. Homesickness was also ameliorated by drawing, as described to me in October 2013 by Mi'kmaw Elder Dorothy Moore: "I remember being outside, sitting on a bench, and the dirt and a little stick. And I would draw my house, the way I remembered my home, with the stick. And even the inside of it, the rooms. And that kind of compensated for your loneliness because you brought yourself back to your home in this way." Of course, the ephemeral nature of a drawing in the dirt was pragmatic since it could be quickly erased if school staff approached.

27 Recorded by Hope (n.d.).

References

Allan, B., and J. Smylie. 2015. "First Peoples, Second Class Treatment: The Role of Racism in the Health and Well-Being of Indigenous Peoples in Canada" (discussion paper). Wellesley Institute, Toronto.

Archibald, J. 2008. *Indigenous Storywork: Educating the Heart, Mind, Body and Spirit*. Vancouver: UBC Press.

Archibald, L. 2012. *Dancing, Singing, Painting, and Speaking the Healing Story: Healing through Creative Arts*. Ottawa: Aboriginal Healing Foundation.

Audet, V., and F. Vollant. 2012. "Aboriginal Popular Music in Quebec: Influences, Issues, and Rewards." In *Aboriginal Music in Contemporary Canada: Echoes and Exchanges*, edited by A. Hoefnagels and B. Diamond, 408–18. Montreal and Kingston: McGill-Queen's University Press.

Brownlie, R., and M.-E. Kelm. 1994. "Desperately Seeking Absolution: Native Agency as Colonialist Alibi." *Canadian Historical Review* 75, no. 4: 543–56.

Castellano, M.B. 2010. "Healing Residential School Trauma: The Case for Evidence-Based Policy and Community-Led Programs." *Native Social Work Journal* 7: 11–31.

Cole, D., J.R. Miller, and M.-E. Kelm. 1994. "Responses and a Reply." *Canadian Historical Review* 75, no. 4: 628–40.

"Commission Report, Church of England." N.d. Shingwauk Archives, Algoma University, Sault Ste. Marie, ON, Dora Cliff Fonds, 2010-024-001-004-010, 1938–50.

Couture, J., R. Couture, and V. McGowan, eds. 2013. *A Metaphoric Mind: Selected Writings of Joseph Couture*. Edmonton: Athabasca University Press.

First Nations of Quebec and Labrador Health and Social Services Commission. 2010. *Collection of Life Stories of the Survivors of the Quebec Indian Residential Schools*. Wendake, QC: Les Copies de la Capitale.

Garneau, D. 2012. "Imaginary Spaces of Reconciliation." *Reconcile This!*, special issue of *West Coast Line* 74: 28–39.

Gone, J.P. 2014. "Colonial Genocide and Historical Trauma in Native North America: Complicating Contemporary Attributions." In *Colonial Genocide in Indigenous North America*, edited by A. Woolford, J. Benvenuto, and A.L. Hinton, 273–91. Durham, NC: Duke University Press.

Graham, E. 1997. *The Mush Hole: Life at Two Indian Residential Schools*. Waterloo, ON: Heffle Publishing.

Graham, H., and L. Leeseberg Stamler. 2013. "Contemporary Perceptions of Health from an Indigenous (Plains Cree) Perspective." *Journal de la santé autochtone* 6, no. 1: 6–17.

Haig-Brown, C. 1993. *Resistance and Renewal*. 6th ed. Vancouver: Arsenal Pulp Press.

Igloliorte, H. 2009. "Inuit Artistic Expression as Cultural Resilience." In *Response, Responsibility, and Renewal: Canada's Truth and Reconciliation Journey*, edited by G. Younging, J. Dewar, and M. DeGagne, 123–36. Ottawa: Aboriginal Healing Foundation.

Johnston, B. 1988. *Indian School Days*. Toronto: Key Porter Books.

Kelm, M.-E. 1998. *Colonizing Bodies: Aboriginal Health and Healing in British Columbia 1900–1950*. Vancouver: UBC Press.

Kirmayer, L.J., C.L. Tait, and C. Simpson. 2009. "The Mental Health of Aboriginal Peoples in Canada: Transformations of Identity and Community." In *Healing Traditions: The Mental Health of Aboriginal Peoples in Canada*, edited by L.J. Kirmayer and G.G. Valaskakis, 3–25. Vancouver: UBC Press.

Knockwood, I. 2015. *Out of the Depths*. Black Point, NS: Fernwood Publishing.

Lewton, E., and V. Bydone. 2000. "Identity and Healing in Three Navajo Religious Traditions: Są'ah naagháí bik'eh hózhó." *Medical Anthropology Quarterly* 14, no. 4: 476–97.

Loiselle, M., and L. McKenzie. 2006. "The Wellness Wheel: An Aboriginal Contribution to Social Work." Paper presented at the First North American Conference on Spirituality and Social Work, Waterloo, ON, 27 May.

Mailhot, J., and M. Mackenzie, eds. 2014. *Aimun mashinaikan/Innu Dictionary*. Innu Language Project, Memorial University, NL, Carleton University, ON, Labrador Innu School Board, NL, Institut Tshakapesh, QC. www. innu-aimun.ca.

Martin, K., and D. Robinson. 2016. *Arts of Engagement: Taking Aesthetic Action in and beyond the Truth and Reconciliation Commission of Canada*. Waterloo, ON: Wilfrid Laurier University Press.

Maxwell, K. 2011. "Making History Heal: Settler Colonialism and Urban Indigenous Healing in Ontario, 1970s–2010." PhD diss., University of Toronto.

Morrow, H. N.d. "Morrow memoire." Shingwauk Archives, Algoma University, Sault Ste. Marie, ON, Collection 2010-047-001-027, 1947–52.

Neylan, S., and M. Meyer. 2006. "'Here Comes the Band!' Cultural Collaboration, Connective Traditions, and Aboriginal Brass Bands on British Columbia's North Coast, 1875–1964." *BC Studies* 152: 35–66.

Nixon, R. 2011. *Slow Violence and the Environmentalism of the Poor*. Cambridge, MA: Harvard University Press.

Ochoa Gautier, A.M. 2014. *Aurality: Listening and Knowledge in Nineteenth-Century Colombia*. Durham, NC: Duke University Press.

Portman, T.A.A., and M.T. Garrett. 2006. "Native American Healing Traditions." *International Journal of Disability, Development and Education* 53, no. 4: 453–69.

Regan, P. 2010. *Unsettling the Settler Within: Indian Residential Schools, Truth Telling, and Reconciliation in Canada*. Vancouver, BC: University of British Columbia Press.

Robinson, D. 2020. *Hungry Listening: Resonant Theory for Indigenous Sound Studies*. Minneapolis: University of Minnesota Press.

Rogers, S., M. DeGagné, J. Dewar, and G. Lowry, eds. 2012. *Speaking My Truth: Reflections on Reconciliation and Residential School*. Ottawa: Aboriginal Healing Foundation.

Schneider, L. 1985. *Ulirnaisigutiit/An Inuktitut-English Dictionary of Northern Quebec, Labrador and Eastern Arctic Dialects*. Quebec City: Laval University Press.

Simon, R. 2013. "Towards a Hopeful Practice of Worrying: The Problematics of Listening and the Educative Responsibilities of Canada's Truth and Reconciliation Commission." In *Reconciling Canada: Critical Perspectives on the Culture of Redress*, edited by J. Henderson and P. Wakeham, 129–42. Toronto: University of Toronto Press.

Simpson, A. 2008. "Commentary: The 'Problem' of Mental Health in Native North America: Liberalism, Multiculturalism, and the (Non)efficacy of Tears." *Ethos* 36, no. 3: 376–79.

Simpson, L. 2004. "Anticolonial Strategies for the Recovery and Maintenance of Indigenous Knowledge." *American Indian Quarterly* 28, nos. 3–4: 373–84.

Stride, B. 2012. "First Nations Brass Bands." In *History of Brass Bands in British Columbia*. Vancouver: Vancouver Association of Brass Bands. http://vabbs. org/hist_bb_bc.php.

Troutman, J. 2009. *Indian Blues: American Indians and the Politics of Music*. Norman: University of Oklahoma Press.

Truth and Reconciliation Commission of Canada. 2012. *They Came for the Children: Canada, Aboriginal Peoples, and Residential Schools*. Interim Report of the TRC on Indian Residential Schools. Winnipeg: TRC.

———. 2015. *The Final Report of the Truth and Reconciliation Commission of Canada*. 3 vols. www.trc.ca.

United Nations. 1948. Convention on the Prevention and Punishment of the Crime of Genocide. http://legal.un.org/avl/ha/cppcg/cppcg.html.

Waldram, J.B., D.A. Herring, and T.K. Young. 1995. *Aboriginal Health in Canada: Historical, Cultural, and Epidemiological Perspectives*. Toronto: University of Toronto Press.

Wilshire, D. N.d. Wilshire interviews. Shingwauk Archives, Algoma University, Sault Ste. Marie, ON, Collection 2010-047-001.

Yúdice, G. 2003. *The Expediency of Culture: Uses of Culture in the Global Era*. Durham, NC: Duke University Press.

Discography

Aglukark, S. 2006. *Blood Red Earth* [CD]. Aglukark Entertainment under licence to Arbor Records.

Donovan, M. 2000. *Journey Home* [CD]. Arbor Records AR-11192.

Hope, B. N.d. *Panik Labradorimiuk/Daughter of Labrador* [CD]. Independent.

Kinew, W. 2009. "Last Word." On *Live by the Drum* [CD]. Indie Ends. https:// www.youtube.com/watch?v=CP9zDbBHMlU.

Lauzon, J. 2006. *Mixed Blessings* [CD]. Ra Records RR 0117.

MacInnis, M., prod. 2013. *Journey of Healing* [CD]. Eskasoni Independent CD.

Palmer, F. 1999. *Pretty Brown* [CD]. New Hayden Music Corporation NHMC1717.

Tzo'kam. 2000. *Ìt'em*. *"To Sing"* [CD]. Red Planet Records RP1011-0103.

KISSED BY LIGHTNING:
Mediating Haudenosaunee Traditional Teachings through Film

NICHOLLE DRAGONE

Mohawk film director and multimedia visual artist Shelley Niro[1] has been mediating both Haudenosaunee and Indigenous women's experiences through film for more than twenty years, beginning with her first short film, *It Starts with a Whisper*, in 1992. In 2009, Niro released her directorial debut feature film, *Kissed by Lightning*.[2] In a 2013 interview with Rachelle Garrow Hayes, Niro briefly states that current atrocities happening in the world influenced her decision to use film to contemporize Haudenosaunee traditional teachings about the confederation of five North American Indigenous Nations: Mohawk, Oneida, Onondaga, Cayuga, and Seneca. Today, this confederacy is known as the Haudenosaunee, Iroquois, or Six Nations Confederacy.[3] Although she did not elaborate in this interview, one can speculate that Niro drew parallels between the violence and bloodshed happening in Africa, the Middle East, and the Balkans during the mid-1990s and what Haudenosaunee traditional teachings indicate happened over 1,000 years ago during a particularly violent and bloody era of history in northeastern North America. It was during this era that a man whom the Haudenosaunee call the Peacemaker unified these five Indigenous Nations through a message of peace, unity, and the good mind.[4] To accomplish this goal, the Peacemaker worked with another man, Hiawatha, to use a ceremony known as condolence to bring people

grieving the loss of loved ones back to a peaceful, rational, healthy state of mind, back to a good mind.

In 1998, Niro began working on *Kissed by Lightning*, a film that would feature Haudenosaunee communities in Canada and the United States and underscore the continued relevance of the Peacemaker's message and the principles by which Haudenosaunee people live. As Niro explains, "such ugliness was coming out of our world and I was interested in studying the journey of the Peacemaker. I wanted to write about kindness to one's self and to fellowman. I also wanted to portray the community that we live in, values we live by, and what to teach our children" (quoted in Hayes 2013). Niro continues to describe her goal as one of contemporizing Haudenosaunee traditional teachings through the fictional story of Mavis Dogblood, a Mohawk woman who finds herself depressed after the untimely death of her husband and classical musician, Jesse Lightning. In an attempt to hold on to her husband's memory, Mavis, an artist, produces a series of twelve paintings[5] that illustrate her interpretation of the stories that Jesse told her about the Peacemaker. To deliver these paintings to a New York City Gallery, Mavis drives from her home on the Six Nations Grand River Reserve (Ontario, Canada) south, across the U.S. border into upstate New York, the original homelands of the five Haudenosaunee nations. This is the same landscape Haudenosaunee traditional teachings tell us the Peacemaker traversed when he established the Confederacy.

It is through this journey that Mavis is healed from her grief and depression and restored to a good mind. As Niro says, Mavis's experience of processing and healing from grief is "the essence of being an Iroquois person" because many Haudenosaunee traditional teachings are largely about restoring unsettled, restless minds to peaceful, healthy, and rational good minds (Kreimer n.d.). In this chapter, I seek to explore how Niro works through Mavis to contemporize Haudenosaunee good mind teachings by paralleling her story with the traditional story of the first condolence, mediating both stories through Mavis's Peacemaker series of paintings, and inviting us to listen to the Peacemaker speak through Jesse's narrations and viola compositions.

To understand better how Niro's *Kissed by Lightning* contemporizes the good mind teachings, I will first review Haudenosaunee traditional teachings about the good mind as they relate to the Peacemaker's journey. In the Mohawk language, the word for "mind" or "consciousness"

is *'nikonhr*. *Ka'nikonhri:yo* has been translated into English as "good mind," "righteous mind," "righteousness," or even "conscious goodwill."[6] The concept of the good mind is one of the three interrelated parts of the Peacemaker's message: peace, unity, and good mind. But what exactly is the good mind? How is it understood and applied today in Haudenosaunee communities?

In 2009, the Six Nations Polytechnic's Indigenous Knowledge Centre published a document on Haudenosaunee philosophy stating that, when humans work for peace, they develop a good mind. The good mind is perhaps best understood as "people using their purest and most unselfish minds [to] achieve great thoughts, words and actions. It occurs when people put their minds and emotions in harmony with the flow of the universe" (Indigenous Knowledge Centre 2009). Haudenosaunee Elders Wendy Gonyea and Frieda Jacques, and Haudensaunee scholars Amber Adams and Christopher Jocks, describe the good mind as conscious goodwill because the mind wills or consciously moves and acts in a good way that leads to goodness, peace, and unity/strength (Adams 2013, 38; Gonyea 2009; Jacques 2014, 14; Jocks 1994, 79, 292–96). Both Adams and Jacques explain that the good mind/will must be consciously cultivated and expressed. When it is "expressed intellectually, rationally, emotionally, and socially," the good mind effects peaceful changes or results "across and between personal, social, and ecological borders" (Adams 2013, 38). And, when the good mind wills, directs, or effects change, and when the change is successful, *sken:en*, or "peace," results. Consequently, in the case of *ka'nikonhri:yo*, "the good" that describes and is effected by *'nikonhr* is associated with "peace." In other words, when people work for peace through the good mind, they unite for a common purpose. Their unity of purpose is strength. Strength flows from the power of their collective good mind and enables them to use rational thought to channel "the inherent good will of humans to work toward peace, a Good Mind and unity to prevent the abuse of human beings and Mother Earth" (Indigenous Knowledge Centre 2009). Thus, the good mind is one part of the set of interdependent and interrelated principles, or values, embedded in the Peacemaker's original message.

Today the good mind remains central to Haudenosaunee ways of being. Oneida Elder/scholar Bob Antone (2013) describes the good mind both as the "centerpiece" or "prized personal quality of the Haudenosaunee personality" and as "a way of being in one's

everyday actions" (13): "The capacity of the Good Mind is the ability at any moment, with or without pressure, regardless of the nature or intensity of the situation, [with which] one is able to respond with a peaceful decisive act. In the history of the Haudenosaunee, this ability to function with [*kanikonhri:yo*] is at the core of the Haudenosaunee understanding of humanity and is fundamental to the survival of the people and their culture" (50). Antone continues on to explain that the good mind also is a "fundamental principle of the Haudenosaunee way of life" and, as such, a vehicle of change, "swinging human tendencies toward the positive side of energy" or the good (50). This connection between contemporary understandings of the good mind and the role of the Peacemaker and his message in modern Haudenosaunee society is important for my discussion because Niro focuses on the good mind as the essence of Haudensosaunee personhood in her film.

It is important to note that good mind traditional teachings predate the Peacemaker and the founding of the Haudenosaunee Confederacy. Mohawk Elder Tom Porter tells us that "the Good Mind starts at the beginning of the world" (2008, 8–9). According to Haudenosaunee Creation traditions, when Sky Woman's eldest grandson, He-Who-Formed-Our-Bodies (incidentally also known as the Good Mind), created humans, he gifted them with a set of original instructions, known today as the Thanksgiving Address or the Words that Come before All Else. These instructions continue to be recited at the opening and closing of almost every Haudenosaunee gathering[7] to remind the people about their relationships with and responsibilities not only to each other but also to all natural world beings, seven generations forward and backward.

Each time the people forgot these instructions, Good Mind sent them a messenger, the first of which was a young man referred to as His Mind Is Great. To reunite the people, His Mind Is Great helped to establish the clan[8] system (Mohawk 2005), which Porter (2008) describes as a social structure intended in part to produce and reinforce the original instructions by fostering peaceful, unified coexistence, as well as being a way for people to deal with grief and loss (Mohawk 2005). When the clans were established initially, as Mohawk scholar Brian Rice (2013) explains, there were eight: the deer, sandpiper, eel, and hawk clans were one sisterhood, and the wolf, beaver, turtle, and bear clans comprised a second sisterhood. The two sisterhoods were

considered cousins. If a member of the beaver clan lost a loved one, for example, then that person and fellow clan members were plunged into a period of mourning for a year. During that time, members of the opposite sisterhood were responsible for helping their cousins in the beaver clan to heal from their grief and loss. The clear-minded, those who had not suffered loss, were responsible for ensuring that the mourning clans were brought back to the good mind and, by extension, that the people of both sisterhoods continued to live in community with each other, unified in peace through the power of the good mind (see also "Funerals" n.d.).

As Porter (2008, 8) explains, the descendants of these two sisterhoods continued to live together in unity, peace, and the good mind, and for "hundreds of years everything was good. [But] then they forgot again, as humans do." When this happened, their communities devolved and were characterized by domestic violence, revenge wars, murders, kidnappings, fear, and depravity. This era of Haudenosaunee history has become known as a time of "great sorrow and terror" or the "dark and troubled times" ("Dark and Troubled Times"; Mohawk 1989, 219).

It was at this point in history that Good Mind sent another messenger—the Peacemaker—to remind people of the original instructions to carry a good mind, to reinstitute the clan system, and to unite the warring nations of the northeast under a "plan for peace and a good mind" (Shenandoah 1994, 11). To establish the Haudenosaunee Confederacy, the Peacemaker himself employed the good mind when approaching individuals and nations with his message of peace (Thomas 1996). This was evident in the Peacemaker's meetings with Jikonsahseh, the Cannibal, Tadodaho, and Hiawatha. These people had lost their ability to live peaceful lives in community with others. Grief over the loss of his wife and daughters caused Hiawatha to abandon his responsibilities as a leader of the Onondaga Nation and to live in isolation from his people; Tadodaho became a despotic tyrant ruling the Onondaga Nation through fear; the Cannibal was a serial murderer who ate his victims; and Jikonsahseh used her position as a host to warriors passing through the Neutral Nation's lands to incite war and destruction.[9]

Jikonsahseh is notable for many reasons. Not only was she the first individual to accept fully the Peacemaker's message of peace, unity, and the good mind, but also she was instrumental in helping the Peacemaker and Hiawatha bring Tadodaho back to the good mind. In

so doing, she was indispensable to the founding of the Haudenosaunee Confederacy. Today, she is known as the Mother of Nations. Prior to the coming of the Peacemaker, Jikonsahseh lived alone in a house somewhere between present-day Victor, New York, and the Niagara Falls–Lake Erie corridor. More specifically, her house was situated within the boundaries of the Neutral Nation, along a road known as the Warrior's Path, a main "road" running east-west from Mohawk territory to Lake Erie. Jikonsahseh opened up her house to the warriors who passed by, and incited war by pitting them against each other. In the eyes of the Peacemaker, she was an obstacle to the establishment of a peaceful confederacy of nations. Eventually, however, Jikonsahseh was restored to a good mind, after which she took on a leadership role as the first clan mother and became known as the Mother of Nations or the Peace Mother (Williams 2018, 145). To do this, "she had to change her beliefs and habits in order to be more reflective of the Good Mind" (Indigenous Knowledge Centre 2009). As the first individual to accept the Peacemaker's message of peace, and as the woman who boarded warriors passing through neutral lands, Jikonsahseh was in a unique position to prepare the way for a peaceful confederation by carrying the message of peace, unity, and the good mind to her guests. After she allied herself with the Peacemaker, he began his journey back east toward the Mohawk Nation and met both the Cannibal and Hiawatha.[10]

The Cannibal was in the process of preparing a soup with human body parts when the Peacemaker first saw him. As the story goes, the Peacemaker was lying on the roof looking down into the Cannibal's house through the smoke hole in the roof. He was positioned in such a way that his visage was reflected in the soup that the Cannibal was making. The Cannibal mistook the face reflected in the soup for his own face. He could not understand how a face as beautiful and peaceful as the one reflected in the soup could engage in something so heinous as cannibalization. While the Cannibal took the pot outside and dumped it, the Peacemaker climbed down from the roof and reached out to him. Again, this was anything but a quick transformation. The Peacemaker spent a long time counselling the Cannibal. As the late Seneca scholar John Mohawk (1989, 219–20) reminds us, although the Peacemaker's exact words are lost to us now, their essence remains,

the idea that all human beings possess the power of rational thought and that in the belief [of] rational thought is to be found the power to create peace. . . . He was not saying that human beings do not possess the potential for irrational thought. He was saying that all human beings do possess the potential for rational thought. Unless we believe that all human beings possess rational thought, we are powerless to act in any way that will bring peace short of the absolute destruction of the other. . . . Thus the first principle that will bring us the power to act is the confidence that all people are rational human beings and that we can take measure[s] to reach accord with them.

By treating the Cannibal as a human being with a rational mind, the Peacemaker facilitated the complete transformation of the Cannibal from an obstacle into a good mind (Longboat 2008, 279–80; Williams 2018, 169–79). In the end, this man, like Jikonsahseh before him, became an agent working on the Peacemaker's behalf to prepare the way for peace, unity, and the good mind (Thomas 1996; Thomas with Boyle 1994).

In due time, the Peacemaker left the reformed Cannibal and headed west toward Mohawk territory. As he travelled through Onondaga territory, however, he was distracted by the sound of a man crying in pain. The Peacemaker followed these cries until he came to a small clearing near the shores of Lake Tully, south of the present-day city of Syracuse, New York. There he saw a man who was clearly in great pain. The Peacemaker stood silently, out of sight at the wood's edge, and watched as this man took a string of shell beads and laid it across a branch, saying "if I should see anyone in deep grief I would remove these shell strings from the pole and console them. The strings would become words and lift away the darkness with which they are covered. Moreover, what I say I would surely do" (Williams 2012, 193–94). Hiawatha was attempting to console himself, to bring himself out of grief and depression. Realizing that this man needed his help, the Peacemaker stepped out from the wood's edge into the clearing. Taking the three strings of shell beads, he metaphorically wiped the tears from Hiawatha's eyes and removed the blocks/lumps of grief from his ears and throat. In this way, the Peacemaker raised Hiawatha up out of

the depths of his depression and despair and restored him to a good mind. In other words, through condolence, the Peacemaker initiated Hiawatha's emotional and psychological healing.

Through this first condolence ceremony, the Peacemaker learned that the cause of Hiawatha's grief was the death of his wife and daughters. Their untimely, tragic deaths plunged Hiawatha into such a severe depression that he walked away from all of his responsibilities as one of the leaders of the Onondaga Nation and isolated himself in the forest near Lake Tully. He existed in a nearly catatonic state of depression until the Peacemaker condoled him and brought him back to a rational, healthy, peaceful state of mind (Gibson and Woodbury 1992; Mitchell 1984; Williams 2012).

After this first condolence ceremony, Hiawatha, now with a good mind, sat and discussed with the Peacemaker the importance of condolence on both individual and national levels. On an individual level, condolence, they realized, could heal a person after any loss, no matter how deep the wound, and restore that person to a good mind. On a national level, condolence could be used to heal a people from their national grief after the loss of a leader by peacefully raising up a new leader in his or her place. Literally, when a Haudenosaunee chief dies, or becomes too infirm or unable to fulfil his responsibilities to his clan, to his nation, and to the confederacy, a man will be nominated and raised up by the clan mother(s) as a chief. Through the condolence ceremony, the people are healed from the grief of their loss, and the peaceful succession of a new leader is ensured when the newly nominated leader is condoled as a chief on clan, national, and confederate levels.

During the first few centuries of contact, a modified version of the condolence ceremony was used by Haudenosaunee and colonial officials to open all political discussions and treaty negotiations. The intent was to restore Haudenosaunee and colonial officials to a good mind, individually, and to unite them through the power/strength of the good mind, collectively. Condolence, then, ensured that all would have healthy, rational minds and thus be able to negotiate peaceful resolutions to the issues facing their respective communities. As Paul Williams (Onondaga) (2012, 2018) explains, the decision to use condolence for the peaceful succession of leadership, or to clear the way for political discussions or negotiations to take place, was predicated

on the Peacemaker's realization that a "powerful spiritual act" was nec-
essary to prepare people to accept the message of peace: "The path to
restoring the [good] mind," Williams says, "[is] a deliberate, structured
and compassionate ceremony, a ritual of both a spiritual and [a] legal
character" (2012, 195). To ensure that the notions of peace, unity, and
the good mind could be heard, understood, accepted, and enacted, it was
necessary to find a way to handle death and how it twisted a person's
mind through grief, depression, anger, bitterness, vengeance, and even
hatred. At its heart, compassion is the threshold of the Peacemaker's
message. After all, the condolence ritual also ends with the reminder
that people must not forget their relationships with and responsibilities
to each other, the natural world, and seven generations forward and
backward. These responsibilities include working together for peace
(Longboat 2008; Mohawk 1989; Williams 2012, 2018).

After Hiawatha was brought back to the good mind through con-
dolence, he partnered with the Peacemaker. Together they brought the
message of peace, unity, and the good mind to the Mohawk, Oneida,
Cayuga, and Seneca Nations. Their mission to establish a peaceful
confederacy, or the Great Peace, took years. Despite their success in
uniting four nations under the Great Peace, they were unable to estab-
lish definitively such a confederation without the Onondaga Nation.
Geographically, Onondaga was located in the middle of the other four
nations. Politically, it was ruled by a despotic tyrant named Tadodaho.
In much the same way that Jikonsahseh had been an obstacle to the
establishment of a peaceful confederacy, Tadodaho's stranglehold on
the Onondaga Nation was an obstacle to lasting peace (Mitchell 1984;
Skye 1998; Thomas 1996; Williams 2012, 2018).

Tadodaho is understood as a despotic tyrant; he is often referred
to as a wizard who used his powers to control the Onondaga people
through fear. Metaphorically, his corrupt rule has been depicted through
the deformities of his body and the snakes nesting in his hair. In some
versions, these deformities resulted from his use of wizardry to control
the Onondaga people. In these versions, the snakes literally grew from
his head like hair. Perhaps his power as a leader of the Onondaga Nation
corrupted him. One of the versions indicates that at one time Tadodaho
was much loved by his people until he inhaled a poison secreted by a
strange bird whose feathers he plucked to decorate his hair. The toxin
caused him to go insane:

No more did he care for their games; no more did he care for the chase, but was sullen and morose and shunned all companionship with his people who also avoided him for he had developed a mania for killing human beings.

The poisonous fire that had burned in his brain had so distorted his features that he became hideous to behold; his long glossy hair fell from his head and in its stead there grew serpents that writhed and hissed when he brushed them back from his face and coiled around his pipe in rage when he smoked. . . . Developing clairvoyance of vision and prophecy, he could divine other people's thoughts and through this power came to dominate the councils, assuming a control that none dared oppose, and ruled for many years with such insane and despotic sway that he broke their hearts and the once powerful, proud and most courageous of all the nations became abject and cowardly and weak. (Converse 1981, 117–18).

Regardless of how Tadodaho became a tyrant, the reality is that his despotic rule, together with the Onondaga Nation's geographical location, resulted in his becoming the most dangerous and difficult obstacle to the Great Peace. In fact, the Peacemaker waited until the people of the Mohawk, Oneida, Cayuga, and Seneca Nations were united through peace, unity, and the good mind. It was through the unity of their good minds that the Peacemaker possessed the strength necessary to go to Onondaga and talk with Tadodaho. To maintain this strength, the people from the other four nations travelled together with the Peacemaker, Hiawatha, and Jikonsahseh to Onondaga.

According to Williams (2018, 244–53), part of the pacification of Tadodaho resulted from the Peacemaker's recital of the "Three Bare Words," the first three parts of the condolence ceremony: wiping the tears, removing the block from the ears, and removing the lump from the throat. The recital of the "Three Bare Words" got the Peacemaker, Hiawatha, and Jikonsahseh through the door. The completion of the condolence ceremony allowed the Peacemaker to comb the snakes from Tadodaho's hair, to straighten out his body, and to bring Tadodaho back to a good mind. According to the version transcribed by John Arthur Gibson and Hanni Woodbury (1992), Tadodaho was literally

restored to humanity. And it was only after he was restored to a good mind that he ceased to be an obstacle to the establishment of a peaceful confederacy of nations. It was necessary for the good mind to become the essence of his personhood before he could sit in peace and join in the discussions with a rational, healthy, and clear mind.

Williams (2018) points out that in each of these cases the Peacemaker recognized the possibilities for and abilities of Jikonsahseh, the Cannibal, Hiawatha, and Tadodaho. Rather than destroying them, the Peacemaker worked through the power of the good mind to transform each into a "power for peace": Jikonsahseh became the first clan mother and was honoured with the title Mother of Nations; the Cannibal became an "advocate for life," preparing the way for the Peacemaker; Hiawatha became the Peacemaker's spokesman and partner; and Tadodaho became the spiritual leader of the fledgling confederacy. They became part of the solution to the warfare and bloodshed that had been plaguing the land (Indigenous Knowledge Centre 2009).

After the Mohawk, Oneida, Onondaga, Cayuga, and Seneca Nations were united, the Peacemaker likened their confederacy to a family living together in a single longhouse. Female leaders were advised always to have and carry a good mind and to ensure that the chiefs worked through the power of the good mind to maintain the peace. Clan mothers were also tasked with ensuring that the good mind remained the essence of Haudenosaunee peoples so that they could continue to live in community and fulfill the original instructions by taking care of each other, the natural world, and the future generations (Thomas n.d.). Male leaders—known as *hoyaneh* or "he of the good mind"—were instructed to work through the good mind to carry out their responsibilities to the clans, the nations, and the confederacy as a whole (Porter 1992, 17). And, as Bev Jacobs (1998) explains, each person was instructed to have a good mind. To maintain peace and to live together as one family in a metaphorical longhouse, it was critical for the leaders—female and male—and the people of these five nations to have and work through the good mind; as Williams (2005, 10) explains, the good minds are the ones that "will seek peace, [will] create peace, and will do so by uniting with other Good Minds." The Haudenosaunee Environmental Task Force (HETF) explains that, by working for peace and a good mind, people develop strength. Furthermore, strength "flows from the power of the good mind to use rational thinking and persuasion to channel

[goodwill] to work towards peace, justice and unity to prevent the abuse of human beings and mother earth" (HETF 2005).

In writing and directing *Kissed by Lightning*, Shelley Niro (2009) sought to represent Haudenosaunee communities in both Ontario and New York and the principles by which they live, namely peace, unity, and the good mind. To accomplish this goal, Niro invites her audiences to see and experience the world through the eyes of Mavis Dogblood. Viewers embark on a surreal journey with her through the dreamscape of her grieving mind, an interior world into which Mavis retreats when her grief and depression become too much for her to bear. As she is condoled back into her family and the Six Nations community, this interior world crumbles. Prior to that, however, viewers encounter the visually jarring and emotionally evocative images of her dreamscape: images of Jesse Lightning, her late husband, superimposed over dramatizations of the Peacemaker's story, and her paintings, which are Mavis's interpretation of stories Jesse told her about the Peacemaker. In rare instances, opaque images of entire paintings and/or images from her memories or dreams fill the screen. More often, however, her dreams and memories become palimpsests over which glimpses of each of her twelve paintings, her memories of Jesse, and/or her imagined dramatizations of relevant portions of the Peacemaker's journey appear and disappear. Often there are many layers of translucent paintings and dramatizations obscuring and illuminating her dreams and memories of Jesse.

In addition to the use of Mavis's paintings and imagined dramatizations of the Peacemaker's story to set the mood, Niro overlays sound effects and voice-overs with foreground music and source music. In Mavis's dreamscapes, the audience usually hears only three things: Jesse's viola, the mournful crying of people in deep emotional distress, and Jesse either directly engaging Mavis in conversation or narrating parts of the Peacemaker's story to her. This is important, for in her dreamscape dramatizations of the Peacemaker, and in one of her conversations with Jesse's teenage son Zeus, Jesse's likeness becomes her artistic representation of the Peacemaker; he had, as Mavis recalls in *Kissed by Lightning*, "the real peaceful look in his eyes."

In contemporizing traditional teachings about the Peacemaker, condolence, and the good mind in *Kissed by Lightning*, Niro invites her audience to listen to the Peacemaker speaking through Jesse's viola and Jesse himself. In one of the opening scenes of the film, Mavis runs

through a sombre wintry dreamscape toward Jesse, who stands on the other side of a frozen river, playing his viola. The terror and grief on her face are palpable. As Mavis stops short of the riverbank, she appears to be repeatedly yelling Jesse's name. However, the only audible sound is that of Jesse playing a hauntingly beautiful melody on his viola. Much later in the film, the audience learns this is one of a series of songs Jesse composed to tell the Peacemaker's story. Mavis recalls him telling her that "[this is] the story of our struggles and our humanity, the beginning of our very existence. This story took place eons ago. This story took place right here in our own territory. I'm writing music about it. Incredible harmonies rush through me all the time. Sometimes I can't sleep." Since this is the song heard most often throughout Mavis's story, understanding what influenced Jesse to compose it is perhaps as important for Niro's audience as it is for Mavis. In one poignant moment during her road trip, Mavis is forced to listen to this song and deal with the memories it resurrects. She passes through the same lands near the Mohawk River in upstate New York that the Peacemaker is said to have travelled when he was establishing the Great Peace. It is night, and she is flipping through radio stations while commenting to her friend Solomon King (a.k.a. Bug) that all she can pick up on the radio is country music. In that moment, the haunting voice of Jesse's viola emanates from the radio, and the DJ comments that the previous song was composed and "performed by Jesse Lightning, whose tragic demise—he was literally struck down by lightning." Before Mavis and by extension Niro's audience have a chance to catch their breath, the DJ continues: "We now continue our retrospective with [Lightning's] final composition, the 'Hiawatha Sonata.'"

As the audience joins Mavis and Solomon in listening to the "Hiawatha Sonata," it becomes clear that Jesse Lightning and his viola music are visually and aurally symbolic of the Peacemaker. In fact, in this moment, Jesse's song clarifies how strongly Mavis's story parallels Hiawatha's. Mavis lost her husband in tragically ironic circumstances—he was struck by lightning. Hiawatha lost his wife and daughters—depending on which version of the oral tradition you hear—to illness, to being accidentally trampled during a lacrosse game, or to murder. After the loss of their loved ones, both Mavis and Hiawatha choose to live in isolation from their communities and surviving family members, and both drift deeper and deeper into

grief-induced depression and mental illness. Hiawatha sits in the forest stringing wampum beads and devising the ritual that becomes condolence, and Mavis alternates between reclining on the futon in her house, absent-mindedly playing with the wampum bead necklace that Jesse gave to her, and painting Hiawatha's story.

Despite these similarities, many of the people in Niro's audience might shy away from this parallel. According to the traditional teaching known as the Code of Handsome Lake, Haudenosaunee people are to avoid the fiddle and fiddle music, which, like card games and alcohol, can entice people away from their responsibilities to each other and/ or to lose themselves in frivolities and sin (Rice 2013; Thomas with Boyle 1994). In light of this, the Handsome Lake followers in the audience might wonder why Niro chose to emphasize the viola, which to an untrained eye might easily be mistaken for the violin or fiddle. That Niro studied classical music and the cello in college might help to contextualize her choice of musical instrument (Indyke 2005). In her interview with Elizabeth Weatherford in 2013, Niro explained that in an orchestra the viola is referred to as the "peacemaker": "When I first started writing this years and years ago, I was thinking at the time of Jesse Lightning being a cellist. But the solo viola, it's interesting and cello like. And it's like a voice. Did you know that the viola in an orchestra is called the 'Peacemaker' because it's between the violin and the cello?" (351). The "voice" of the viola, symbolically, becomes the voice of the Peacemaker as he expresses his message of peace, unity, and the good mind. Weaving classical viola music into the narrative as an aural representation of the Peacemaker and his message is one way in which Niro contemporizes this Haudenosaunee traditional teaching for her twenty-first-century audience.

Niro also contemporizes this teaching through the series of twelve paintings that Mavis creates to interpret the stories that her late husband told her about the Peacemaker and the origins of the Haudenosaunee Confederacy. In her capacity as a multimedia artist, Niro produced the twelve paintings attributed to Mavis. Although the paintings are the protagonist's way of creating a tangible remembrance of her husband, most of them portray recognizable events from the Peacemaker's story, including his journey across Lake Ontario in the stone canoe, his meetings with Jikonsahseh and the Cannibal, the deaths of Hiawatha's daughters, Hiawatha's condolence, and the

Figure 7.1. *Calla Lilies*, one of twelve paintings Mavis Dogblood paints to illustrate the Peacemaker's story and the First Condolence. Artwork by Shelley Niro.

combing of the snakes from Tadodaho's hair. However, like Niro's use of the viola to voice the Peacemaker's message, one painting stands out and makes her audience think critically about why and how this painting relates to the Peacemaker and his message about the good mind. It is an enormous painting of two calla lilies. At first glance, there appears to be one white lily and one purple lily set against a reddish-black background. However, a closer look reveals that deep inside the throat of the white calla lily is a deep purple interior. Likewise, the purple calla lily is edged in white.

What do calla lilies, flowers never mentioned in traditional teachings about the Peacemaker, have to do with his message? Consider the shape of a calla lily, similar to that of a quahog shell. The quahog is one of two shellfish (the other being the whelk) used to craft the shell wampum

beads. Mavis's calla lilies, like the quahog shell and the wampum beads crafted from this shell, are purple and white. Wampum, as noted previously, plays a pivotal role in the condolence ceremonies used to bring Hiawatha, Tadodaho, and other grieving people back to the power of the good mind and to unite them together in peace.

Mavis's calla lilies, at least in part, represent the balancing of Sky Woman's grandsons, Good Mind and Flint, and by extension the balancing of Creation, which supports and sustains life. In Haudenosaunee teachings, the creation of Turtle Island (North America) begins when a very pregnant Sky Woman falls from her home in Sky World to a water world below. Turtle offers his back for her to rest on while the water animals—beaver, muskrat, and otter—dive down into the depths of the waters to retrieve the mud necessary to create the land needed for her survival. After all, Sky Woman has neither the webbing between her fingers and toes nor the lung capacity to survive in a water world. She lays down the mud that muskrat brings back and begins to dance on it in ever-increasing counter-clockwise circles. As she dances, the land mass increases. With the help of the water animals, Sky Woman initiates the creation of Turtle Island.

Sky Woman's daughter, grows up, and marries Turtle Man (or the West Wind, depending on who is telling the story). They have twin sons, Good Mind and Flint, who compete with each other to continue the work of creation. One could argue that their competitive nature gives rise to their works of creation and keeps the world in balance. For example, Good Mind creates the rose; Flint gives it the thorns necessary to protect itself. Good Mind creates vegetarian game animals; Flint creates carnivorous game animals. Good Mind creates rivers with currents going in both directions; Flint throws stones into the rivers in order to create the whirlpools, rapids, and eddies necessary to prevent the currents from flowing in both directions. This, he reasons, will prevent life from becoming too easy for the humans (when they are created). Each brother becomes representative of different aspects of Creation (Mohawk 2005). Good Mind represents day, warmth, and the lightness of life; Flint represents night, cold, and the blackness of death. In an interesting twist, white wampum also represents the lightness of life, and purple wampum represents the blackness of death. For this reason, purple wampum was referred to as black wampum until very recently (Williams 2012, 411–12). Understood in this way,

Mavis's calla lilies are symbolic of the twin minds of Haudenosaunee Creation, Good Mind and Flint. One purple with white edging and the other white with a deep purple throat, the lilies also represent the balance of life necessary to ensure the continued survival of the world and, importantly, the person (or nation) restored to the good mind and balance through condolence.

In some versions of the Peacemaker's story, we are first introduced to shell wampum when Hiawatha, mourning the deaths of his daughters, leaves his village in Onondaga territory and travels south. A flock of water birds rests on Tully Lake, the largest in a series of small kettle lakes. As Hiawatha approaches the lake, the birds all fly off together, taking the water with them on their wings. In other versions, Hiawatha asks the birds to fly away and take the water with them. Either way, he crosses a dry lakebed and collects shells as he walks. He forms wampum beads from these shells and strings them together. Sitting isolated in the forest near Lake Tully, he begins to speak out loud to himself, saying that, if he found someone grieving as he was, then he would take these strings of beads and condole[11] the person (Williams 2012).

At this point in the story, as noted above, the Peacemaker steps out of the woods, takes hold of the strands of shell wampum beads, and performs what is now known as the first condolence: "The Peacemaker knew that it must be performed to help heal [Hiawatha's] mind and make it clear again. Using wampum strings and a speech with each string the Peacemaker removed the tears from his eyes so he could see clearly, cleared his ears so he could hear again and removed the lump in his throat so he could communicate clearly" ("Funerals" n.d.). Mavis's painting of the first condolence depicts this scene.

Her interpretation deals with one of two types of condolence ceremony performed in the Haudenosaunee Confederacy today: a small condolence for individual Haudenosaunee people ("Condolence Ceremony" n.d.). According to the Haudenosaunee Confederacy Oshwe:ge Grand River website, this ceremony is performed for any individual who has suffered emotional trauma, loss, or death. Its purpose is to heal the mind of this distress and to raise the individual's mind back up, to enable the person to think rationally and peacefully through the power of the good mind ("Condolence Ceremony" n.d.; see also "Funerals" n.d.). This condolence ceremony is not practised as frequently as the second and larger condolence ceremony.[12] The latter

Figure 7.2. *First Condolence*, one of twelve paintings Mavis Dogblood paints to illustrate the Peacemaker's story and the First Condolence ceremony used to restore Hiawatha to a good mind by symbolically wiping the grief from his eyes, ears, and throat with wampum. Artwork by Shelley Niro.

ceremony is designed to condole nations "for the passing of leaders and the peaceful raising up [of] their successors" ("Condolence Ceremony" n.d.). Both types of condolence are rooted in the Peacemaker's work to unite the Mohawk, Oneida, Onondaga, Cayuga, and Seneca Nations as one confederated family. For Niro's purposes in *Kissed by Lightning*, the small condolence, particularly the wiping of the tears, and the restoring of the grieving mind to the good mind, becomes a metaphor for the

importance of people working together to bring minds clouded by the grief of loss—like Hiawatha's and Mavis's—back to healthy, reasonable, peaceful minds.

It is worth repeating here that, although Hiawatha was inspired to fashion the wampum and to outline the beginning of what became condolence, he was unable to restore himself to the good mind. Likewise, Mavis, who possesses and plays with a wampum necklace throughout the movie, is also unable to heal herself. Niro, interpreting the Peacemaker's teachings for her twenty-first-century audience, reminds us that it was as necessary for the Peacemaker to help restore Hiawatha to a good mind as it is for Josephine Lightning (Jesse's grandmother) and Solomon King (Mavis's future husband) to work together to restore Mavis Dogblood to a healthy, rational, peaceful mind. Just as Hiawatha symbolizes the people, so too does Mavis. More important still, as Williams argues, had the Peacemaker not chanced upon Hiawatha and helped to restore him to the power of the good mind, the Peacemaker would not have understood how important the spiritual act of condolence was. It was only after he condoled Hiawatha that the Peacemaker realized that the people "would not be prepared to accept his message unless their minds were first made good" (2018, 201). As Williams continues,

> the path to restoring the rational mind was a deliberate, structured, deeply caring and compassionate ceremony, a ritual of both a spiritual and a legal character. It was necessary to learn how to deal with death. . . . Compassion is indeed the threshold of the Great Law of Peace.
>
> The two of them together—the clear-minded one and the grieving one whose mind was cast down to the ground—created the Condolence. This is not merely a powerful partnership: it also shows how two-sidedness [as in Creation with Good Mind and Flint] . . . can be effective and right. There would be no structure without the Peacemaker's great compassion; there would be no restoration of the Good Mind without Hiawatha's decision to passively accept the condolence rather than take up the path of vengeance. (201–02)

Both the ceremony and the metaphorical path leading to condolence continue to be necessary to bring people back to a place where their

minds are healthy, peaceful, and capable of rational thought. This ceremony is indispensable to ensuring that the essence of Haudenosaunee personhood remains the good mind.

Importantly, the beads on each strand of wampum used in a condolence ceremony are strung in specific patterns. According to Williams (2012, 416), wampum strings reflect the organization of what would otherwise be "the chaos of scattered beads," and—far from being randomly strung or woven into belts—the beads are strictly designed to reflect ceremonial, political, and social protocols. Williams also states that in Haudenosaunee traditions white wampum beads typically represent peace, sociability, and desire for understanding, whereas purple beads are often, though not always, symbolic of mourning, death, and misfortune (49). Furthermore, according to Jolene Rickard (1996, 8–9), there is a dynamic relationship between the person who holds the wampum and the power of the message of condolence as it is spoken and represented through the wampum: "The process of linking the word to the visual [through wampum] is an Iroquoian creative tradition constructed to inspire the power of the good mind." It is, in part, this dynamic relationship that is represented through the purple and white calla lilies in Mavis's painting.

In *Kissed by Lightning*, Niro often pairs the painting of the calla lilies with Mavis's memories of Jesse or the Peacemaker's condolence of Hiawatha. For example, during one of her flashbacks, Jesse and Mavis are kissing after they look at some of her paintings. Interestingly, however, our view of this private moment is obscured by the calla lilies, glimpses of which have been superimposed onto her memory of this kiss. Likewise, later in the film, as Mavis drives through the original Mohawk territories in upstate New York, the audience hears the sound of a swiftly flowing river. That sound is then paired with a glimpse of the painting of Jesse as the Peacemaker. Painted beneath his head, and across his chest and shoulders, is the Hiawatha wampum belt, the symbolic representation of the Great Peace and the unification of the original five nations into the Haudenosaunee Confederacy. The sound of the river fades, allowing Niro's audience to hear Jesse narrate the Peacemaker's story to Mavis: "The story took place right here, in our own territories. . . . Incredible harmonies rush through me all the time." As his voice fades, the audience sees and hears a small waterfall and the river swollen with the melting snow of spring rushing under a bridge.

For the first time during the film, instead of music from Jesse's viola, the audience hears a woman singing sweetly in Mohawk. The camera pans to Mavis sitting on a hilltop in a red chair drawing. It looks like early spring. Jesse walks up behind her, slowly, and tells her, "If I could paint you, I'd paint you now, just as I see you." Mavis gets up and walks to him. Superimposed onto this memory/dream are the paintings of the Peacemaker standing behind a woman, his arms outstretched; the calla lilies; and a woman in mourning, eyes closed and head tilted back. Just as Mavis reaches for him, Jesse backs away from her. The voice of her travelling companion, Solomon King, becomes audible as he reads the story of the Mohawk saint Kateri Tekakwitha on a New York State historical marker at the Kateri Tekakwitha shrine (Fonda, New York).[13] Images of Hiawatha and the Peacemaker, symbols of the Haudenosaunee Confederacy, are juxtaposed with pictures of the Kateri Tekakwitha historical marker. Solomon finishes reading the historical marker as the image of Jesse backing away from Mavis into the mists of her memories flashes across the big screen.

As the film continues, Niro solidifies the mnemonic relationship between wampum and the calla lilies when Mavis flashes back to the night that Jesse gave her the wampum necklace that she wears throughout the film. The memory of their lovemaking is embedded in layered glimpses of a dramatization of the "dark and troubled times" that necessitated the Peacemaker's journey. Through Mavis's eyes, Niro's audience gazes at people sitting around fires in the woods grieving. All the while, Jesse tells Mavis that, if he could paint, he would paint the Haudenosaunee people's struggle and humanity. While he is talking, flashes of her paintings flicker across the screen: images of people grieving, of women holding their starving children, of Hiawatha combing the snakes from Tadodaho's hair, of the first condolence ceremony, and, of course, of the calla lilies. The lilies come into focus fully and remain a few seconds before they fade into an image of Jesse putting the wampum bead necklace around Mavis's neck. As Jesse and Mavis resume their lovemaking, they fade into the calla lilies. While the lilies remain in focus, Jesse, dressed as the Peacemaker, says, "Tell the people that I am coming; I have been sent by the Creator." The sequence of images in this scene highlights the importance of the wampum necklace and its relationship to the lilies. It is a symbolic reminder of the relationship of condolence to the ability of a person, clan, or nation to have the good

mind and to live in peace and unity with one another.

This relationship is further illuminated by how Mavis interacts with the wampum necklace. In some scenes, she holds it in much the same way that Hiawatha might have held the wampum strings while waiting to be condoled. At the end of the film, Mavis moves from the role of the grieving, depressed widow to the role of the clear-minded condoler, as evidenced by her help in bringing peace to Jesse's teenage son, Zeus, in what appears to be a private family condolence ceremony. In this scene, she takes the necklace and lays it, together with her wedding band, in a photo album filled with Jesse's pictures and gives it to Zeus while Jesse's grandmother plays the water drum and sings. Throughout the film, the audience is reminded that the creative process of stringing wampum, of weaving it into belts, or of artistically representing it through purple and white calla lilies—a flower often associated with both funerals and weddings—links the Peacemaker's message of peace, unity, and the good mind to the visual in a creative tradition "constructed to inspire the power of the good mind" (Rickard 1996, 8).

As a storyteller working through the genre of film, Niro parallels Hiawatha's story with Mavis's story, in part to highlight the continued relevance of this oral tradition's message of healing to twenty-first-century Haudenosaunee communities. In her master's thesis, Niro acknowledges that she often includes Hiawatha in her art because "he demonstrates the human element" and because "his need to express his deepest emotions is channelled through the Peacemaker's quest" (1997, 4). She also says that Hiawatha's healing through the condolence ceremony is an example of "pre-modern medicine" in that "we are shown through the Peacemaker's example ... how to heal the psyche ... [and] how to bring someone out of a state of depression" (4). In *Kissed by Lightning*, it is clear that Hiawatha's journey from depression and grief back to a good mind is mirrored in Mavis's journey of healing after the tragic and untimely death of her husband. This is evident not only in her Peacemaker series of paintings and her imagined dramatizations of the Peacemaker's teachings starring her late husband but also in her pairing of the haunting melodies of Jesse's viola with his narration of Hiawatha's story: "Did you know Hiawatha was a man of the people? Like a politician, he was chosen to be their spokesman. His family perished suddenly; he went crazy with grief. The Peacemaker knew Hiawatha was confused, emotionally and mentally. He found him and

wiped away his tears of sorrow. He regained his spirit. Can you imagine back in those days?" As Jesse tells Mavis the story of Hiawatha's condolence, the screen is filled with an opaque image of her painting of the condolence. Jesse's narration of this traditional teaching concludes with an explanation not only that Hiawatha was restored to the good mind but also that he became the Peacemaker's spokesman, actively helping to unite the territories under the Great Peace as one family. Jesse explains that, for "the great prophet [the Peacemaker], being born with a defect must have been a sign of some sort. It made it difficult for him to speak. Having the ability to be an orator was essential. Hiawatha knew this and agreed to be his spokesman. These two men brought the nations and the territories together." In much the same way, Jesse's grandmother condoles Mavis and restores her to a good mind, and she then becomes one of the Peacemaker's spokespeople by telling his story to a new generation of Haudenosaunee people.

Kissed by Lightning, Shelley Niro's first feature-length film, ends with Mavis Dogblood uniting the various members of Jesse Lightning's family—his grandmother, his ex-wife, and his teenage son, Zeus—at a private family condolence ceremony. Niro drives home the importance of restoring people to the good mind through condolence; she told Kreimer (n.d.), good mind is "the essence of being an Iroquois person." By contemporizing the Peacemaker's traditional teachings in a way that highlights women, instead of men, as central to the process of restoring a grieving mind to a good mind, Niro ensures that this teaching is understood as equally relevant to Haudenosaunee women and Haudenosaunee men. She accomplishes this by paralleling Mavis's story with Hiawatha's story, by mediating both of their stories through Mavis's Peacemaker series of paintings, and by inviting us to listen to the Peacemaker speak through the voice of Jesse's viola as it "sings" the "Hiawatha Sonata."

Appendix: Peacemaker Series of Paintings by Mavis Dogblood[14]

Paintings 1–8: Identified by Michelle Murdock (2009) of the Fenimore Art Museum

1. *The Grandmother's Dream* tells the story of the Peacemaker's grandmother, who nearly murdered her grandson, believing him to have been the result of her unmarried daughter's indiscretion.

Eventually, a spiritual being tells her to leave her grandson alone since he has an important mission of peace to complete.

2. *The Peacemaker and His Canoe* marks the beginning of the Peacemaker's journey across Lake Ontario to what became the territory of the Haudenosaunee Confederacy.

3. *The Face of Peace* tells the story of the importance of women in the founding of the confederacy.

4. *Dark Times* tells the story of the five Haudenosaunee Nations whose citizens lived in a time of great sorrow and terror, barely surviving wars of reprisal and revenge.

5. *Monster Man* tells the story of a man whose mind was so twisted by the horrors that he was living through that he resorted to hunting, killing, and eating his fellow humans. It was not until the Peacemaker helped to restore him to a good mind that he was able to put cannibalism behind him and contribute to the peace and security of the nations.

6. *Dreaming of Cornfields* tells of Hiawatha's isolation from his own people after the death of his wife and daughters left Hiawatha wandering in the wilderness in a nearly paralyzing state of grief.

7. *The Healing of Hiawatha* tells the story of the Peacemaker coming to Hiawatha and using strands of wampum to condole him and restore him to a good mind.

8. *The Peacemaker Combs Snakes from His Hair* tells the story of how the twisted mind of the embittered, hate-filled Onondaga Chief Tadodaho is healed when the Peacemaker, Hiawatha, Jikonsahseh, and the people of the five Haudenosaunee Nations unite the power of their good minds and how the snakes said to be nesting in his hair were combed out by Hiawatha.

9. *Calla Lilies*, one white and one purple.

10. *The Peacemaker, Hiawatha, and Jikonsahseh*: the faces of the three good minds whose united efforts joined the people together into a confederacy. The white roots of peace are visible over their heads.

11. *Flowers*.

12. *Note*: I was unable to identify the subject matter of the twelfth painting from the movie.

Notes

1 Niro is an accomplished and award-winning photographer, painter, bead worker, multimedia artist, and independent filmmaker (Niro 2013). Born in Niagara Falls, New York, in 1954, Niro is a member of the Turtle Clan and a citizen of both the Mohawk Nation and the Haudenosaunee Confederacy. Although she grew up on the Six Nations Grand River Reserve (Ontario), she is a member of the Tyendinaga Bay of Quinte Mohawk Reserve (Ontario).

2 In 2019, Niro released her second feature-length film, *The Incredible 25th Year of Mitzi Bearclaw*.

3 Tuscarora historian Cusick (1961) proposes that the Haudenosaunee Confederacy was founded at least 1,000 years before Columbus bumped into the North American coastline. The New York State historical marker bordering Ganondagan—the Seneca historical site run by Seneca Elder Pete Jemison—states that the confederacy was founded about 900 AD. Wereas Tooker (1981) theorizes that confederation might have occurred as late as 1630 AD, Mann and Fields (1997) correlated astronomical data on eclipses with Haudenosaunee oral tradition and other documentary evidence, postulating 1142 AD as the date of confederation (see also Johansen 1995). Originally, five nations confederated: Mohawk, Oneida, Onondaga, Cayuga, and Seneca. It was not until the early 1700s that the Tuscarora Nation (originally located near the Neuse River in what is now North Carolina) petitioned to join the confederacy in response to wars with the colonial settlers in North Carolina. In the early 1700s, they moved to New York, settling in Oneida and Cayuga territories. In the aftermath of the American Revolution, many Tuscarora people moved to what is now the Six Nations Grand River Reserve in Ontario. Still others moved to lands given to the Tuscarora by the Seneca Nation near present-day Niagara Falls, New York. For more information, see Printup and Patterson (2007) and Rickard and Graymont (1973).

4 Although the Mohawk words *sken:nen*, *ka'shatstenhsera*, and *ka'nikonhri:yo* have been glossed in English as "peace," "power," and "good message" (Alfred 1999) or "peace," "power," and "righteousness" (Wallace 1986), I have chosen to use "peace," "unity," and "good mind." Mohawk Elder/scholar Dr. Dan Longboat (2008, 110) explains that the Peacemaker's message was based on three principles: *sken:nen*, *ka'shatstenhsera*, and *ka'nikonhri:yo*, which he interprets as "peace," "strength," and "good mind." *Sken:nen* is interpreted as "peace" and "health." In his discussion of the Peacemaker's message, allied scholar Paul Wallace (1986, n.pag.) says that peace is what happens "when minds are sane and bodies are cared for." Building upon this, Oneida Elder Bob Antone (2013, 35) explains that peace is related to and dependent on strength because maintaining peace is about enacting good thoughts about each other. In this way, people and families unite together as one mind, as one family. Unity, Antone argues, is strength. Likewise, Longboat (2008, 114) interprets *ka'shatstenhsera* as both "strength" and "power." And, like Antone, he says that "there is no power in the world greater than that of people of good minds uniting for a single common purpose of 'Peace'" (110–11). *Ka'nikonhri:yo*—the root of this word is *'nikonhr*, is interpreted as "mind" or "consciousness" by Mohawk scholar Christopher Jocks (1994) and Nancy Bonvillain (1989). Jocks interprets the entire word *ka'nikonhri:yo* as "good mind" (79). *The Haudenosaunee Code of Behaviour for Medicine Healers* booklet (Mitchell 2006) interprets *ka'nikonhri:yo* as "righteous mind." Longboat (2008, 280) explains that the Peacemaker's work to establish the Great Peace "demonstrates an approach to addressing irrational behavior and restoring" *ka'nikonhri:yo* ("good mind") to establish unity and peace. As a scholar

of Lakota descent who grew up in Haudenosaunee territory, I find that the English terms "peace," "unity," and "good mind" best help me to understand the concepts of *sken:nen*, *ka'shatstenhsera*, and *ka'nikonhri:yo*.

5 On 30 March 2012, Cornell University's American Indian Program hosted a showing of Niro's *Kissed by Lightning*. After the movie, Niro spoke at length with the audience. She said that she had produced the twelve paintings for the movie very quickly. In email correspondence with her, she informed me that the paintings were shown at a couple of galleries in Canada and the United States; however, she has since sold them. At the end of this chapter is an appendix that lists eight of the paintings shown at the Fenimore Art Museum in Cooperstown, New York. I was able to identify three of the four remaining paintings. The twelfth painting remains a mystery to me. Toward the end of the movie, they are shown at a fictitious New York City gallery. The paintings are large; I estimate that each is a minimum of six feet long and six feet high.

6 See note 4 for more detail.

7 The Thanksgiving Address is not recited at funerals, the related Okihweh feasts, or condolence ceremonies, perhaps because it is first necessary to restore persons lost in grief to a good mind before reminding them of their responsibilities to each other, the natural world, and the generations. For more information on the Thanksgiving Address, see Haudenosaunee Environmental Task Force (2005).

8 For more information on the traditional teaching that establishes the clan system and explains how it functions, see Mohawk (2005, 85–96).

9 Jikonsahseh was not originally a citizen of the Haudenosaunee Nations. She is often associated with both the Erie (a.k.a. Cat) and the Neutral Nations. Oral tradition indicates that her house was situated within the boundaries of the Neutral Nation, somewhere between the Seneca Nation's western boundary and the shores of Lake Erie. Some versions of the oral tradition place her near Niagara Falls. Other versions place her just outside Victor, New York, at the present-day site of Ganondagan. The New York State historical markers at Ganondagan claim this as the site of her home.

Wherever her house was situated, the warriors' path ran in an east-west direction past it. Warriors from all of the nations using this road would stop at her house. Some versions indicate that, though she was a woman living by herself, she had nothing to fear from the warriors because she lived within the boundaries of the Neutral Nation. Warriors passing through these lands apparently respected the neutrality of this nation. Other versions indicate that Jikonsahseh might have been a powerful medicine person or witch and that her power protected her from the many warriors who stayed at her house on their travels.

Once she accepted the Peacemaker's message, Jikonsahseh became the "custodian of the Good Tidings" of peace, unity, and the good mind. She also became the first clan mother and is known as both the Mother of Nations and the Mother of Peace (Jemison 1991, 22; Kelsey 2014, 66, 68; Williams 2018, 189). When the time came, Jikonsahseh provided the wisdom and ideas necessary to find "the solution to persuade Tadodaho" (the dictatorial leader of the Onondaga Nation) to consent to the Great Peace (Jemison 1991, 23). As Williams (2018, 185) explains it, without Jikonsahseh, "without the women's voice, the work of peace would have failed."

10 In the versions by Williams (2012, 2018), he references earlier translated/transcribed versions of the Great Law, some of which indicate that the Cannibal and Hiawatha are considered the same person. This reference to earlier versions is intriguing because, on more than one occasion, my Elders have said that Hiawatha should not be confused with the Cannibal.

11　Please note that the proper Haudenosaunee usage of the word is to *condole* the person, the clan, or the nation who has lost a relative. Moreover, when a chief dies, and another man is raised up in his place as chief, the new chief has been condoled. Until a chief is condoled, he is not officially a chief of the confederacy.

12　The original, shorter version of this chapter was presented at the 2013 Native American and Indigenous Studies Association conference. After my presentation, I was approached by a woman from Grand River who reminded me that this smaller condolence ceremony has fallen out of practice. I would be remiss not to mention that here lest the reader think that the smaller ceremony still happens every time a citizen of the Haudenosauee Confederacy passes away.

13　Kateri Tekakwitha was a young Mohawk woman who chose to walk away from all things Haudenosaunee to become a Catholic nun at a time when European-introduced diseases and French invasions into Mohawk territory forced the diasporic relocations of the Mohawk to new village sites. Kateri was canonized as a Catholic saint in October 2012. For more information on her, see Jacobs (2019); Palmer (2014); and the website Lily of the Mohawks (http://kateritekakwitha.net).

14　The appendix lists and briefly describes Mavis's paintings. In reality, these paintings are the work of Niro. After the movie was released, she sold the paintings. To view them, one must gain access through the owners. I have included these lists and the descriptions to facilitate the reader's understanding of the paintings.

References

Adams, A. 2013. "*Teyotsi'tsiahsonhátye*: Meaning and Medicine in the Haudenosaunee (Iroquois) Story of Life's Renewal." PhD diss., University of New York, Buffalo.

Alfred, T. 1999. *Peace, Power, Righteousness: An Indigenous Manifesto*. Toronto: Oxford University Press.

Antone, R. 2013. "*Yukwalihowanahtu yukwanosaunee tsiniyukwaliho:t˙* As People of the Longhouse, We Honor Our Way of Life *tekal'hsal˙ tsiniykwaliho:t˙* Praise Our Way of Life." PhD diss., State University of New York, Buffalo.

Bonvillain, N. 1989. "Body, Mind, and Idea: Semantics of Noun Incorporation in Akwesasne Mohawk." *International Journal of American Linguistics* 55, no. 3: 341–58.

"Condolence Ceremony." N.d. Haudenosaunee Confederacy Oshwe:ge Grand River (accessed 8 October 2014).

Converse, H.M. 1981. *Myths and Legends of the New York Iroquois*. Edited by A.C. Parker. Albany, NY: SUNY Museum. (Originally published in 1908.)

Cusick, D. 1961. *Ancient History of the Six Nations*. Lockport, NY: Niagara County Historical Society.

"Dark and Troubled Times." 1998. In *The Great Peace: The Gathering of the Good Minds* (CD-ROM). Brantford, ON: Working World Training Centre.

"Funerals." N.d. Haudenosaunee Confederacy Oshwe:ge Grand River (accessed 8 October 2014).

General, N., and E. Antone. 1998. "The Good Mind—Post Secondary Values." In *The Great Peace: The Gathering of the Good Minds* (CD-ROM). Brantford, ON: Working World Training Centre.

Gibson, J.A., and H. Woodbury. 1992. *Concerning the League: The Iroquois League Tradition as Dictated in Onondaga.* Winnipeg: Algonquian and Iroquoian Linguistics.

Gonyea, W. 2009. "Haudenosaunee Lives." *Indigenous Policy Journal*, 16 December. https://ipjournal.wordpress.com/2009/12/16/haudenosaunee-lives/.

Haudenosaunee Environmental Task Force. 2005. *The Words that Come before All Else.* Cornwall Island, ON: North American Indian Travelling College.

Hayes, R.G. 2013. "Mohawk Artist Shelley Niro Shows Movie *Kissed by Lightning.*" *Indian Time*, 18 April. https://www.indiantime.net/story/2013/04/18/news/mohawk-artist-shelley-niro-shows-movie-kissed-by-lightning/9537.html.

Indigenous Knowledge Centre. 2009. *Five Branches of Hodinohso:ni/ Rotinonshyonni Philosophy: Cultural Underpinnings of the Indigenous Knowledge Centre.* Ohsweken, ON: Six Nations Polytechnic. http://artmatters.ca/wp/wp-content/uploads/2014/10/WEBSITE-IKC-document-Five-Branches-of-Haudenosaunee-Philosophy.pdf.

Indyke, D. 2005. "Native Artist | Shelley Niro." *Southwest Art Magazine*, 15 March. https://www.southwestart.com/native-american-arts/shelly_niro.

Jacobs, B. 1998. *Rekindled Spirit: Research Project in Preparation for the Law Commission of Canada.* Ohsweken, ON: Bear Clan Consulting.

Jacobs, M. 2019. *Indian Pilgrims: Indigenous Journeys of Activism and Healing with Saint Kateri Tekakwitha.* Tucson: University of Arizona Press.

Jacques, F. 2014. "Use the Good Mind." *Teachings of Wellbriety* 2, no. 1: 9–10.

Jemison, G.P. 1991. "Jikonsaseh and the Woman of Nations." *Knowledge of the Elders: The Iroquois Condolence Cane Tradition*, edited by Jose Barreiro and Carol Cornelius, 22–23. Ithaca: Northeast Indian Quarterly, Cornell University.

Jocks, C. 1994. "Relationship Structures in Longhouse Tradition at Kahnawà:ke." PhD diss., University of California, Santa Barbara.

Johansen, B.E. 1995. "Dating the Iroquois Confederacy." *Akwesasne Notes* 1, nos. 3–4: 62–63.

Kelsey, P. 2014. "Tribal Feminist Recuperation of the Mother of Nations in Shelley Niro's *Kissed by Lightning*: A Rematriating Reading of the Women's Nomination Belt." In *Reading the Wampum: Essays on Hodinöhsö:ni Visual Code and Epistemological Recovery*, edited by Penny Kelsey, 65–80. Syracuse, NY: Syracuse University Press.

Kreimer, B. N.d. "Producer Profile: Shelley Niro." NAPT: Native American Public Telecommunications. https://www.mixcloud.com/discover/

indian+napt+native-american-public-telecommunications/ (accessed 5 June 2013).

Longboat, D. 2008. "Owehna' shon:a (The Islands): The Haudenosaunee Archipelago: The Nature and Necessity of Bio-Cultural Restoration and Revitalization." PhD diss., York University.

Mann, B., and J. Fields. 1997. "Sign in the Sky: Dating the League of the Haudenosaunee." *American Indian Culture and Research Journal* 21, no. 2: 105–63.

Mitchell, M. 1984. "The Birth of the Peacemaker." In *Traditional Teachings*, edited by Barbara K. Barnes, 17–30. Cornwall Island, ON: North American Indian Travelling College.

———. 2006. *The Haudenosaunee Code of Behaviour for Traditional Medicine Healers*. Ottawa: National Aboriginal Health Centre.

Mohawk, J. 1989. "Origins of Iroquois Political Thought." In *New Voices from the Longhouse*, edited by J. Bruchac, 218–29. Greenfield Center, NY: Greenfield Review Press.

———. 2005. *Iroquois Creation Story: John Arthur Gibson and J.N.B. Hewitt's Myth of the Earth Grasper*. Buffalo, NY: Mohawk Publications.

Murdock, M. 2009. "Niro's Journey." *Fenimore Art Museum Blogspot*, 25 June. https://fenimoreartmuseum.blogspot.com/2009/06/niros-journey.html.

Niro, S. 1997. "An Essential Personal Journey through Iroquois Myths, Legends, Icons and History." MA thesis, University of Western Ontario.

———, dir. 2009. *Kissed by Lightning* (motion picture). Turtle Gal Productions.

———. 2013. "The Journey's Discovery: An Interview with Shelley Niro." With E. Weatherford. In *Native Americans on Film: Conversations, Teaching and Theory*, edited by E. Marrubio and E.L. Buffalohead, 337–58. Lexington: University Press of Kentucky.

Palmer, V.A. 2014. "The Devil in the Details: Controverting an American Indian Conversion Narrative." In *Theorizing Native Studies*, edited by A. Simpson and A. Smith, 266–96. Durham: Duke University Press.

Porter, T. 1992. "Men Who Are of the Good Mind." In *Indian Roots of American Democracy*, edited by J. Barreiro, 12–19. Ithaca, NY: Akwe:kon Press, Cornell University Press.

———. 2008. "The Good Mind: Tom Porter, Bear Clan, Mohawk Nation Speaks Out." *First Nations Drum*, November, 8–9.

Printup, B., and N. Patterson. 2007. *Tuscarora Nation, NY*. Mount Pleasant, SC: Arcadia Publishing. Rice, B. 2013. *A Traditional Iroquoian History Through the Eyes of Teharonhia:wako and Sawiskera*. Syracuse: Syracuse University Press.

Rickard, C., and B. Graymont. 1973. *Fighting Tuscarora: The Autobiography of Chief Clinton Rickard*. Syracuse, NY: Syracuse University Press.

Rickard, J. 1996. "Indigenous and Iroquoian Art as Knowledge: In the Shadow of the Eagle." PhD diss., State University of New York at Buffalo

Shenandoah, L. 1994. "Foreword." In *White Roots of Peace*, edited by P. Wallace, 9–15. Santa Fe, NM: Clear Light Publishers.

Skye, R. 1998. "The Birth of the Great Law." In *The Great Peace: The Gathering of the Good Minds* (CD-ROM). Brantford, ON: Working World Training Centre.

Thomas, J. N.d. "Clan Mothers' Role." The Great Law, Tuscaroras.com. (accessed April 2001).

———. 1996. *Legend of the Peacemaker: The Great Law, John Arthur Gibson's Version.* Wilsonville, ON: Jake Thomas Learning Centre.

Thomas, J., with T. Boyle. 1994. *Teachings from the Longhouse.* Toronto: Stoddart Publishing.

Tooker, E. 1981. "Eighteenth Century Political Affairs and the Iroquois League." In *The Iroquois in the American Revolution: 1976 Conference Proceedings*, edited by C.F. Hayes III, 1–12. Rochester, NY: Rochester Museum and Science Center.

Wallace, P.A.W., ed. 1986. *The White Roots of Peace.* Saranac Lake, NY: Chauncy Press.

Williams, P. 2005. *The Great Law. Draft 1. April, 2004. Indian Law Course No. 808 Course Packet.* Profs. E. Meidinger and J. Mohawk. Buffalo, NY: University of Buffalo School of Law.

———. 2012. *Kayanerenkó:wa: The Great Law of Peace.* Collection of P. Williams, Middleport, ON.

———. 2018. *Kayanerenkó:wa: The Great Law of Peace.* Winnipeg: University of Manitoba Press.

MINOBIMAADIZIWINKE (CREATING A GOOD LIFE):
Native Bodies Healing

PETRA KUPPERS AND MARGARET NOODIN

To begin, in order to locate ourselves, we remember—*mikwendan*, which in the Anishinaabe language (Anishinaabemowin) literally means "to find consciousness in our thoughts." We are only two of the members of Miskwaasining Nagamojig (the Swamp Singers), a women's drum group who sings all songs in the Anishinaabe language and centres an Anishinaabe space and ways of being and healing. We are thinking of healing people and places through the steady beat of songs on skins, moving from studio space to sacred mounds, from land to water and all of the physical and intellectual spaces in between. In some of these spaces, we work within an Anishinaabe-centred framework, and all participants move with this understanding. In other spaces, such as at a symposium[1] or in a museum, our emphasis is more on cross-cultural ways of knowing, and there our different identifications as Anishinaabe or settler become more important. Together we investigate border zones, boundary waters, ways of being in flow with one another. We locate our writing and being through stories of the water flowing near us and the cities settled around us. *Minobimaadizi*, our "good life," encompasses many rivers, lakes, and cities—Detroit, Milwaukee, Toronto—places that suffer but can welcome our performance interventions to reach new ways of understanding health.

Maadweziibing: "Rivering"

Let's enter one of these complex spaces. We are at a symposium, Native Women Language Keepers, and creating a video entitled *Maadweziibing*, which translates (complexly) as "Rivering" or "becoming one with the river." The title holds echoes of Anishinaabemowin linguistic specificity, importing into English an active verb form of description layered over a noun-based static identity. The event was held at the University of Michigan in Ann Arbor in 2012, co-organized by Margaret, now a professor of American Indian Studies and Associate Dean of the Humanities at the University of Wisconsin–Milwaukee, and Petra, a professor of English and Women's Studies at the University of Michigan. The symposium was a week-long exploration of Native women's practices that included language teachers, activists, and artists, with many stories of women as keepers of water and language.

We created a video documentation, as a visual archive and memory space for the symposium, to record both the languages and the movements contributed by the participants. The resulting short video was curated and vetted by video performance specialists and by Elders, ensuring multiple audiences in culturally respectful language culture revitalization communities, health and well-being frameworks, and cross-cultural performance practices. In the video, we see the women participants introduce themselves by respectfully using a protocol similar to Māori *mihimihi* ("formal introduction"). In this way, we centre global Indigeneity and Indigenous ways of being in a community that did not share any one cultural form. Our way of sharing culture and identity is like rivering, all of us knitting our past and present selves into land and public history, acknowledging multiple points of location. Our words on that day show how identities and ways of connecting to place are shared. Through stories of water and land, we hear one another as we connect and remember our rivers:

> **Noodin:** If you say "water place," I think first of lakes, I think of Chigaming [i.e., the great sea, origin of the name Michigan] and those great lakes. But I also think of what we now call the Mississippi, the Michiziibing, that river ... is a big part of who we are.
>
> **Kuppers:** My river is the Rhine [in Europe]. So I come from a community where every waterway has a nixe, a mermaid

or a merman, every waterway has something living in it and something moving in it.

Noodin: And even our nation, in the U.S., what is east of that waterline [the Mississippi] and what is west of that waterline is a big part of the history of where Native people were [so many, over thousands of years, still in close relation to the waterways and lands surrounding this central river] and how the United States defined people.

Kuppers: And I remember growing up that each river and each tiny *Flüsschen* ["little river"], we would call them in German, each of those would be inhabited by dancing women.... Lots of my choreography comes out of living alongside rivers or alongside oceans. (Noodin and Kuppers 2013)

Other women, participants in the gathering, enter the watershed and dance into the space of remembering healing places. Ojibwe playwright Marcie Rendon[2] recalls that,

before I knew language, the sound that I knew was the sound of the Red River . . . and the leaves of the cottonwoods, there is a certain sound that they make that is like home to me. And then the other river would be the very beginning of the Mississippi. My grandfather was a logger up around in northern Itasca, up in the Jack pines. For me, it's that water and those trees that I hear. One of the first things that I tried to do in theatre was to get a musician that could actually make the sound of the cottonwood trees. Because that's the sound that is so important to me. (Noodin and Kuppers 2013)

Nimiipu language teacher Angel Sobotta[3] describes what our sharing of space does for us as a group: "And so right now we are speaking of place, the place of river and mountains. 'River' . . . for us is *ptik'un*, and 'mountains' is *méexòsem*. When I am listening to everybody speak about their river and their mountains, I have no idea where you are talking about. But what I do know, and this is going to be the same for me when I describe where I am from, . . . what I do know is that there's wisdom that sits in these places, there's wisdom in these places, there is power in these places" (Noodin and Kuppers 2013). Together we find

balance in the land, with the land, healing the land, healing ourselves, allowing our efforts to take shape in song and motion, in public, through cross-cultural engagement, in sites at multiple edges of colonial and postcolonial encounter where land and water meet, where the swamp sings, where the drum represents the sound and motion of pounding, pulsing places, rivers flowing into crevices in the land.

We sing together while our hearts and drum create a rhythm:

> Shkaakaamikwe g'gikenmaanaa
>
> (Mother Earth we know her)
>
> G'gikenmaagonaan pii nagamoyaang
>
> (She knows us when we sing). (Noodin and Kuppers 2013)

Presence emerges in the vibrations of sound that always go well beyond what is audible and that vibrate our human membranes in conjunction with the skins of other animals, the sinews of deer, the wood of the frame. Vibrations travel, and the drum heals.

In our ear is sociologist Avery Gordon's (2008) formulation of ghosts as "dense site," and we remember the opening, layering, breathing action of drumming as we know it: density gets unpacked, opened out, comes to consciousness. When you beat a drum, your bones get nourishment; you can feel the beat running right into your feet and the crown of your head. It is calming to drum; it creates alternative rhythms that override our nervous sensoria and realign us anew: fluffed, aired, beaten, stretching density out into a field of sound.

In the heart and circle of the drum, many people find connection. In the *Madweziibing* video (Noodin and Kuppers 2013), Daphne Odjig's painting of a woman/spirit/drum becomes animated as our video editor JaiJai Noire pulses the image in rhythm with the drums. Odjig, born in 1919 and a member of the Woodland School, is recognized as being responsible for revitalizing legends, for finding wisdom relevant to contemporary practices, and her voice becomes a part of the conversation as the swirling embodiment of people dancing bulges into the video space.

Performance studies scholar Diana Taylor (2003, 82), in her discussion of memory, archive, and the repertoire, uses the image of the heart as a way of thinking about the inevitability and uncontrollable nature of memory emerging in life: "Memory, like a heart, beats beyond our capacity to control it." These organic connections between the blood

pulse, the drumbeat, the heart, and the memories embedded in territory push through us as we think about different art traditions in confluence. We witness them in flow with one another, streaming the dense sites of ghosting, opening them up in the beat of the drum. There is a worrying like water around a rock, the rock of the inhumanity, injustice, and genocidal violence of colonialism, and there is a people's drumming, singing survivance.

To shift these gravities, to allow a new path to be forged, chiming with old songs and older waters seems to be a way of coming together of different people in ways that respect site, land, and language. But this embodied theorizing, making art together, drumming, must understand itself to be a syncope, a singularity, respecting and weaving back into the breath of the drum, respectful of the moments when there is no beat, when we do not know what people's experiences were and are. Our performance marks the presence of ghosts, makes them part of our lifeworlds, but does not dismiss them.

We live in a global net that allows us to drum and sing for many occasions, to hear of exciting projects at conferences, to find traces online, and to connect and reconnect joyously with fellow art practitioners, community members, and relatives who work to reshape the public sphere. Living collectively and practising *minobimaadizi* in an artful world comprise the horizon of our desires as art practitioners and teachers, but any documentation witnesses only some of the meanings that the artists encode in their work. Living well within all of that and finding ways to connect readers and viewers to new experiences without offering an illusion of grasped knowledge are their own particular cross-cultural jazz.

In the context of this particular performance piece, this means recognizing that the different languages at play—drumming, singing, different Indigenous and settler protocols such as Māori *mihimihi* or the conventions of a black box theatre—are cultural expressions and fields of discourse that will be more or less recognizable to members of different communities, to people with different affective citizenships. Tribal members will respond differently from people who identify predominantly as settlers or from those who have the privilege never to think about how they identify on this continuum. And affective communication is at play within and beyond the more traditional discourses supported by academia: historical reclamation and truth

seeking, the marking of atrocities, rights, and treaties. In this discussion of our symposium, our drumming, and our video, we mark the site of affective encounters, the facts that something happened and that someone recorded it and made it available to a larger public than the one witnessing in the flesh. As we move through the remainder of this chapter, these tactics remain vital to us: experiences that have meaning in the moment and in the audiencing that happens from afar. We keep ourselves well, in our locations, and in our wider world.

Waawiyatenong: Detroit

Centred by the relationship between land and water, seeking the heart-beat of continuity, one early fall day we assemble for our drive to Fort Wayne, a public park in Detroit, Michigan. The Anishinaabe name for the city is Waawiyatenong, describing the rhythmic and powerful whirlpools of the place between Lake Huron and Lake Erie. In his history of Detroit, Silas Farmer (1890, 225) describes the location of Fort Wayne as "in the township of Springwells, three and one half miles from the City Hall, at the only bend in the river, and also at its narrowest point." This space at the edge of the city where land and water meet has been significant for centuries. It is the original location of a group of mounds dating back to the year 1000 BCE (Halsey and Stafford 1999) and the former site of a Potawatomi village from 1710 to 1771 (Clifton and Porter 1987). One mound remains, and according to archaeologist Carl Homquist (Holmquist 1945) two bodies remain inside it. Our wheelchair-accessible van, rented from the university, carries an undergraduate student, a fellow professor from a nearby university, and Petra, a wheelchair user. With us, safely tucked away, are our drums and regalia, for we are going to perform at the Healthy Families powwow after our performance action/ritual.

The sun is shining golden on us as we make our way through the iconic landscape of East Detroit. This is the area usually referenced in TV shows and documentaries that wish to show what some of us call "Detroit porn": the romantic devastation of burned-out buildings, graffiti, and unused railway tracks. Finally, we arrive. And a surprise is in store for us. We had not announced our coming: Fort Wayne is a public park, and the remaining burial mound that we've come to honour and nourish is open to all. But this Saturday is different, and our Performance Studies hearts beat more quickly. There is a Civil War

re-enactment going on this weekend. Performances upon performances upon performances. Here we are, a female Anishinaabemowin-singing hand drum group, with some non-Indigenous members learning the language. We are here to end a year-long exploration of the way that Indigenous women heal the land and themselves that began as the Native Women Language Keepers collaboration, the symposium discussed above. This weekend allows us to deplete our research funds for this project, which included the large-scale, week-long symposium with guest artists and fellows from across Turtle Island. Celebrating the temporary end of our journey, we think that it is fitting to end with a community arts–style engagement with a local site, bringing the Swamp Singers out to one of our significant sites in need of healing. With our drums, we were planning to honour our ancestors and mark the passing of time on this land, on which Indigenous peoples of many centuries and nations; French, British, and American soldiers; and eventually a variety of American settlers have left their now deteriorating marks. All kinds of temporalities and people mix—dead, alive, killed in wars, and honoured by survivors.

The guard who speaks to us through the open van window is well aware of the weight of this moment: American Indians coming to honour ancestors whose graves are currently the host sites for crino-lines, cannons, and pup tents of Confederate soldiers. The guard speaks quickly, and words tumble out of his mouth: he has been working here for decades, it seems, and has seen money for restoration and upkeep come and go with the fluctuating fortunes of Detroit. He is eager to tell us how happy he is to see us and how he has tried his best to keep the mound safe, and allow access to the site even when the city had shut down all services, when no one at all cared for this historical site. But now he has to work out what to do in his position of authority, his position as gatekeeper, and the uncomfortable responsibilities that come with it. He is on his walkie-talkie. It's getting sorted out. We have to pay a parking fee, but no entrance fee to the re-enactment extravaganza, it turns out. Just follow him. He shows us where to park.

Among us are Elders: the father of one of the students and a rec-ognized master dancer and huntsman; a healer; and a naturopath and analyst. Among us are youngsters: daughters of some of the singers. We all emerge from our vehicles and spread out blankets near the mounds, curiously surveying where we find ourselves. The buildings are made

from the red bricks so often associated with Detroit: mellow, aged, a crumbly terracotta-fired orange. The architecture is "military fort circa 1840s": square, big buildings, utilitarian. Some have seen some torching, it seems, black on red tooth marks. Some are barred shut. But some are open.

We blink. The strangest mélange of people is milling about the site. They are thinly spread: in keeping with Detroit aesthetics, sparseness and spaciousness also characterize this assembly. This is not the clusters of activity with which we are familiar from images of battle re-enactments. But there they are: people in blue and grey, pressed trousers, caps in their hands or on their heads. There are women with swinging, muted-coloured, upturned tulip shapes, crinolines with hidden cages likely—plastic or whalebone or cane, who knows? Some of us do not really look at the people closely, for they are far away, across the street, and we are keeping up with our own friends here. There is a strange sense of us versus them. For a moment, our group is a collection of individuals, each taking in the situation differently.

Petra, as a European settler with her own story of arrival in this place, recalls the scene. My friends in our group are spiffed up, but I am so familiar with their dress: this is what I see most Mondays when we assemble for drum group practice. Pendleton blankets, all the women in skirts. I did buy a second-hand skirt particularly for participation in the Swamp Singers. No one made me or asked me to, but it seemed to be the respectful thing to do after turning up to lots of events with my usual leggings. Lots of rules seem to be unspoken or there to be picked up on when ready to do so. I am a foreigner here, one way or the other, and usually quite happy to roll with such shrouded protocol. No need to ask all the time. As we wheel and walk along, one woman draws near us and just keeps on asking us questions. If I felt in a different frame of mind, then I'd really like to inspect her closely, but that would signal way too much interest in our conversational moment. She's decked out in quasi-Victorian gear, with little jet black ornaments heaving on her bosom, and I feel like I am standing in a historical detective novel. "I am giving a storytelling session in the house over there, why don't you come and join us?" She chirps at us, very friendly but a bit too pressing. Lady, see us walking quietly to that mound over there? Not to the house. Away from the house. Observe the backs of this row of people, with whom I form a chain, stretching by you as you try to draw me into

conversation, a row intent on where we are going, an arrow pointing directly at the one feature of the terrain not made from brick or board, not festooned with war paraphernalia.

Margaret's view of the scene is an attempt to move out of time. These mounds are remnants of several former mounds that once stood along the edge of the Detroit River. Some are ancient, and others are more recent. Potawatomi historian Michael Zimmerman has told us of the leader who lived in this place, Ininiwizh. It matters that he lived in the late 1700s as the settlers began shifting the earth to create walls and divide cultures and that in 1771 he left this place, this river, and these waters. It matters that his name means "milkweed," the sole food of monarch caterpillars. We need to listen for the bees, for the whisper of the grass, the rattle of beads attached to drums, letting the sun warm the centre of the skin so that it is stretched tight and the beats will be strong.

Concluding a circle around the mound, our thoughts are once again together and centred on the present as a man with a walkie-talkie speaks, when pressed, about the possibility of finding the key to the big lock that keeps the mound separated from the fort. We wait for a while, but he does not rematerialize. Handing us the key might be too big a step for a gatekeeper and might require some authority beyond his own. He tried, we are certain; he seems to be a kind and fair man, just flustered by the clash of cultures enacted here today in what still strikes us as a Performance Studies tableau.

We offer tobacco together, and we find accessible spaces together. We are at the mound. Everybody is getting cozy, shifting blankets, getting out drums, rattles, sage, and important items. Some of us wander off to find a loo. We won't get going for a while. The woman in the Victorian getup tries to engage us again, and we smile and veer away. Petra's wheelchair rolls easily on the concrete paths. We even find an accessible toilet in this site halfway between devastation and tourism reclamation.

People, politics, space, and access shift, layer into each other. Writing later about the strange mound visit/Civil War re-enactment performance by the river, Petra remembers a talk that she recently heard about an ex-slave who came to Detroit, bathed in the river, was baptized with a new name, and didn't cross over to the freedom of Canada but instead stayed in Michigan. She switches back into the first person to share the story and her response to hearing it.

"He went to the Detroit River, got baptized and newly born into his post-slavery name." This is a quotation from our guide that day, in Ypsilanti. In all the richness of material presented by Matt Siegfried, our historian guide to Black Ypsilanti, this image captures me and rises up to me in all its sensual richness: the flowing water, the boundary separating the land of slavery and Canadian freedom. The step down into the cool river, likely with a group of supporters, spiritual guides, a minister, a solemn crowd, a new circle. The immersion, a disorientation, a renewal, and emergence yet again. Not on the side of freedom, of escape, but the freed man taking up residency on the U.S. side, ready to make a new life, with a new name, washed free. I rein in my imagination before I go too far, before I begin to romanticize this historical image, before I get too close, see water drops on dark skin. This image is not mine to bathe in. But its lyricism and rightness settle deep down and combine with the sound of spirituals, "go down to the river," crossing Jordans. Other images rise up: the Alvin Ailey company dancing "The River," set to Duke Ellington's first symphonic score written for dance. The river draws and tumbles, rushes and waltzes, slows and speeds, and both dancers and musicians have drawn on these fluxes of the watery realm.

"He went to the Detroit River." We stand together in Detroit on the same river's banks, a few hundred yards down from one of the new sturgeon release stations, during our visit to the mound. The big bony fish are back, one at a time, beginning to repopulate what had become a cloaca between the ex-slave's time and our own, in twenty-first-century Detroit in its post-industrial period. The St. Clair/Detroit River area is beginning to see new dark shadows, its own river monsters, harbingers of cleaner times and healthier habitats for all. We are singing and drumming for the water, at the point where Fort Wayne shelves down to the river, just down from a large burial mound. One in our group lowers a small copper cup into the swift and broad river, careful not to fall in, some of us holding hands with her to anchor her to the land. All around us, open patches remind us of the burnings, clearings, and decline and renewal of Detroit. To go down to the river here means connecting anew to the trade routes and waterways that marked the land before labels such as United States and Canada held much weight. The name of the river comes from the French, Rivière du Détroit, River of the Strait. It is the narrowing, the chafing, of two land

masses close to one another, a place of tension, of traffic, of exchange, of new names and French forts that try to take hold of the land. And of pulling together: today the river is the only one to be designated as an American Heritage River and a Canadian Heritage River. "He went to the Detroit River": the meanings of the phrase shift across cultural crowds, solemn groups going fishing, going to perform rituals, going to carve up water streams to cool nuclear stations and release poison, going to release ancient bony fish. The water is a watershed, a site of reckoning. You will be judged here, and who will release you back, onto which land, and how will it name you?

These fragments of memory of Detroit are sites of cultural mixing, cultural violence, encounters in awkward, violent, and healing modes. The drum connects these sites and the being-with the Miskwaasining Nagamojig. Much needs healing here—from unclean waters to military sites, from declining civic health to language revitalization—as we sing. By being here, and remembering being here, we mark that we can work on the land, on ourselves, on histories, on new stories and songs drumming into the future.

Minowaki: Milwaukee

Later the same summer, the Swamp Singers travel to Milwaukee, Wisconsin, along the western shore of Lake Michigan where the Milwaukee River reaches into another urban landscape. In this place, the healing of land and community comes in the form of leaves and light. Milwaukee is one of many cities working to shed an industrial past and emerge as a greener, healthier space. The non-profit group Beintween organized an arts showcase in The Artery, a new park in the Harambee neighbourhood. The space was designed by community members through an initiative called Creational Trails and was once part of the Old Milwaukee Railroad's Gibson Yards. It is now a walking trail being reclaimed by plants and people. In this space, Miskwasining Nagamojig (the Swamp Singers) work with the artists and activists of the Overpass Light Brigade (Ishpaa'ii'waaskone'aazhogan) to host a walk that invites participants to sing and celebrate the native medicinal plants growing once again in the area. The event began with a song that is a reminder of the four directions and our relationships with land and water:

Shkaakaamikwe, Mazikaamikwe, Shkaakaamikwe (Mother
Earth)

Gidaanisag bimosewag (Your daughters, they walk)

Giiwedinong (from the homing place, North)

Waabanong (from the place of light and sight, East)

Zhaawaanong (from the warm direction, South)

Ningaabii'anong (from the place where it melts into the
water, West)

We chose to sing this song because "Shkaakaamikwe" is a signature song
for our group. The lyrics reminded us of the concept of the Earth as a
sustaining force, and though it is often translated as "Mother Earth," the
literal meaning of the words is a combination of the murky, indefinable
source of life, the transformation of eggs and seeds, and the feminine
power to divide cells and create life from liquid.

Singers and neighbours walked half a mile together, stop-
ping to collect preharvested and dried leaves and berries. Signs in
Anishinaabemowin and English pointed out where to find *waabooyaan-
ibag* ("mullein"), *mitigwaabimin* ("mulberry"), *niniwish* ("milkweed"),
and *wiingash* ("sweetgrass"). We engaged in impromptu and diverse
conversations comparing ways to steep, singe, and sample these plants.
One of the main messages that resonated with our group was that
everybody is an entire system with unique reactions and responses,
dispelling the notion that a single prescription can cure a population.
On the commons in this way, the interdependence of individuals was
stressed. How can a community be healthy if the hearts and minds with-
in it are not? To balance that question, how can individuals heal if the
social and ecological arteries on which they depend are not sustained?

After people gathered herbs in bundles, palms, and pockets, the
group reached a fire centred in a circle of stones. Those who wished to
offer a few leaves to the flames did so. Others simply took a seat warmed
by the heat of the fire. On a nearby stage, the Swamp Singers and mem-
bers of the Overpass Light Brigade presented a lesson in translation.
With audience members each holding one large letter, words appeared
and were rearranged, with translation and pronunciation guided by the
group. The words were a poem in ever-shifting lines:

Niimi (Dance)

Giniimi (You dance)

Giniimimin (We dance together)

Giniginige (We mix)

Michigaming (A Great Sea)

Mino (Goodness)

Minoabii (Good Water)

Minowakii (Good Land [Milwaukee])

Miskoasin (Red Stones, Copper Land [Wisconsin]).

Learning these words, gathering the medicines, neighbours reconnected (human and non-human, plant and person, smoke and mud, wind and grass), and the sense of space and time shared was restored in a way that can be carried into the streets. In Anishinaabemowin, the word for "town" is *odena*, meaning the heart, the place where resources are exchanged, where transfer takes place, where what is needed is energized, redefined, and sent out via arteries to restore and continue the cycles of life.

Mississauga: Toronto

Our last effort of the year to reconnect people to water and the flow of life takes us back east and back in time to Fort York National Historic Site in Ontario, Canada, which marks the place called Toronto (Tkaronto) by the Mohawk and Mississauga by the Anishinaabeg. Both names referred to a narrow waterway good for fishing. Through a flight of eco-imagination, curators at the Fort York Museum partnered with the Cities in Time project to represent history using virtual reality and apps that allow people who visit Fort York to step back in time. This is a strange proposition that requires a critical conscience. The fort is considered the "birthplace" of modern Toronto and is now the site of innovative museum work, including physical and virtual interpretive experiences (see http://citiesintime.ca/toronto/).

From an Indigenous perspective, the actual history of Fort York National Historic Site is one of cataclysmic warfare. The site rests on what was once the shore of Lake Ontario, now an artificially constructed

system of streets. It is also home to Canada's largest collection of 1812-era military structures. The Visitor Centre itself is a forty-three-acre park and set of buildings, which opened in the fall of 2014 for the 100th Anniversary Commemoration of the Great War. Of course, the "greatness" of that war is one of many points to be reconsidered. The northwest shoreline of Lake Ontario was once inhabited by the Huron, then later by Haudenosaunee and Anishinaabeg people. The Mohawk of the Haudenosaunee Confederacy called the place Tkaronto, and the Anishinaabeg called themselves and the place Mississauga, both in reference to the water and the vast space available for fishing. Situated near Lake Simcoe and not far from the southeastern shore of Lake Huron, it is a space defined by the relationship between water and land: "Since the seventeenth century, the Toronto area has been a borderland, a sometimes contested and sometimes shared territory of importance because of its salmon fisheries and its strategic access to Georgian Bay" (Freeman 2010, 32). Like Detroit and Milwaukee, Toronto is a city with a complex and cosmopolitan past. It was a contact zone where the Mississauga and Mohawk peoples traded with French and British settlers (Spillman 2003, 163). There is a long history of Indigenous presence in this space that brings us to the connection between the Swamp Singers and Fort York.

Working collaboratively with the museum, visitors to the area use web-enabled mapping devices to see the past. In one of a series of videos, the shoreline is reimagined, showing two Anishinaabeg navigating the water in a birchbark canoe. The rower sings a fishing song, and the fisher pauses, spears a fish, and then offers a few crushed leaves of *kinickinick* in thanks. The strong woman rowing sings:

> Maashkinoozheg, kinoozheg (Muskies, pikes)
>
> Ganebigomegoog, nameg (Eels, sturgeons)
>
> Maada'ookiiying zibii (We share the river)
>
> Ezhi-maashkoziyeg (The way you are strong)
>
> Maada'oozhiyaang (You share with us).

And then, after a spear slices through the water, the man says, "Gimiigwechwigo gii bagidenindizoyan (Thank you for sacrificing yourself)." The questions that arise are of cement and perspective. Is

it possible for an ephemeral electronic palimpsest to plant a seed of empathy, perhaps even encourage much-needed ecological healing? Of course, it is an admirable goal for the people of Toronto to see that ancestral image of the shore still geologically present under their city, to think about the language that is as endangered as the eels and sturgeon. How can that strong woman rowing be seen as the great-great-great-great-grandmother, the *ankobijigan* ("the connected one"), who embodied "stewardship" and "sustainability" before such terms were used? Would she have known the pain of missing women and children? Could she have imagined a future in which over 1,200 Indigenous women are missing or were murdered in a place called Canada? How can the cell walls between politics and arts be permeated in a way that inspires healing? For the Anishinaabeg, Fort York and many of the Great Lakes forts are sites of genocide and burial. How can history be repatriated? Imagine if the song contributed to the virtual exhibit was the song still sung around fires in the Great Lakes area to call Tecumseh's ghost and assure him that we have not forgotten.

Deweganag ("Living Drums")

In these stories of presence, performance, and memory, we always circle back to the healing, to the way that a circle of skin can create connections, to how a rhythm shared can extend life. At the centre of so many of the activities of the Swamp Singers is a drum—small, handmade, hand-held, and often warmed by the friction of palms to ensure that the tone is strong. The word for "drum" (*dewegan*), like the word for "town" (*odena*), connects to the notion of "heart" (*ode*), an epicentre of water cycling through bodies. However, more than a physical system of chambers, veins, and arteries, the concept of the drum and the heart centres on the beats, synonymous with energy. Just as the heart depends on a steady impulse to continue, so too does a song. The impulse, when examined, is the same that drives all life, a biological ability to transfer matter into energy. Both a heartbeat and a drumbeat signify the continuity of connected systems, liquid and air, earth and fire, a river of time. For eels, this might be water through the gills, for humans it is air into the lungs, for singers it is the entwinement of patterns of sound and meaning. Our journeys beside waterways are attempts to reconnect the land and the water, the matter and the energy, and to know that this can be done in the shadow of big cities and with the vision of continuity.

Notes

1 A version of the symposium section of this chapter will also appear in Petra Kuppers's forthcoming book *Eco Soma: Pain and Joy in Speculative Performance Encounters* (University of Minnesota, 2022).

2 Marcie Rendon (Anishinaabe) is a theatre maker and writer activist who supports and encourages other writers to write in Ojibwe. Among her projects are a writing residency that she facilitated on the White Earth Reserve as part of a three-phase Project Hoop Residency to create theatre projects at a community level. At the symposium, she led a ten-minute play, *Friends. . .*, published in *Performing Worlds into Being: Native American Women's Theater*.

3 Angel Sobotta (Nez Perce) is a language teacher in the tribal headstart, local schools, and at the Lewis-Clark State College in Idaho. She is also a writer and documentary filmmaker of projects such as '*Ipsqilaanx heewtnin' weestesne—Walking on Sacred Ground—the Nez Perce Lolo Trail* and *Surviving Lewis and Clark: The Niimiipuu Story*, winning the Aurora and Telly awards respectively. She is also a theatre maker with the Lapwai Afterschool Programs, teaching language by adapting legends and directing youth, including *Niimiipuum Titwaatit—The People's Stories*, an anti-bullying project in 2012. Angel is a University of Idaho interdisciplinary master's student. Her thesis involves an immersion experience for language teachers by adapting the Nez Perce Creation story, written in the Nez Perce language, into a stage play.

References

Clifton, J., and F.W. Porter. 1987. *The Potawatomi*. New York, NY: Chelsea House Publishers.

Cornell, G., and J. Clifton. 1986. *People of the Three Fires: The Ottawa, Potawatomi, and Ojibway of Michigan*. Grand Rapids: Michigan Indian Press, Grand Rapids Inter-Tribal Council.

Farmer, Silas. 1890. *History of Detroit and Wayne County and early Michigan*. New York: Munsell and Company.

Freeman, V. 2010. "'Toronto Has No History!' Indigeneity, Settler Colonialism and Historical Memory in Canada's Largest City." *Urban History Review* 38, no. 2: 21–35.

Gordon, A. 2008. *Ghostly Matters: Haunting and the Sociological Imagination*. Minneapolis: University of Minnesota Press.

Halsey, J.R. and M.D. Stafford, eds. 1999. *Retrieving Michigan's Buried Past: The Archaeology of the Great Lakes State. Bulleting 64*. Bloomfield Hills, MI: Cranbrook Institute of Science.

Holmquist, Carl E. 1945. "The Fort Wayne Mound." Detroit: The Aboriginal Research Club.

Miskwaasining Nagamojig. 2016. "Shkaakamikwe: Mother Earth." 2 April. http://ojibwe.net/songs/womens-traditional/shkaakaamikwe-mother-earth/.

Noodin, M., and P. Kuppers, dirs. 2013. *Maadweziibing (Rivering)* (motion picture). Olimpias. www.youtube.com/watch?v=vKHtaHYQ5CQ.

Spillman, L. 2003. "When Do Collective Memories Last? Founding Moments in the United States and Australia." In *States of Memory: Continuities, Conflicts, and Transformations in National Retrospection*, edited by J.K. Olick, 161–92. Durham, NC: Duke University Press.

Taylor, D. 2003. *The Archive and the Repertoire: Performing Cultural Memory in the Americas*. Durham, NC: Duke University Press.

Part 4

Resistance, Resurgence, and "Imagining Otherwise"

CHAPTER 9

BODY COUNTS:
War, Pesticides, and Queer Spirituality in Cherríe Moraga's *Heroes and Saints*

DESIREE HELLEGERS

Heroes and Saints, by Chicana poet, essayist, and playwright Cherríe Moraga, explores the toxic transformations of the land and the bodies of farm and factory workers in a fictionalized town in California's San Joaquin Valley. Debuting as a staged reading in 1988, and as a full production in 1992, the play was inspired by the United Farm Workers' (UFW) grape boycott of the 1980s, which focused public attention on the health effects of pesticide exposure on low-wage farmworkers. An arts-based community health intervention, the play diagnoses the intersecting social determinants of farmworker health and prescribes collective resistance to the toxic effects of agribusiness. The play represents the environmental health effects of pesticide contamination as part of an unfolding history, stretching from the San Joaquin Valley through Mesoamerica, of neocolonial violence against workers and the land. The play conflates the exploitive labour practices of California agribusinesses with paramilitary violence against Indigenous peasant farmers—or campesinos—in El Salvador and Guatemala in the 1980s and 1990s. *Heroes and Saints* situates the workers' struggle, and environmental justice organizing more broadly, within the context of radical—and expressly queer—transnational anticolonial resistance.

In this chapter, I devote particular attention to Moraga's play in relation to her talk "Art in América con Acento," delivered on 8 March 1990 at California State–Long Beach, while *Heroes and Saints* was still

in development, and her 1994 essay "Queer Aztlán, the Re-Formation of Chicano Tribe," based on a presentation delivered in May 1992, a little over a month after the premiere performance of *Heroes and Saints*. In these talks/essays, Moraga discusses *Heroes and Saints* in the context of her engagement with multiple and intersecting sites of transnational movement formation. Drawing on her own observations about the play and its relationship to movement politics, I examine tropes of disappearance, dismemberment, and silencing in the play that constitute unlikely links among UFW organizing, ACT-UP, the Mothers of East LA (MELA), and mothers' movements in Latin America, including the Mothers of the Plaza de Mayo in Argentina and the CoMadres in El Salvador.[1] I argue that the play's intersectional queer feminism links the silent deaths of campesinos/farmworkers in the United States and Latin America with homophobia and the AIDS crisis, queering, feminizing, and Indigenizing Latin American liberation theology.[2] In the process, I examine and critique ideological barriers to coalition building among communities whose lives and bodies are routinely relegated to the status of disposable commodities. I also touch, finally, on important questions that the play raises about the links between dioxin contamination—including pesticides, fumigants, and defoliants—and U.S.-sponsored neocolonial violence, from the Vietnam War to the War on Drugs.

Introduction

In the author's notes to *Heroes and Saints*, Moraga specifically acknowledges the impact on the play of the 1986 UFW-produced documentary *The Wrath of Grapes*, which focused on farmworker communities in the San Joaquin Valley struggling with a wide range of health issues, from cancer and chloracne to miscarriages and congenital birth defects. One image in particular centrally informs Moraga's play: that of six-year-old Felipe Franco, born "with tiny flippers where his arms and legs should have been" (Setterberg and Shavelson 1993, 20), whose story is documented in the UFW film. Among the many chemicals that Felipe's mother, Ramona, was exposed to while working in the fields during her pregnancy was Captan, "a fungicide whose chemical composition resembles Thalidomide" (Setterberg and Shavelson 1993, 21). A drug marketed to pregnant women in the late 1950s and 1960s, Thalidomide drew international visibility and a long-standing ban when it was

linked to a wide range of birth defects, including a condition clinically and rather euphemistically termed "limb deficiency." In contrast to Thalidomide, which affected a relatively privileged population with access to prenatal care and prescription drugs, the effects of concentrated levels of Captan exposure are limited to low-income farmworkers who have little access to health care.

The fictionalized town at the centre of Moraga's play is based largely on the town of McFarland, just six miles away from Delano, the home not only of Felipe Franco but also of the UFW and, in the 1960s, César Chávez, who co-founded the UFW with Dolores Huerta in 1962. Both McFarland and Delano are located in the San Joaquin Valley. Dubbed the "breadbasket of the world," the San Joaquin Valley is "the largest agricultural zone" in California and "the richest in the United States" (Walker 2004, 42) in terms of the profits that it generates for growers. However, counties in the San Joaquin Valley rank among the poorest and most food insecure in California.[3] In the 1980s, Kern County, in which both Delano and McFarland are located, had the distinction of being the "second leading pesticide use county in California" (Moses 1989, 123). In the 1980s, childhood cancer rates in McFarland shot up to "more than 300 percent above the normal rate expected for a town of 6,200" (Setterberg and Shavelson 1993, 9). Undoubtedly, those most at risk of pesticide exposure and the resulting health effects were—and remain to this day—the predominantly Indo-Hispanic farmworkers exposed to toxins in the fields. Worldwide, "from production to consumption and disposal, farmworkers, the poor, women, children, indigenous people and people of color" are disproportionately affected by the health risks of pesticide exposure (Pellow 2007, 150).

In Moraga's play, concerned with multiple forms of agency—corporeal, sexual, cultural, and political—Felipe Franco's condition is vividly reimagined in the character Cerezita, the unlikely protagonist. Cerezita—or Cere—is a literal talking head whose absent body is an effect of the exposure that the character's mother suffered in the field. At the same time, Cere's absent body—including genitals—calls attention to the cultural construction of gender and challenges binary constructions of gender. Because, as I will argue, Cere's gender identity is non-binary, I will refer to the character throughout this chapter using the gender-neutral pronouns *they* and *their*. Cerezita's name, meaning "little cherry," is one of many gestures in the play that links the wounded

bodies of agricultural workers with the toxic agricultural landscape that surrounds them. The name also aligns with the play's critique of the Catholic fetishization of virginity and preoccupation with the control of women's sexuality. Cere delivers their lines from atop a "rolling table-like platform" or mini stage, referred to as their *raite* or "ride," a vehicle that resonates with the power that they progressively assume as an orator if not an oracle (90).

Over the course of the play, Cere struggles against the attempts of their mother, Dolores, to shield their injured body—or lack thereof—from public view. Periodically, they escape their mother's control long enough to help orchestrate a series of mock crucifixions to raise public awareness of the lethal effects of exposure to pesticides and other toxic contaminants over which the town was built. Cerezita and their collaborators display the bodies of children who have recently died from cancer. The public display of the bodies garners media attention from the reporter Ana Perez and helps to spur others, including the activist Amparo, and the timorous Father Juan Cunningham, to action. The play culminates with Cerezita transforming and publicly displaying themself in the image of the Virgin of Guadalupe before they and Juan lead a revolt against the growers, who fire at them from the helicopters that hover menacingly above the community throughout the play.

The play's concern with forging transnational alliances between exploited Chicanx[4] farm and factory workers and Indigenous campesinos fleeing repression in Central America and seeking refuge—and work—in the San Joaquin Valley is evident in the multiple allusions to Olmec, Aztec, and Mayan cultures in particular. All three cultures extended throughout Mesoamerica. As a "head of human dimensions," Cere, nonetheless, is represented in the production notes as "assum[ing] nearly religious proportions"; the "huge head figures of the pre-Columbian Olmecas," Moraga observes, "are an apt comparison" (1994, 90). Although the geographical reach of the ancient Mesoamerican Olmec extended from the Gulf of Mexico to present-day Nicaragua, Mayans still inhabit portions of traditional homelands that extend from southern Mexico through Guatemala and Belize and into western Honduras and El Salvador. The southern reach of the Aztec Empire extended through Guatemala and El Salvador into Honduras, but its northern boundary is contested, with estimates ranging from central

Mexico to as far north as the area of the southwestern United States, incorporated by force under the 1848 Treaty of Guadalupe Hidalgo.

In the late 1960s in particular, the Aztec Empire—figured as Aztlán—became an animating element of the Chicano nationalist movement.[5] Following the Chicano Youth Leadership Conference in 1969, at which the poet Alurista read his manifesto "El plan espiritual de Aztlán," equating the American Southwest with the Aztec Empire, Aztlán served as a "compensatory symbolic mechanism" for Chicano nationalists (Labarthe 1990, 80). Aztlán served as a rallying cry for Chicanx self-determination in the face of Anglocentric ideologies that, as Gloria Anzaldúa has observed, relegate the "inhabitants of the [American Southwest] borderlands" to the status of "transgressors, aliens—whether they possess documents or not" (1987, 25). At the same time, however, Aztlán effectively effaced Chicanxs' culturally and geographically diverse Indigenous roots, which range from the southwestern American states annexed in the wake of the Mexican-American War to the Yucatan Peninsula. "Chicanos' Indian roots," as Moraga observes in "Queer Aztlán," "encompass a range of nations including Apache, Yaqui, Papago, Navajo, and Tarahumara from the border regions, as well as dozens of Native tribes throughout México" (1993, 166). The "ancestral" lands claimed as part of the historical Aztec homeland, then, also "squarely overlapped the claims of Native American nations to the same lands" (Price 2004, 73).

Although in its references to the Olmec and Mayan cultures *Heroes and Saints* effectively challenges the centrality of Aztec culture in constructions of Chicanx identity, ironically it erases any mention of more historically and culturally specific Indigenous territorial claims to the San Joaquin Valley. Entirely absent from the play is any mention of the Yokuts, Miwok, and other tribes native to the San Joaquin Valley.[6] In this respect, Moraga falls short in *Heroes and Saints* of the attentiveness to coalition building between Chicanxs and Native Americans that infuses her analysis in "Queer Aztlán." In that essay, she articulates the goal of "defend[ing] remaining Indian territories" as a central commitment of the "new Chicano nationalism" that she envisions (1993, 174). In *Heroes and Saints*, however, Moraga's goal of forging transnational alliances between Chicanxs and Indigenous peoples fleeing U.S.-sponsored violence in Central America clearly eclipses her concern with coalition building between Chicanxs and Native Americans.[7]

Engendering Resistance:
Queer Aztlán, the UFW, and Transnational Solidarity

In the 1960s, the UFW struggle for living wage jobs became a light-ning rod for the Chicano Movement, and as the daughter of an Indo-Hispanic mother Moraga grew up listening to stories about her experiences as a farmworker. In her collection *Loving in the War Years*, Moraga (2000, 42) recalls "stories of her [mother] being pulled out of school at the ages of five, seven, nine and eleven to work in the fields, along with her brothers and sisters." In "Art in América con Acento," Moraga (1992, 158) explicitly glosses Cerezita as a response to the silencing and exploitation of mestizas and Indigenous women. Indigenous women's bodies have been "made invisible and dismem-bered" through exploitive pay and working conditions—reduced to the metonymic "bent back in the field" and "assembly line fingers." Moraga's play, then, performs a critique that addresses the health effects of pesticides and other chemical contaminants that wound, maim, and dismember Indigenous bodies. Moraga's critique calls for women's con-trol over both their labour and their sexuality, as well as for their central role in the work of movement formation.[8] Disease, deformation, and disability are both literal and figurative in the play, concerned both with the disabling effects of chemical contaminants and injuries and with toxic, disabling, and coercive constructions of gender and sexuality that sanction violence against women (and queers more broadly), devalue the body, and obstruct and constrain decolonizing struggles.[9]

This nexus of concerns is also addressed explicitly in "Queer Aztlán," in which Moraga (1993) critiques and challenges the patriarchal and heteronormative ideologies that shaped the Chicano Movement of the 1960s and 1970s. Her essay identifies concerns that inform her intersectional feminism and liberatory politics in general and *Heroes and Saints* in particular. "Chicanos," she argues, "are an occupied na-tion within a nation, and women and women's sexuality are occupied within [the] Chicano nation" (150). For Moraga, the re-formation of the Chicano Movement—and implicitly decolonizing movements more broadly—necessitate examining, critiquing, and "unravel[ling] how both men *and* women have been formed and deformed by racist Amerika and our misogynist/catholic/colonized mechicanidad" as a means of "healing those fissures that have divided us as a people" (162). She critiques the "selective memory" that informed a "generation ...[of]

nationalist leaders ... drawing exclusively from those aspects of Mexican and Native cultures," including "Aztec warrior-bravado," that "served the interests of male heterosexuals" (156). Moraga looks to the "Two-Spirit" tradition[10] in some Native American cultures and emphasizes the need to "draw ... from the more egalitarian models of Indigenous communities" in the formation of new models of family, community, and decolonizing movements "that can allow for the natural expression of our femaleness and maleness and our love without prejudice or punishment" and in which "there would be no freaks, no 'others' to point one's finger at" (164). The AIDS crisis in particular, as she notes, serves as a powerful impetus for challenging normative gender roles and homophobia. "'Passing' gay men," she observes, "have learned in a visceral way that being in 'the closet' and preserving their 'manly' image will not protect them, it will only make their dying more secret" (163).

Although the Latin American Solidarity Movement merits only fleeting mention in "Queer Aztlán," it is a central focus of "Art in América con Acento." Moraga (1992) takes pains to note that she wrote her talk on the "one-week anniversary of the death of the Nicaraguan revolution," following the 25 February presidential election in Nicaragua of U.S.-backed Violeta Barrios de Chamorro. The defeat of the Sandinista Party and the incumbent Daniel Ortega, Moraga asserts, was the fruit of political violence and economic coercion: "It was bullets and bread. ... The U.S.-financed Contra war and its economic embargo ... forced their hand" (154).[11] For Moraga, the election marked one of those "critical junctures in our evolution, where we are forced to take stock and reevaluate our purpose, our mandate as artists" (154). The defeat of the Sandinistas, she observes, was a watershed event in her life as an artist and "catapulted me into reconsidering my work/my role as a Chicana artist living in the United States" (154). The playwright proceeds to frame the defeat within the broader context of U.S.-backed violence in Central America, including the November 1989 assassination of six Jesuit priests, their housekeeper, and her daughter by the "ruling Arena party and its death squads"[12] and the December 1989 invasion of Panama (155). Moraga represents the U.S.-financed and -sponsored "advancing robbery of the nations in Latin America" as a repetition of the Spanish colonial conquest and the Mexican-American War: "We stand on land that was once the country of Mexico. And before any conquistadors began to stake out political boundaries, this

was Indian land and in the deepest sense remains just that. A land sin fronteras ['without borders']. Chicanos with memory banks like our Indian counterparts understand what colonization of the spirit and flesh means. We are an internally colonized people" (156). The "United States' gradual consumption of Latin America," she goes on to observe, "is bringing the Americas together. The United States is changing face. What was largely a Chicano/Mexicano population in California is now guatemalteco, salvadoreño, nicaragüenese" (156). The shifting demographics in California and the unfolding violence in Latin America represent new challenges for artists in the United States "living in las entrañas del monstruo ['the belly of the beast']" (154), whose works must catalyze "the creation of tribe, clan, a community of resistance" (159), committed to "resistance to domination by Anglo-America, resistance to assimilation, resistance to economic exploitation" (157). *Heroes and Saints*, Moraga indicates, marks her attempt to confront these complex political and artistic challenges.

Agribusiness, Neocolonial Violence, and Indigenous Rites of Resistance

The links among contemporary transnational struggles that *Heroes and Saints* (Moraga 1994) forges, along with the analogies that it invokes between pesticide use and paramilitary violence, have generated minimal critical inquiry.[13] To understand these connections, it is necessary to begin with the play's conclusion, which marks the brief entry of Cerezita into the public arena before they are cut down by helicopter gunfire. Cere's physical appearance represents a radical departure from their image to this point in the play. They are transformed in this scene ostensibly into an image of the Virgin of Guadalupe. "La virgencita will protect us now," exclaims their mother, Dolores (146). The priest Juan Cunningham leads the people in a prayer attributed to St. Francis of Assisi, the patron saint of animals, the figure most foundational to Catholic/Christian ecotheology.[14] "Come señorita. Come see how my baby se vuelve a santita. Come show the peepo" (148), pronounces Dolores to the journalist Ana Perez, celebrating Cerezita's transformation and clearly viewing it through a traditional Latin American Catholic lens.

But Cere's speech departs dramatically from that more traditional theology. Their speech foregrounds the spiritual hybridity of Latinx/

Latin American Catholicism and its roots in Indigenous Mesoamerican spirituality. Their opening line, "Put your hand inside my wound" (Moraga 1994, 148), echoes Gloria Anzaldúa's (1987, 24) representation of the border as a "1,950 mile-wide open wound" and immediately blurs gender binaries, associating Cere with the penetrable body of the crucified Christ.[15] The next line—"Inside the valley of my wound, there is a people. A miracle people" (Moraga 1994, 148)—collapses the boundaries between the body and the land, the crucified Christ and the Indigenous-mestiza/o workers, in the process undermining clerical authority and hierarchy. The passage evokes, as Yvonne Yarbro-Bejarano (2001, 79) has noted about the play as a whole, the "centrality of sacred sacrifice in Aztec and Mayan cultures," as well as in Catholicism, but it also explicitly links the farmworkers' struggle to the suffering and revolutionary struggles of campesinos throughout Mesoamerica.

The passage is suffused with references to blood and the colour red, which link the bodies of workers with both the land and the history of colonial violence and exploitation that Cerezita invokes to catalyze resistance. "You are Guatemala, El Salvador. You are the Kuna y Tarahumara," pronounces Cere. "You are the miracle people, too, for like them the same blood runs through your veins" (Moraga 1994, 148). Although the lines can be read as evoking an essentialized Indigenous heritage that links geographically dispersed workers from California to as far south as Panama, it can also be read as a nod to the changing demographics of California, during a period in which *la violencia* in Latin America spurred a new wave of migration to the United States, with many of the refugees relegated to the status of undocumented migrant workers.

Following the Indigenous blessing presided over not by Father Juan, the church-sanctioned cleric, but by Cere, Juan and Cere proceed out into the poisoned fields to display the body of Cere's dead infant niece, staging her death as one of a series of chemical crucifixions effected by the growers. But when gunfire rains down from the sky onto them, Cere's brother Mario incites the workers to "Burn the Fields," and they echo his call in Spanish, punctuating it with cries of "¡Asesinos!" (Moraga 1994, 149). The label *asesinos*—or "assassins"—the play suggests is fitting not simply for Central American oligarchs but also transnational agribusinesses and petrochemical companies operating in the San Joaquin Valley. Setterberg and Shavelson (1993, 262), in

particular, recognize how the play's conclusion superimposes the political violence in Central America onto the San Joaquin Valley, deeming the scene "a powerful moment" "unpersuasive" in its "exaggeration."[16] This critique fails to acknowledge, however, the extent to which tropes linking the struggles of California farmworkers and Central American campesinos permeate not only the play but also the 1986 UFW film *The Wrath of Grapes*, as well as the activism of the Mothers of East LA, who participated in the UFW campaign and whose influence is clearly evident in Moraga's play.

Before the opening credits, the UFW film features a shot of a black helicopter, silhouetted against a blood-red sky, spraying pesticides as it bears down ominously on the land. The scene is soon followed by a clip of César Chávez. Exhorting the crowd at a UFW rally, he represents the use of pesticides as a war on farmworkers, one that demands a reciprocal, albeit non-violent, response: "We're declaring war on the pesticides that are poisoning and killing our people." The film goes on to speak to the violence committed by growers who will stop at nothing to thwart unionization. "Grape workers face powerful opponents," pronounces narrator-actor Mike Farrell. "Corporate giants like Jack Pendol, Giumarra Vineyards, and Tennaco Oil Company own thousands of acres. They've ruled over the valley for decades." The workers, Chávez goes on to observe, were "killed, pressured, black-listed, physically attacked." The video includes footage of Dolores Lopez, who recounts the experience of sitting by the hospital bed of her unrecognizable son, twenty-one-year-old farmworker Rene Lopez, shot in the face in September 1983 after casting a ballot for the UFW. Footage of his funeral follows, the casket draped with the UFW flag bearing the image of an Aztec eagle. An elderly woman, her head covered with a black shawl, weeps as the narrator speaks of Lopez as one of many UFW "martyrs." Part of the rhetorical force of the brief documentary, then, rests on the parallels that it implicitly evokes between the violent repression of UFW organizing and events unfolding throughout Central America.

Moraga's (1994) description of the play's setting represents the landscape and workers as being under a militarized regime of control and surveillance. With the "manicured uniformity" of the houses and their "obligatory crew-cut lawn[s]" (91), the agribusiness company town, built overtop a toxic waste dump, is indistinguishable from a military base. "The endless sea of agricultural fields" that encircles the community,

"like the houses," is "perfectly arranged into neatly juxtaposed rectangles" (91). The layout of the town, the houses, and the fields was carefully plotted for maximum control and profit. Contemporary agricultural communities, in this regard, are the outgrowth of the corporate-owned and -operated "model" labour camps that began to emerge in California in the late 1920s and that, as Don Mitchell has extensively documented, were designed with the intent of circumventing and defusing labour discontent and organizing.[17]

The power that agribusiness wields in the San Joaquin Valley is rooted in what geographer David Harvey (2004) has termed the dynamics of "accumulation by dispossession," beginning with assaults on the traditional lands of the Yokuts with the arrival of the Spanish in the first decade of the nineteenth century. And, though narratives of Aztlán as an Indigenous Chicano homeland coexist uneasily with the land claims of Native Americans "struggl[ing] to maintain sovereignty of [their] land in the United States" (Aldama 2012, 160), the refusal of Anglos to acknowledge the complex Indigenous roots of Chicanxs has been integral to the economic exploitation and marginalization of Chicanxs by corporate agribusiness in California.[18] Yet, particularly after 1870, the consolidation of power and profit that built agrarian capitalism in California and "absolutely marked [it] off from the mainstream of American farm history" was inextricably linked to a "vast, repetitive cycle of recruitment, employment, exploitation and expulsion" (Walker 2004, 66).[19] Native Americans, Chinese, Japanese, Filipino, · and Chicanx/Mexican workers were all variously subjected to this cycle of exploitation. Richard A. Walker (2004, 73) has argued, however, that the cheap, exploited labour afforded by millions of Mexican guest workers under the Bracero Program, or the Mexican Farm Labor Program, as it was formally known, "helped underwrite the [growers'] postwar spurt in profits and accumulation."[20] The Bracero Program, he argues, helped to spur the "rise in land prices and land concentration, and investment in machinery, irrigation, and petrochemicals" (73). Like the Bracero Program itself, the organo-chlorine, organo-phosphate, and carbamite pesticides that became integral to "the petrofarming package at the middle of the 20th century" also have their roots in war; they are "descendants of World War I nerve gases" that "only later [were] discovered to have insecticidal properties" (185). By the end of the Second World War, DDT was being heralded as "the atomic bomb

of the insect world" (185). It was used on U.S. troops in the field, and the procedure was extended to participants in the Bracero Program, who confronted mandatory fumigation upon entry into the program.[21]

But the extreme congenital health issues suffered by Felipe Franco—dramatically embodied by Cerezita—also evoke broader comparisons to the intergenerational effects of Agent Orange, the defoliant at the centre of the U.S. military's chemical spraying campaign in Vietnam. Although studies have linked Agent Orange exposure to a host of health issues, from chloracne to cancer, it has also been linked to severe congenital birth defects, including spina bifida, resulting in paralysis and incontinence, as well as anencephaly.[22] "The Vietnam Red Cross estimates that Agent Orange has affected 3 million people spanning three generations, including at least 150,000 children born with severe birth defects since the war ended in 1975" (Brown 2013).

This history of defoliant use is echoed in the policies that the U.S. government began embracing in Latin America in the 1990s under the auspices of Plan Colombia and the War on Drugs. By 1999, the United States had embarked on the aerial application of Monsanto's herbicide Roundup in Colombia. In "late 2000, the public health services in the department of Putumaya were inundated with complaints" from "no fewer than 5,929 people from 292 villages," including 81.5 percent suffering from "medical conditions they had never experienced before" (O'Shaughnessy and Branford 2005, 70–71). Although ostensibly targeting illegal coca crops, indiscriminate spraying resulted in the eradication of subsistence crops and other legal food crops, as well as the contamination of soil, groundwater, and waterways, resulting in widespread reports of health issues, including "burning eyes, dizziness and respiratory problems" (Van Royen 2000). In November 2000, following ten consecutive days of spraying over the 8,000-hectare Aponte Indian Reservation "in the south of Colombia," according to Josi Tordecilla, a physician at the community health clinic, "80% of the children of the community ha[d] fallen ill" (Van Royen 2000). The spraying was also cited as a substantial factor in Colombia's growing displaced population, which the United Nations Human Rights Commission for Refugees (2013) estimated at 3.8 million people in November 2011.

The historical roots of U.S. military incursions in Latin America, beginning in the nineteenth century, are inextricably linked with U.S. agrarian capitalist interests. Among the most notorious examples of

those links was the 1954 CIA-engineered overthrow of the democrat-
ically elected government of Jacobo Arbenz, the former president of
Guatemala, whose Agrarian Reform Law of 1952 constituted a radical
challenge to the power and profit of the United Fruit Company, the
"largest property owner in the country" (Schlesinger and Kinzer 1982,
75). The country's coffee oligarchs also would have been affected by the
land reform program, whose principal beneficiaries would have been
landless Indigenous peasants. In the decades of bloody civil war between
1960 and 1996, "over 200,000 Guatemalans were killed or forcibly
disappeared. . . . Of those victims identified in the U.N.-sponsored
Historical Clarification Commission, 83.33% were indigenous Maya"
(Commission for Historical Clarification 1999, 85).[23] In El Salvador,
during the civil war that extended from 1980 to 1992, U.S. intervention
propped up the power of a military dictatorship that served the interests
of "the fourteen families," agrarian capitalists made rich by exploiting
Indigenous labour. The *matanza* or "slaughter" of the 1930s, in which
as many as 30,000 people were killed, most of them Indigenous, was
a precursor to the brutal repression of the civil war, during which an
estimated 75,000 people were killed. In El Salvador, as in Guatemala,
torture, rape and sexual mutilation, dismemberment, and decapitation
were among the tactics used by U.S.-trained death squads.

From the first scene of Moraga's (1994) play, Cere's absent body is
represented as the smoking gun, the most persuasive evidence of the
damage caused by pesticides. Their mother's motives in shielding Cere
from public view are explored in one of several scenes in the play that
link pesticide poisoning, the "poisonous reproduction of [normative]
gender roles" (Yarbro-Bejarano 2001, 67), AIDS, and the political
violence unfolding in Central America. The scene opens with Cere
observing their sister Yolanda breastfeeding as they reflect on their
earliest experience of fear, which dates to infancy: "I remember the
first time I tasted fear. I smelled it in her sweat. It ran like a tiny river
down her breast and mixed with her milk. I tasted it on my tongue.
It was very bitter. Very bitter" (95). For Cere, pesticide exposure is as
potent a form of violence as the helicopter gunfire that the growers'
agents use in this fictionalized scenario to try to silence their outspoken
critics, including the activist Amparo, the godmother of the children
of Dolores. When Yolanda informs Dolores that "the guys in the heli-
copters" fired at Amparo "through her windows," Dolores responds not

with an expression of sympathy but by lashing out at Amparo: "She better learn to keep her damn mouth shut. . . . I saw her talking to the TV peepo last week right in front of the house. It scare me" (96). As the scene unfolds, repeated attempts by Dolores to silence variously Amparo, Cerezita, and Cere's brother Mario are deconstructed as an effect of colonial violence and as a coping strategy that only reinforces the power of the growers.

Queering Resistance: From ACT-UP and the UFW to Mothers' Movements in the United States and Latin America

In the exchange that follows in *Heroes and Saints* (Moraga 1994), the silence of Dolores about pesticide poisoning is linked with the silence and shame surrounding homosexuality and the AIDS epidemic of the 1980s. The trajectory of the scene shifts somewhat as Dolores interrupts a furtive exchange between Cerezita and Mario about his upcoming trip to San Francisco.[24] Yolanda's teasing response—"Better stay away from the jotos,[25] you don't wanna catch nothing" (97)—reinforces the stigma against which Mario continually struggles. His teasing response, "I got it covered, hermana" (97), affirms his identification with "the jotos" and, presumably, his use of safe-sex practices. The fact that he does contract AIDS serves as a reminder of the lethal effects of normative gender roles, of shame and silencing in the era of AIDS. Dolores interrupts the exchange, demanding to know "What are you two whispering about?" When Mario responds "Nothing, ama," Dolores responds "Secrets kill sometimes," an unwitting self-indictment (97). Mario's health and survival are contingent on open dialogue about sexuality in urban spaces such as San Francisco, rather than in his own small town, while Dolores, and arguably implicitly the UFW, are linked with the broader culture of homophobia that ACT-UP—or the AIDS Coalition to Unleash Power—contested.

Beginning in 1987, ACT-UP engaged in a succession of protests to draw much-needed attention to the lethal effects of AIDS, with demands that included public education, needle exchanges, and affordable access to drug treatments.[26] Implicitly linking ACT-UP and UFW campaigns, the passage above suggests that the ACT-UP campaign motto, "Silence=Death," adopted in 1987,[27] might be suited as well to the UFW campaign. Despite the threats of violence posed by the growers, the UFW campaign offers the only possibility for survival for

a community exposed daily to the toxic and potentially lethal effects of pesticide exposure.

Paralleling her homophobia, Dolores stigmatizes homeless and mentally ill people, which similarly flies in the face of direct action campaigns in the 1980s calling attention to the suffering engendered by Reagan-era cuts to social services. San Francisco is associated for Dolores with "those crazy peepo que sleep on the street nowadays. You never know one could come up and shoot you right in the head" (Moraga 1994, 97). Yolanda's response, "They're shooting us here anyway" (97), calls out Dolores for her displacement of her fears and anxieties onto other marginalized and embattled communities. Her response returns attention to the inescapable violence that the growers pose to the community—whether through gunfire or toxic contamination—advancing the play's argument of the need to move from silence, avoidance, and lateral violence to activism and public confrontation.

In their willingness to risk death to draw visibility to the deaths in their community, both Cere and Amparo are identified with the visibility strategies first spawned in Argentina by the Mothers of the Plaza de Mayo and subsequently adopted in El Salvador under the auspices of the CoMadres or "Mothers of the Disappeared."[28] In both Argentina and El Salvador, activists whose children were murdered or "disappeared" protested publicly, invoking their roles as mothers in an attempt to minimize the inevitable retaliation and repression that they would face from patriarchal military juntas. The mothers defied paramilitary death squads and threats of physical—and specifically sexual—torture to demand political accountability and the return of the "disappeared." As Diane Taylor (1994) noted, the women "turned their bodies into walking billboards, carrying banners, placards and photographs of their children" (287). Their "self-conscious manipulation of the maternal role—understood as performative—makes the movement the powerful and intensely dramatic" and effective "spectacle that it has been" (293). The tactics of visibility of the mothers' movements in Latin America were subsequently adopted by MELA (the Mothers of East LA). MELA's activism, beginning with a protest against the construction of a prison, and then a waste incinerator. MELA called attention to the health effects of environmental contaminants, including, in the UFW campaign, pesticides.

These mothers' tactics infuse two protests that the activist Amparo in *Heroes and Saints* helps to organize. "Our homes are no longer our homes," she pronounces at the first rally. "They have become prisons" (Moraga 1994, 110–11), she observes, in a nod to the Mothers of East LA, whose organizing first gained visibility in a campaign to resist the construction of a prison. Her rhetorical question, "How many babies' bodies pile up on top of each other in the grave?" (111), links high rates of miscarriages and infant and child mortality to the indiscriminate murders committed by death squads. Her counsel to the crowd is to "Look into your children's faces. They tell you the truth. They are our future. Pero no tendremos ningún futuro si seguimos siendo víctimas ['But we have no future if we continue to be victims']" (111). The influence is even more evident in the protest in Act 1, Scene 3, in which the protesters are identified as "MOTHERS" in the staging notes and wear the white bandanas that the Mothers of East LA wore in solidarity with the mothers' movements in Latin America. The protesters carry placards with pictures of their dead children, along with their medical diagnoses. The police beating of Amparo and other protesters toward the end of the scene is met with cries of "¡Asesinos! ¡Asesinos! ¡Asesinos!" (133), foreshadowing the play's conclusion and linking both pesticide exposure and police assaults on the UFW with the use of death squads in Latin America.

Although Cere resists their mother's attempts to silence them and confine them to the domestic sphere, thus aligning them with the mothers' movements in Argentina, El Salvador, and East LA, their absent body itself constitutes a challenge to essentialist constructions of gender, motherhood, and sexuality.[29] They also repeatedly defy heteronormative Catholic constructs of *la familia* and *comunidad* that informed the mothers' protests in Latin America and East LA. From the arrival on the scene of the mestizo priest Juan Cunningham, Cerezita repeatedly turns the tables on the priest, serving as an inquisitor who interrogates and challenges the limits of his theology, critiquing his closeted sexuality. In his failure to act decisively to challenge the growers, Father Juan is implicitly contrasted to the six Jesuit priests whose assassination is announced on the radio in Act 1. The priesthood is a closet that distances Juan from the shame of his homoerotic desire; he became "a man of the cloth" because he was drawn to the "vestments, the priest's body asleep under that cloth. The heavy weight of it tranquilizing him"

(Moraga 1994, 115). Cerezita's rejoinder—"The 'theology of liberation,' it's a beautiful term. The spiritual practice of freedom. On earth. Do you practice what you preach, Father?" (115)—suggests that liberation from compulsory heterosexuality is integral to spiritual liberation. Juan's response—"It's the people that are to be liberated, not the priests. We're still caught in the Middle Ages somewhere, battling our internal doubts Spanish-Inquisition style" (115)—invokes the Spanish Inquisition's historical role in prosecuting "sodomy" as an unnatural act, a perversion punishable by execution.[30]

As a number of critics have noted, the scenes building up to Cere's unlikely seduction of Father Juan align Cerezita with the historical figure of La Malinche, a Nahua woman who served as a translator to Cortes, bore children by him, and in turn was abandoned by him. "In Mexican Spanish, over time the term 'malinche' evolved into an insult signifying 'traitor' or 'sell-out'" (Contreras 2009, 109), with associated connotations of sexual penetration and victimhood, as *la chingada* or "the fucked one" (Anzaldúa 1987, 44).[31] Moraga's alignment of Cerezita with La Malinche must be read within the context of a broader Chicana feminist tradition that emerged in the mid-1970s of recuperating the historical figure, "transforming it from a figure of destructive social and sexual agency (a traitor and a whore) to one of affirmative agency (a cultural bridge and translator)" (Sánchez 1998, 118).

Although La Malinche was often referred to as "Cortes's tongue," in a protracted exchange between Cerezita and Juan, the former represents their own tongue as their "most faithful organ," which they use to expose the limits of his liberation theology and as an instrument of seduction. Resisting the equation of their absent body with sexual purity, they vaunt the sexual agency embodied in the muscular definition of their tongue: "Think about it Padre. Imagine if your tongue and teeth and chin had to do the work of your hands . . . you know" (Moraga 1994, 108). In their subsequent sexual encounter, Father Juan experiences orgasm against the back of Cere's *raite*—her mobility device—denying Cere the specifically oral experience that they seek, one in which they can exercise their own sexual agency. In so doing, Juan demonstrates his complicity in the colonial project and the link between sexual shame and dominance as he relegates Cere to the status of *la chingada*, the one who is fucked. His subsequent self-defence—"I'm a priest, Cere. I'm not free. My body's not my own" (144)—serves as both an attempt to

justify his actions as a defence of his vows and his commitment to sexual purity and an implicit admission of the links between Catholicism and colonial violence and repression.

Cerezita's response links Father Juan's denial of their sexual agency with the injuries inflicted on Cerezita by the growers and their wanton disregard for the bodies and lives of the mestizo/Indigenous workers: "It wasn't your body I wanted. It was mine. All I wanted was for you to make me feel like I had a body because, the fact is, I don't. I was denied one" (Moraga 1994, 144). Cere proceeds to unleash their repressed rage—against Juan, the growers, and their father, who abandoned the family: "I'm sick of all this goddamn dying. If I had your arms and legs, if I had your dick for chrissake, you know what I'd do? I'd burn this motherless town down and all the poisoned fields around it. I'd give healthy babies to each and every childless woman who wanted one and I'd even stick around to watch those babies grow up! ... You're a waste of a body" (144). In this speech, Cere represents Juan not as an object of heterosexual desire but as a sexual proxy that they look to in order to experience "the dick" that chemical injury has denied them. Although Cere is denied the erotic experience that they seek, their performance of queer desire associates sexual agency with revolutionary politics guided not by patriarchal violence and domination but by a commitment to the health and well-being of women and children.

Conclusion

The final scene of *Heroes and Saints* punctuates the erotic challenges that Cere/La Malinche/La Lengua poses throughout the play to patriarchal/heteronormative constructions of gender and sexuality. Cere's transformation into the figure of Guadalupe/Tonantzin comes closely on the heels of their sexual encounter with Father Juan, an encounter for which Cere, in contrast to Juan, is wholly unrepentant. Rather than purging Cere of sexual desire and agency, the final scene invests the goddess figure with queer erotic desire more in keeping with the preconquest fertility figure Tonantzin than with the Catholic Virgin of Guadalupe. Cerezita's final performance reflects an investment in excavating and celebrating Aztec and Mesoamerican spiritual traditions that might provide a foundation for specifically queer feminist anticolonial transnational resistance.

The disjunction, finally, between the scenes that unfold in private and the public performance of the virgin can also be read as an acknowledgement of the pressures that activists in Latin America confronted in fashioning the public performance of Catholic motherhood on which their own lives and the lives of their children and their neighbours' children depended.[32] It is only in *Watsonville*, the sequel to *Heroes and Saints*, that we learn from Juan, who has left the priesthood, that he and Cere became separated in the field amid the gunfire and that he found them, the veil torn from their head impaled "onto a thick grapevine.... They had forced the post through her mouth and had hung the veil like a sign around her neck. And on it, in blood ... her blood, they had written the words: 'AND THOU ART WRETCHED'" (Moraga 2005, 68–69). The scene perhaps evokes Moraga's own fear of the critical backlash that her multi-pronged critique might engender, but it can also be read both as a reminder of the extreme violence that so many labour and human rights activists confronted in Latin America during wars of resistance, which continued into the 1990s, and as a call to take courage from them.

However, if Catholic theology serves as an important spiritual foundation for workers' resistance in Latin America, Moraga seems to be unwilling to embrace it. The ex-priest's reflections on the sight of Cere's Olmec-like impaled head seem to implicate both the growers and the Catholic Church. "And then I understood," he observes, "[h]ow profoundly those men, with all their land and all their power, hated us. And I knew that they would do anything, anything not to know their hate was fear. (*Pause*). And I knew I would never be afraid again. Not even of God" (Moraga 2005, 69). The God of Catholicism, for Moraga, remains an instrument of neocolonial violence.

Notes

1 I address each of these movements later in the chapter. On ACT-UP, the international direct action movement that emerged in 1987 to advocate for public policy shifts, medical research, and accessible treatment to address the HIV/AIDS crisis, see Shepard and Hayduk (2002). On MELA, a grassroots environmental justice group that emerged in 1984 to protest a proposed waste incinerator in a format strongly influenced by the Argentinian Mothers of the Plaza de Mayo and the El Salvadoran CoMadres, see Pardo (1990). On the Mothers of the Plaza de Mayo, see Bouvard (2002). The movement began in April 1977 when mothers

began holding a vigil in front of the presidential palace in Buenos Aires to protest the disappearance of their children, among tens of thousands dragged away by security forces, tortured, and murdered in the wake of a coup and the emergence of a brutal U.S.-supported military junta. The CoMadres in El Salvador adopted similar tactics beginning in December 1977. Like the "motherist" activists in Argentina, they confronted brutal reprisals—including in some cases rape and murder—to protest the disappearance of their children, family members, and community members in the face of U.S.-supported death squads and military repression. On the construction of Latina motherhood in both movements, see Bejarano (2002). I will leave it to other scholars to ponder the connections between mothers' movements in Latin America, MELA, and the unfolding work of the Mothers United for Black Lives, which formalizes the role that Black mothers have long played in organizing to address epidemic rates of lethal and disabling police violence in the United States. See, for example, Cineas (2020) and Pedroja (2020).

2 Although Latin American liberation theology first emerged as a movement within the Catholic Church in the 1950s, the term "liberation theology" was coined in the 1970s by Peruvian theologian Gustavo Gutiérrez: "To know God is to do justice, is to be in solidarity with the poor person ... as he or she exists today.... [T]o know or love God, one must come to grips with the concrete life situation of the poor today, and undertake the radical transformation of a society that makes them poor" (quoted in Smith 1991, 34). Catholic liberation theology became an important foundation for resistance among poor campesinos throughout Latin America. The movement was often at odds with Vatican authorities. An extensive literature exists on the historical role of the Catholic Church in the colonization of Latin America and of the American Southwest; see, respectively, Dussel (1992) and Jackson, and Castillo (1996). On the complex relationship between the Catholic Church and the UFW struggles of the 1960s and1970s, see Prouty (2008).

3 See Bohn and Levin (2013) and Chaparro et al. (2012).

4 I have opted to use the gender-neutral, inclusive, albeit anachronistic term "Chicanx" except when referring specifically to the Chicano Movement. On the use of anachronistic gendered terms, see Rohy (2009).

5 Beginning in the 1960s, Mexican American activists embraced the historically pejorative term "Chicano/a," signalling their resistance to Anglo racism, projects of apartheid or assimilation, and their affirmation of their mestiza/o Indian ancestry. Mestiza/o in this context refers to people whose background includes both Native American and European ancestry. The most influential articulation of Chicana mestiza identity is Anzaldúa (1987, particularly 99–113). For an overview of the historical construction of racialized hierarchies in California, which assigned Mexican mestizos/as a relatively privileged position with respect to "'uncivilized' Indian populations," see Almaguer (2008). In her essay "La Güera" in her collection *Loving in the War Years*, Moraga (2000) explores the relative privilege that she enjoys as a light-skinned Chicana compared with that of her dark-skinned Indo-Hispanic mother. For a critical examination of the links between Chicana Indigenism and modern primitivism, see Contreras (2009).

6 For an overview of the history of tribes in California, including those in the San Joaquin Valley, see Hurtado (1988).

7 No discussion of the shortcomings in Moraga's queer coalition-building would be complete without noting Moraga's transphobic comments in an essay/chapter entitled "Still Loving in the (Still) War Years" in her 2011 book. Whatever critiques

have been made of her concern that butch lesbians might "become a dying breed," her silence about–and erasure of–trans women, who are routinely targeted for violence, is more problematic still. See Collado (2012).

8 Both Bost (2010) and Yarbro-Bejarano (2011) situate the disembodied Cere within Moraga's broader preoccupation with wounded and dismembered bodies.

9 Yarbro-Bejarano observes that "Moraga rewrites the mythic head of Valdez's play as female to visually engage the idea that Cere is deprived of her body by environmental racism *and* through the teaching of Mexican Catholicism, reproduced by her mother, that women should repress their bodies as weak and sinful and that they should live only in their 'head'" (2011, 13).

10 Moraga was writing in the wake of the conference in Winnipeg in 1990 at which Indigenous activists adopted the term "Two-Spirit" as an alternative to the term "berdache," which Daniel Heath Justice calls an "offensive anthro-fetish" (Justice, Rifkin, and Schneider 2010, 11). As Qwo-Li Driskill observes in a special issue of *GLQ: A Journal of Gay and Lesbian Studies*, "while our traditional understandings of gender and sexuality are as diverse as our nations, Native Two-Spirit/GLBTQ people share experiences under heteropatriarchal, gender-polarized colonial regimes that attempt to control Native nations. These experiences give rise to critiques that position Native Two-Spirit/GLBTQ genders and sexualities as oppositional to colonial powers" (2010, 69). See also Gilley (2006) and Jacobs (1997).

11 In 1979, the Frente Sandinista de Liberación Nacional defeated the dictatorial Somoza regime, which had ruled Nicaragua, with the backing of U.S.-based agribusiness interests, since 1936. Under the leadership of Daniel Ortega, democratically elected in 1984, the Sandinista Party instituted a wide range of reforms, including a massive literacy campaign and the redistribution of hundreds of thousands of acres of agricultural lands to peasant farmers. In the wake of the Sandinista victory, and in contravention of both international law and the Boland Amendment, the United States funnelled millions of dollars of military aid to the "Contras" and launched a trade embargo against Nicaragua that crippled the country's economy and was lifted only in 1990 following the election of Chamorro. For a critical overview of U.S. intervention in Nicaragua, see LaFeber (1993, 225–41).

12 See Lernoux (1980) on the U.S. government's collaboration with Latin American oligarchs in the targeting of Catholic priests, nuns, and lay workers who espoused liberation theology. Clergy and laity were jailed, tortured, and targeted for death squad activity alongside union organizers, human rights activists, and suspected sympathizers. On the murder of the six Jesuit priests, who were proponents of liberation theology and taught at Universidad Centroamericana in San Salvador, see Whitfield (1994).

13 Brady notes that "the play explores the cost of misogyny and homophobia and shows how the destruction of the environment must be related to the devastation of AIDS and the destructive wars in Central America" (2002, 166), but the latter two issues are peripheral to her analysis. Greenberg (2009, 180–81n14) deals with the links only tangentially but does include an informative footnote on Taylor's analysis of the Mothers of the Plaza de Mayo. I address Setterberg and Shavelson's (1993) analysis later in the chapter.

14 As the term suggests, "ecotheology" marks the intersections of theology and ecology/environmental studies. Catalyzed by the essay "The Historical Roots of Our Ecological Crisis" (White 1967), ecotheology examines the role that religious narratives and ideologies, including perhaps most notably the Judeo-Christian story

in Genesis, have played in the degradation of the environment. Ecotheology also fosters critical re-examination of seminal religious texts to foster an understanding of human interdependence with non-human communities.

15 Yarbro-Bejarano notes that the lines "capture ... the play's hybrid crossing of the feminine Virgin and the masculine 'body of Christ'" (2011, 78). She also reads the conclusion of the play, however, as effecting a sacrificial erasure of Cere's agency in a manner that reinforces traditional imperatives for women's self-sacrifice.

16 Similarly, Yarbro-Bejarano notes the links that the play forges between the UFW struggle and the El Salvadoran Civil War, but she questions whether "the play entirely succeeds in pulling off this bold juxtaposition of representational strategies" (2011, 79).

17 On work camps as a means of policing and controlling labour, see, especially, Mitchell (1996, 164–97).

18 But as Arturo J. Aldama has observed, "Chicanas and Chicanos are defined by a heterogeneity of historical origins (Indian, African, and Spanish) that for the most part include an ancestry to indigenous or first peoples communities in what is now the Southwest [United States]," as well as Indigenous peoples "in different regions of Mexico" (2012, 155).

19 Walker (2004, 66) sees California as "more closely linked to the rest of the Southwest and Florida" in this regard.

20 The Bracero Program was inaugurated in 1942 in response to labour shortages in the wake of the U.S. entry into the Second World War. Promises of prevailing agricultural wages and quality housing often went unfulfilled. The deportation of "guest workers" at the end of the season provided the ideal conditions for routine wage theft. The program was discontinued in 1964. See, for example, Calavita (2010) and Craig (2015).

21 Participants in the Bracero Program recalled the dehumanizing experience of DDT fumigation in the documentary *Harvest of Loneliness: The Bracero Program* (Price, Gonzalez, and Salinas 2010).

22 See Doyle (2004). The spraying campaign, which spanned from 1961 to 1970, targeted forests that could serve as cover for Vietcong soldiers and sympathizers. But the chemical variant of Agent Orange, Agent Blue, was also broadly used to eradicate crops in the countryside as part of a program of forced relocation to U.S.-controlled cities and strategic hamlets.

23 The Commission for Historical Clarification was a truth commission formed in 1994 as part of the peace agreement ending the Guatemalan civil war; the report was presented to the UN secretary general in 1999.

24 Mario refers to visiting "San Pancho" (Moraga 1994, 97), the frequently used nickname for the Mexican resort town of San Francisco, though his destiny is more likely the LGBTQ-friendly city in California.

25 *Jotos* is a pejorative Mexican-Spanish term for homosexual.

26 On the mission and impact of ACT-UP, see, for example, Shepard and Hayduk (2002).

27 The motto of ACT-UP, "Silence=Death," resonates strongly with Audre Lorde's comments in her essay "The Transformation of Silence into Language and Action" on her struggles as a Black lesbian cancer survivor: "I was going to die, if not sooner then later, whether or not I had ever spoken myself. My silences had not protected me. Your silences will not protect you" (2007, 41).

28 Argentina, El Salvador, and Central America more broadly suffered bloody civil wars through much of the 1970s and 1980s, with the United States subsidizing paramilitary death squads that targeted human rights and labour activists. On U.S. military intervention in Central America, see LaFeber (1993).

29 For a broader analysis of Moraga's writing as it "critiques the language of Chicana nationalism that conflates 'family' and 'race' as biologically and culturally determined," see López (1999, 161).

30 For a historical overview of perspectives on sodomy in Latin America, see Sigal (2003). See also Tortorici, who argues that sodomy was more aggressively prosecuted in Brazil and Goa than in "New Spain," noting that the Mexican Inquisition's "jurisdiction over unnatural acts" was limited to cases in which "such acts were . . . coupled with heretical statements" (2012, 167).

31 Sánchez (1997, 125n9) traces the origins of this usage to Octavio Paz.

32 Taylor (1994, 293) argues that it is "the conceptual distance between the essentialist notion of motherhood attributed to the [Madres de la Plaza de Mayo] and the self-conscious manipulation of the material role—understood as performative—that makes the [Madres'] movement the powerful and intensely dramatic spectacle that it has been."

References

Aldama, A.J. 2012. "Fears of Aztlán/Fears of the Reconquista: White Men as New (Old) Nativ(ist)e Americans." In *Comparative Indigeneities of the Américas: Toward a Hemispheric Approach*, edited by M.B. Castellano, L.G. Nájera, and A.J. Aldama, 155–70. Tucson: University of Arizona Press.

Almaguer, T. 2008. *Racial Fault Lines: The Historical Origins of White Supremacy in California*. Berkeley: University of California Press.

Andouard-Labarthe, E. "The Vicissitudes of Aztlán." *Confluencia* (1990): 79–84.

Anzaldúa, G. 1987. *Borderlands: La frontera*. Vol. 3. San Francisco: Aunt Lute.

Bejarano, C.L. 2002. "Las Super Madres de Latino America: Transforming Motherhood by Challenging Violence in Mexico, Argentina, and El Salvador." *Frontiers: A Journal of Women Studies* 23, no. 1: 126–50.

Bohn, S., and M. Levin. 2013. *Poverty in California*. Public Policy Institute of California. http://www.ppic.org/main/publication_show.asp?i=261.

Bost, S. 2010. *Encarnación: Illness and Body Politics in Chicana Feminist Literature*. New York: Fordham University Press.

Bouvard, M.G. 2002. *Revolutionizing Motherhood: The Mothers of the Plaza de Mayo*. Lanham, MD: Rowman and Littlefield.

Brady, M.P. 2002. *Extinct Lands, Temporal Geographies: Chicana Literature and the Urgency of Space*. Durham, NC: Duke University Press.

Brown, D. 2013. "4 Decades after War Ended, Agent Orange Still Ravaging Vietnamese." McClatchy, DC, 22 July. http://www.mcclatchydc.com/news/nation-world/world/article24751351.html.

Calavita, K. 2010. *Inside the State: The Bracero Program, Immigration, and the INS*. New Orleans: Quid Pro Books.

Chaparro, M.P., B. Langellier, K. Birnbach, M. Sharp, and G. Harrison. 2012. *Nearly Four Million Californians Are Food Insecure*. UCLA Center for Health Policy Research. http://cfpa.net/CalFresh/Media/CHIS-HealthPolicyBrief-2012.pdf.

Cineas, Fabiola. 2020. "How Portland's Wall of Moms Collapsed—and Was Reborn under Black Leadership." *Vox*, 4 August. https://www.vox.com/21353939/portland-wall-of-moms-collapses-to-form-moms-united-for-black-lives.

Collado, M. 2012. "On Actually Keeping Queer Queer." *NU Writing* no. 1: n.pag.

Commission for Historical Clarification. 1999. *Guatemala, Memory of Silence Tz'Inil Na'Tab'al*. Guatemala City: Commission for Historical Clarification.

Contreras, S.M. 2009. *Blood Lines: Myth, Indigenism, and Chicana/o Literature*. Austin: University of Texas Press.

Craig, R.B. 2015. *The Bracero Program: Interest Groups and Foreign Policy*. Austin: University of Texas Press.

Doyle, J. 2004. *Trespass against Us*. Monroe, ME: Common Courage Press.

Driskill, Q.-L. 2010. "Doubleweaving Two-Spirit Critiques: Building Alliances between Native and Queer Studies." *GLQ: A Journal of Lesbian and Gay Studies* 16, nos. 1–2: 69–92.

Dussel, E.D. 1992. *The Church in Latin America, 1492–1992*. Vol. 1. New York: Orbis Books.

Gilley, B.J. 2006. *Becoming Two-Spirit: Gay Identity and Social Acceptance in Indian Country*. Lincoln: University of Nebraska Press.

Greenberg, L.M. 2009. "Learning from the Dead: Wounds, Women, and Activism in Cherríe Moraga's *Heroes and Saints*." *MELUS: Multi-Ethnic Literature of the US* 34, no. 1: 163–84.

Harvey, D. 2004. "The New Imperialism: Accumulation by Dispossession." *Socialist Register* 40: 63–87.

Hurtado, A.L. 1988. *Indian Survival on the California Frontier*. Vol. 35. New Haven, CT: Yale University Press.

Jackson, R.H., and E. Castillo. 1996. *Indians, Franciscans, and Spanish Colonization: The Impact of the Mission System on California Indians*. Albuquerque: University of New Mexico Press.

Jacobs, S.E. 1997. *Two-Spirit People: Native American Gender Identity, Sexuality, and Spirituality*. Champaign: University of Illinois Press.

Justice, D.H., M. Rifkin, and B. Schneider. 2010. "Sexuality, Nationality, Indigeneity." *GLQ: A Journal of Lesbian and Gay Studies* 16: 5–39.

LaFeber, W. 1993. *Inevitable Revolutions: The United States in Central America*. New York: W.W. Norton.

Lernoux, P. 1980. *Cry of the People: United States Involvement in the Rise of Fascism, Torture, and Murder and the Persecution of the Catholic Church in Latin America*. New York: Doubleday.

López, T.A. 1999. "Performing Aztlán: The Female Body as Cultural Critique in the Teatro of Cherríe Moraga." In *Performing America: Cultural Nationalism in American Theater*, edited by J.D. Mason and J.E. Gainor, 160–77. Ann Arbor: University of Michigan Press.

Lorde, A. 2007. *Sister Outsider: Essays and Speeches*. New York: Ten Speed Press. (Originally published in 1984.)

Mitchell, D. 1996. *The Lie of the Land: Migrant Workers and the California Landscape*. Minneapolis: University of Minnesota Press.

Moraga, C. 1992. "Art in América con Acento." *Frontiers: A Journal of Women Studies* 12: 154–60.

———. 1993. "Queer Aztlán: The Re-Formation of Chicano Tribe." In *The Last Generation, Prose and Poetry*, 145–74. Boston: South End Press.

———. 1994. *Heroes and Saints and Other Plays (Giving Up the Ghost, Shadow of a Man, Heroes and Saints)*. Albuquerque, NM: West End Press.

———. 2000. *Loving in the War Years: Lo que nunca pasó por sus labios*. Boston: South End Press.

———. 2011. Still Loving in the (Still) War Years/2009. In *A Xicana Codex of Changing Consciousness*, 175–92). Duke University Press.

———. 2005. *Watsonville, Some Place Not Here, and Circle in the Dust*. 2nd ed. Albuquerque, NM: West End Press.

Moses, M. 1989. "Pesticide-Related Health Problems and Farmworkers." *AAOHN Journal* 37, no. 3: 115–30.

O'Shaughnessy, H., and S. Branford. 2005. *Chemical Warfare in Colombia: The Costs of Coca Fumigation*. Vol. 5. Clun, UK: Latin America Bureau.

Pardo, M. 1990. "Mexican American Women Grassroots Community Activists: Mothers of East Los Angeles." *Frontiers: A Journal of Women Studies* 11, no. 1: 1–7.

Parlee, L., and L. Bourin (producers). 1986. *The Wrath of Grapes*. https://www.youtube.com/watch?v=Wq48o4ftL4A.

Pedroja, C. 2020. "The Black Mothers at the Heart of the Portland Protests." *Refinery29*, 13 August. https://www.refinery29.com/en-gb/2020/08/9963850/moms-united-for-black-lives-portland-protests.

Pellow, D.N. 2007. *Resisting Global Toxics: Transnational Movements for Environmental Justice*. Cambridge, MA: MIT Press.

Price, P.L. 2004. *Dry Place: Landscapes of Belonging and Exclusion*. Minneapolis: University of Minnesota Press.

Price, V., G. Gonzalez, and A. Salinas, dirs. 2010. *Harvest of Loneliness: The Bracero Program* (documentary). Films Media Group.

Prouty, M. G. 2008. *Cesar Chavez, the Catholic Bishops, and the Farmworkers' Struggle for Social Justice.* Tucson: University of Arizona Press.

Rohy, V. 2009. *Anachronism and Its Others: Sexuality, Race, Temporality.* Albany, NY: SUNY Press.

Sánchez, M.E. 1998. "La Malinche at the Intersection: Race and Gender in Down These Mean Streets." *Publications of the Modern Language Association of America* 113 no. 1: 117–28.

Schlesinger, S.C., and S. Kinzer. 1982. *Bitter Fruit: The Untold Story of the American Coup in Guatemala.* Garden City, NY: Doubleday.

Setterberg, F., and L. Shavelson. 1993. *Toxic Nation: The Fight to Save Our Communities from Chemical Contamination.* New York: J. Wiley.

Shephard, B., and R. Hayduk. 2002. *From ACT UP to the WTO: Urban Protest and Community Building in the Era of Globalization.* Brooklyn, NY: Verso.

Sigal, P. 2003. *Infamous Desire: Male Homosexuality in Colonial Latin America.* Chicago: University of Chicago Press.

Smith, C. 1991. *The Emergence of Liberation Theology: Radical Religion and Social Movement Theory.* Chicago: University of Chicago Press.

Taylor, D. 1994. "Performing Gender: Las Madres de la Plaza de Mayo." In *Negotiating Performance: Gender, Sexuality, and Theatricality in Latino America*, edited by D. Taylor and J. Villegas, 275–305. Durham, NC: Duke University Press.

Tortorici, Z. 2012. "Against Nature: Sodomy and Homosexuality in Colonial Latin America." *History Compass* 10, no. 2: 161–78.

United Nations Human Rights Commission for Refugees. 2013. "Columbia." http://www.unhcr.org/pages/49e492ad6.html.

Van Royen, M. 2000. "Driven Mad by Itch." *NRC Handelsblad*, 28 December. http://www.marjonvanroyen.nl/index.php?option=com_flexicontent&view=items&cid=147:about-marjon-van-royen&id=525:driven-mad-by-itch&Itemid=85.

Walker, R. 2004. *The Conquest of Bread: 150 Years of Agribusiness in California.* New York: New Press.

White, L. 1967. "The Historical Roots of Our Ecological Crisis." In *This Sacred Earth: Religion, Nature, Environment*, edited by R.S. Gottlieb, 184–93. New York: Routledge.

Whitfield, T. 1994. *Paying the Price: Ignacio Ellacuría and the Murdered Jesuits of El Salvador.* Philadelphia: Temple University Press.

Yarbro-Bejarano, Y. 2001. *The Wounded Heart: Writing on Cherríe Moraga.* Austin: University of Texas Press.

CHAPTER 10

THE LANGUAGE OF SOUL AND CEREMONY

LOUISE HALFE

I have written this chapter to stimulate a healthy discussion about ceremony and protocol. There is a lot of mistrust, fear, and misunderstanding about conduct in, and approach to, ceremony. I was aided by a language specialist and six female Elders who clarified language and provided guidance. Elders teach that words must be used with caution. This chapter is an exploration of the Plains Cree language to highlight the teachings within it. Language, *pîkiskwêwin*, loosely translates as "to take something apart from the female body of life that is within the wind." I explore the teachings from both the language and the Elders.

Not every Elder practises the same way, nor does one Elder have expertise in all areas of spirituality or medicine. Each one is gifted differently. One must explore, ask, and discover how a particular Elder should be approached. This exploration in itself is a lesson in humility and respect.

In *nehiyâwêwin* (the Cree language), Cree spirituality is not a religion but a lifeway—*isîhcikêwin* or "the way things are done"—and *kihci–isîhcikêwin* means the "sacredness of the way things are done." Protocol, *nîkân isîhcikêwin*, is "the way ceremony was conducted since the beginning of time." The teachings are as old as our language itself—since the beginning of time. They are elemental, derived from the wind, the fire, the rock, the earth, and all its animate and inanimate forms. When studied closely, these ancient spirits simply "do" their business.

In English, Earth-based spirituality is referred to as paganism. In Latin, *pagan* means "at the hearth." Prayer began within the cave. Spirituality is a holistic journey and calls on both the individual and the community, *wâhkôhtowin* ("kinship"), or a whole. It is a profound journey that covers the medicine wheel and its four elements: mental, physical, emotional, and spiritual. The mind, the heart, the gut, and desire coexist and are directly related. This travel opens the door to transformation, if one is open to it. The Elders encourage lines of inquiry when they teach *tânisi kititêyihtên* or "What does your heart feel?" The second teaching is *kiya*, meaning "It's up to you." The third is *mâmitonêyihtamâso*, meaning "You have a mind, think for yourself." This journey, though communal, is also a private one and therefore responsible to the self and others: "Ceremony increases one's knowledge and understanding of self, as well as one's place and belonging in the world" (Ross 2014, 207).

When people are honoured with the right to carry on a ceremony, they take a vow, *kihci-asotamâkêwin*, or "give their word since they have been blessed with *sawêyihtâkosiwin*, these responsibilities." Within these teachings are the values of "respect," *kistêyihtowin*, and "caring," *kisêwâtitâtowin*, for oneself and others; the word *manâcihiwêwin* implies "respect and the binding of people within this value system." When individuals honour and respect others, in essence they show the same respect to their *ahcahkwa* or "soul." The soul arises from within the union of wind and spirit. To put this in cultural terms, the *nêhiyawak* (the Cree people) take direction from that place of spirit within the wind.

In recent times, there has been more conflict over dress, protocol, and ceremony. Unfortunately, these conflicts again divide the people in ways that the government and other colonial institutions would applaud. These are the very establishments that brought such damage and confusion to Indigenous peoples. The ensuing conflict within our own community led to this exploration of protocol in both Cree and English. It is essential, however, to discuss the issue of protocol within a ceremonial context.

The concept of ceremony is not so different, but perhaps it is more superficial in English. In the *Oxford English Dictionary*, the word *ceremony* is defined as

> (1) a formal act or set of acts performed as prescribed by ritual or custom;

(2) a conventional social gesture or act of courtesy;

(3) strict observances of formalities or etiquette;

(4) a formal act or ritual often set by custom or tradition, performed in observation of an event or anniversary;

(5) a religious rite or series of rites;

(6) the formal activities conducted on some solemn or important public or state occasion;

(7) a gesture or act of politeness or civility;

(8) formality.

Ceremony is a prescription of spoken or unspoken modes of dress and behaviour to which one adheres. It is implied that without these traditions one would not have celebrations or laws to abide by, and chaos could prevail. The traditions direct social conduct and instill order and values that enhance and bring meaning to one's life.

The English word *protocol* is derived from the Latin word *protocollum*, which means "the first sheet of a volume." In Greek, *protokollon* is the "first sheet glued onto a manuscript." It is essentially the same in both languages and marks the beginning of something of more depth and substance. Although these words, in both Cree and English, have ancient origins, they still have value in the here and now.

Spirituality is a companion to the sensual. We explore and discover and analyze through our five senses. The eyes (or *miskisikwa*, which means "big heavens" or "infinite heavens") have the capacity to see more than appearances. The mouth, *mitôn*, not only tastes, eats, ingests, and regurgitates life; we also spill from our mouths what we have thought and learned. The nose, *mikot*, pinpoints odour or helps us to determine the direction and place of the scent. It works alongside the eyes and the ears; it sends out feelers to absorb the scent and aura of another entity or being. The word for ears, *mihtawakaya*, implies a "digging through the tunnel to receive the information." In essence, the ear acts as a "gut" as it discerns and digests what it has heard or hears. The hands, *micihciya*, are the "feelers of skin attached to muscle, the heart, and the rest of the body," *miyaw*. The hands carry out the directions from the other senses.

It is not surprising, then, that a sweat lodge is shaped like a cave, a lodge, a den if you will. In Indigenous spirituality, *nêhiyawak* receive their gifts and their teachings from the earth, plant, insect, and animal

life around them. Interestingly, "the word for animal is derived from animale meaning animated which comes from the word anima or soul. Animals are those not only [with] whom we share this earth and this physical universe of space and time, but also with whom we share a soul" (Fox 1999, 158). Visions or visitations are received through the Vision Quest, the Sun Dance, and other ceremonies, as well as in dreams. One becomes aware of her or his *pawâkan* through deep observations during one's participation in ceremony. The *pawâkan* is one's dream spirit and helper. In essence, *"animals line our souls"* and, yes, our physicality (Fox 1999, 163).

The teepee (*mîkiwâhp*, "where one sits and sees from") can be a decorated structure that enfolds, akin to a nest or a hive. It is shaped like a woman, full and circular. Originally, animal skins dressed her skeletal frame. The teepee poles extend from the ground into the sky, as if her arms hail the heavens in prayer. Each pole represents a principle and together the values and morals of the culture. Each peg inserted into the ground provides steadfastness and is "grounded" in duties and beliefs. The doorway, in essence, is the vaginal opening to the womb. It is from this hearth that women share their teachings and their place in the universe.

Tobacco ties are made for particular ceremonies such as the Shake Tent or Vision Quest. They are generally not acceptable to be presented to an Elder to gather information or for the more common sweat lodge. It is more honourable to present a whole pipe or pouch of tobacco than a pinch, for that indicates respect for the knowledge that the Elder has accumulated over many years of discipline, reflection, and gathering. This tobacco is used to enter ceremony with spirit, to receive and learn how to share what is being requested. It is advisable for the recipient to gift the Elder in *nâcinêhikê* in return for gathering information, knowledge, stories, songs, medicine, or ceremony. *Nâcinêhikê* is an Elder term to suggest to the receiver that "there is a valuable exchange for his or her request" and that "it is not for nothing." One must remember that Elders have earned their knowledge through many years of ceremony, sacrifice, and humility in their own quest for understanding.

A "bundle" is another term often confused. Elders say that a true bundle—*nayâhcikan*—contains the hair and clothing of a deceased person. Sweetgrass and tobacco are wrapped in prayer cloth along with these personal remnants. However, this bundle must go through

ceremony to be honoured and blessed and to carry on the memories and teachings of the deceased. To accept the responsibility of a bundle is a lifelong commitment that requires the correct protocol and the participation in ceremony, such as the Ghost Dance and other related ceremonies. In the Walking with Our Sisters ceremony and art installation, the beautifully created moccasin vamps of the missing and murdered Indigenous women are symbols, a remembrance of their lives. The vamps are a bundle in their own way. Creating them was a commemorative reminder of their complete absence. They are unique bundles, not to be confused with the original *nayâhcikan*, but worthy of having their own ceremony and protocol carefully developed through community consensus.

In many *nêhiyaw* communities, *iskwêwak*, "women," are asked to refrain from participating in most ceremonies when they are in their moon. Unlike the common assumption that stems from many Christian beliefs, this request is not because they are dirty, polluted, or unwanted. On the contrary, it is because it is a time of power: "When Creator called for the universal energies to come together in that sound, that vibration, what came were the universal energies to create Mother Earth. It is those universal energies that came together that manifest the physical form of her behaviour in women. We emulate everything that she teaches the universe must be. So it isn't just Mother Earth, it is how we are connected" (Anderson 2001, 71). Creator's, Mother Earth's, women's ability to bring new life; this ability places women as *intermediary* between the Earth and the spiritual world. The potential to help a new soul transform, to cross from the other world into this world, is the heart of *feminine potency*. Regardless of the gender with which people identify, they will never forget the body form that they came in at birth. That was the beginning of their story.

In *nêhiyawêwin*, birth is referred to as *mamahtâwisiwin*, "arriving from a spiritual place filled with medicine powers." The arrival of a woman's period is sometimes referred to as "her grandmothers have arrived," which insinuates the "innate wisdom," *kiskêyihtamowin*, that the woman possesses. Wisdom in Latin and Greek means to "taste life." In *nêhiyawêwin*, *kiskêyihtamowin* loosely means "the sacred things I know from which my heart has eaten." Matthew Fox, a theologian, writes that "there are two places to find wisdom: in nature and religious traditions. . . . Nature is a powerful source of wisdom" (Fox 1983, 9).

Some Elders believe that not every woman is a grandmother, and it is only through pregnancy and childbirth that this right has been earned.

There are ceremonies dedicated to each full moon and the first moon time period. Moon, *tipiskâwi-pîsm*, translates loosely as the "night moon" or, more accurately, the "tumbling over or turning over of the night sun." It is also referred to as *nôhkom âtayôhkan*, which means "Grandmother Legend Keeper," the sacred holder of knowledge and legends of Cree *pimâtisiwin*. At a deeper level, *pimâtisiwin* means the "blowing life of the wind," which is life and sometimes referred to as culture. The word *psyche* in Latin means "one's spirit and wind." The Old Ones teach that our ceremonies, our culture, are our psychology.

The moon time is a time of reflection, power, and consideration. It is the awakening of women's fiery spirit; during the last week of her cycle, a woman is waiting, wishing, meditating, and dreaming. It is a time of learning, memory, moderation, and deliberate action. In *nêhiyawêwin*, this is referred to as *pîsimâspinêwin* or "the moon's behaviour/psyche has taken over." The time of menses is about transformation, regeneration, and death. During a ceremony, the protocol asks that people be mindful of dress, sitting position, and moon management. This is not because Elders are being disrespectful; rather, they are merely asking that the ceremony be respected. Participants are in fact humbling themselves, *ê-tapahtêyimocik*, in "the sacredness of ceremony." Contemporary Elders did not invent these wishes; these practices have been here long before the Elders were born and are inherent in our language.

Dress, *miskotâkay*, more literally means "to switch into another skin to cover up one's private parts." For ceremonial purposes, the word used is *mamahtâwisîho*, which means "in honour of one's sacred entity, one dresses." Those who conduct a ceremony might be in opposition to women wearing pants, but the *ospwâkan*, "the pipe," cannot turn people away. The circle will be broken if it is so. Everyone therefore must grapple with and be accountable for what they perceive to be humble and respectful. Those responsible for the pipe, whose belief system is entrenched in the dress protocol, are free to establish that boundary for themselves, the ceremony that they conduct, and whether the protocol is necessary for others. How they handle this is entirely their journey. They know for themselves what it is to dress appropriately, sit on the earth, and be in ceremony with humility and respect. The question

for them is do they project this onto others? How will they welcome innocent seekers and share their knowledge?

There is also a misconception that one is a "pipe carrier." In essence, *ospwâkan*, "the pipe," *carries us. Ospwâkan* is the namesake of the pipe. To be carried by *ospwâkan* is not only an honour but also a significant responsibility. To honour *ospwâkan*, perhaps ironically, is an earned *kispinacikêwin* and "a difficult burden." *Ospwâkan* opens most ceremonies. It does so to clarify the expectations of rituals before ceremonies begin. All participants are guests in this process and follow protocol. It is not without flexibility. Women who avoid a dress can be offered a blanket and be encouraged to honour their feminine side or moon time.

I am deeply grateful to the language itself for these gifts of awareness and to the Elders who guided this chapter. This chapter was written with respect and brought into ceremony. I might have offended some by the publication of this material. It is my hope that in releasing this information it will open the door to further discussion and help those in need. There is no end to the quest for knowledge. Reading and research are one thing; it is yet another to gather information through active participation in ceremony and direct communication with an Elder. One grows when one accepts and honours mistakes and pays attention to the corrections. Our Elders are diminishing in numbers; time is running short. More than ever we are in need of their wisdom.

References

Anderson, K. 2001. *A Recognition of Being: Reconstructing Native Womanhood.* Toronto: Canadian Scholars' Press.

Fox, M. 1983. *Original Blessing.* Santa Fe, NM: Bear and Company.

———. 1999. *A Spirituality Named Compassion: Uniting Mystical Awareness with Social Justice.* Rochester, NY: Inner Traditions International.

Ross, R. 2014. *Indigenous Healing: Exploring Traditional Paths.* Toronto: Penguin Canada.

SÂKIHIWÂWIN:
Land's Overflow into the Space-tial "Otherwise"

KARYN RECOLLET

> As our mana flows again, as the barriers crumble, this is
> when we, naked, practice the courage to say yes to our
> power to create something that does not exist. Say yes to
> vulnerability, our stories stretching to receive the rushing
> wave, wind and rain. Say yes to chaos, as we are shaken
> by the new world we are writing in mud, in faith, in root.
> Decolonial love places our wild feelings up in the sky
> where they can puncture the darkness and guide us toward
> integrity, a new home. (Yamashiro 2015)

I am a visitor on the Dish with One Spoon treaty territory steward-
ed by the Wendat Confederacy, the Onondowaga (Seneca) of the
Haudenosaunee Confederacy, and the Michi Saagiig (Mississaugas)
of the Anishinaabe Three Fires Confederacy. I acknowledge the
space-making practices of African diasporic, Afro-Caribbean, Afro-
Indigenous, and other diasporic peoples' creative work and geographical
knowledge informed by rich traditions of radical Black thinkers. In
doing so, I honour the sonic and visual activations and genealogies
that continue to create meaningful landing relations in Tkaronto, the
place where the trees stand in the water. In introducing myself to you,
the reader/listener/witness, it is important to acknowledge that the
complicated histories, exiles, displacements, and violent upheavals
of Afro-diasporic and Indigenous peoples cultivate an "otherwise"
landing acknowledgement whose reach extends toward everyday re-
lationships with landing, an extension of atmospherical relationalities
that considers cosmologies, earth-working practices, and other forms

of space-making practices as Black and Indigenous projects of love, abolition, mutual care, and justice.

In this chapter, I discuss celestial movement practice in *Spine of the Mother* (choreographed by Starr Muranko), Cherokee-Mohawk rapper Dio Ganhdih's *Pussy Vortex*, and the sonic-digital aqueous work of (Anishinaabe, Métis, and Irish) Elizabeth LaPensée's *Honouring Water*. As Indigenous mappings, these cultural productions push back against the flattening of the terrestrial and gesture toward the sky and the waterways. In my analysis, I centre the practice of "glyphing" (Recollet 2015) as the modalities or forms that activate *sâkihiwâwin* ("love in our actions") in multiple geographic scales or levels (night sky, lake, river, stream). Thus, an understanding of radical relationality through *sâkihiwâwin* permeates through boundedness to illuminate the overflow of lands, lives, and loves. Jumping scales from terrestrial, subaqueous, and celestial modes of being acknowledges forms of radical relationality as kinstillatory connections between human and non-human entities.

The cultural productions explored in this chapter contribute to a larger body of Indigenous-shaped activations that, inasmuch as they become sites of cultural production, also inform an analytic that holds space through multi-scalar formations. The term "kinstillatory" dreams up possibilities for thinking about kinship networks that can hold space for Indigenous rematriative (WE ARE 2016) mappings and produce new worlds as spaces "otherwise" (Crawley 2015; 2016). It is my understanding that stars that form constellations in fact mobilize technologies of holding space through the forms of dark matter. Kinstillatory describes the formations and shapes of the relationships with spaces/places that extend the reach of popular ideologies of land, to overflow into other layerings, realms, and rememberings. These celestially and rhizomatically rooted, intersecting formations find magic in dark matter and are patterned inclusive of our relations with more/other than human beings. Kinstillatory describes the complex and gorgeous scales of kinship that comprise the dark matter holding the stars together. I believe that Indigenous choreographers, dance makers, digital artists, and song makers are in fact manifesting dark matter[1] through a series of codifications that can be read as sets of organizing principles. This dark matter—the intelligence, the spaces between (and the site of possibility for future change)—extends in all directions, including those that have yet to be named. Swampy Cree star knowledge

holder Wilfred Buck (2009) references the multi-scalar directionality of consciousness when he situates lifeways and processes in space to mirror what happens on Earth. Using the simple phrase "what is above is mirrored below" (3). Buck extends terrestrial land formations, beings, and organizing principles (the creation of camps) into sky worlds. Thus, my goal in this chapter is to begin a conversation about land's overflow into the different scales, suggesting not only that land is rhizomatically rooted vertically downward but also that it is tentacular and celestial in its reach of all things.

Sâkihiwâwin as Revolution

During a session at the Native American Indigenous Studies Association conference in the winter of 2015, Cree scholar Dr. Alex Wilson mobilized the Nêhiyawêwin concept of *sâkihiwâwin* to reveal how love is an activation. This propelled me to think through *sâkihiwâwin*'s sonic and kinesthetic affect in forming our relationships to land. Practised in Idle No More's forms of leadership and organizing, *sâkihiwâwin* infuses and mobilizes lands' different scales through sonic and kinesthetic forms such as round dancing. Idle No More round dances, or rather *pîcicîwin/wâskâsimowin* (Cree translation provided by Charlotte Ross, 2021), across Turtle Island were moments when *sâkihiwâwin* was unleashed, forming circuitous choreographies of profound care and protection for Indigenous lives and lands. The gestural worlding in this dance reflects a process of kin making and affirming relationality as centered in *wâhkôhtowin* and activated through the process of *sakicihcênitowak* (holding hands). This terminology references a gestural vocabulary of those beings, both human and more than human, that fill the interstice or active space between spaces (the dark matter). These practices of embodying an interstice also suggest the kinds of futurity work that round dances activate—it is in these glitches, these spaces that we can imagine new possibilities for Indigenous socialities in these moments in which we find ourselves. These processes establish and renew land/territory relationships through dance and ceremony, reminding us that breath and circuitous motion are principles of kinstillatory worlding. This process of *sakicihcênitowak* within the context of *wâhkôhtowin* speaks of letting go of the need or desire to possess our loves and, instead, offer processes of delinking from heteropatriarchal patterns of power and control over all of our relationships (Yamashiro

2015). These careful and intentional kin-making practices release us from normative gestures to reveal our collective interior geographies as they expand outward to imagine and create new worlding strategies and forms.

Idle No More's round dances contain gestural vocabularies that outline social and structural change as they map space into rematriative choreographies. Indigenous sovereign bodies sonically and physically map territories in these processes and thus renegotiate spatial and temporal borders through Indigenous scales. The round dance revolution can be viewed as hubs or a series of urban meeting spaces, shaping multi-scalar and shifting terrains. These moments are as well evoked on communal, national, and international scales, but they also inhabit interiority, intimacies and the worlding projects that ascend from these interior spaces of possibility. Round dances can be said to activate relational meaning making, producing countermaps with each reconfiguration, viewed as spaces of settler colonial critique achieved through repetitive gestures shifting into the "otherwise." The represencing of Indigenous bodies in circuitous motion in hubs of capitalist exchange reconfigures and displaces overdetermined colonial geographical scales of containment and erasure. Consequently, these active forms of Indigenous care refuse state structures and carceral forms of containment as settler practices of violent "care." Round dances (specifically flash mob round dances, though I perceive ceremonial round dances in a similar fashion) activate our connections to land through creative land intimacies, producing geographic sites of radical decolonial love that shift to the atmospheric—that gesture toward kinstillatory relationality and forms of care. The round dance revolution produced spatial tags (technologies of Indigenous countermaps) of resistance and futurity, as "sites of persistence, resistance and resurgence" (Wilson 2015, 272):

> Our visible presence (not shopping, driving, or legislating, but doing what we are not supposed to do drumming, dancing and protesting) transforms these spaces into political spaces. They become sites of persistence (we are here today because we love and care for our people and our nations and we will be standing here tomorrow), resistance (we are here to put an end to the harm colonization inflicts on our people and our nations), and resurgence (we are here to repair that

harm and reclaim the sovereignty of our bodies and our peoples) (Wilson 2015, 273).

Reflecting on hip-hop scholar Tricia Rose's (1994) analysis of hip-hop as a vehicle for social transformation, I have observed that the spatial mechanics of the urban flash mob round dance include hand drum singers who formulate the innermost cypher/circle, layered with double beat drum soundscape, syncopated with the reverb interstice (created through a technique that hand drummers use aurally to accentuate the interstice or space between the beats), layered with hand embraces, love songs, and a stride-and-shuffle to the left. According to this formula, the round dance highlights layers by generatively expressing the interstices in acts of reclamation of urban Indigenous space. The layering and syncopation achieved via the concentric circularity of the round dance carry the potential to unmark bodies of difference and instead to inscribe multi-plexed Indigeneities as a product of the reverb interstice created through the drum. As ethical spaces (Ermine 2007), these interstitial spaces formulate a reconfiguration and dislocation of power. Similarly, I would suggest that other forms of Indigenous embodiment as kinstillatory gesturing, such as voguing, occupy the interstices/producing generative glitches (glyphs as glitches) that spiral us into an otherwise.

Complex diasporic Indigeneities are rooted but also routed and in constant motion. As glyphs, flash mob round dancing in cities ideologically and intrinsically situates lands and bodies in space, presenting Indigenous forms of sonicality and embodied spatiality that converge to worlding maps as glyphs. These glyphing practices become ways to think alongside a set of principles stemming from kinstillatory thinking, whereby celestial patterns become the worlding practices of those below through processes of "jumping scale" (Harjo 2014).[2] This dance embraces human-non-human radical relationships and our present futures and future pasts—flipping the settler colonial spatial/temporal scales. As a main force behind the Idle No More movement, *sâkihiwâwin* informed the collective and localized forms of organizing to extend protection and love to water/land spaces—and, I would add, landing practices of Indigenous and Black people. It is my understanding that love in our actions is sourced through Indigenous cultural expression in radical relationship with lands and landing glyphs. These

relationships express consent among the multiple scales of lands—in terms of building protocols and processes that acknowledge territory in ways that exceed the flattening of settler colonial mapping to include, for instance, those glyphs co-constituted in radical relational practices of extending care to each other.

The multiple activations involved in Idle No More and the Sacred Stone Camp, Red Warrior Camp, and Oceti Sakowin camp mobilized *sâkihiwâwin* through Two-Spirit and queer Indigenous feminist leadership activating organizing principles of solidarity. These camps, town halls, and occupations were hubs of organized leadership and collective decision making in which multiple strategies activated the land/water spaces to resist environmental destruction. The construction of the Dakota Access Pipeline (given the go-ahead by the Trump administration) threatens the traditional and treaty-guaranteed great Sioux Nation territory. This pipeline would transport hydraulically fractured (fracked) crude oil from the Bakken Oil Fields in North Dakota to connect with existing pipelines in Illinois. A statement from the Black Lives Matter (n.d.) network that travelled to North Dakota to stand in solidarity with Indigenous peoples expressed that "we are clear that there is no Black liberation without Indigenous sovereignty. Environmental racism is not limited to pipelines on Indigenous land, because we know that the chemicals used for fracking and the materials used to build pipelines are also used in water containment and sanitation plants in Black communities like Flint, Michigan."[3] With this element of relational kinship, it is important to consider how Black and Indigenous folks *land*, as a verb. How do we land, how do we fall into sets of relationships, and what are our strategies for reworlding together? Among the interstitial spaces of possibility are the languages that we use for our landing strategies. For instance, instead of climate change, we consider atmospheric relationality, and we consider the knowledges of Black and Indigenous earth workers as strategies for reworlding together.

Otherwise Spaces of Possibility

Our collectives oriented toward the rematriation of Indigenous lands and lives rely on healthy/consensual *sâkihiwâwin* as a vessel or bundle that can hold spaces for all of these tentacular reaches. Highlighting the multi-scalar reach and orientation of land, *sâkihiwâwin* (as a form of "decolonial love"[4]) or as a practice of mutual aid and care within our

communities, is choreography—in that it creates, builds, and shapes complex forms of relational spheres to imagine and create alternative and future-oriented geographies. These choreographies resist an orientation toward utopia or a freedom from the messiness, rupture, and fragmentation (B.R. Belcourt, in conversation, September 2016). Situated within a kinstillatory web of radical relationalities, both human and more/other than human, the activations shared here are not free from this messiness but extend out toward all of love's reaches. These tentacular reaches—housed in the bodies of dance makers' movement, play, music, film, video production—challenge the containerization of Indigenous bodies as *land locked* (Cornum 2015). Perhaps this thinking echoes these multi-scalar *âtayohkêwina* (sacred stories about the constellations that Buck 2009 references). They take us closer to a landing praxis of being in good relation with the atmospheric as a site for visiting, visioning, and world making.

Sâkihiwâwin teaches me that love overflows our relationships with terrestrial land spaces into intimate spaces.[5] This relationship is multi-scalar—messy, rupturous, and impermanent (I write about this in Recollet 2015). In these activations, land surfaces and is transmitted through forms of love accountable to body/land relationships. *Sâkihiwâwin*, perhaps, is time travel, a journey into and a technology of the "otherwise." According to Ashon Crawley (2016, n.pag.), "otherwise is the enunciation and concept of irreducible possibility, irreducible capacity, to create change, to be something else, to explore, to imagine, to live fully, freely, vibrantly. Otherwise Ferguson. Otherwise Gaza. Otherwise Detroit. Otherwise Worlds. Otherwise expresses an unrest and discontent, a seeking to conceive dreams that allow us to wake laughing, tears of joy in our eyes, dreams that have us saying, I hope this comes true." These otherwise spaces of possibility include aesthetic principles that allow for the emergence of alternative modes of social organization and pods of mutual aid, leading to healthy, sustainable spaces. Feeling otherwise, according to Crawley, though tied to ongoing projects of settler colonialism and radicalized capitalist logics, can also be mobilized as a critical analytic—through otherwise feeling and being. According to Crawley, otherwise can be registered at the sonic and feeling levels. Or as, Crawley so beautifully offers, a "choreosonic encounter" and to "think of otherwise possibilities for organizing, for thinking projects that neither make the flesh diminutive

nor discardable" (Crawley, 2017, 23). Robin D.G. Kelley characterizes these forms of cultural expression as transcending the scales of mere resistance, leading to the production of countercultural symbologies that turn communities and collectives into spaces of joy and pleasure. For instance, Kelley states, "while some aspects of black expressive culture might help inner city residents cope with, or even resist ghetto conditions, most of the literature ignores what these cultural forms mean for the practitioners. Few scholars acknowledge that what might be at stake here are aesthetics, style, and visceral pleasures that have little to do with racism, poverty, and oppression" (1997, 9). However, Crawley is also asking of us to think through "how to move, in such a world wherein your resistance against violent conditions—resistance as prayer meetings or protests, resistance as simply wishing to breathe—produces the occasion for violence" (Crawley 2017, 23).

Expressing love in our actions is also, in my opinion, connected with joy and pleasure—being in love with the land spaces that we find ourselves in means something to us sometimes as diasporic Indigenous folks falling into a set of relations in the urban/citified landing sites. The chosen forms alongside which I think in this chapter extend visual and sonic creation processes that embody particular orientations toward the future. These activations extend glyph-making practices, shaping "otherwise spaces of immense possibilities" (Crawley 2015; 2016, n.pag.). These forms are oriented toward the future by modelling certain leadership and organizing principles in their sonic and visual coding. For instance, an orientation toward the stars tells us that we are connected in a kinstillatory way to each other and that all of us need to make changes. Through the guidance of Dine, Navajo body somatic practitioner Nazbah Tom, I have learned to explore the shapes and forms of our gatherings/collectives as pathways to consider how we orient celestially. These shapes bring me to the work of dance makers, visually and sonically inspired artists, to explore the depths of these shapes and forms as kinstillatory spatial practices of love, protection, care, and joy. Kinstillatory describes one of the shapes through which we gather, and perhaps this concept carries the potential for how we might "do" kinships in urban spaces. Kwakwaka'wakw scholar Sarah Hunt (2014), for instance, reminds us of the importance of accountability through witnessing as a framework for the governance of gatherings. Kinstillatory offers answers to the questions "who are your people?"

"Whom do you create with?" "Whom are you building futures with and for?" As Kelley (2017) suggests, love needs to be at the centre of renewing our habits of assembly. Kelley also stresses the importance of building a community in which there is *no outside*.

Glyph Making

Glyphing is a process of activating relationships to land through embodied, sonic, and/or visual practice. My use of the concept here refers to the creation of glyphs as mnemonic devices (the creation of petroglyphs as cultural symbologies through the artistic/spiritual practice of applying clay medicines to rocks and other surfaces). Glyphing can be imagined as an ongoing technology to name, record, and gesture our movements on urban Indigenous territories. Produced and curated by Anishinaabe artists/activists/scholars Susan Blight and Hayden King, the Ogimaa Mikana (Leader's Trail) Project is one such glyphing practice with the intentions of an Indigenous spatial project of joy and futurity. Ogimaa Mikana is multi-scalar and rematriative. Ogimaa Mikana is a tribute to all of the strong women leaders of the Idle No More movement, including the founders, Nina Wilson, Sheelah McLean, Sylvia McAdam, and Jessica Gordon. Ogimaa Mikana spatially tags Tkaronto through the resurgent practice of renaming and reclaiming Indigenous territorial geoscapes such as Gete-Onigaming (formerly Davenport Road); Ogimaa Mikana (Queen Street and McCaul); Anishinaabe Mikana (Path of the Original People); Ishpadiina (Spadina); the Queen and Dufferin intersection claiming Biskabiiyang (North Bay); Peterborough (Anishinaabe Manoomin inaakonigewin gosha); and Animikii-waajiw (Thunder Bay). Billboards activating Anishinaabemowin (Anishinaabe/Ojibway language systems) include the billboard in Parkdale highlighting the Dish with One Spoon wampum belt to remind us that we have obligations of mutual care toward each other coded within the governance wampum—that collectively we must relearn these obligations (Ogimaa Mikana). These acts of Indigenous remapping (Goeman 2013; Hunt and Stevenson 2017; Razack, Smith, and Thobani 2002) are spatially remapping *sâkihiwâwin* projects of joy, producing kinstillatory relationships among the multi-scalar layers of Indigenous lands and lives. These glyphing practices can be read alongside the powerful Black geographical creative and thought work of Camille Turner as they theorize and explore otherwise hidden Black geographies in their digital

WalkingLab project the BlackGrange. This project is a walking tour of the Grange, a Tkaronto neighbourhood with Black history and presence.

Glyphing water and celestial spaces (a process rooted in Indigenous artistic cultural expression) reorients and reproduces space/time into an atmospheric of possibilities, intervening in the flow of continual forms of capitalistic, extractive, and harmful relationships to land and landing praxis. These multiple reorientations map embodied choreographies as geographies of possibility. These forms of multi-scalar movement recontextualize orientations toward sky worlds and our relationships with terrestrial land spaces. For instance, Duane Linklater's project Monsters of the Urban Unconscious reactivates clay beds through the creation of gargoyle sculptures at the river's edge, bringing the celestial into deeper relation with the terrestrial—thus, I believe, a kinstillatory project of radical relational beingness that gestures toward a rich Indigenous otherwise geography that can be read in relation to the Ogimaa Mikana project and BlackGrange to explore the interconnections of kinstillatory mapping projects in Tkaronto. This project sets its sights on "bringing Toronto's skyline to ground level" (Lum 2017) with replicas of gargoyles situated to reorient the "substrate" (Linklater, quoted in Lum 2017) by reuniting these celestial beings that watch over our city with the rich clay deposits of their original making. Another kinstillatory project focusing on care took place during the 2017 Jaime Black residency, hosted by Women and Gender Studies at the University of Toronto. A fulcrum of this gathering was a decolonial body somatic exercise during which Nazbah Tom guided students, community members, and University of Toronto faculty through a somatic exercise orienting our intentions and bodies to the underground water of Taddle Creek (a repeatedly buried creek in Tkaronto that extended to Lake Ontario). Tom's body somatic process on land activated a collective radical remembering, accounting for, and form of holding space for the land and water beneath our feet. During this land activation, our bodies were aligned with the layers beneath us through collective breathing and centring. Our arm and hand movements released imagined currents of water into the inner circle— washing water through and over each other's body. A choreographic moving glyph, this land/body work reflected a process of stretching time and space to create an otherwise space of possibility (Crawley 2016) on Anishinaabe and Haudenosaunee land spaces. Our bodies mobilized this dark matter as a way of holding space for the underground waterways

and their connections with the geoscapes of the sky. Thus, this kinstillatory gathering rooted our bodies as the landing glyph.

Echoing these orientations, Sonny Assu's *We Come to Witness* illuminates Indigenous forms of visiting and witnessing as celestial beings imprinted on Emily Carr's classic colonial paintings. *Sâkihiwâwin*'s kinesthetic affect in such instances roots love by creating potential kinstillatory spaces for the interventions and disruptions of colonial relationships to land spaces. I imagine these formations in relation to ongoing forms of resistance and struggle and draw understanding for the reading of alternative atmospheric mappings that focus on Black and Indigenous lives. Such strategies and organizing principles necessarily orient us toward a rhizomatic relationality as complicated and complex landings from our unique experiences of the fall. This work acknowledges our relationships with land and belonging as multi-scalar and rooted in fierce Indigenous love. Assu activates this connection through "abstract ovoid and U-shapes rooted in iconography of the Kwakwaka'wakw art style, digitally overlaid on Carr's landscapes as graffiti-esque tags" (Cheung 2017). This intervention of colonial aesthetics, such as *Spaced Invaders* (Assu 2014), tags multi-scalar relationships with the land that challenge fixed/flattened/colonial conceptions of land as nation-state—static and valuable only as property. Similar to the multi-scalar work of Ogimaa Mikana's glyphing, Turner's BlackGrange work, and Linklater's multi-scalar gargoyle art, Assu's imaginary conceptualizes land as sky world/space, a process that also activates alternative ways of being together. These shapes and formations are as holding patterns for how we can organize ourselves collectively. Such experiences are kinstillatory in their abilities to mobilize these spatial layers/realms to create portals as otherwise spaces where all things are possible. Such inter-scalar transgressions create possibilities to intervene in the perceptions and subsequent erasures associated with thinking of land as property. The harmful and even catastrophic practices that accompany such perceptions of land (e.g., the fracking and other harmful processes created by the construction of the Dakota Access Pipeline) affect the bodies and lives of Indigenous women, Two-Spirit, queer, youth, and adults in our communities through increasing forms of intersectional violence. Practices of organizing collective life such as those manifested by Indigenous feminists and queer, Two-Spirit community members, artists, and activists imagine and activate otherwise spaces where lands

and lives are intimately connected to all of lands' overflow. For instance, the intellectual and cultural production of Erin Konsmo creates spaces for Indigenous queer and Two-Spirit people to hold spaces for each other. Indigenous art such as Aura Last's *Constellations of Stars* and Margaret Nazon's (Tsiigehtchic NWT) creation of beaded galaxies, nebulas, and other cosmic images create rematriative, kinstillatory, and otherwise spatial mapping processes that offer joy and ask us to return to the atmospheric to consider our landing praxis. Similar practices of archiving symbols of joy can be found in the choreographic futurist *Spine of Our Mother* by choreographer/dance maker Starr Muranko (Cree-Métis).

Spine of the Mother: Symbols of Joy

Muranko's collaborative performance *Spine of the Mother* was brought to Native Earth Performing Arts Weesageechak Begins to Dance Festival in 2015. *Spine of the Mother*, activated on Dish with One Spoon treaty territory, expresses consensual relationships that exist within and among stars. I suggest that this process acknowledged Dish with One Spoon treaty territory by activating patterns of kinstillatory relationships. Such relationships between moving bodies and celestial bodies (lands) can be read as technologies of kin making in urban Indigenous territories, wherein stars cluster as maps/models to organize collective life. I perceive kinstillatory patterns of stars, each maintaining an ethic of body governance. *Sâkihiwâwin* can be experienced as forms of collective organizing, situating ethics and responsibilities in relation to space. These ethics include consensual relationships with Indigenous lands and lives expressed through urban hubs, such as the Native Youth Sexual Health Network (NYSHN; see Women's Earth Alliance and Native Youth Sexual Health Network 2016). NYSHN is a collective of fierce Indigenous community organizers and Indigenous youth leaders who support communities to develop culturally safe and nation-specific responses to intersectional forms of violence. As an example of an urban kinstillatory hub, NYSHN maintains consensual, harm-reductive, body-sovereign practices. Kinstillatory approaches to community care and harm reduction include the following calls to action: being open to and supportive of the myriad ways in which folks and land spaces advocate for themselves; asking the question "What do you need to feel safe?"; organization and leadership using a seasonal framework

(i.e., "What is the moon doing?" "What moon are we in?"); centring the importance of witnessing (Hunt 2014); being attentive to the activations of land/art (e.g., the sound of two stars rubbing up against each other) as it issues a call—waiting for our response; the establishment and development of clear boundaries; centring our accountability to our bodies, lands, and each other.

Viewers of *Spine of the Mother* (Muranko 2015) are transported to the beginning of the celestial body that is Earth. Sensorially orienting witnesses to star intimacies—we sit in darkness—our senses are activated through the sonic scraping of two rocks (the creation of dark matter). In one section of the choreography, dance artist Tasha Faye Evans reaches to grasp stars from the constellatory scrim behind her, stars that manifest themselves into small rocks that Evans then places on the body of dance maker Andrea Patriaus, forming an "on the ground" constellation. Positioning outward to mirror star worlds and constellations, this activation reminds me of how choreography can become a modality of writing or glyphing bodies to reworld and reshape how we radically relate to each other. Sonic star language precedes a constellatory mapping to be activated later on the body of Patriaus, establishing consent. Patriaus maps her response to this celestial call to take the shape of a collective—in an embodied organizational principle of holding dark matter. This suspension of time/space is the sonic vibration of the return of stolen land doing its creative process of worlding. I realized, as I witnessed Muranko's movement practice, that radical forms of love are embodied, sonic, and kinesthetic. In this particular moment, the sonic vibrations and frequencies brought into motion through two rocks rubbing together reveal a pattern of sonically mapping consent.

Muranko's (2015) choreography utilizes decolonial Indigenous feminist geographies as forms of somatic remapping through the placing of rocks as a constellation on the body of dance maker Patriaus. In this way, somatic and kinesthetic vocabulary can imagine and activate "Native futures without a settler state" (Tuck and Yang 2012, 13). I look at this piece as a series of overlays or spatial mapping practices that point toward imagining an otherwise. This otherwise is momentary—this is a glitch in the system—and we pattern rock and stone, our spatial ground tactics, not to evade the violence but to realign the body, once again to breach that space of rupture (I am grateful to Billy-Ray Belcourt for sharing his insight). Muranko's (2015) movement practice teaches us

this realignment, preparing us to transition into that glitch space. I suggest that, in thinking about organizing work, these are the ceremonies that can be done in urban spaces to make these transitions into glitch space. These embodied choreographic processes carry potential as constellatory "theories of change" (Tuck 2009, 57), organizing principles based on movements and patterns showing us how to orient our intentions collectively.

Relationships between Indigenous love and land are tagged spatially through glyphs (Indigenous loves and lives) in territorial activations. *Spine of the Mother* (Muranko 2015) is attentive to the differences between conflating Indigenous *bodies* with land (as though bodies are separate from land) and perceiving Indigenous lives and loves as inherent in Indigenous activations of traditional geographical spaces.

Pussy Vortex: Orienting Space-tial Otherwise

Cherokee-Mohawk queer Indigenous rapper Dio Ganhdih's music video *Pussy Vortex* (2015) maps the visual space with stars and galaxies, imagining Indigenous futurities that exceed the narrowed spatial possibilities of being "land locked" (Cornum 2015).[6] Ganhdih's work illuminates stars and constellations (including the Milky Way) as our doorways to an otherwise spatial realm. This work can be perceived to be in relationship with Elizabeth LaPensée's *Space Canoe* (2015). Digital futurisms such as those of Ganhdih and LaPensée are technologies of glyphing futurities through forms of spatial tagging in space that is delicious for folks like me who identify as urban Cree. According to Cornum (2015), "the Indian in space seeks to feel at home, to undo her perceived strangeness by asking: why can't indigenous peoples also project ourselves among the stars? Might our collective visions of the cosmos forge better relationships here on earth and in the present than colonial visions of a final frontier?"

By spatially situating this video among the stars, Ganhdih (2015) jumps scale into the present futures by offering forms of embodied sovereignty through lyrics that proclaim self-determining futures, as in "don't give it to me straight baby, give it to me gay." Ganhdih's sonic and visual interventions in heteronormativity and heteropatriarchy express alternatives, presenting worlds otherwise. Through this work, we can see the reach of futurities as a primary site of cultural production but also perhaps as an analytic linking queer orientations and the creation

of an otherwise sonic and visual space/world. This is solely my reading; however, it is possible that lovemaking that intervenes gender binaries helps us to jump scale from a singular trajectory of land as our only hope for futurity. Black/brown queer activations, through embodied forms of sovereignty, carry the potential to inform ways of thinking and being in the world that intervene in the settler colonial fetishization of our bodies. That which takes into consideration being "gender fabulous" (Native Youth Sexual Health Network 2013), through sonic sovereignty, calls for activations of lands and bodies that supersede settler colonial structures asserting patriarchy over defined bodies and land spaces. The activations of sexual and gender sovereignty, such as those created by Indigenous artists, provide alternatives to gendered and racialized violence against Indigenous trans, Two-Spirit, queer, and cis women. Expressive of Indigenous feminist futures, Indigenous feminist hip-hop activates a form of sonic haunting—the "something that must be done" (Gordon 2011, 1). Haunting as an activation is achieved through the very act of other-worlding by expressing the "gender fabulous" as queer, trans, and Two-Spirit people occupy the sacred spaces in the sonic lodges. For instance, the ceremony at the Great Lakes Gathering hosted by the Onaman Collective in Garden River, Ontario, activated Indigenous, Two-Spirit, "gender fabulous," physical ceremonial space within the lodge through what became a form of calling-in ceremony. I witnessed Métis artist Moe Clark sing a "moon song" as a form of kinstillatory calling that shaped "sonic futurities activating solidarities" (M. Murphy, personal communication, June 2016). These kinstillatory forms of organizing assert embodied sovereignties over body and territory by decolonizing gender norms and constructs.

Indigenous hip-hop navigates, negotiates, and produces its own flows emergent out of Black culture and the generative creation of Black English, and the lives and expressive forms of Black artists, activists, and communities are the foundations upon which sonic solidarities and movements have been built. As Indigenous peoples, we recognize this important contribution to the organizing and social movement building practices that have been created and activated by Black communities articulating responses to structural violence and racism (police murders of Black women, men, trans, queer, and children) such as Black Lives Matter. We are in an important moment of solidarity building between Indigenous to Turtle Island and Afro-Caribbean and other folks within

the Black diaspora living on Turtle Island. This is a moment of radical relationality as the struggle for abolition and Black liberation asks us to mobilize these deep kinstillatory patterns of centring Black life as a kinstillatory practice. We ask how are we falling into each other? What kinds of landing glyphs are we offering to our future ancestors? As such, it is important that we think deeply about our landing practices, acknowledging and being committed to each other's livability on these lands. Sonic forms of landing are deeply integral to our worlding strategies. We acknowledge the histories and genealogies of what has been coined as forms of sonic sovereignty (Campbell 2015), the creation and activation of languages that encode care and love—and I am deeply interested in the incredible surge of hip-hop space/place making within the spaces where we gather.

An exploration of the literature and a witnessing of the scene illuminate that hip-hop feminism's critiques and strategies provide helpful tools to dismantle how heteropatriarchy produces and ascribes fixed gender roles on Indigenous lands and bodies by providing a space in which to address the systematic violence of transphobia and homophobia. These are necessary technologies in our worlding strategy. Cree-Métis-Saulteaux curator and writer Jas M. Morgan offers an understanding and praxis to mobilize a degendering of water through the adoption of a genderless pronoun:

> While I do identify with the feminine spirit, I also identify with the masculine spirit—both within myself, and throughout all creation. I use the term aabitagiizhig to signify a gender fluidity that exists outside the bounds of the colonial gender binary; a self-determined, resurgent gender, based in my own ways of being and knowing my gender. I feel that I embody both feminine and masculine spirit. How then do I move through these spaces and honour creation in ways that connect to the Two Spirit life that surrounds me? How can I navigate moving between these defined spaces present at [the] water ceremony—between keeping the fire and praying for the water? (Nixon 2016a)

Ganhdih's video illustrates how forms of radical love can also be sonically glyphed into otherwise spaces of possibility. The potential of sonic glyphing is housed in the use of Indigenous languages and love

encapsulating the persistence of love through Nêhiyawêwin. This activation of Nêhiyawêwin to describe the complexities and multi-modalities of an activated love mirrors the commitment to *sâkihiwâwin*, or "love in our actions" (Wilson 2015), which has been activated as the centre of the Idle No More movement:

> miywâsin kâ-nêhiyawêhk (It's good to speak Cree and to be Cree)
>
> miywâsin ôta askîhk kâ-wîkiyahk (It's good to be on this land, to live on this land)
>
> nisakihtan pimâtisiwin (I love life)
>
> nisakihawak niwahkomakanak (I love my relatives)
>
> nisakihawak nitayisînîmak (I love my people)
>
> kîyanow ôma ê-maskowisiyahk (We are all strong)
>
> kîyanow ôma ê-sohkisiyahk (We all have strength).
> (Eekwol 2010)

Eekwol's storied narrative in *Look East* expresses the process of transcendence as a moment in which we "Look to the East where the night meets the day / yeah hey / hear the old ones say." Both Longjohn's and Eekwol's songs reference the same circuitous motion in the sky world to speak about radical love's points of convergence, where we can imagine love's futurity as kinstillatory. This point of convergence, the sonic space in between the beats, between day and night, life and death, is the dark matter—the space of Indigenous intimate love. Love as a poetic gesture and manifestation of life force is extended through the round dance to encompass all of our relationships with the past, the "now," propelling us into our futurity in a process of survivance and persistence of movement.

Eekwol's mobilization of Nêhiyawêwin centres love as the foundation for radical relationality and in doing so activates Indigenous epistemologies as a form of sonic survivance. Code-switching into Indigenous languages has been described by Cherokee hip-hop scholar Jenell Navarro (2015) as part of the multifaceted process of decolonization. Indigenous/ancestral languages function as "sonic acts of opposition" (Navarro 2015) to settler colonial practices of epistemic and bodily erasure as an attempted project of erasure. Love as a pedagogy/

poetics of hope continues to emerge from the spoken word, street art, b-girl and b-boy body formations of joy. Eekwol's provocation "Look to the East" is a spatial mapping project of orienting oneself to Indigenous spatial scales.

Honouring Water: Sonic Glyphing

Elizabeth LaPensée's (2016) digital application *Honouring Water* activates Anishinaabemowin (Anishinaabe language) songs gifted by Sharon Day, the Oshkii Giizhik Singers, and Elders. *Honouring Water* is a sonic technology of rematriating Indigenous land and life, a fluid process of being in relationship through the motion-based, migratory, affective, kinesthetic waves of water. *Honouring Water* activates Indigenous intelligence by voicing forms of "sonic intimacies" (Campbell 2015) between bodies and waters in digital space-time (Gaertner, Recollet, and LaPensée 2019) as forms of creating sonic intimacies through the act of singing Anishinaabe water songs. In *Honouring Water*, the body is realigned/reoriented in relationship with the sound kinesthetic (how sounds shape spaces) produced through singing in Anishinaabemowin. The sonic remapping that takes shape through a process of singing love songs to the water reifies relationships and exercises sonic agency and more than human agency of life in the waters.

Water walks are forms of kinstillatory glyphing in the sense of being non-permanent choreographic collective forms activating the water's edge. The 2017 Mother Earth Water Walk led by the late Elder Josephine Mandamin, during which water walkers offered prayers, songs, and petitions to the waters carrying a copper vessel and an eagle staff from Spirit Mountain, Duluth, Minnesota, to the St. Lawrence Seaway at Matane, Quebec. Alongside a sister journey by Edward George (Josephine's son) paddling in solidarity through the Picking Up the Bundles canoe journey, Mandamin and other water protectors/walkers journeyed 5,144 kilometres. These sister journeys mobilize collectives as we reorient our bodies and lives toward the waters. The forms that these movements take on can be looked at as upholding the dark matter that in this case is the water. Water becomes the dark matter that connects water protectors in a kinstillatory way. *Honouring Water* (LaPensée 2016), in relationship with the water walking of the Great Lakes, can be thought of as a collective mapping process through sound

and kinesthetic/somatic movement by singing love songs to the water. Since water holds space beneath the gravel and concrete of the cities, *Honouring Water* is a potential modality of social organizing around water—an exercise of spatially/sonically mapping the often hidden (paved over, buried) underground waterways in citified Indigenous territories. Singing love songs evokes a process whereby human beings can radically relate to more than human celestial and aqueous bodies. These actions carry the possibilities for envisioning and activating a consciousness of radical alterity building. As a form of cyphering, walking at the edge of bodies of water indicates creation/recreation as a form of glyphing decolonial love. These embodied acts of radical relationship building create an activated form of futurity in which anything is possible. *Honouring Water* asks us to contemplate how Anishinaabemowin might activate different futures for the waters in the citified Indigenous territories in which we live. LaPensée's digital application also helps us to consider how sound shapes movements, flows, and migrations throughout the cities as gathering spaces. Sonically mapping bodies of water reveals Indigenous scales—also achieved through the aural kinesthetic (Johnson 2012) strategies of singing love songs to water and the creation of spectral graphs of water sounds. We have a futurity because, through the act of the cypher, I have seen it. We can think about the water walk as the creation of the cypher—in which a consciousness is unearthed as in earth diver cartographies/choreographies of creation.

Honouring Water (LaPensée 2016) sonically maps the futurities of water through the creation of vibratory sonic reverbs to flow with the movements of the waters. Sounds' futurity choreography extends beyond scales of settler colonial languages into the verb, an actualization of Anishinaabe wording practices. These forms of sovereignty are also mobilized through breath, tone, syncopation, and movements shaping the collectives sonically into forms of collective organizing around water. Sonic sovereignties can be forms of reclaiming our genealogies (especially as urban diasporic Indigenous peoples), in which our origin stories can be made from fissures, ruptures, and our own inabilities to say our ancestors' names. These other forms of "textual" creativity hold spaces for those names that we might not even know. Water can hold space; it can be the dark matter for our own kin-making desires. I was reminded of these gorgeous/sometimes painful absences through the poetry of Jamaica Osorio, which shows that our genealogies include

those absences, our forgetting, our not knowing. Rematriative cartographies can be embodied practices whereby the health and well-being of Indigenous peoples are intimately linked to radical relationships and a consciousness of viewing land as multi-scalar—as consisting of underground rock, fire, waterways, surface waterways, and celestial cartographies. I believe that it is important to think through what it means to be in relationship with celestial bodies so that we might be able to mimic those processes to find new vocabularies (sonic/visual frequencies and vibrations, including textures and colours) to imagine and create love otherwise—when we might intentionally fall in love with that star, that mountain, or that waterway . . . bringing us closer to who we are.

Notes

1 Imani Kai Johnson describes dark matter as a metaphor for the hip-hop cypher in her 2009 dissertation: "Dark matter is a concept from physics describing the non-luminous matter comprising the majority of the universe. Because it has no light, the force of the dark matter is 'seen' and understood only by way of its gravitational influence on surrounding visible matter. It is thus a metaphor for the invisible force in cyphers that helps hold them together" (11).

2 My use of "jumping scale" references Muscogee Creek scholar Laura Harjo's (2014) application of the term to contextualize acts of body sovereignty (through the stomp dance) to create hidden Indigenous scales on urban Indigenous territories. These activations intervene in the process of containerization of settler colonial scales as pre-fitted scales that we have to conform to. We can ask ourselves "What are the hidden Indigenous scales that gesture 'otherwise' in spaces like Tkaronto?"

3 Black Lives Matter (n.d.) goes on to mention that "the same companies that build pipelines are the same companies that build factories that emit carcinogenic chemicals into Black communities, leading to some of the highest rates of cancer, hysterectomies, miscarriages, and asthma in the country. Our liberation is only realized when all peoples are free, free to access clean water, free from institutional racism, free to live whole and healthy lives not subjected to state sanctioned violence."

4 For further reading, see Belcourt (2017); Benaway (2016); Lee (2016); and Simpson (2013a).

5 Perhaps urban Indigenous peoples embody land by carrying home with us in the form of bones and star matter. In these ways, we also carry rupture (since in space things are constantly blowing up). This rupture can also be useful in generative ways through the collective practice of *sâkihiwâwin*.

6 Cornum (2015) further indicates that, "instead of imagining a future in bleak cities made from steel and glass teeming with alienated white masses shuffling under an inescapable electronic glow, Indigenous futurists think of earthen space crafts

helmed by black and brown women with advanced knowledge of land, plants, and language."

References

Assu, S. 2014. *Spaced Invaders: Digital intervention on an Emily Carr Painting.* http://www.sonnyassu.com/images/spaced-invaders.

Belcourt, B-R. 2017. *The Wound Is a World.* Calgary: Frontenac House.

Benaway, G. 2016. *Passage.* Neyaashiinigmiing: Kegedonce Press.

Black Lives Matter. N.d. "Black Lives Matter Stands in Solidarity with Water Protectors at Standing Rock." *blacklivesmatter.com.* blacklivesmatter.com/solidarity-with-standing-rock/.

Buck, W. 2009. "Atchakosuk: Ininewuk Stories of the Stars." *First Nations Perspectives* 2, no. 1: 71–83.

Campbell, M.V. 2015. "Sonic Intimacies: On Djing Better Futures." *Decolonization, Indigeneity, Education and Society,* 25 March. https://decolonization.wordpress.com/2015/03/25/sonic-intimacies-on-djing-better-futures/.

Cheung, S. 2017. "Meet the Indigenous Artist 'Tagging' Emily Carr Paintings: Sonny Assu on His Exhibit 'We Come to Witness,' on now at Vancouver Art Gallery." *Tyee,* 3 January. https://thetyee.ca/Culture/2017/01/03/Sonny-Assu-We-Come-to-Witness/.

Cornum, L.C. 2015. "The Space NDN's Star Map." *New Inquiry,* 26 January. http://thenewinquiry.com/essays/the-space-ndns-star-map/.

Crawley, A. 2015. "Feeling Otherwise." Talk given at Gallery TPW, Toronto, 7 October. http://gallerytpw.ca/parallel-programming/discursive-programming/ashon-crawley/.

———. 2016. "Otherwise, Ferguson." *Inter Fictions Online: A Journal of Interstitial Arts* 7 (October). http://interfictions.com/otherwise-fergusonashon-crawley/.

———. 2017. *Blackpentecostal Breath: The Aesthetics of Possibility.* New York, Fordham University Press.

Deiter-McArthur, P., S. Cuthand, and Federation of Saskatchewan Indian Nations, eds. 1987. *Dances of the Northern Plains.* Saskatoon: Saskatchewan Indian Cultural Centre.

Ermine, W. 2007. "Ethical Spaces of Engagement." *Indigenous Law Journal* 6: 192–203.

Gaertner, D., K. Recollet, and E. LaPensée. 2019. "Indigenous." *Digital Pedagogy in the Humanities—Concepts, Models, and Experiments | MLA Commons.* https://digitalpedagogy.mla.hcommons.org/keywords/indigenous/.

Ganhdih, D. 2015. *Pussy Vortex* (video). https://www.youtube.com/watch?v=yHqHejoaUyA.

Goeman, M. 2013. *Mark My Words: Native Women Mapping Our Nations.* Minneapolis: University of Minnesota Press.

Gordon, A.F. 2011. "Some Thoughts on Haunting and Futurity." *Borderlands* 10, no. 2: 1–21.

Harjo, L. 2014. "Indigenous Scales of Sovereignty: Transcending Settler Geographies." Paper presented at the meeting of the Native American Indigenous Studies Association, Austin.

Hunt, D. and S.A. Stevenson. 2017. "Decolonizing Geographies of Power: Indigenous Digital Counter-mapping Practices on Turtle Island." *Settler Colonial Studies* 7 no. 3: 372–92.

Hunt, S. 2014. "Witnessing the colonialscape: Lighting the intimate fires of Indigenous legal pluralism." PhD diss., Simon Fraser University.

Johnson, I.K. 2009. "Dark Matter in B-Boying Cyphers: Race and Global Connection in Hip Hop." PhD diss., University of Southern California.

———. 2012. "Music Meant to Make You Move: Considering the Aural Kinaesthetic." *Sounding Out!* 18 June. https://soundstudiesblog.com/2012/06/18/music-meant-to-make-you-move-considering-the-aural-kinesthetic/.

Kelley, R. 1997. *Yo' Momma's Disfunktional! Fighting the Culture Wars in Urban America.* Boston: Beacon Press.

———. 2017. "Robin D.G. Kelley and Fred Moten in Conversation." Great Hall, Hart House, University of Toronto, 3 April.

Knight, L. [Eekwol]. 2009. *Look East* (video) 20 October. https://www.youtube.com/watch?v=ChmYE5M-kNE/.

LaPensée, E. 2015. *Spacecanoe* (digital art). *elizabethpensee.com.* http://www.elizabethlapensee.com/#/art/.

———. 2016. *Honor Water.* Pinnguaq [Computer Game].

Lee, E.V. 2016. "Land, Language and Decolonial Love." *Red Rising Magazine,* 7 November. http://redrisingmagazine.ca/land-language-decolonial-love/.

Longjohn, M. 2010. *Alexis Round Dance 2010* (video). https://www.youtube.com/watch?v=7dXIZd5Syew.

Lum, J. 2017. "Monsters of the Urban Unconscious." *canadianart.ca,* 8 June. http://canadianart.ca/features/duane-linklater-don-valley-toronto/.

Nason, D. 2013. "We Hold Our Hands Up: An Indigenous Woman's Love and Resistance." *Decolonization: Indigeneity, Education and Society,* 12 February. https://decolonization.wordpress.com/2013/02/12/we-hold-our-hands-up-on-indigenous-womens-love-and-resistance/.

Native Youth Sexual Health Network. 2013. "Our Bodies Are a Ceremony of Indigenous Nationhood." 21 November. https://www.nationsrising.org/our-bodies-are-a-ceremony-of-indigenous-nationhood/.

Navarro, J. 2015. "WORD: Hip-Hop, Language, and Indigeneity in the Americas." *Critical Sociology* 42, nos. 4–5: 567–81.

Nixon, L. 2016a. "My Pronouns Are Kiy/Kin." *Red Rising Magazine*, 13 May. http://redrisingmagazine.ca/my-pronouns-are-kiy-kin/.

———. 2016b. "Visual Cultures of Indigenous Futurisms: Sâkihito-maskihkiy acâhkosiwikamikohk." *Guts: Canadian Feminist Magazine*, 20 May. http://gutsmagazine.ca/featured/visual-cultures.

Ogimaa Mikana. N.d. *Reclaiming/Renaming*. http://ogimaamikana.tumblr.com.

Razack, S., M. Smith, and S. Thobani, eds. 2002. *Race, Space, and the Law Unmapping a White Settler Society*. Toronto: Between the Lines.

Recollet, K. 2015. "Glyphing Decolonial Love through Urban Flash Mobbing and Walking with Our Sisters." *Curriculum Inquiry* 45, no. 1: 129–45.

Rose, T. 1994. *Black Noise: Rap Music and Black Culture in Contemporary America*. 6th ed. Hanover, NH: University Press of New England.

Simpson, L. 2013a. *Islands of Decolonial Love: Stories and Songs*. Winnipeg: ARP Books.

———. 2013b. "Politics Based on Justice, Diplomacy Based on Love: What Indigenous Diplomatic Traditions Can Teach Us." *Briarpatch Magazine*, 1 May. https://briarpatchmagazine.com/articles/view/politics-based-on-justice-diplomacy-based-on-love.

Spine of our Mother. By Starr Muranko, Choreographer. Weesageechak begins to dance 28: An annual festival of Indigenous Works, Aki Studio. Toronto, Nov. 20, 2015.

Tuck, E. 2009. "Re-visioning Action: Participatory Action Research and Indigenous Theories of Change." *Urban Rev* 41: 47–65.

WE ARE: the ReMatriate Collective. 2016. *NewJourneys.ca*. 12 October. https://newjourneys.ca/en/articles/we-are-the-rematriate-collective.

Wilson, A. 2015. "A Steadily Beating Heart: Persistence, Resistance and Resurgence." In *More Will Sing Their Way to Freedom: Indigenous Resistance and Resurgence*, edited by E. Coburn, 272–75. Winnipeg: Fernwood Publishing.

Women's Earth Alliance and Native Youth Sexual Health Network. 2016. *Violence on the Land, Violence on Our Bodies: Building an Indigenous Response to Environmental Violence*. landbodydefense.org.

Yamashiro, A. 2015. "Some Baby Steps towards a Decolonial Love Story." *Ke Ka'upu Hehi 'Ale*, 11 May. https://hehiale.wordpress.com/2015/05/11/some-baby-steps-toward-a-decolonial-love-story/.

ACKNOWLEDGEMENTS

This collection has certainly been a long time coming—but the result, we hope, is worth the wait. The initial idea was born out of the 2013 Native American and Indigenous Studies Association (NAISA) annual conference, held at the University of Saskatchewan. Because of the wealth of Indigenous health research at the conference, the editors were able to assemble two edited collections: *Global Indigenous Health* (Eds. Henry, LaVallee, Van Styvendale, and Innes), published by the University of Arizona Press in 2018; and this collection, *The Arts of Indigenous Health and Well-Being*.

First, we would like to express our gratitude to the contributors for their patience and commitment to the project. Your knowledge is a gift.

We also thank Amanda LaVallee, Miriam Muller, and Boabang Owusu. Your work as research assistants in the early stages of the project was critical in providing feedback to the contributors.

We thank the Canadian Institutes of Health Research (CIHR) for providing funding through a health dissemination grant, which supported the mentoring of graduate students and the initial development of the collection. We also thank the Awards to Scholarly Publications Program (ASPP). Finally, we thank the University of Manitoba Press. We are grateful for the care and attention that you brought to the publishing process. The collection is stronger because of your dedication to it.

Adesola Akinleye, PhD, is a choreographer, an artist-scholar, and an assistant professor, dance, at Texas Woman's University. She began her career as a dancer with Dance Theatre of Harlem (United States), later working in Canadian and UK dance companies and running her own dance foundation in the 2000s. She is currently the founder and co-artistic director of DancingStrong Movement Lab (www.dancing-strong.com). Over the past twenty years, she has created dance works ranging from live performances (often site-specific and involving a cross-section of the community) to dance films, installations, and texts. Akinleye's work is characterized by an interest in voicing people's lived experiences through creative, moving portraiture. A key aspect of her process is the artistry of opening up creative practices to everyone from ballerinas to women in low-wage employment to young audiences. She has won awards internationally for her choreographic work, and she is a published author in the areas of dance and cultural studies. Contact: adesola@me.com.

Beverley Diamond is a professor emerita in Ethnomusicology at Memorial University of Newfoundland. She was the first Canada Research Chair in Ethnomusicology at Memorial University, where she established and directed the Research Centre for the Study of Music, Media, and Place (MMaP) from 2003 to 2015. Diamond is known for her research on gender issues, Canadian historiography, and Indigenous music cultures. Her research on Indigenous music has ranged from studies of traditional Inuit and First Nations songs and Saami *joik* to Indigenous audio recording, traditional protocols for access and ownership, and expressive culture in relation to the Truth and Reconciliation Commission on Residential Schools in Canada. Her latest book is *On Record: Audio Recording, Mediation and Citizenship in Newfoundland and Labrador*. Contact: bdiamond@mun.ca.

Nicholle Dragone teaches Native American and American Studies at Dickinson College. She completed her PhD in American Studies and JD at SUNY at Buffalo. She has published articles and book chapters on Native American literature and film, Indigenous rights, and Haudenosaunee history. Contact: dragonnd2@gmail.com.

Until her untimely passing into the spirit world in 2016, **Jo-Ann Episkenew** was director of the Indigenous Peoples' Health Research Centre (Universities of Regina and Saskatchewan and First Nations University). Her research included applied literatures, narrative medicine, narrative policy studies, and trauma studies. Her book *Taking Back Our Spirits: Indigenous Literature, Public Policy, and Healing* (2009) won two major book awards.

Linda Goulet is a professor emerita of Indigenous Education at the First Nations University of Canada, where she taught Indigenous pedagogies, health, and arts education. Her research with First Nations youth using the arts to explore social issues of health grew out of her interest in exploring effective teaching with Indigenous youth. In addition to many other publications, she co-authored a book with Keith Goulet published by UBC Press and entitled *Teaching Each Other: Nehinuw Concepts and Indigenous Pedagogies*. Contact: lgoulet@fnuniv.ca.

Born on the Saddle Lake Reserve in Two Hills, Alberta, in 1953, **Louise Bernice Halfe** is the award-winning author of four poetry collections. Her books *Bear Bones and Feathers*, *Blue Marrow*, *The Crooked Good*, and *Burning in This Midnight Dream* have received numerous distinctions and awards. Her work has been shortlisted for the Governor General's Literary Award for Poetry, the Pat Lowther Award, and the Saskatchewan Book of the Year Award, among others. She has received honorary degrees from Wilfrid Laurier University, the University of Saskatchewan, and Mount Royal University.

Desiree Hellegers is an associate professor of English and affiliated faculty and a founding co-director of the Collective for Social and Environmental Justice at Washington State University Vancouver. Her books include the oral history collection *No Room of Her Own: Women's Stories of Homelessness, Life, Death and Resistance* (Palgrave Macmillan, 2011), which she has adapted into a play. She is a poet, a member/producer of the Socialist-Feminist Old Mole Variety Hour Radio

collective on KBOO Radio in Portland, and a periodic contributor to *Counterpunch* magazine. Contact: desiree.hellegers@wsu.edu; https://www.desireehellegers.com.

Robert Henry, PhD, is Métis from Prince Albert, Saskatchewan, and an assistant professor at the University of Saskatchewan, Department of Indigenous Studies. His research areas include Indigenous street gangs and gang theories, Indigenous masculinities, Indigenous and critical research methodologies, youth mental health, and visual research methods. He is the co-editor of two recent publications, *Global Indigenous Health: Reconciling the Past, Engaging the Present, Animating the Future* (2018) and *Settler City Limits: Indigenous Resurgence and Colonial Violence in the Urban Prairie West* (2019). He has also published in the areas of Indigenous masculinity, Indigenous health, youth subcultures, and criminal justice. Contact: rob.henry@usask.ca.

Robert Alexander Innes is a member of Cowessess First Nation and an associate professor in the Indigenous Studies Program and the Department of Political Science at McMaster University. He is the author of *Elder Brother and the Law of the People: Contemporary Kinship and Cowessess First Nation* (University of Manitoba Press, 2013), the co-editor along with Kim Anderson of *Indigenous Men and Masculinities: Legacies, Identities, Regeneration* (University of Manitoba Press, 2015), and the co-editor along with Robert Henry, Amanda LaVallee, and Nancy Van Styvendale of *Global Indigenous Health: Reconciling the Past, Engaging the Present, Animating the Future* (University of Arizona Press, 2018). Contact: rob.innes@usask.ca.

Petra Kuppers is a disability culture activist, a community performance artist, a professor at the University of Michigan, and an adviser on Goddard College's MFA in Interdisciplinary Arts. She leads The Olimpias, an international disability performance research collective. Her academic books engage disability performance, medicine and contemporary arts, somatics and writing, and community performance. She is also the author of a dark fantasy collection, *Ice Bar* (2018), and her most recent poetry collection is the ecosomatic *Gut Botany* (2020). She lives in Ypsilanti, Michigan, where she co-creates Turtle Disco, a somatic writing space, with her wife and collaborator, Stephanie Heit. Contact: petra@umich.edu.

Warren Linds, an associate professor in the Department of Applied Human Sciences at Concordia University in Montreal, has worked since 2005 as part of the Indigenous Peoples' Health Research Centre in partnership with the File Hills Qu'Appelle Tribal Council Health Services Youth Action Program (YAP). His research and pedagogical interests are in arts-based research and inquiry, ethical practice, and social justice. He has had extensive experience in popular theatre and community development. This background has been critical to his teaching, in which he brings practical experiences and theoretical approaches together. Linds has published in the areas of group facilitation, anti-oppression and anti-racism pedagogy, the fostering of youth leadership, and alternative and arts-based approaches to qualitative research and documentation. Contact: warren.linds@concordia.ca.

Gail MacKay, an assistant professor in the College of Education at the University of Saskatchewan, is Anishinaabe Métis from the Sault Ste. Marie area. Her chapter in this collection was part of her PhD dissertation, a substantive exploration of a local Indigenous rhetoric. In material culture, she found a system of meaning that conveys the principle and philosophy of living life well. Contact: gail.mackay@usask.ca.

J.D. McDougall is a Métis PhD candidate in the Department of English at the University of Saskatchewan whose dissertation focuses on Métis family stories as culturally embedded practices of political kinship within local community history narratives. J.D. has provided illustrations and cover designs for publications such as *Engaged Scholar Journal* (Spring 2018), *Road to La Prairie Ronde* by Cort Dogniez (2020), and this volume. They are currently an instructor of Indigenous Literatures in English at First Nations University of Canada, and an artist-mentor for the Saskatchewan History and Folklore Society's Youth Storytelling Workshop program. Contact: jmcdougall@firstnationsuniversity.ca.

Margaret Noodin received an MFA in Creative Writing and a PhD in Linguistics from the University of Minnesota. She is currently a professor at the University of Wisconsin—Milwaukee, where she also serves as the director of the Electa Quinney Institute for American Indian Education and a scholar in the Center for Water Policy. She is the author of *Bawaajimo: A Dialect of Dreams in Anishinaabe Language*

and Literature and two bilingual collections of poetry, *Weweni* and *Gijigijigikendan: What the Chickadee Knows*. Her poems are also anthologized in *New Poets of Native Nations, Poetry, Michigan Quarterly Review, Water Stone Review*, and *Yellow Medicine Review*. Her research spans linguistic revitalization, Indigenous ontologies, traditional science, and prevention of violence in Indigenous communities. To see and hear her current projects, visit www.ojibwe.net, where she and other students and speakers of Ojibwe have created space for language to be shared by academics and the Indigenous community. Contact: noodin@uwm.edu.

Mamata Pandey is a research scientist at the Saskatchewan Health Authority in Regina. She employs innovative research techniques to identify evidence-based strategies that can improve the quality of care for patients in the health region and in rural and remote First Nations communities in Saskatchewan. She started her career as a clinical psychologist in India and then completed her second master's degree and a PhD in Experimental and Applied Psychology from the University of Regina in 2013. She was a postdoctoral fellow at the Indigenous Peoples' Health Research Centre. Having lived and worked in three different countries (India, Switzerland, and Canada), she has knowledge of health-care services and systems in countries around the world. Contact: mamata.pandey@saskhealthauthority.ca.

Karyn Recollet is an assistant professor in the Women and Gender Studies Institute at the University of Toronto. She is an urban Cree whose research explores the multiple layered relationships that urban Indigenous folks have with lands' overflow. Karyn's focal points are choreographic fugitivity, Indigenous futurities, and decolonial love/processes of creating radical relationalities with kin. Contact: karyn.recollet@utoronto.ca.

Nuno F. Ribeiro is a senior lecturer and research cluster lead, Tourism and Hospitality Management, RMIT University, Vietnam. His research agenda deals primarily with the comparative study of culture and behaviour in tourism and leisure contexts. Broadly, his research interests comprise culturally derived belief and behaviour models in tourism destinations, young people's behaviour in tourism destinations, visual methods in tourism research, and cross-cultural tourism behaviour. Contact: nuno.ribeiro@rmit.edu.vn.

Andrea Riley-Mukavetz is an assistant professor of Integrative, Religious, and Intercultural Studies at Grand Valley State University. She is a co-chair of the American Indian Caucus, the past chair of the Cultural Rhetorics Conference, a board member of the Cultural Rhetorics Consortium, and the current editor of the pedagogy blog for *Constellations: A Journal of Cultural Rhetorics*. Her scholarship has appeared in *Studies in American Indian Literature, College Composition and Communication, Enculturation, Rhetoric, Professional Communication, and Globalization*, and *Composition Studies*. Her book *You Better Go See Geri: An Odawa Elder's Life of Resilience and Recovery* is forthcoming from Oregon State University Press in 2021. She is a citizen of the Chippewa of the Thames First Nation (Deshkan Ziibiing Anishinaabek) and of Chaldean and Lebanese heritage. In her spare time, she enjoys gardening, spending time at Lake Michigan, making ribbon skirts, and caring for her two daughters. Contact: rileymua@ gvsu.edu.

Alena Rosen is a settler-Canadian educator, researcher, and artist living in Treaty 8 territory in northern Alberta. She holds an MA in Native Studies from the University of Manitoba. She currently teaches Indigenous Studies online at several Canadian post-secondary institutions. She co-developed and coordinated the massive open online course "Indigenous Canada" for the University of Alberta. Contact: alena.e.rosen@gmail.com.

Prior to her retirement, **Karen Schmidt** was the health educator for the File Hills Qu'Appelle Tribal Council in Fort Qu'Appelle, Saskatchewan, and the community partner of the research project Acting Out! But in a Good Way. She has experience teaching in the public school system and in a postsecondary teacher education program. As a health educator, she provided information to schools and communities for topics such as FASD, HIV/AIDS, sexual health, smoking, and healthy medication use. She was the driving force behind the Healthy Communities: Healthy Youth Project, in which a committee of youth and adults gather regularly to address issues of self-esteem and healthy living for youth.

Nancy Van Styvendale is an associate professor in the Faculty of Native Studies at the University of Alberta who researches and teaches in the fields of Indigenous carceral writing; arts-based programming in prisons; and community-engaged learning. She has co-edited two previous collections: *Narratives of Citizenship* (University of Alberta Press, 2011) and *Global Indigenous Health* (University of Arizona Press, 2019), as well as a special issue of *Engaged Scholar Journal* on community service learning in Canada (2018). Contact: nancy.vanstyvendale@ualberta.ca.

INDEX

Aboriginal Healing Foundation, 124
Adams, Amber, 149
Aglukark, Susan, 139
AIDS crisis, 198, 203, 209, 210. *See also*
 HIV
Akan, Linda, 27, 37n2
Akinleye, Adesola, *Rose's Jingle Dress*:
 the boy-with-no-voice, 62–63;
 connection and interaction, 67–69;
 Heyokha, 62; Jingle Dress dancing,
 65–66; Kaydence, 9, 60, 61–62,
 64–65, 69–70; *mitakuye oyasin*,
 61, 73; performance as cathartic
 ritual, 60; Raelene (*tiyospaye* niece),
 61; Rose walking, 65–66; signifier
 of Western concept of identity,
 70; *tiyospaye* (extended family/
 kin group), 9, 60, 61, 65, 67, 69;
 Western dualism, 72; witnessing
 and storytelling, 63–67
Aksayook, Etuangat, 84
Akulukjuk, Anna (Elder), 83
Allan, B., 141
Alurista, 201
Anawak, Jack, 89
Anishinaabe culture: pedagogical practice
 of self-directed contemplative
 inquiry, 23; philosophy of
 education, 24; relationship to
 Saulteaux culture, 37n2; teachings
 of being alive well, 23
Ansloos, J.P., 98
Antone, Bob (Elder), 149–50, 171n4
Anzaldúa, Gloria, 201, 205, 216n5
Appiah, Kwame, 70, 72
Applegate Krouse, Susan, 56
Archibald, Linda, 1, 97
Arnakak, Jaypetee, 89
Arnaquq, 83
arts programming for Indigenous youth:
 areas of benefit to Indigenous
 research, 97; benefits of, 98–99;
 community responses to and
 involvement with, 98, 103, 107;
 documentary video program, 101–
 2, 103–4, 105, 107; effect of safe

space, 95, 96, 98, 100, 105, 108, 110;
 goals of project, 103; graffiti wall
 program, 101–2, 104, 105, 106–7,
 108, 109; implications of the study,
 109–10; importance of imagination
 in, 95–96; as intervention for youth,
 112; mask program, 101, 102, 108;
 pride gained from, 108, 109, 111,
 114–15; promotes good health,
 95; as vehicle for information
 collection and dissemination,
 96–97. *See also* facilitating arts
 programming for youth
asema (tobacco), 35, 48–50, 83, 185, 226
Assu, Sonny, 240
Awiakta, Marilou, 1
Aztec cultures, 200–201, 203, 205, 214

Barthes, Roland, 28
Bear, Cheryl, 139
bimaadiziwin/pimadizewin (being alive
 well/the good life) (Anishinaabe),
 8, 34, 37n2. *See also* Indigenous
 concepts of health and wellbeing
Black, Jaime, 239
Blight, Susan, 238
Boas, Franz, 83
Brertton, George (Elder): *Wahkohtowin:*
 The Relationship of Cree People and
 Natural Law (2009), 2
Brooks, Lisa, 8–9, 43–44, 48
Brownlie, R., 126
Buck, Wilfred, 231–32

Campbell, Maria, 27, 29
Carr, Emily, 240
Carson, A. J., 98, 111, 114
Cartwright, L., 28
ceremonies, 29; *Calla Lilies* (Niro), 161,
 163; contribute to living the
 good life, 4, 7; criminalization of,
 134; Elders and, 223, 226; Fox,
 Matthew, 227; gathering basket
 weaving materials, 54; *Heyokha*,
 73n4; *iskwêwak* (women) in,
 227–28; in *Kissed by Lightning*